'GLASGOW GIRLS'

WOMEN IN ART AND DESIGN 1880-1920

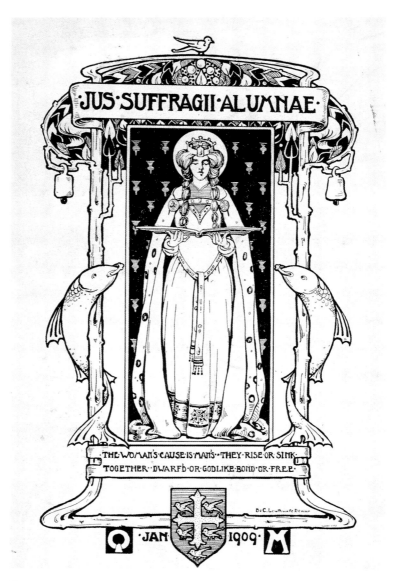

fig. 1
The Woman's Cause is Man's, De Courcy Lewthwaite Dewar, 1908, 20.5 × 15.3. (Coll: H.L. Hamilton. Photo: Glasgow Museums and Art Galleries)

'GLASGOW GIRLS'

WOMEN IN ART AND DESIGN 1880-1920

EDITED BY JUDE BURKHAUSER

CANONGATE

First published in Great Britain in 1990 by
Canongate Publishing Limited, 16 Frederick Street, Edinburgh
with Jude Burkhauser, 'Glasgow Girls' Research, Mackintosh School of Architecture, Glasgow School of Art, Glasgow

The Publishers acknowledge subsidy from the Scottish Arts Council and The Paul Mellon Centre for Studies in British Art towards the publication of this volume.

Design of the catalogue: Isabelle C. McGuire and Angie McCallum
Titles: McColl Design

British Library Cataloguing in Publication Data
'The Glasgow Girls': Women in Art and Design 1880—1920.
 1. Scotland. Strathclyde Region. Glasgow. Visual Arts,
 history
 I. Burkhauser, Jude
 709.41443

ISBN 0-86241-306-0 hardback
ISBN 0-86241-332-2X paperback

Set in Bembo by Advanced Filmsetters, Glasgow
Printed and Bound in Great Britain

cover: Detail: Opera of the Sea, Margaret Macdonald Mackintosh, 1920—1. Courtesy Hessisches Landesmuseum
 Above: Sketch, Helen Paxton Brown, 1897
 Editor's Photo: Valerie Josephs

 SOTHEBY'S

Subsidised by the
Scottish **A**rts Council

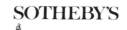 Funded from Glasgow District Council's Festivals Budget.

This book is published in conjunction with the major retrospective Exhibition of the same title presented in association with Glasgow Art Galleries & Museums and The Glasgow School of Art and organised under the aegis of The Glasgow Junior Chamber of Commerce (Glasgow Girls Exhibition) Ltd. and curated by Jude Burkhauser.

Made possible through the generous support of:
Strathclyde Regional Council

with funds from
Glasgow District Council's Festivals Budget

The McColl Arts Foundation
Sotheby's

and subsidised by the
Scottish Arts Council

with seed funding from
The Scottish Development Agency

The organisers gratefully acknowledge the assistance of the following who have provided sponsorship and or services to the exhibition: Concord Lighting; W. & M. O'Neill (Contractors) Ltd.; the sponsorship of W. & M. O'Neill has been recognised by an award under the Government's Business Sponsorship Incentive Scheme which is administered by the Association for Business Sponsorship of the Arts (ABSA); N. S. Macfarlane Charitable Trust; Lithgow Charitable Trust; British Midland; Timber Terminal: Robert Fleming Holdings.; J. S. Armstrong (Painting Contractors) Ltd.; Artworks The Framemakers; Rab Ha's; Apollo Window Blinds; Wylie & Bisset CA; B & S Colour Lab Limited; McClure & McClure Solicitors, Clyde Colour Laboratories; Compaq Computers Manufacturing Ltd.

For . . . the next generation
and their grandmothers

There is one elementary TRUTH — the ignorance of which kills
countless ideas and splendid plans:
The moment one definitely commits oneself, then Providence
moves too. All sorts of things occur to help one that
never otherwise would have occurred. . . .

Whatever you can do,
Or dream you can do,
Begin it.
Boldness has genius, power and magic in it.
Begin it now.

—Goethe.

ACKNOWLEDGEMENTS

Special thanks for encouragement and assistance to: Jacqueline McColl whose enthusiasm saw me through the rough patches and whose support and encouragement were 'Providence' moving for me; to Ailsa Tanner whose advice was invaluable, to Dr Thomas Howarth for generous encouragement, advice and support; to H. L. Hamilton for patience and hospitality in allowing me to work with the De Courcy Dewar archives; to Mary Armour, Honorary President of Glasgow School of Art, for a warm and genuine welcome and acceptance of an 'American in Glasgow'; to Hugh and Joan, Elspeth, Ian and Robert McClure, my Rotary 'family' in Scotland who welcomed me into their home and their lives for what they thought would be a year, now evolved to three and to the Rotary International Foundation Scholarship Program for International Understanding; Professor David MacGowan for early encouragement and assistance; Ewan MacPherson and the Scottish Development Agency who provided the 'bridge across the Atlantic' which allowed me to continue the project in its earliest stages; special thanks to Simon Cottle, Depute Keeper, Glasgow Art Gallery and Museum for his invaluable assistance; to the Directors and members of The Findhorn Foundation, whose support and inspiration allowed the seeds of the project crucial energy, space and time in which to grow; special thanks to Professor Andy Macmillan, Mackintosh School of Architecture, for providing a project base for the 'Glasgow Girls' to fully evolve; to Stephanie Wolf-Murray and Neville Moir of Canongate Publishing for their patience and advice; and special thanks to my family, especially my mother, Dorothy Burkhauser, whose four granddaughters – Alexis, Susie, Laura and Cassie – will never want for female role models.

Sincere appreciation also to my support staff: Editorial Assistants: Jessica Russell, Bille Wickre, and Sarah Hodgson; Project Coordinator: George Fairfull-Smith; Project Assistants: Suzanne Finn, Susan Taylor, Lise Bratton, Veronica Matthew, Susana Whitman, Sheila O'Neill, Elizabeth Mackintosh; Sally Darlington; Graphic Designers: Isabelle McGuire and Angie McCallum; Volunteers: Fiona McArthur, Jenny Lennox, Susan Maresco, Melanie Sims; and to Elizabeth Cumming and Margaret Stewart.

Thanks also to those who helped in numerous ways: The Honourable James Jennings, Strathclyde Regional Convenor; Susan Baird, The Lord Provost, City of Glasgow District Council; Catriona Reynolds, Robert Bain, Lindsay Johnstone-Colville, John Taylor, Pamela Brown, and the Junior Chamber of Commerce; Ian Woodburn, Marion Love and Norma Mackay, Strathclyde Regional Council 1990 Office; Bob Palmer, Neill Wallace and Tessa Jackson, Glasgow Festivals Unit 1990; Glasgow Museums and Art Galleries: Julian Spalding, Director, Stewart Coulter, Depute Director; Decorative Art Department: Brian Blench (Keeper), Depute Keeper Simon Cottle, Liz Arthur, Charlotte Haw; Jonathan Kinghorn, Department of Fine Art: Anne Donald (Keeper), Hugh Stevenson; Deborah Haase; Andrew Patrizzio and Geraldine Glynn, Norman Ferguson, Jem Fraser, Ian Urquhart, Alexandra Miller, Jim Stewart, Ellen Howden, Davina Graham, Maureen Kinnear, Maria Fernanda Medina; Glasgow School of Art: William Buchanan, Lesley Paterson, Peter Trowles (Mackintosh/Taffner Curator), Ian Monie and George Rawson, (Library); Michael Moulder; Michael Graham; the Department of Historical and Critical Studies, especially Ray McKenzie, Laura Rae, Lynn McLaughlin; Dr Alec James, Michael Strang and Robert Strong, Mackintosh School of Architecture Computer Room; Bill Winger, Scottish Development Agency; Philippe Garner, Richard Purchase, Cathy Lawless, Sue Pollen, Michael Heseltine, Hugh Kelly and Keith Lloyd of Sotheby's, London; Anthony Weld-Forester, Sotheby's, Glasgow; Christina Orobitz, Sotheby's, Toronto; Willem de Winter, Sotheby's, Amsterdam; Veronique Schwabelande, Sotheby's, Munich; Gudrun Ludin, Sotheby's, Frankfurt; Harry McCann, Maggie Bolt, Robert Livingston, Scottish Arts Council; Mr. Stewart McColl, Alex Ritchie, Fiona Grant, Nick Corney, Terry MacGillicuddy, Simon Scott-Taylor, Paul Byrne, McColl Design; Andrew McIntosh Patrick and Roger Billcliffe, Fine Art Society; Hunterian Art Gallery, University of Glasgow: Pamela Robertson (Mackintosh Curator); Barclay Lennie; Dr. Sigrun Paas, Hessisches Landesmuseum, Darmstadt; Glasgow Society of Women Artists: Louise Annand (President); Torquil MacFadyen, Wylie & Bisset CA; McClure & McClure Solicitors; the staff of the Glasgow Room, Mitchell Library; Eddie Friel, Greater Glasgow Tourist Board; Janet Turner, Concord Lighting; William O'Neill,

Margo Clyde, W. & M. O'Neill (Contractors) Ltd.; Liz Bryan, British Midland; Sir William Lithgow; Professor Michael Kitson; Alistair Hopkins; Rab Ha's; Peter Devlin and Wendy Hamilton, Timber Terminal; James Armstrong, J. S. Armstrong (Painting Contractors) Ltd.; T. & R. Annan and Sons Ltd.; Steven Carruthers, Artworks The Framemakers; Andy Page and Douglas MacGregor, Clyde Colour; Compaq Computers Manufacturing Ltd.; Robert Fleming Holdings; Susan Laidler, Laider Stained Glass and Design; Judy Moir; Whitford and Hughes; Piccadilly Gallery; Steven M. Shear, Mark D. Brown, S. E. Shear, Gordon Bosworth, B & S Colour Lab Limited; James Macaulay, Catharine Stevenson; William Connelly; Jennifer Shewan May; Dr Mabel Tannahill and Dr. David Jones; Janet Wilkie; Joseph Farrell; Ann Smith; Anne Ellis; Valerie Josephs; Mrs Chandler Bigelow; Mr Allen P. Bigelow, Mr C. Burnham Porter; Herbert Press, London; Frau Anna Muthesius; Joachim Buehler; Wilhemina Holiday (Founder), Lee Hall (Director), Susan Sterling (Curator), National Museum of Women in the Arts, Washington, D.C.; Mrs. Marion Reid and Mr. John Lyle; Karen Mountain and Helen Petrie.

We would like to thank the following individuals and institutions for lending works of art, photographic and archival material and for their assistance in many other ways:

Institutions and Public Collections, UK:
Aberdeen Art Gallery; City of Edinburgh Art Centre; Dumbarton District Libraries; Glasgow Museums and Art Galleries; Glasgow School of Art; Glasgow Society of Women Artists; E. A. Hornel Trust, Kirkcudbright; Fine Art Society, Glasgow; Fischer Fine Art, London; Imperial War Museum, London; Lillie Art Gallery, Milngavie; Manchester City Art Gallery; McLean Museum and Art Gallery, Greenock; Mitchell Library, Glasgow; National Galleries of Scotland; National Gallery, London; National Library of Scotland; National Museums and Galleries on Merseyside, Walker Art Gallery; National Portrait Gallery, London; National Trust For Scotland; Paisley Museum and Art Galleries; Royal Museums of Scotland; Scottish National Gallery of Modern Art; Scottish National Portrait Gallery; Tate Gallery, London; Victoria and Albert Museum; Hunterian Art Gallery, University of Glasgow; Special Collections, University of Glasgow Library; University of Glasgow Archives; University of Liverpool Art Gallery; special thanks to the Stewarty District Council and the Trustees of the E. A. Hornel Estate who hold the copyright to Jessie M. King material. The director of Environmental Health and Leisure Services Department, Canon Walls, High Street, Kirkcudbright DG6 4JG is the point of contact for use of this material.

Institutions and Public Collections, International:
Austrian Museum of Applied Art, Vienna; Bibliotheque des Arts Décoratifs, Paris; Hessisches Landesmuseum, Darmstadt; KröllerMüller Rijksmuseum, Otterlo; Österreichische Galerie, Vienna; Stedelijk Museum, Amsterdam; National Museum of Women in the Arts, Washington, D.C.

Individuals:
The Alexander Family, Lady Lorna Anderson, Dr Edward Armour, Victor Arwas Esq, Lady Alice Barnes, Miss Vea Black, John Blackie, Esq and Jane Blackie, Mrs M. Briscoe, Miss Jean Stewart Brown, Mr and Mrs K. D. M. Cameron, Ruth Currie, Mr I. S. Davidson, the Family of P. Wylie Davidson, Baroncino De Piro, Mrs Joan Valerie Dunn, Mrs Lena Fleming, Cyril Gerber, the Family of Mary and Margaret Gilmour, H. L. Hamilton Esq, Mrs Mary-Anne Heap, Mrs R. M. Hedderwick, Michael Heseltine Esq, Dr Thomas Howarth, Jolien Hudson Esq, Professor and Mrs Inglis, H. R. Jack, S. I. Jackson Esq, John Jesse, Judy Kerr, Vincent Kosman, Mrs Vivien Latta, Robert Lawrence Esq, Barclay Lennie Fine Art, Dr I. D. Lloyd-Jones, Dr and Mrs J. P. Lomax, Christine Lyons, Mrs Sheena MacBryde, Mr and Mrs Stewart McColl, Mr W. McLean, Brian and Liz McKelvie, Ms Liz Mackinlay, Mrs Sheila Macmillan, Frances, Jean and Elspeth MacRobert, Professor Ronald Mavor and James Mavor Esq, Mrs Rachel Moss, D. Murray, Mr and Mrs S. Norwell, Martin Reid Esq, Mrs Campbell Reynolds, Ms Catriona Reynolds, Mrs J. W. Robson, Dr Gillian Rodger, Margot Sandeman, Mr Peter Shakeshaft, Mr David Somerville, Dr Mabel Tannahill, John W. D. Thomson Esq., Anne Paterson Wallace, Ms Jean Wannop, Judith Witt, George Wyllie Esq, and to all those lenders who have asked to remain anonymous.

CONTENTS

Contents (continued)

ILLUSTRATION LIST

Unless otherwise indicated, sizes in the captions are in centimetres, height before length, without frames.

Key to abbreviations: GSA = Glasgow School of Art; GMAG = Glasgow Museums and Art Galleries; HAG = Hunterian Art Gallery; Annan = T & R Annan and Sons Ltd., Glasgow; PC = Private Collection; V&A = Victoria and Albert Museum, London

fig. 2
Exterior, Glasgow School of Art, Charles Rennie Mackintosh, 1897–99, 1907–09. (Glasgow School of Art)

14

FOREWORD

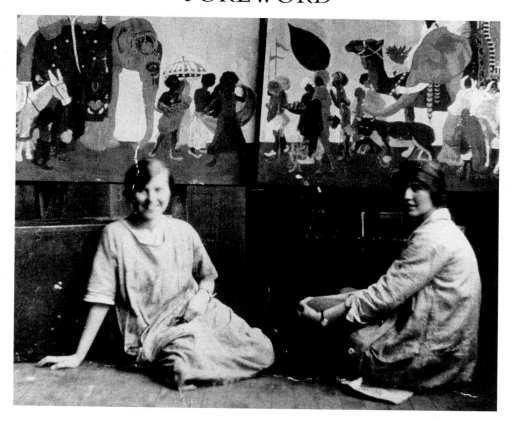

I am delighted *'Glasgow Girls'* is being presented. Some may find it surprising to see the high quality of work of the women artists and designers included in this book. There is great need for the book and it is remarkable it is being done at long last. Although there have been excellent women artists and designers from Glasgow, Scottish women have never been very assertive at promoting their work. In fact, until the 1988 Exhibition '"Glasgow Girls": Women in the Art School 1880–1920' at Glasgow School of Art, I had never exhibited my work in the School.

I remember my first day at the Glasgow School of Art in 1920. At Hamilton Academy my art mistress Penelope Beaton had called my father in to ask him to send me on to the Art School for training and he had agreed. I was so excited and nervous and carrying so much that I got stuck in Rennie Mackintosh's swinging door! I must have looked confused and a tall girl came up and asked me if she could help. She was Margaret Nairn (d. 18th May, 1990), who later spent a lot of time painting in Morocco, and we've been friends ever since.

I remember well most of the people mentioned in this book: Fra and Jessie Newbery, Ann Macbeth with her dresses covered in embroidery, Dorothy Carleton Smyth in startling, unusual clothes that she had made herself and De Courcy Lewthwaite Dewar in her enamelling classes—they were all there at the School. I

was asked to teach in the first-year studio of Dorothy Carleton Smyth while I was still a student. Newbery brought up Anning Bell and Maurice Greiffenhagen from the south to teach painting. Then Forrester Wilson arrived and we had the first of the Scottish Colourist painters. It was quite a time.

Now, if you had told me the day I was caught in the front door that one day they would make me the President of the place, I would not have believed it. But it's true. They invited me to be the Honorary President of the School a few years ago. My advice to any young woman walking through that door today: it won't be easy, the life of an artist is never easy, things have changed some, though, and there are now more and more opportunities for women in art and design. No, it won't be easy and you may get caught in the doors, but you *can* do it. This book shows what women can and do accomplish in art, if they are given opportunities and are able to meet the challenges and difficulties and keep working.

Mary Armour
Honorary President Glasgow School of Art

fig. 3
Mary Armour and a friend seated before a mural at the Glasgow School of Art, 1920s. (Glasgow School of Art)

PREFACE

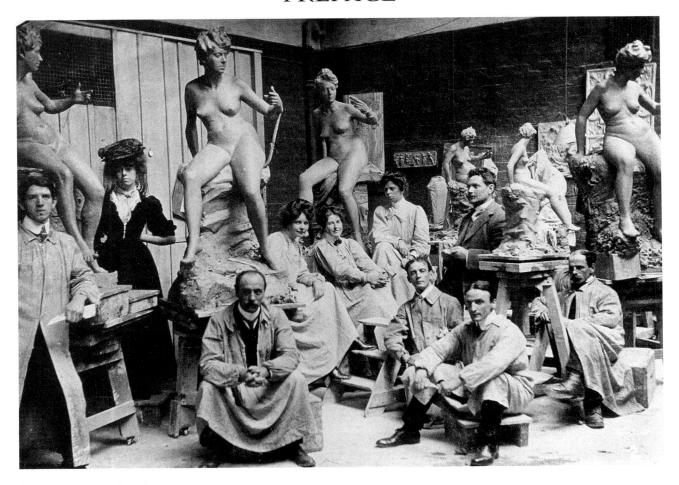

fig. 4
William Reid Dick, tutor, with students in a sculpture class at Glasgow School of Art, *c.*1900. 'The New Woman' at Glasgow School of Art, was found in the sculpture studios alongside the men. (Glasgow School of Art)

This book provides a comprehensive overview of the work of women artists and designers in Glasgow at the turn of the century. It is an investigation into their lives, their achievements and the historical circumstances in which they found themselves. Because of the breadth of its scope, it has involved gathering together contributions by a number of scholars working in a variety of different specialisms. Several of the texts are reproduced from earlier articles which have proved so influential that it was felt they deserved to be brought to a much wider readership. Placed in the context of an extensive body of new writings, the result is intended to offer as complete a survey of relevant scholarship in this field as is possible at the present time.

The overall editor of this volume, indeed the driving force behind the entire project, has been Jude Burkhauser, with whom I had the privilege of collaborating in the summer of 1988 on an exhibition presented at Glasgow School of Art under the deceptively similar title of '"Glasgow Girls": Women in the

Art School 1880–1920'.[1] Although this focused on the specific issue of education, it was clear from the extraordinary richness of historical material it brought to light that a more wide-ranging treatment of the subject was required. It was this that provided the stimulus for the present study.

Although it is not part of my task here to become too closely involved with the various issues that are examined in the essays which follow, a few words must be said about our use of the expression 'Glasgow Girls'. Some misunderstanding was created by the adoption of this ambiguous sobriquet as the title for the pilot show, and it is important that our reasons for repeating it here are explained.

Of course we were aware from the beginning of the semantic risk involved in using the diminutive 'Girls' in relation to mature women artists. Indeed, given the often vexed arguments that surround the question of gender-specific nomenclature, it would have been naïve to suppose otherwise. Even so, we were a little

surprised by the hostility it provoked from the small minority of critics who found our phraseology objectionable. Cordelia Oliver, for example, seems to have been more disturbed by its title than any of the works it contained, recommending, within somewhat questionable taste, that it should have been 'drowned at birth'.[2] At least one other writer claimed in private correspondence to have found the term 'both problematic and distasteful'.

Although these criticisms are not to be dismissed as idle carping, they did seem to us to represent a rather crudely literal response to the name. For one thing, they ignored the deliberate allusion to the better known group of Scottish male artists known as the Glasgow Boys, the implications of which were central to the exhibition. But more crucially they also overlooked the fact that our exhibition was by no means the first occasion on which the expression 'Glasgow Girls' had been used. In fact, by 1988 the term had already acquired an independent history of its own—a brief one, to be sure but one that nevertheless illuminates an important issue: the relationship between language and our changing perception of the contribution of women to art history.

Consider some basic facts about the recent emergence of feminist concerns in Scottish art history. Less than thirty years ago, Glasgow Art Gallery presented an exhibition of *Scottish Painting* in which a heavy emphasis was placed on the late nineteenth century.[3] Although the Boys were featured in abundance, not a single work by a woman artist was included. Describing itself as 'a generous representation' of late nineteenth-century artists, and designed to offer 'a new look at their achievements', it may be taken as the *tabula rasa* of our subject, with women's issues registering as zero on the scale of Scottish cultural concern. In 1968 the Scottish Arts Council organised a more comprehensive exhibition of the work of the Boys, and it is in William Buchanan's catalogue essay for this show that the phrase 'Glasgow Girls' appears to surface for the first time.[4] Admittedly, its use here is immediately qualified by the reminder that their 'proper title' should really be the Glasgow Society of Lady Artists, but at least the issue had found its way on to the historical agenda. In 1976 Ailsa Tanner wrote for the catalogue, *West of Scotland Women Artists*, and laid the foundation for a programme of serious scholarly research which is only now beginning to come to fruition. In the meantime, and on a much broader front, we have seen the growth of the women's movement, with all this has implied in terms of its impact on our understanding of the processes of history. Feminist methodologies have not only proved an effective tool for bringing the work of previously neglected women artists into the mainstream of historical debate, but have, in the process, forced many sectors of the academic community to reconsider their approach to the whole task of historical analysis. It was in the new context of this emergent historical consciousness that three feminist artists—Jacki Parry, Kaye Lynch and Sheena MacGregor—published their manifesto for *Women Artists in Glasgow*,[5] which presented the issue of women artists' participation in Glasgow's art history as a challenge to orthodox art critical thought. 'Everyone has heard of the Glasgow Boys,' they concluded, 'but there were and are the Glasgow Girls too.'

The value of this brief etymological digression is that it mirrors a wider pattern of developing awareness, with the changing connotations of the phrase 'Glasgow Girls' providing a lucid illustration of how attitudes are now slowly being transformed. It marks the stages through which women artists in Scotland have emerged from the penumbra of history to become the centre of a demand that the cultural record should now be examined in full.

The fact that the phrase used in our title continues to be regarded by some as problematic demonstrates how thoroughly our language is still strewn with the booby-traps of gender inequality and prejudice. If it is 'distasteful' to describe Bessie MacNicol as a 'Girl', why do we encounter no such moralistic qualms when art historians routinely designate her friend E.A. Hornel as 'one of the Boys'? The entire strategy of this book has been devised to place questions of just this kind under scrutiny. What the term 'Glasgow Girls' signifies is that a method of analysis has been employed which is concerned to expose the power-structures through which history operates, rather than merely document the events that occur within it. Glasgow at the turn of the century was a melting-pot of conflicting historical and cultural forces, the complexity of which is nowhere more clearly registered than in the changing situation of women artists. It is this situation, with all its multiple ramifications, that this book sets out to unravel.

Ray McKenzie
Glasgow School of Art

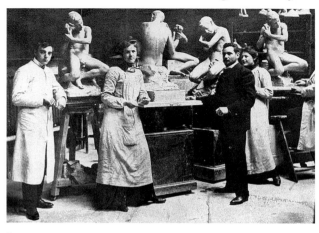

fig. 5
Women in the Sculpture Studios at Glasgow School of Art, *c.*1890s.
(Glasgow School of Art)

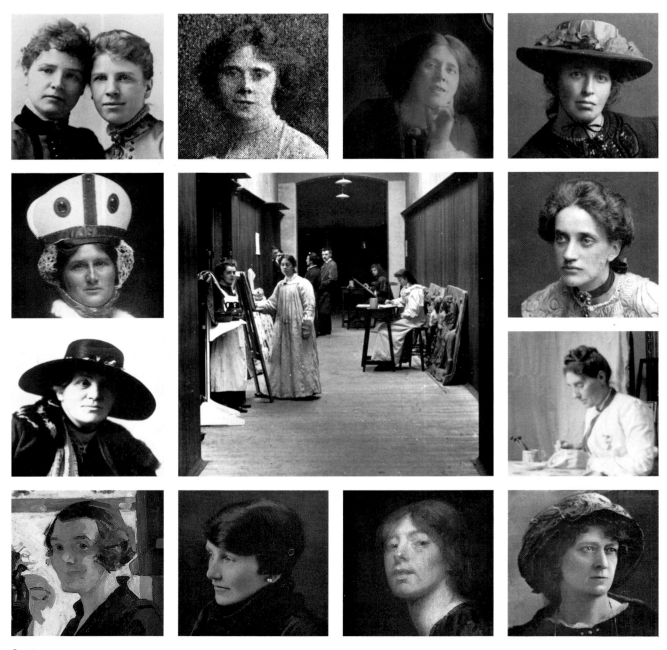

fig. 6
Women in Art and Design in Glasgow 1880–1920. Included top left clockwise: *Margaret Gilmour* (right), c.1900, *Frances Macdonald*, 1903, *Margaret Macdonald*, 1900, *Jessie Newbery*, c.1900, *Ann Macbeth*, c.1900, *Helen Walton*, c.1900, *Annie French*, c.1900, *Bessie MacNicol*, c.1894, *Norah Neilson Gray*, c.1918, *Dorothy Carleton Smyth*, n.d., *Jessie M. King*, c.1920, *De Courcy Lewthwaite Dewar*, c.1940. Centre: Women students at the Glasgow School of Art, c.1900. (T & R Annan and Sons, Ltd., Glasgow. Photo: Glasgow School of Art)

'RESTORED TO A PLACE OF HONOUR'
by Jude Burkhauser

One century ago in Glasgow an art movement emerged which 'burst upon the European scene' known as the Glasgow Style (*c*.1895–1920). Many talented female personalities were central to its development including Margaret and Frances Macdonald, Jessie Newbery, Ann Macbeth and Jessie M. King. It was 'their progressive ideas' which contributed to a 'broadening of the social, educational and aesthetic directions of their time.'[1] One of the most significant influences upon this group was the Glasgow School of Art which each of them attended and through which they came into contact with each other's work (fig. 2). An outgrowth of this contact was the Glasgow Society of Lady Artists' Club, the first residential club in Scotland run by and for women which was to play a central part in Glasgow's cultural life. Although the Glasgow Style refers primarily to avant-garde design developments, there was also a movement in painting, known initially as the Glasgow School and later by the epithet 'Glasgow Boys' (1880–*c*.1910) which also typifies the then 'revolutionary' nature of the work being done.

The years of the Glasgow phenomenon, from *c*.1880 to 1920, are bordered by major movements including Arts and Crafts, Art Nouveau, Art Deco and the Modern movement and by important visual art movements including Impressionism, Post-Impressionism, Fauvism, Cubism, and Expressionism. The role of women within these movements has been largely neglected and this book is one of an increasing number which answers a growing demand by women to uncover, understand and document their heritage in the arts. As a group of contemporary Glasgow women artists have stated: 'If we are to create a context for ourselves then it is vital that we initiate research, assembling and collating material about women's lives and the traditions established by women, especially those within local grasp which have been lost, hidden, or edited out. It is then equally vital that this archive is made available and accessible.'[2]

International focus on the Glasgow Style, precipitated by world-wide recognition of its major figure, Charles Rennie Mackintosh, has helped to illuminate the work of his early collaborators—'the Four': his wife Margaret Macdonald, her sister Frances Macdonald and Herbert MacNair. This has resulted in growing interest in the contribution made by women to the 'Scotto-Continental' Art Nouveau movement. *'Glasgow Girls'* documents the remarkable women who played a very important role in the development of the Glasgow Style and while it cannot be comprehensive due to lack of documentation available and the number of women involved, it presents the main protagonists and provides a new context for recognition of their accomplishments.

Writing in 1980 of the lack of information available on Scottish women artists, freelance art historian Ailsa Tanner stated that although there had 'been women artists working in Scotland for the last two hundred years and more . . . little was known about them and less than justice had been given to them in print.'[3] Although in 1980 there was almost no critical work published on Scottish women in art and design,[4] some progress was made and several articles and essays emerged, written primarily by the authors in this book. Despite their varied and significant contributions, until *'Glasgow Girls'*, there was no comprehensive overview of women's roles in this fascinating period of Glasgow's cultural history. Tanner initiated a series of local exhibitions on West of Scotland women artists and produced essays on Scottish women painters. In this volume, she documents in depth the major figures in painting including Bessie MacNicol. Another important painter, Norah Neilson Gray, whose contribution had never been fully explored, is documented by Catriona Reynolds and myself. An essay by Ray McKenzie, tutor in Historical and Critical Studies at Glasgow School of Art, provides a concise and informative overview of the 'Glasgow School' painters and the location of women in relation to the 'Boys'. It was not until 1984 that the first series of biographical references for the Glasgow Design movement appeared in the *Glasgow Style* exhibition catalogue (1984). Two of the authors, Juliet Kinchin and Jonathan Kinghorn, together with Liz Bird, now provide an overview of the social history which promoted the Glasgow phenomenon and accompanied its decline. Liz Bird's work on women in art education in *Uncharted Lives* (1983), paved the way for her essay in Chapter 2 which now places Glasgow women within the context of the rapidly expanding opportunities in art education for women throughout Great Britain. The essay which accompanies Bird's follows from my exhibition catalogue, *'Glasgow Girls': Women in the Art School 1880-1920* and affirms the central role of Francis (Fra) Newbery, Headmaster (fig. 8) and his partner Jessie Rowat Newbery (fig. 7) and the Glasgow School of Art in the development of 'Scotto-Continental' Art Nouveau. Unquestionably, the central figure of the era is Charles Rennie Mackintosh and his well-known and highly regarded biographer, Dr Thomas Howarth, Professor Emeritus, University of Toronto School of Architecture, provides an informative new perspective on Mackintosh and the women of the Mackintosh group. Many researchers since Howarth's seminal work on Mackintosh (1952) have approached the architect's contribution but none have considered it from Timothy Neat's perspective found in Chapter 4 which should prove controversial and will no doubt expand the parameters of the debate on the Glasgow

fig. 7
Jessie Newbery (née Rowat), c.1885, 'viewed embroidery in a new light' and with Ann Macbeth, brought the Glasgow School of Art Embroidery Department to international recognition. (Glasgow School of Art)

fig. 8
Francis (Fra) Newbery, c.1885, the dynamic new Headmaster of the Glasgow School of Art whose enlightened direction provided equal encouragement to male and female students. (Glasgow School of Art)

phenomenon. Curator of the Mackintosh Collections at the Hunterian Art Gallery, University of Glasgow, Pamela Reekie (now Robertson) curated an exhibition and wrote the first significant monograph on a woman of the group, Margaret Macdonald Mackintosh, in 1983. Her essay (now out of print) has been updated for this book. Liz Arthur, Keeper of Textiles at Glasgow Art Gallery and Museum, co-authored a catalogue essay on the Glasgow School of Art Embroidery movement which now informs her analysis of central figures Jessie Newbery and Ann Macbeth in Chapter 4. In addition, the inclusion of a body of unpublished new research on as yet undocumented women provides a first-time resource on this fascinating era, the women, and their achievements. Louise Annand, President of the Glasgow Society of Women Artists, writes on designer Annie French. Progressive ideas of the group who called themselves the 'Immortals' are presented in the New Woman section, along with essays on the Glasgow Society of Lady Artists' Club and the Artistic Dress movement. The Glasgow Style and its genesis are outlined from a new point of view and the significance of the Macdonald sisters' 'New Woman' in

art is presented in my essay in Chapter 3. Ian Monie documents the female contributors to *The Magazine*; essays by myself and Janice Helland explore the enigmatic Frances Macdonald; an essay on De Courcy Lewthwaite Dewar, afforded through discovery of a series of private letters, was also written by myself with research assistance from Susan Taylor; a perspective on the 'Sisters' Studios' movement including such unrecorded figures as Dorothy and Olive Carleton Smyth, Helen Paxton Brown, Jane Younger and others is provided by Liz Arthur, Anne Ellis, Bille Wickre and myself.

Any reclamation of women's history in art and design must be undertaken with a consciousness of new perspectives in art historical methodology which have emerged primarily from theorists in Britain during the last decade. The work we consider here must be re-evaluated within a fully informed context, and in an effort to 'cultivate an awareness which in itself might yield a different future'[5] Hilary Robinson and Adele Patrick provide feminist-informed analysis of visual iconography in Chapter 5. This view may be an unfamiliar one to some readers yet is essential to a valid re-assessment of the period. In an effort to define

the need for this perspective more clearly a brief explanation of the genesis of the 'Glasgow Girls' project is important here.

In 1987–89 I enjoyed the opportunity to work as research scholar at Glasgow School of Art. My independent studies prior to this had acquainted me with the distinguished history of the School, most notably Charles Rennie Mackintosh. But it was Anthea Callen's book, *Angel In the Studio: Women in The Arts and Crafts Movement 1870–1914* which truly raised my interest—for here I learned that a group of Glasgow women designers had achieved prominence in the arts contemporarily with Mackintosh, yet the accounts I had read had never mentioned their contribution to the development of the Glasgow Style. Here, I learned, Jessie Newbery and Ann Macbeth had 'pioneered' new concepts in design, both in education and textiles, which had spread around the world; and here, I learned, Margaret Macdonald was more than an appendage to her husband Charles Rennie Mackintosh and had (it was claimed) with her sister Frances Macdonald, been 'central to the evolution of the Glasgow Style.'[6]

What was it, I wondered, that had given rise to these accomplishments, so rarely recorded of women at that time? Why Glasgow? How Glasgow? And why, if these women artists had been so visible in 1900, had they become 'invisible' in 1988? Why, for example, had I not been able to read about them before this? Perhaps, I reckoned, it was because I had been living in America not Scotland, not in Glasgow, where surely they would be fully documented and well-known?

It was not until my participation in the first Women-in-Art seminar to be offered in the history of the School, that the clear focus of the project emerged. For, although I graduated in 1970 from a college of art and design in the USA after four years of lectures based on Janson's *History of Art*, (wherein not one woman had been mentioned as an artist),[7] I found I had arrived years later at Glasgow School of Art to discover that Gombrich's *The Story of Art* (wherein not one woman had been mentioned as an artist),[8] was the first text recommended for first-year students. It is not surprising that the students with me in the seminar had never heard of most of the women in this book. This scenario is a familiar one in many art schools where the search for textual materials which present a fully balanced view of the history of art turns up little. There is much work to be done before the Gombrichs and Jansons of art history have been re-edited to include the chapters on women that have been edited out or never written.

In an article in *Arts Magazine* (1981), 'Beyond Gardner, Gombrich, and Janson: Towards a Total History of Art', Eleanor Tufts called for a re-editing of women artists into traditional texts.[9] This echoed Gloria Orenstein, who called for reclamation of women's art history saying: 'When the names of important women artists are included in art history

books and courses we will know that women have made a significant revolution in intellectual and cultural history.'[10] But such reconstructive methodology was unacceptable to 'second generation' feminist critics such as Griselda Pollock and Carol Duncan who proposed deconstructive tactics and claimed, 'more and better criticism within established modes—old art history with women added were not the real solutions.' Instead they claimed, 'the value of established art thinking and how it functions as ideology must be critically analysed, not promoted anew.'[11] British theorist Pollock defined the responsibility with which she saw art history invested regarding representation of women in art, claiming its role a crucial one, for 'on the one hand art history takes as its object of study a form of cultural production and ideology—art. On the other hand, the discipline itself is a component of cultural hegemony maintaining and reproducing dominative social relations through what it studies and teaches, what it omits and marginalises, and through how it defines what history is, what art is, and who and what the artist is.'[12]

In Glasgow, Liz Bird found evidence to support this theory when she examined shifting art historical biases in relation to ideological biases concerning the 'minor' (decorative) arts versus the 'major' arts (painting, sculpture, architecture) in relation to the Glasgow Style. Examining Glasgow artists she found: 'Compared to the previous and subsequent development of the visual arts in Scotland, women were here being recognised as artists, and were able to earn their living through their art by working as teachers and selling their designs,' but also noted 'the relative invisibility of these women when viewed through the spectacles of art history which obscure the work of women and illuminate the work of men.' Bird contended this was because of the 'operation of the dominant ideology which constantly centralises some art products and marginalises others.'[13]

Pollock and Parker had further explored this issue in *Old Mistresses* where they postulated there was no place for women in the language of art history where the 'myth of the free, individual creativity is gender specific . . . exclusively masculine.' They insisted the issue could not be resolved by overcoming neglect of women by art historians, or exposing diverse forms of discrimination but claimed that to discover the history of women and art we must account for the way art history is written. Their research revealed women were always involved in the production of art, but in the twentieth century, 'with the establishment of art history as a widely taught, institutionalised academic discipline . . . women artists were systematically obliterated from the record.'[14] To achieve new balance in accounts 'second generation' critics have proposed a new theoretical discipline be formed to counter women's omission. They urge 'historical recovery of data about women artists to refute the misconceptions

about them.' In addition, they argue for 'deconstruction' of 'old' art history, for they propose monographs which document women artists and how they 'negotiated their conditions and situations,' are important, but insist this analysis be done without falling into the trap of the 'great artist' model monographs which even with a feminist perspective only reinforce the 'circumscribed, Romantic concept of greatness and genius.' The magnitude of the task this informed consciousness had set up was one that, I realised, would require contributions from many who could reclaim bits of the larger story before the Gombrichs and Jansons could be rewritten or discarded entirely for balanced sources.

'Glasgow Girls', a collaborative project which emerged from this awareness, aims to contribute to that larger story. Bringing together nineteen authoritative voices, it concerns itself with rediscovery and re-definition of the group of women artists whose common link was their attendance at and involvement with Glasgow School of Art. Investigation of their common bond—educational opportunity—adds credence to the thesis of Linda Nochlin's essay, 'Why Are There No Great Women Artists?' in which she states: 'the fault lies not in our stars, our hormones, our menstrual cycles, or our empty internal spaces, but in our institutions and our education. . . .'[15] 'Glasgow Girls' affirms the importance of access to enlightened education and the provision of significant role models for women art students in their process of self-determination and individuation, still a recent phenomenon in the history of civilisation:

> . . . all those nonexistent female Newtons and Bachs and Leonardos and Shakespeares . . . have had no more chance of leaping up from the prison of their societal fates than any Greek slave, or a nomad's child in Yemen today. The emancipation of women is spectacularly new . . . it is clear that emancipation does not instantly result in achievement. Enlightenment must follow. And enlightenment has, for women, and especially by women, not yet occurred.[16]

There was a 'period of enlightenment' both *for* women and *by* women, which occurred at Glasgow School of Art from about 1885 to 1920 and which resulted in a significant but unrecorded period of international visibility. One of the most valuable contributions of these forgotten women may be the fact that they stood as exceptions to the rule in pursuit of a career in the arts *at all* within the span of their lifetimes. Nochlin points out: 'for a woman to opt for a career at all, much less for a career in art, has required a certain amount of unconventionality, both in the past and at present . . . deprived of encouragements, educational facilities, and rewards, it is almost incredible that a certain percentage of women . . . actually sought out a profession in the arts.'[17] In an article on the portrayal of women in American fiction, Wendy Martin contends that literature needs to create a new mythology for women, 'a new vision of Eve—of a woman who is self-actualising, strong, risk-taking, independent, but also capable of loving and being loved. . . .'[18] So, too, is there great need for a new mythology in the visual arts, not only through the portrayal of women in the images produced by artists, but also in the patterning of personal role models—the 'new Eve'—with whom women in the arts may identify, for: 'The importance of women entering "masculine" professions . . . may not so much be that the profession itself is directly changed, but that the aspirations of the rising generation of women are.'[19] It is through creation of their own 'mythology' and in this 'writing of their own histories' that 'Glasgow Girls' contributed toward that 'new Eve'. The fact of their lives as artists at the brink of women's emergence from centuries of invisibility stands as a significant fact to be reinserted when the chapters on women, quietly edited out, are written in again. For here, in 'rich, raw, Glasgow' at the turn of the century, a group of women were for the first time in history able to attend classes in the day sessions of the city's art school and for the first time in history had access to live models (albeit draped ones, under chaperone).[20] And here, in the Glasgow School of Art under the tutelage of an enlightened new Director, they found 'encouragements, educational facilities, and rewards' for their work. Yet the fact that this group of Glasgow art students subsequently contributed a new form to the history of figurative representation dubbed by their critics 'The Spook School';[21] were part of the then revolutionary Scottish Impressionist school of painting known as the 'Glasgow Boys';[22] had their work featured in some of the most prestigious, avant-garde international art journals of the day (*Ver Sacrum, Dekorative Kunst, The Studio*); that their work contributed significantly to the development of a clearly definable and distinctive Glasgow Style that resonates even today in the history of design;[23] and that their paintings, prints and varied decorative artworks were well represented in international exhibitions and their illustrations and philosophical works published throughout Great Britain and abroad is not blazoned in the art histories.

As Anthea Callen has shown in *Angel In The Studio*, the work of women artists was widely published and acknowledged at its time as a 'womanly' art form but when this Victorian assessment vanished from the record with no category to replace it, so too, did women artists and designers, including those from Glasgow School of Art.[24] From that time the work of women tended to be dismissed as a footnote. As with S.T. Madsen, in his important work, *Sources of Art Nouveau* (1923) who dismissed the significance of women in the 'Scotto-Continental' movement and particularly the work of Jessie Newbery in his footnotes:

11 J. Meier-Graefe, Enwicklungsgeschichte der modernen Kunst, I–III Stuttgart, 1904–05, vol. II, p. 620. 'In Glasgow English Art was no longer hermaphrodite but passed into the hands of women.'

12 G. White, Some Glasgow Designers, Part III, The Studio, vol. XII, 1898, p. 48. There is nothing especially new in her maxims, but it is interesting to see the decorative principles of the time, so clearly put into words, particularly her feelings for opposition of straight lines to curved, which contrasts with Chr. Dresser's view. See 'Cult of Plant and Line,' note 26.[25]

While Madsen sees 'nothing especially new in Newbery's maxims' except to note that they 'contrast' with the ideas of Christopher Dresser, and relegates her to a 'footnote', Rozsika Parker argues in *The Subversive Stitch* (1984) that: 'aspects of her [Newbery's] "creed" completely transgress the confines of femininity. She speaks the language of desire, not that of duty, says firmly what she likes and what she wants. . . . She renounces obedience and announces her independence of "our fathers". . . . Not only does she reject the self-denying stance of femininity, but she views embroidery in a new light. . . .'[26] Parker demonstrates that, contrary to Madsen's opinion, there *was* something 'especially new' in Newbery's design maxims (fig. 9). In a recent article in *Arts Magazine*, John Loughery writes of exactly this type of 'delimiting of woman's talent and achievements' and what will be needed to counteract it:

> . . . a group of New York women artists, appalled at the small number of women included in MOMA's famous re-opening show, the 1984 'International Survey of Recent Painting and Sculpture', meet to band together as an agitprop political group. They call themselves 'THE GUERILLA GIRLS'. They will be, they say, the conscience of the art world. . . . The Guerilla Girls . . . don't want a quota system for Biennials or theme shows. They're not talking about a feminist version of affirmative action. They are interested, one gathers, in something larger—more like a deeper perception of the ways in which this delimiting of woman's talent and achievements takes place, an awareness which in itself might yield a different future. . . .[27]

This awareness can be cultivated through the re-examination of women such as Newbery, relegated to the footnotes of art-historical accounts.[28]

A new art criticism is emerging, created and refined by women themselves. For too long we have been presented with a partial account determined by gendered attitudes, beliefs and preconceptions. A 4th October, 1941 review in *Cue Magazine* of American artist Louise Nevelson demonstrates this bias: 'We learned the artist is a woman, in time to check our enthusiasm. Had it been otherwise we might have hailed these sculptural expressions as surely by a great figure among moderns.'[29] This same gender-bias may be observed in relation to 'Glasgow Girl' Margaret Macdonald (fig. 12). In letters from architectural critic

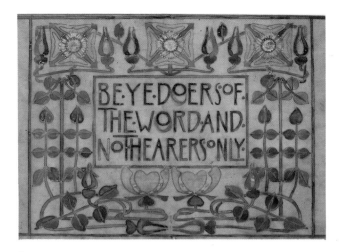

fig. 9
Be Ye Doers of the Word, Jessie Newbery, watercolour, design for pulpit fall, *c.*1900, 35.5 × 50.1. Newbery's affirmation of self-determination is summed up in her credo '*that* for our fathers, *this* for us'. The scriptural verse Newbery chose to embellish this pulpit fall, 'Be Ye Doers of the Word and Not Hearers Only' affirms her philosophy of active rather than passive participation by women. (Glasgow School of Art)

P. Morton Shand to William Davidson, executor of the Mackintosh estate, during preparations for the Mackintosh memorial exhibition held in Glasgow in 1933, Shand strongly objected to Macdonald's inclusion. We see his prejudice, not only toward women but also toward 'artists', Art Nouveau, and 'purely decorative' art *per se*:

> I was . . . glad to notice . . . Mackintosh's partial adherence to that *baneful 'art Nouveau'* movement was realised and deplored. I say 'Deplored' because, speaking for myself I rather hope that the emphasis of the exhibition will be on the abiding (the structural) qualities of his work as a great pioneer, and not on what might be called his 'artistic' contributions, which merely reflected a happily transient phase of taste. *It seems to me clearer than ever that this side of his work was the result of his wife's influence.* If I stress this point it is simply that I should not like leading foreign architects . . . to think that Mackintosh was being honoured in his native city as much for what has no abiding value in his work as for what the whole Continent pays tribute to. If I may put it so without offence, Mrs Mackintosh was scarcely even a Mrs Browning to her Robert. His mentality anticipated the future with amazing prevision, hers was statically contemporary, and contemporary to a *still-born, purely decorative phase of art.* Doubtless Mackintosh was what is called *an 'artist', a word now happily passing into disuse*, but he was also an architect, and a very great one. It is for these reasons that I hope that the exhibition may not be so arranged or announced as to give the impression that Mrs Mackintosh was in any sense considered

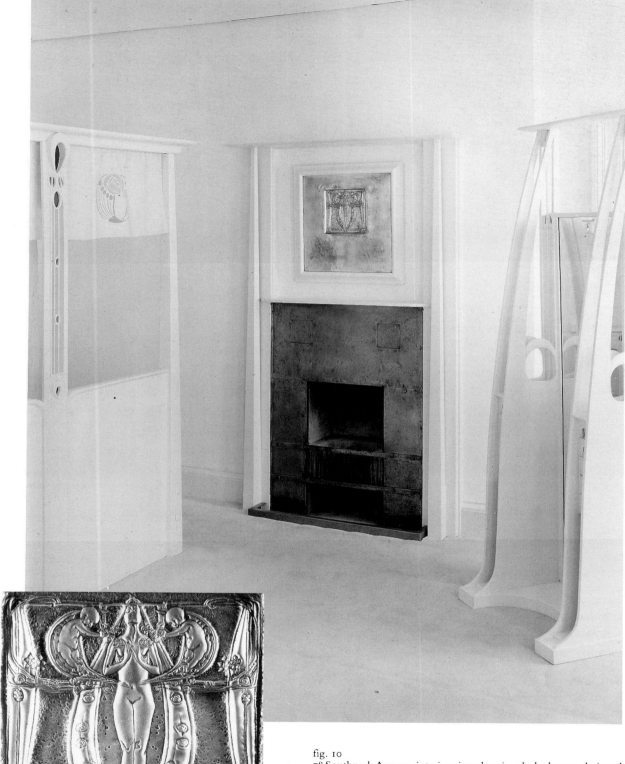

fig. 10
78 Southpark Avenue, interior view showing the bedroom, designed by Charles Rennie Mackintosh with Margaret Macdonald Mackintosh, *c*.1906. (Hunterian Art Gallery)

fig. 11 (*inset*)
Metal inset for over-mantel in bedroom at 78 Southpark Avenue, designed and made by Margaret Macdonald Mackintosh, 1899. (Hunterian Art Gallery)

fig. 12 and 13
Margaret Macdonald and Charles Mackintosh, collaborators, c.1900. Margaret was credited by Desmond Chapman-Houston as 'an artist of high gifts' who had 'undoubted influence on the development of her husband's style, an influence and inspiration which he was always proud to acknowledge, and which no student of his work can fail to observe.' (*Artwork*, 1930, Vol. 6, No. 21). (T & R Annan and Sons Ltd., Glasgow)

her husband's equal, or 'alter ego'. Outside of circles of loyal friends in Glasgow and Chelsea her work is either unknown, or long since forgotten; and the future is scarcely likely to see her rather thin talent restored to a place of honour.[30] [my italics]

In attributing Mackintosh's 'artistic' contributions to Macdonald, Shand affirms the extent of her influence on what now constitutes a highly respected phase of his work. Critics attributed to Macdonald what they judged the 'weakening' of Mackintosh's work; the use of certain colours in his interior schemes, particular curvilinear aspects in his design motifs, and certain panel insets in furniture. As the architect's reputation fluctuated according to current critical thought, with it too fluctuated the reputation of Macdonald. As acceptance evolved with regard to the Glasgow Style and Mackintosh's international recognition was affirmed, attributions were quietly reversed. Davidson defended Macdonald's inclusion saying that in the interest of the estate he was pledged to show the work of both artists. Shand further clarifies his dismissal of Macdonald:

> I did not wish to advocate elimination of her work, so much as anything which would seem to imply that her work was in any sense of comparable importance with her husband's. . . . Roughly speaking, what will interest the Continent is purely Mackintosh's architectural-structural work; *not the dead and forgotten 'artistic' or 'decorative' frills which so often marred it.* . . .[31] *Only when he had to build, and so work in single harness, does he seem to have seen beyond that narrower orbit of his own vision which was his wife's.* It would appear to have been the florid coarseness of her wholly inferior decorative talent and a firm insistence on 'me too'

that too often led him into an uxorious ornamental vulgarity.[32] [my italics]

By the 1960s when Macdonald and Mackintosh's work was selected for inclusion in the 'International Exhibition of Modern Jewellery', and the design arts had begun to gain respect again internationally, the citation for Margaret Macdonald would read: 'Married C. R. Mackintosh 1900, and then *collaborated in all his work, considerably influenced the development of his style.*' And for Mackintosh: 'Architect *and designer*, the most original British *artist* of his day and leader of the "Glasgow School", a *pioneering group* of architects *and designers* who exercised great influence in England, on the Continent, and in America.'[33] [my italics]

What follows is an attempt to step beyond the gendered stereotypes and limiting beliefs which misinformed and pre-determined Shand and his colleagues' approach to art history and look again at Margaret Macdonald's work and the work of her contemporaries. This exercise is undertaken not with the intention to vindicate Macdonald by disputing Mackintosh's central position in the Glasgow School, but rather by questioning the relevance of an art historical methodology which thrives on the notion that great artists somehow transcend the concrete circumstances of history. As Ray McKenzie noted, 'the fact that this generation of women artists valued such things as co-operation and mutual support, and were

motivated by genuinely collective aspirations may never cut much ice among those who subscribe to Shand's view of history. The research on which 'Glasgow Girls' is based suggests that it is high time we considered the alternative view'.[34]

In *A Woman's Touch*, Isabelle Anscombe re-represented design history from this inclusive perspective and pointed out that although the practical influence of women on modern design was enormous 'the fact that their contribution has been overlooked has led to a narrow and distorted interpretation of the true scope and achievements of the design movements of the twentieth-century'. In documenting an international selection of women in design from 1860 to the present day including the Macdonald sisters she maintained that 'the study of the lives of women designers and their pragmatic approach to design leads inevitably to a radical reassessment of the history of twentieth-century design'.[35]

'Glasgow Girls' helps to mark the trail. Not only does it identify and document a selection of women who played a significant role in the avant-garde movement in Glasgow, but places them in this new context, examining some of the conditions and situations they negotiated in their struggle to define themselves as artists. In the process, one hopes that this book may allow a contemporary audience the opportunity to re-evaluate their contribution and that it will add to the ongoing reassessment of art and design history of the twentieth century.

What is important is that women face up to the reality of their history and their present situation, without making excuses or puffing mediocrity. Disadvantage may indeed be an excuse; it is not, however, an intellectual position. Rather, using their situation as underdogs in the realm of grandeur and outsiders in the realm of ideology as a vantage point, women can reveal institutional weaknesses in general, and, at the same time that they destroy false consciousness, take part in the creation of institutions in which clear thought—and true greatness—are challenges open to anyone, man or woman, courageous enough to take the necessary risk, the leap into the unknown.[36]

Here is a group of women in art and design from Glasgow who took that leap.

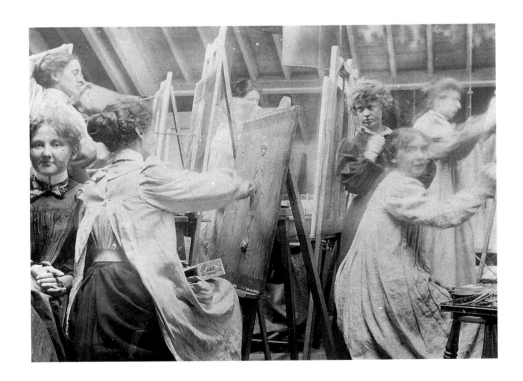

fig. 14
Ann Macbeth and Annie French in drawing class at the Glasgow School of Art, *c*.1910–12. (Glasgow School of Art)

'SECOND CITY OF THE EMPIRE': GLASGOW 1880–1920

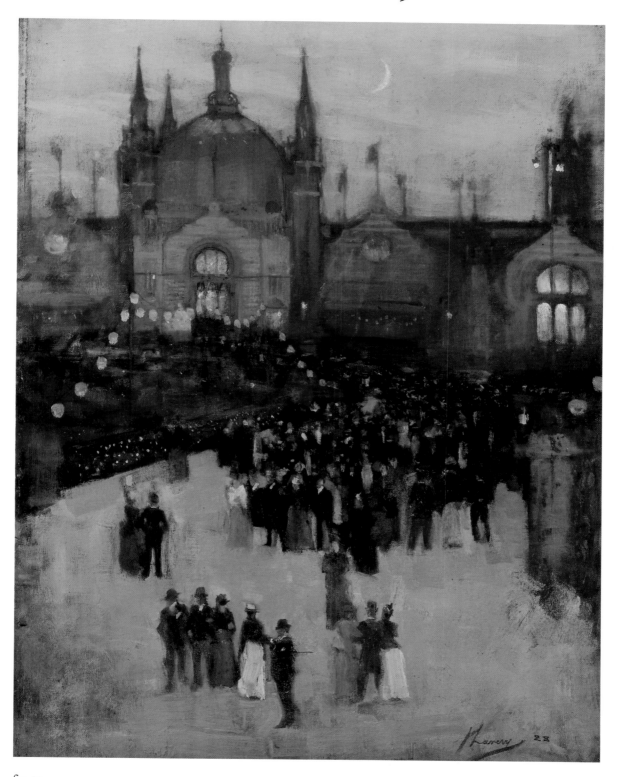

fig. 15
The Glasgow 1888 Exhibition, Sir John Lavery (1856–1941), 61.0 × 45.7, oil on canvas, signed and dated 1888. (Glasgow Museums and Art Galleries)

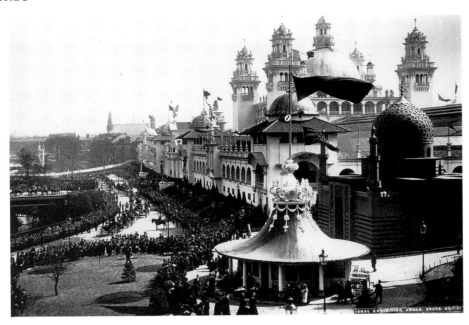

'SECOND CITY OF THE EMPIRE'
by Juliet Kinchin

By 1900 Glasgow was one of the richest cities in the world, the 'Second City' of the British Empire, with a population of around three-quarters of a million people. It had become the successful commercial, social and service centre for a huge hinterland, and through its advantageous coastal location, commanded a vast international market. All the components of industrial pre-eminence were at hand: a ready supply of skilled, cheap labour and technological expertise; a great river for steam power and transportation; easy access to both raw materials and imports. The production of textiles, which had been central to Glasgow's economy since the eighteenth century, was steadily outstripped by the growth of new, heavy engineering industries, in particular ship and locomotive-building. The scale of such enterprises was phenomenal—North British Locomotives, an amalgamation of three companies formed in 1902, was the largest company of its kind in the world; approximately half the ships afloat world-wide at the turn of this century were Clyde-built.

The mushrooming of Glasgow's population was accompanied by a general rise in standards of living. More people had more money to spend than ever before. Improvements in the transportation infra-structure meant that for the middle classes, workplace and home became increasingly distinct, and that those who could afford to moved away from the vicinity of the slums and factories in the eastern districts of the city in search of greater amenity. New middle-class residential districts were developed rapidly in the west end and south of the river. In such a mobile society, visual differentiation through fashion and domestic furnishings became ever more important and the desire

to consume was further dramatised and accentuated by Glasgow's relative economic instability—fortunes were rapidly made and lost. A whole host of mutually supporting specialised trades contributed to the Glasgow interior. Even the more modest tenement flats had elaborate plasterwork, with stained glass and decorative tiles in the close (the common stair). Still more prestigious was the purchase of fine art.

The growth in domestic spending was mirrored in the ever-growing demand for new institutional, commercial and recreational buildings—theatres, pubs, factories, warehouses, railway stations, etc. Tremendous civic pride and funds were invested in public buildings, such as the new University complex on Gilmorehill (1878), the grandiose Municipal Chambers (1888), and the Glasgow Art Gallery and Museum, Kelvingrove (1901). Another huge area of demand which was crucial to the development of Glasgow's furnishing industry was the kitting out of ships and trains. They had close-fitting, odd-shaped compartments which required high quality joiner work. Many yards had their own cabinet and upholstery works. The floating palaces built on the Clyde (fig. 17) helped to disseminate the reputation of Scottish firms for well-made, stylish furnishings all over the world.

The growth of consumption and demand encouraged the multiplication of supply businesses, which

fig. 16
A view of the Glasgow 1901 International Exhibition opening day parade. The royal party arriving outside the Industrial Hall on opening day. The mosque-like structure on the right is the pavilion of James Templeton and Co., the famous Glasgow carpet manufacturer. (T & R Annan and Sons, Ltd., Glasgow)

became increasingly specialised and sophisticated. As in other manufacturing centres, there were major changes in methods of production, distribution and retailing. The new 'scientifically' organised factories being built along the banks of the river Clyde were geared to production levels way exceeding local demand. Wylie and Lochhead's paperstaining factory, for example, was producing some 1,000 miles of wallpaper every fortnight by the 1880s. Many such firms had branches abroad, backed up by further networks of agents and buyers spread throughout Europe, the Empire and America. Templeton's carpet factory (architecturally modelled on the Doge's Palace, Venice) opened in 1889 for the operation of thirty Axminster patented looms, and fed branches of the firm in Manchester, London, Melbourne and Montreal. Production in such factories was increased through the introduction of new machinery and/or the intensive division of labour. In Glasgow the increasing separation of production from selling was also marked. Key shopping promenades were gradually shifted from the Trongate near the medieval core of the city, towards the newly built-up area in the west where the more fashionable and wealthy clientèle was to be found. The experience of shopping was transformed by the development of huge and glamorous department stores. Through a complex combination of retailing, manufacturing and subcontracting, such emporia catered for their clients' every need from the cradle to the grave.

Social and economic change in Glasgow expressed itself in the creation of two types of social space: one was the public world, peopled largely by men, the other was the private or domestic sphere inhabited by women and children. The ways in which art and design of the period were both produced and consumed reflected this dichotomy. The split was also symbolised through conventions governing the use of certain materials, colours, styles and motifs.

There was a strict hierarchy within the arts. The major official Fine Arts of oil painting, sculpture and architecture were dominated by men with women largely confined to the lesser arts of watercolours, drawing, design and handicraft. Although the latter were considered ladylike pursuits, such art was not taken very seriously by the establishment and commanded little commercial value. The main artistic institutions were run by and for men and the growing public support for the arts in the municipal institutions did not change the gender balance. Women were absent from the public spheres of local government just as they were absent from the artistic institutions. The places of exhibition and display, the social venues for fine artists and the sources of patronage and support, all centred on networks which were almost exclusively masculine. It is only when we turn our gaze from the public to the private or domestic that women become visible. If we make another shift, from the fine to applied arts of

fig. 17
Ship and Crane on the Clyde, Mary Viola Paterson, *c.*1930, wood engraving. (*The Engravings of Viola Paterson*, Centaury Press, 1983)

design and craft, we also discover that here women played an important and significant role.

ART INSTITUTIONS IN GLASGOW

by Liz Bird and Juliet Kinchin

Three important art institutions existed in Glasgow by 1880. The first, and perhaps most important of these was the Glasgow School of Art, which primarily trained designers from its inception as a Government School of Design in *c.*1840.[1] Design skills were vital to Glasgow's economy, and employers increasingly came to recognise the selling power of artistic product design and marketing. The way artefacts looked was too important to leave to the whim of a machine operative, and the activity of designing was rapidly hived off from production. It was to meet the need for trained designers rather than artists that the Glasgow Government School of Design was founded. In 1852 the school was placed under the control of the South Kensington Science and Art Department in London, although it was still largely funded and administered by members of Glasgow's industrial élite.

Design and craftwork were less socially prestigious than fine art, and a recurrent fear expressed in debates concerning art education at this time was that design students would be encouraged to ris above their station through aspiring to be artists. In general, manufacturers were more interested in technical facility than artistic originality. Civic and artistic interests

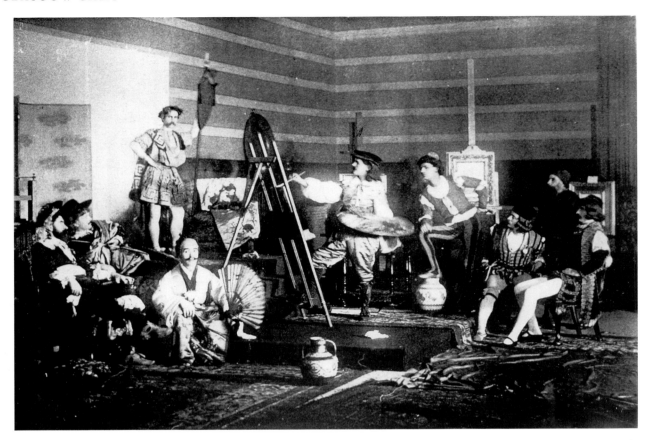

merged over the issue of design education. The provision of art schools, galleries and museums was seen as directly beneficial to local prosperity and progress. Apart from conferring municipal prestige and raising standards of design, such institutions were viewed as weapons for social improvement.

The Glasgow School of Art was a crucial focus for women artists and designers in this period. First located on Ingram Street, its second home was in galleries which belonged to the Corporation of the City of Glasgow, the Corporation having inherited the liabilities of the building and the collection of paintings which it contained through the will of Archibald McLellan who died in 1856. McLellan's paintings formed the nucleus of the civic or public collection. During our period the School of Art was to move into its own premises, designed by Mackintosh, and opened in two stages in 1899 and 1909. The funding and responsibility for the school came under the jurisdiction of the Scottish Education Department in 1899, having been transferred from South Kensington.

The second important art institution in the city was the Glasgow Institute of the Fine Arts, a private exhibiting society which had been founded in 1861 and held an annual exhibition of work for sale. In c.1880 it had just moved into new purpose-built galleries on Sauchiehall Street. The history of the Institute demonstrates the virtual exclusion of women from the fine arts. The lay members who formed the governing

Council and the joint hanging committee of artists and lay members were entirely composed of men. Women could exhibit at the Institute but their numbers were very small, ranging from eighteen works by women out of 672 in 1878 to thirty-four out of 1,000 works in 1882.[2] The women exhibitors also tended to work in the less prestigious medium of watercolour. There was an increasing local public involvement in the housing of the municipal art collections. The McLellan Galleries on Sauchiehall Street had been condemned as inadequate at the same time as the pictures were discovered to be highly valuable. Eventually, new galleries (now known as Kelvingrove) were built and opened for the '1901 International Exhibition', funded by a mixture of private donations, the surplus of the '1888 International Exhibition', and municipal money. It became increasingly accepted that educating the citizens of Glasgow in the appreciation of the arts was a public duty and other galleries were opened in the industrial quarters of the city.

A third artistic institution in Glasgow in 1880 was the Glasgow Art Club. This was a society of local artists which had been formed in 1867 by a group of amateur 'gentlemen' artists who had enjoyed sketching excur-

fig. 18
The 'Glasgow Boys', 1889. Major figures of the Glasgow School movement, many members of the all-male Glasgow Art Club, dressed as famous artists for the Grand Costume Ball, 1889. (T & R Annan and Sons, Ltd., Glasgow)

sions together. The club had just acquired permanent premises in 1878 and was exclusively for artists who were likely to be professional rather than amateur. Membership was hotly contested and was confined to men. The club admitted lay members from 1886 and acquired its own building in 1892.

The period 1880 to 1920 overall saw the growth in importance of publicly funded institutions, although the private societies survived and were added to by the formation of the Lady Artists' Club, originally created as the Glasgow Society of Lady Artists in 1882. The club was constituted on similar lines to the male Art Club, and in 1893, it too acquired its own premises and admitted lay members. Both clubs provided studios, exhibitions and sale facilities for their members. Artist membership was restricted to trained artists.

COLLECTORS, PATRONS, AND DEALERS

by Liz Bird

Despite this growth in publicly funded art institutions, support for the production of art and design in Glasgow remained a largely private affair. Art collecting by wealthy individuals became increasingly significant in the period. Glasgow had few aristocratic families. The Duke of Hamilton and the Marquis of Bute lent works to public exhibitions, but a new generation of industrial patrons created an established taste for French painting from the Barbizon School and Dutch painting from the Hague. The best known of these collectors is William Burrell, a Glasgow shipowner, whose collection is now more valued for its medieval and Impressionist items. Other industrialist collectors included T.G. Arthur (retailing), W.A. Coats (textiles), and James Reid of Auchterarder (railway engines). Some private collections survive in donations to public galleries but most were broken up and sold.

These patrons were the wealthiest and most conspicuous section of the larger art-buying bourgeoisie, and the artistic institutions of sale and exchange reflect the rise of demand for selected art products. Artists and designers living and working in Glasgow did not necessarily benefit from such patronage when the demand was for foreign or English work. However, pictures and objects were supplied by fine art dealers whose numbers grew from four in 1895 to thirty-two in 1905. Such dealers were a mixed bunch of interior decorators, lithographers, photographers and antique dealers, but their galleries did provide a means of exhibition for local artists and designers.

The most famous of the Glasgow dealers is Alexander Reid, (fig. 19) who set up La Société des Beaux Arts some time around 1889, having returned from working at Goupil's in Paris where he became friendly with Theo and Vincent Van Gogh. Another dealer, Craibe Angus, had French and Dutch connections through Van Wisselingh, whom his daughter married in 1887. Van Wisslingh was a dealer

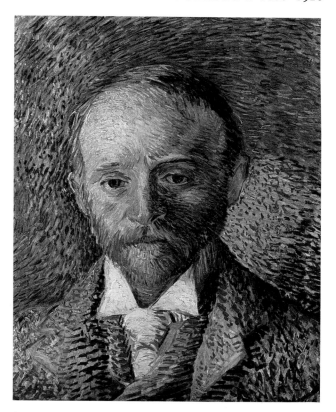

fig. 19
Portrait of Alexander Reid (1854–1928), Vincent Van Gogh, 1886, oil on board, 42.0 × 33.0. Reid's connections with artists in France and his active promotion of the arts to the 'new wealth' in Glasgow, along with similar efforts by other dealers, encouraged the 'modern movement' in the city. (Glasgow Museums and Art Galleries)

from the Hague employed by Cottier and Co., artists and art dealers specialising in stained glass and Dutch and French paintings. Through his connections with Cottier, Craibe Angus linked with the firm of Guthrie and Wells, formed in the 1890s by a partnership of Andrew Wells, who had worked for Cottier in Australia, and J. and W. Guthrie. The axis of Cottier, Angus and Reid thus brought together the Aesthetic and Arts and Crafts movements, French and Dutch painting, and the importing of Impressionist works by Degas and Manet into Glasgow collections.

Alexander Reid and William Burrell are both known to have been supporters of the group of painters known as the Glasgow School (fig. 18). Historical accounts of this group of painters differ in who is assigned as belonging to the group and in estimates of how long it lasted, whether it constituted a distinct group and whether it even merits the name of a Glasgow School. However, we can distinguish important moments, such as the exhibitions of their work at the Grosvenor Gallery and in Munich in 1890 when Reid was involved in both the selection and framing of their work. Reid's gallery also exhibited work by Glasgow School artists such as Macaulay Stevenson, James Paterson, E.A. Hornel and George Henry. William Burrell bought work by

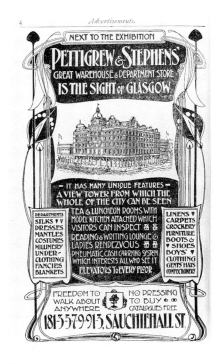

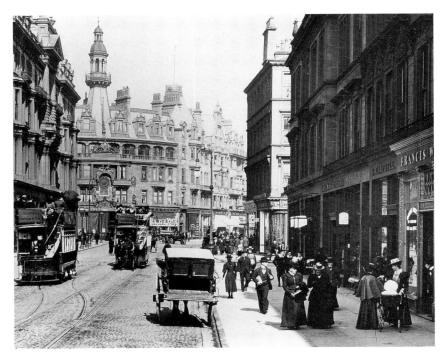

fig. 20
Pettigrew and Stephens, Sauchiehall Street, advertisement, 1901. Women exercised choice as consumers and influenced the design industry. (Catalogue to the International Exhibition, 1901, Mitchell Library)

fig. 21
Shopping day on Sauchiehall Street looking towards Charing Cross, Glasgow, c. 1900. (T & R Annan and Sons, Ltd., Glasgow)

Crawhall and Guthrie through Reid. Reid was also the major Glasgow dealer for the Scottish Colourists whose works were often bought along with Impressionist painting in the period after the First World War.

The support of local dealers and a few local patrons was vital to the survival of the Glasgow School, although its reputation was made largely by exhibitions in London and Germany, as was the reputation of the Glasgow Style, which was always regarded more highly abroad than at home. It is not easy to compare painters and designers as the kinds of patronage are different, but it is clear that while the Glasgow School painters did not enjoy much local patronage, Mackintosh as a designer received even less. The support of the School of Art and its Director Newbery was crucial, as Mackintosh secured very few public commissions. The firm of Guthrie and Wells commissioned some furniture designs from Mackintosh, and other designers working in the Glasgow Style were able to sell their designs through the local manufacturers. Mackintosh did enjoy the loyal support of several private patrons: two men who commissioned houses from him, William Davidson, a Glasgow merchant, and Walter Blackie, the publisher, and one woman, Miss Cranston, who commissioned the tea-room designs. The predominance of men as dealers and patrons for the fine and public arts can be contrasted with the growing importance of women as consumers in the private domestic sphere.

WOMEN AS CONSUMERS AND PATRONS

by Juliet Kinchin

'Art' clearly cost money and conveyed social prestige whether consumed by men or women. What differed was the type of capital investment and form of art considered appropriate to each. On the whole men bought fine art, i.e. paintings, a commodity which was likely to retain or increase its market value and was sold and exhibited in the public sphere. Women, on the other hand, tended to purchase art for use and display in a private, domestic world. Fortunes could be spent on decorative art in the form of fashionable clothes and tasteful furnishings. Unlike investments in fine art, such expenditure was difficult to recoup. Women's art was consumed through the agency of department stores and furnishing shops rather than through fine art dealers or institutions. Public patronage of the arts by women was more often a form of philanthropy than connoisseurship, an extension of their nurturing role within the home.

For women, money-spending and enforced idleness were inseparable from bourgeois domesticity. Women were expected to be arbiters of taste within the family; they were to show refinement and an artistic, cultured temperament. As wives and mothers, they transmitted cultural traditions and moral values to the nation at large. Personality, morality and social status were reflected in the kind of clothes and furnishings they

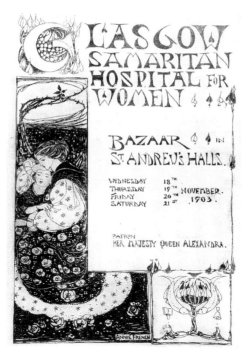

fig. 22
Glasgow Samaritan Hospital, Annie French, cover design for a bazaar programme, 1903, 30.5 × 25.5. Many decorative items made by women were produced and sold at local bazaars. French was a tutor at Glasgow School of Art. (Glasgow Samaritan Hospital Collection, Greater Glasgow Health Board Archives)

purchased.

As 'Angels of the Hearth' women were entrusted with resisting the erosion of traditional skills in an increasingly industrialised society. It is not surprising, therefore, that women took an active role in maintaining and reviving various craft traditions in Scotland. They brought to such ventures the values of their class in that they promoted a work ethic while keeping women in the home. It was a means of tapping women's culture without disturbing the suppressed place of women within the larger society.

Following models of aristocratic philanthropy, various 'ladies anxious to lend a helping hand to their poorer neighbours' banded together in the 1880s to found various technical schools.[3] The efforts of the Houston, Wemyss Castle and Menzies Schools of Needlework, and the Ayrshire whitework revival pioneered by Mrs Vernon, were seen as a means of relieving the acute social distress caused by industrialisation of the Scottish textile industry, and of stemming the drift of the rural populace to towns. These rather isolated schemes were given additional momentum by the establishment in 1889 of the more widely based Scottish Home Industries Association, run almost exclusively by and for women.[4] Significantly the Scottish Home Industries focused on assisting rural craftworkers rather than trying to alleviate the sweated labour of women in the urban textile and clothing industries. The dividing line between cottage industry and industrial homework was a thin one.[5] Although the Association drew on the language and philosophy of the Arts and Crafts movement, the system of production they encouraged was little different from industrial piecework in the cities. Nevertheless, the Association and the Scottish Women's Rural Institute which developed out of it did much to establish as artistic crafts what had previously been subsistence activities.

The craze for bazaars, organised by well connected ladies in the late nineteenth century was also in this philanthropic tradition (fig. 22). These fund-raising ventures were often elaborate affairs and gave women a chance to socialise in public. Most of the items on sale were both made and purchased by women. It was easy for men to denigrate their efforts as neither serious nor useful. Neil Munro fired many a tirade against bazaars.

> They're the worst form o' sweatin' that we have in this country . . . they're filled wi' fancy-work no rational mortal soul could fancy. The first thing a woman does in the way o' contributin' to a stall is to cut up something useful and turn it into something ornamental, and the poor misguided body that buys it and brings it home is chaffed a lot about it by her husband.[6]

These comments reflect the pressure on genteel ladies to produce art and handicraft that was not commercially viable. Inevitably it tended to be exchanged or bartered only amongst themselves, rather than on the open market.

Patterns of women's patronage and consumption are difficult to document in any detail as they rarely owned a substantial income in their own right, even after the Married Woman's Property Act of 1882, which enabled wives to own land and keep their own earnings. The names of various women appear as bequeathing or lending paintings for public display, but this was usually in their capacity as widows administering their late husbands' collections.[7] As often as not they are invisible in records such as financial ledgers, sequestrations/bankruptcies, wills and inventories, which tended to be constructed in the names of men—whether relatives, husbands or trustees. It is clear from novels, magazines, manuals of household taste and advertisements of the period, however, that it was usually females who bought 'decorative' or 'useful' art for the home and family. In this passage from a tale by Neil Munro, for example, while the money clearly comes from Erchie, it is his wife who is under social pressure to consume 'Art':

> 'I can easy tell ye whit Art is,' says I, 'for it cost me mony a penny . . . when Art broke oot, Jinnet took it bad, though she didna ken the name o' the trouble . . . The wally dugs, and the worsted thing, and the picture o' John Knox, were nae langer whit Jinnet ca'd the fashion, and something else had to

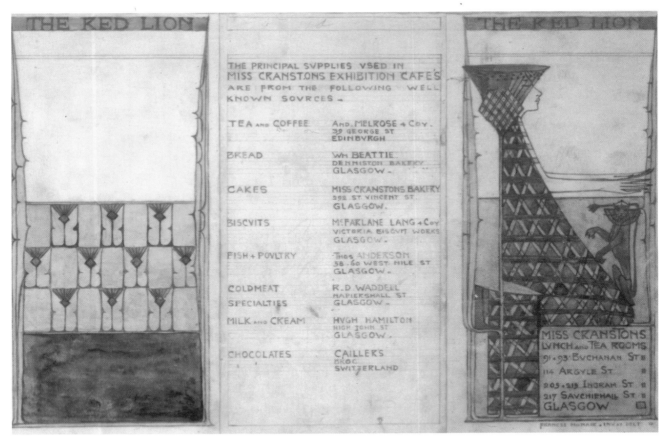

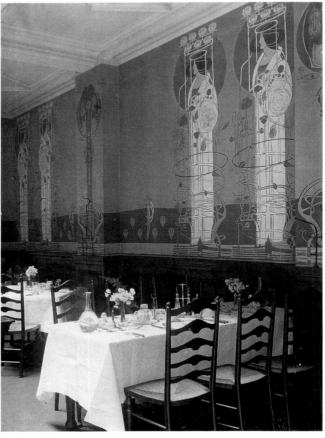

tak' their place. That was Art: it's a lingering disease; she has the dregs o't yet, and the whiles buys shillin' things that's nae use for onything except for dustin'. . . .'[8]

He constantly ridicules her social and artistic aspirations and her susceptibilites to the vagaries of fashion.

Shopping was trivialised as a frivolous and essentially feminine activity. The new department stores and warehouses were steadily divorced from the factory and workshop districts of the city and were clearly aimed largely at a middle class female clientèle. A visit to the shops with a break for tea was regarded as a legitimate means of socialising in public.

Although excluded from key areas of production, women were able to affect style and the appearance of objects through exercising choice as consumers, whether for moral or purely aesthetic reasons. Female taste was identified with high quality, handcrafted, 'artistic' goods.[9] In many ways the Glasgow Style appealed to these feminine qualities. Mackintosh spoke of transmitting 'instinct', 'emotion' and 'poetry' through his work, all of which were identified with the more spiritual female persona.[10] Perhaps we should not be surprised, therefore, that his most generous and consistent patron was a woman, namely the redoubtable Kate Cranston.

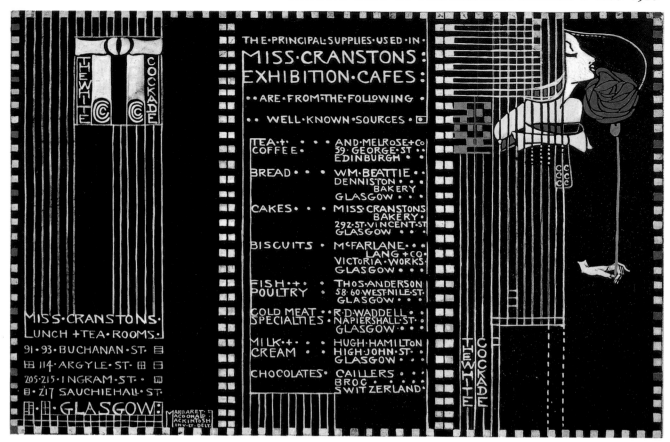

'A TOKIO FOR TEA ROOMS'— GLASGOW TEA-ROOMS

by Juliet Kinchin

One rather remarkable institution through which women strongly affected taste and social habits, both as consumers and as purveyors, was the Glasgow tea-room.[11] Tea-rooms in Glasgow were nothing to do with amateurish faded gentlewomen; they were serious business, a practical and successful response to distinct needs—those of men just as much as women. They flourished at a time when the women of the Temperance Movement were exerting powerful pressure on society. By supplying an excellent service without nagging or propaganda, the tea-room exerted a quietly civilising influence accepted by people of all persuasions.

The founder of the first was Stuart Cranston, a tea dealer who began to offer his customers sample cups in 1875, and from that small start built up a major business. The Cranstons were well-known cousins of the highly respected Edinburgh Cranstons, pioneers of Temperance Hotels. It was Stuart's sister Catherine— 'Kate'—beginning modestly in the basement of Aitken's Temperance Hotel in Argyle Street three years later who became the figure most strongly identified with the 'movement'. She took the artistic tea-room to international renown through her predilection for advanced design. A formidable and individual character who became one of Glasgow's best-loved figures, Kate was from the beginning a very strong role model, followed by many women who saw in tea-rooms a wonderful new opening for respectable business activity.

The great boom in Glasgow tea-rooms came in the 1890s, growing until in 1901 the city could be described as 'a very Tokio for tea rooms'.[12] Comfortable, pleasant little places multiplied in the commercial area of the city, catering cheaply and conveniently for the Glasgow businessman's 'coffee habit' and lunch, while others on the fashionable shopping streets were aimed more at women out about the town in the afternoon. Tea-rooms were places where both sexes could go freely; ladies felt at ease entering unescorted, while men—clerks and bosses alike—could bolt to the female-free zones of smoking and, in the larger es-

figs. 23 and 24 *(opposite)*
Design for menu card for Miss Cranston's Exhibition Café, The Red Lion, Frances Macdonald, 1911, pencil and watercolour on vellum, 30.0 × 20.0. (Private Collection. Photo: Sotheby's)
Photograph of Miss Cranston's Buchanan Street Tea Room, Glasgow, murals designed by Charles Rennie Mackintosh, 1897. (T & R Annan and Sons, Ltd., Glasgow)

fig. 25 *(above)*
Design for menu card for Miss Cranston's White Cockade Tea Room at the 'Glasgow International Exhibition'. Margaret Macdonald, 1911, gouache and watercolour, 25.2 × 31.8. (Hunterian Art Gallery)

tablishments, billiard rooms.

Glasgow already had a strong tradition of quality in its restaurant provision, but to this the tea-rooms brought a distinctively feminine accent. A typical tea-room could be portrayed in 1895 as a couple of old basement rooms, transformed by the touch of the 'Artistic Decorator', upon whose heels followed the 'Artistic Upholsterer'.[13] The elements of homely comfort that went with this decor—starched tablecloths, flowers, plates of cakes set out ready on the tables, comely waitresses—had a powerful appeal to men, who accepted feminine taste without sneers in this context, and contrasted their tea-rooms thankfully with 'the cold marble slabs' of the chain teashops which had become established in other cities, but never broke into Glasgow.

When Miss Cranston (whose first premises in Argyle Street and, from 1886, Ingram Street, typified this loosely 'artistic' style) pushed forward into distinctly progressive interior design she took the public with her. Instead of terminating her working life in the conventional manner, marriage in 1892 only financed new expansion for Miss Cranston, who retained her maiden name in business. While she played safe with the architect of the new building, who produced a pretty revivalist design, she trusted her own taste in choosing artistic 'novelty' for the interiors. The elegant furniture and fittings were designed by George Walton, whose decorating business she had inaugurated while he was still a bank clerk with a small commission at her original tea-rooms in 1888, while the young Charles Rennie Mackintosh produced some spectacular murals. In Miss Cranston's big expansion of her Argyle Street premises in 1897 Mackintosh was allowed to experiment with the furniture, producing in the course of this his first tall-backed chair, while Walton handled the wall decorations and fittings.[14]

After Walton, now well launched, left Glasgow in 1897, Miss Cranston turned for every new job, most notably the building of the famous Willow Tea Rooms on Sauchiehall Street in 1903, and a sequence of developments at Ingram Street, to Mackintosh. His wife, Margaret Macdonald, was closely involved with these projects and contributed gesso panels as well as a wider influence to the schemes. Miss Cranston also commissioned graphic designs for menus and cards from both Margaret Macdonald, her sister Frances and from Jessie King (figs. 23, 25, 27). She was indeed Mackintosh's most loyal patron, commissioning new work even after the couple left Glasgow. She allowed him a free hand and his work for her evolved through all periods of his interior design: from heavy oak and organic forms, through white paint and squares to the brilliant zig-zags of a new style seen in the last project, the underground 'Dug-Out' at the Willow Tea Rooms in 1917. After this, shattered by her husband's death, the aging Miss Cranston sold her business and retired, while the Mackintoshes eventually gave up the struggle to find work in London and moved to France.

The uncompromisingly avant-garde might seem a strange choice for someone catering for a mainstream middle-class clientèle. To a certain extent Miss Cranston, who also commissioned both Walton and Mackintosh privately, was following her own tastes, but her business instinct was involved too, and vindicated. Ordinary people, who could never have lived with anything of the sort, loved the strangeness of Miss Cranston's Mackintosh house style as a special, almost theatrical experience. Even those who thought it outlandish respected her bold eccentricity and regarded the tea-rooms as one of Glasgow's special features. She made the Glasgow Style in a very complete form part of people's experience, and the taste for it seeped out widely into the more 'normal' versions marketed by companies like Wylie and Lochhead. Miss Cranston, as noted, was influential, and less extreme versions of the artistic tea-room were numerous in the years before the First World War. An article in 1903 featured, for instance, Mrs Schiller, who employed W.G. Rowan very effectively to redesign cramped premises in West Campbell Street; 'An Old Oak Tea-Room' in James Salmon's new 'Hatrack' building in St Vincent Street, run by Miss Scofield; and the Regent Tea Rooms in another new office building at 51 West Regent Street.[15] Women proprietors did not have the monopoly of artistic rooms, but many others could be named from this period including the exotic 'Madame Bain', who appeared briefly in 1901 dealing in 'oriental curios, rare cabinets, pictures, etc.' from her tea-rooms in Sauchiehall Street. The Arcadian Gallery or Food Reform Café (1907–12), for which Jessie King designed a menu card, could also be mentioned as a place combining sale of art work with provision of progressive refreshment, vegetarian in this instance.

Even if the owner of a tea-room was male, the daily administration was almost wholly female, generally under the proprietor's wife or a manageress. The identities of these highly competent women are generally lost to history, unless like Rose Rombach, one of Miss Cranston's manageresses, they left to set up their own tea-rooms. Miss Rombach established in 1910 a stylish business which ran on under her name for many years, though she sold it to her brother when she later married. Miss Buick, a softer character, similarly founded in the same year a lasting business, more homely in style, and emulated Miss Cranston in continuing to run 'Miss Buick's' after her marriage. All three 'Misses' married late and were childless. The distinctly feminine standards they set were characteristic of what was best about the Glasgow tea-rooms of this period.

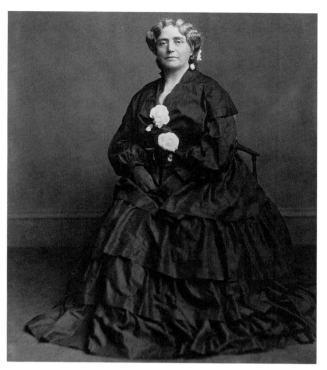

fig. 26
Miss Cranston, an astute businesswoman and an underrated 'Glasgow Girl', c.1904. (T & R Annan and Sons, Ltd., Glasgow)

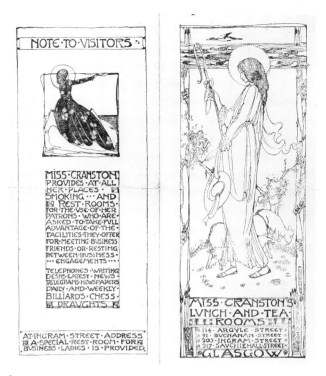

fig. 27
Miss Cranston's Tea Rooms, Menu Cover, Jessie M. King, 1917. The bill of fare for one of Miss Cranston's Glasgow establishments. (Glasgow Museums and Art Galleries)

MISS CRANSTON: A GLASGOW ENTREPRENEUR

by Thomas Howarth

In the context of the 'Glasgow Girls' we should consider more specifically perhaps, the contribution of one of Glasgow's most important leaders of fashion, an outstanding business woman, and an intelligent patron of the arts, the greatly under-rated 'Glasgow Girl', Catherine Cranston (fig. 26). Miss Cranston, a strong individualist, had a highly developed social conscience and was acutely aware of the potential role of women in the commercial world—almost exclusively a man's world in the 1880s. Against the wishes of her family, she opened a small teashop at 114 Argyle Street, Glasgow, in 1884, the year in which Mackintosh was apprenticed to the architect John Hutchison, and enrolled for evening classes at the School of Art—and a year before Francis H. Newbery was appointed headmaster at the School. This venture was very successful, but Miss Cranston had much greater ambitions. Daytime drunkenness had become a serious problem in the city, whose taverns provided more or less the only lunch-time venue for out-of-town workers and others. The tavern, unlike the English pub, was primarily a drinking place with few, if any, social pretensions. In an attempt to counter this situation, Miss Cranston decided to set an example by making her tea-room into a miniature social centre

where, at lunch time, her male patrons could not only enjoy good food, but relax over a game of dominoes, draughts (checkers), or even play billiards and smoke. For her female patrons she provided a special 'ladies' corner' where they could escape the attention of the men and have some privacy. However, like many women, she realised that only by sacrificing some of her independence could she achieve her main objective. So, in 1892, she married Major John Cochrane, an engineer, and promptly took over the whole of 114 Argyle Street, as a wedding present, it is said!

Fortunately, marriage enhanced rather than detracted from Miss Cranston's activities. In 1895, she acquired premises in Ingram Street and Buchanan Street and employed well-known, but not particularly imaginative firms of architects to remodel both—and at this time also she engaged George Walton, the bank-clerk-turned-designer, to assist with decorations and furniture.

Then, in 1896, Mackintosh was introduced to her by Fra Newbery. There can be little doubt that Miss Cranston was well aware of events at the School, if only through exhibitions of students' work; and there can be little doubt also that she recognised in the young architect a kindred spirit as scornful as she herself of the rigid conventions of the day. She became one of Mackintosh's most loyal and generous patrons, a partnership that lasted over twenty years.

The School group must have been greatly impressed

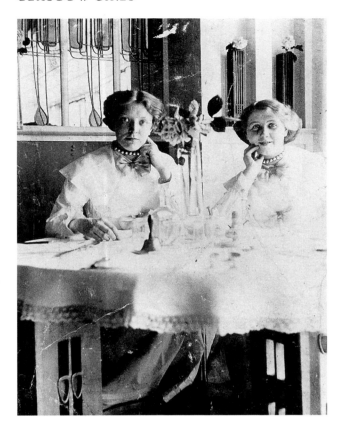

and encouraged by the example of this woman who, in her own field, was as selfless and as dedicated as they themselves. Who, in fact with their help, raised the business of restaurateur in Glasgow to an art which could be enjoyed by ordinary people and which came to be admired by architects and designers throughout the world.

Miss Cranston's contribution and her influence upon the Glasgow Designers has been underestimated and we should, perhaps, glance briefly at her organisation—for organisation it was—and her methods of establishing high standards of service for her customers and of performance by her employees. Her fastidiousness and her attention to detail parallels that of Mackintosh himself. When Mackintosh took control of the decorations and furnishing of the tea-rooms, shortly after George Walton's departure from Glasgow in 1897, they became models of their kind. With Miss Cranston's approval, he and Margaret Macdonald determined the colour schemes and designed the furniture, cutlery, carpets, curtains, metalwork, lighting and incidental works of art (fig. 31). It has been claimed that they even designed the waitresses' uniforms, but this has not been verified. Miss Cranston personally supervised the arrangement of each room and everything had to be impeccable. She selected a willow-pattern design for her china which could not be

duplicated, and there were always flowers sent in from her estate, Hous'hill, Nitshill, three times a week, with written instructions as to precisely where and in which room they had to be placed.

In this somewhat ruthless industrial society the hours of work at the tea-rooms were 7 a.m. to 7 p.m., the commencing wage of employees was four shillings per week (i.e. twenty per cent of one pound sterling). A waitress was not allowed to be out of sight of her customers, and she was provided with anything she required by 'runners' who also collected and removed the used dishes. A 'runner' graduated to a waitress at nine shillings a week after undergoing strict training under the personal supervision of Miss Cranston, or one of her manageresses. The girls were taught, for example, how to cut and butter bread, cutting thinly, trimming all round and carefully buttering to the edges and corners; among many other duties they cleaned the silver, washed it in hot soapy water and rinsed it in clear boiling water.

Before becoming a waitress, a runner had to pass the test of serving in the 'Ladies' corner', part of each restaurant reserved for ladies only, where the strictest discipline and efficiency were demanded. At the Argyle Street establishment Miss Cranston and her husband had lunch daily and prospective waitresses had to wait at their table for final approval. Before engaging a girl, Miss Cranston visited the home and spoke with the parents so that she knew what kind of a person she was hiring. The girl's hands and finger nails were carefully examined; she was not permitted to wear squeaky shoes, and always had to speak quietly. She was provided with two clean aprons each day, and the cords were always tied into neat bows by the supervisor—all had to be identical.

On one occasion, two girls broke a large serving plate and, when questioned, both claimed responsibility. Miss Cranston said she couldn't afford to have such plates broken, and she must deduct the cost from their wages. This she did, and there were few breakages thereafter. However, twelve months later, to the exact day, she handed each girl a package containing the amount deducted, and said: 'In the future, be as careful with my dishes as I've been with your money and we'll all be wealthy women someday.'[16]

Thus Miss Cranston, like Fra Newbery, was a stern yet highly respected disciplinarian—and a warm-hearted, generous person. She delighted in the charm and efficiency of her tea-rooms and was, in fact, more concerned with the comfort and satisfaction of her patrons and the well-being of her staff than in mere profit-making. Knowing something of her background and temperament one can better understand why she responded so readily to the idealism of Mackintosh and Margaret Macdonald.

fig. 28
Waitresses in the Room de Luxe, Willow Tea Room, c.1904. (T & R Annan and Sons, Ltd., Glasgow. Photo: Glasgow School of Art)

fig. 30 *(opposite lower left)*
Willow Tea Rooms, Sauchiehall Street, Glasgow, 1903–04, facade. (T & R Annan and Sons, Ltd., Glasgow)

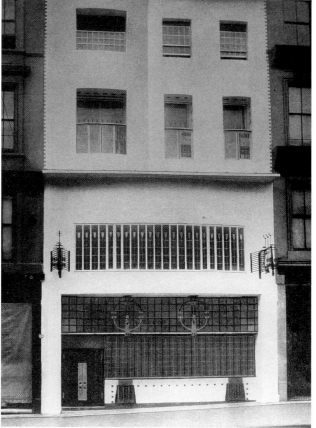

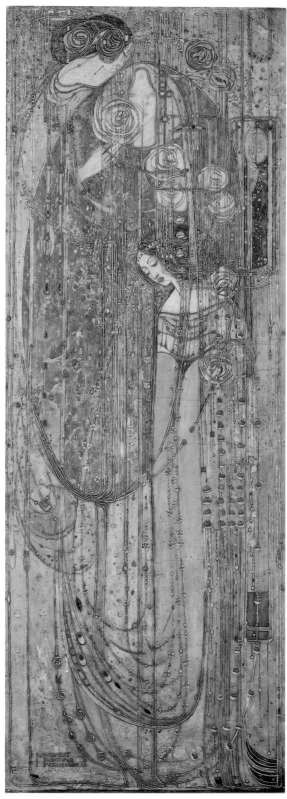

fig. 29 *(top left)* and 31 *(above)*
The Willow Tea Room showing Margaret Macdonald Mackintosh's
O Ye That Walk in Willow Wood gesso panel in situ, 1903–04. (T & R
Annan and Sons, Ltd., Glasgow). Painted gesso with twine and
coloured glass beads, 164.5 × 58.4. (London Regional Transport
Pension Fund. Photo: Glasgow Museums and Art Galleries)

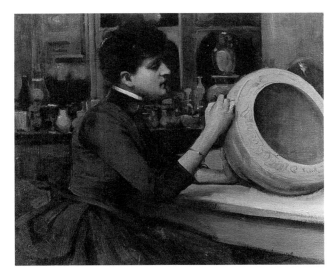

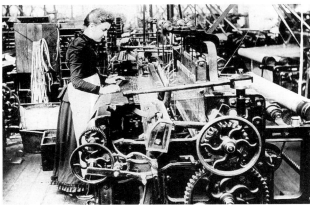

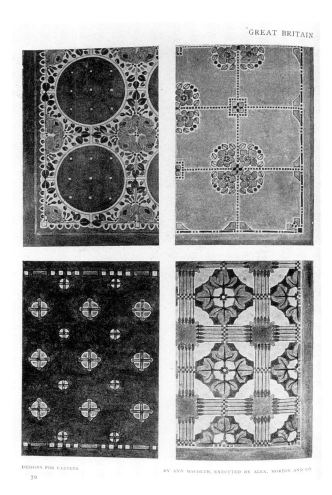

DESIGNS FOR CARPETS
70
BY ANN MACBETH, EXECUTED BY ALEX. MORTON AND CO.

WOMEN IN INDUSTRY

by *Juliet Kinchin*

Women's participation in international exhibitions reflected the dominant bourgeois ideology which carried over, albeit in weakened form, to training opportunities at the Glasgow School of Art where the majority of female students came from middle class backgrounds. As Erchie explained to his friend Duffie: '". . . they bash brass and hack wud, and draw pictures." "And can they make a living at that?" "Whiles, and their paw helps".'[17] When pushed such women could earn a living as art or domestic science teachers, but were not otherwise seriously expected to live by their art and craft. Women were taught a range of skills in addition to drawing and painting, which included embroidery, bookbinding, metalwork, china and glass painting, gessowork, chip carving, poker-work, and staining. Most of these represented an extension of socially accepted domestic duties or genteel accomplishments, and were not therefore incompatible with the domestic ideal. Women did not, for example, study cabinetmaking, engineering design or architecture. For the bulk of women working in industry, however, no training was required.

fig. 32 *(above left)*
Woman painting a pot at the Glasgow International Exhibition 1888, Sir John Lavery, 1888, oil on canvas, 38.1 × 45.7. The ceramic industry employed many women of the 'artisan' class. While the painting of ceramic ware was done by middle class women who set up their own production studios, 'china painting' was a 'hobby' for many others who sold their wares at bazaars. (Glasgow Museums and Art Galleries)

fig. 33 *(lower left)*
Women machine operatives in Templeton's carpet factory, c.1900s. (Glasgow Museums and Art Galleries)

fig. 34 *(above)*
Design for carpets for Alexander Morton & Company, Glasgow, Ann Macbeth, published in *The Studio Yearbook*, 1914. Morton's commissioned carpet designs of a number of women including Ann Macbeth and Jessie Newbery.

fig. 35 *(opposite right)*
Paisley Thread And The Men Who Made It, Jessie Newbery, design for bookcover, 1907, 21.6 × 16.5. This bookcover bears the characteristic square and distinctive style of lettering that was the 'signature' of architect Charles Rennie Mackintosh. Newbery's father was in the Paisley Shawl industry near Glasgow. The Paisley thread industry referred to in the title began when a woman by the name of Christian Shaw (born *c.*1685), daughter of John Shaw, laird of Bargarran, who married Rev. John Miller in 1718 but was left a widow in 1721, brought a twisting mill over from Holland, then the major producer of thread. The mill, turned by hand, ran twelve bobbins. The thread was sold under the name of *Bargarran Thread* and became famous, bringing much industry to Paisley including the world famous company of J. & P. Coats. (Paisley Museum and Art Galleries)

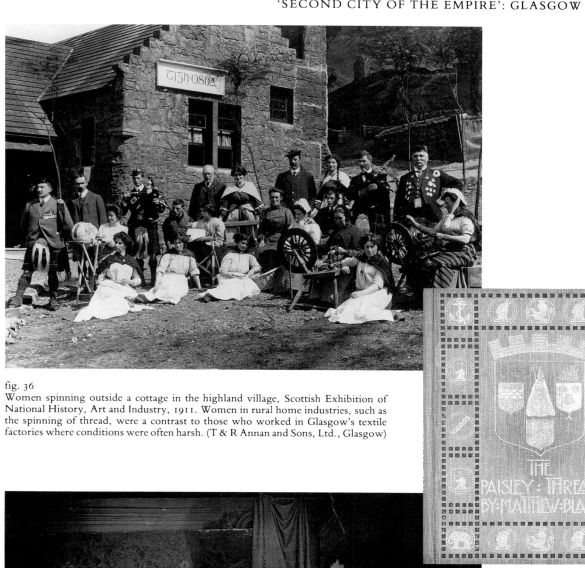

fig. 36
Women spinning outside a cottage in the highland village, Scottish Exhibition of National History, Art and Industry, 1911. Women in rural home industries, such as the spinning of thread, were a contrast to those who worked in Glasgow's textile factories where conditions were often harsh. (T & R Annan and Sons, Ltd., Glasgow)

fig. 37
Pattern tracers, Hyde Park Works, c. 1900. The entry of women tracers into the locomotive industry was seen as a challenge to male workers' jobs. (Mitchell Library, Glasgow)

As with patterns of consumption, the facts and figures of women's roles in the production and retailing of industrial arts are difficult to establish. Records such as the census did not take into account the irregular nature of women's work.[18] It is clear, however, that the majority of women in full-time employment in Scotland were single and under twenty-five, the average marriage age, and that the number of home-workers exceded those in the factories.

Women were viewed as a source of cheap, unskilled labour to be brought in and out of the economy as required. The assumption that men were the bread-winners was not seriously challenged, regardless of the reality in some cases. A woman's duty lay first and foremost in the home as wife and mother. Men and women rarely did the same work and the sexual division of labour was justified by an ideology defining feminine character and abilities. Despite the increasing diversification of women's employment in the late nineteenth century most still worked in relatively few industries and occupations.[19] Arguments used against the employment of women invariably focused on their physical, temperamental and intellectual weakness; also on the threat they posed to men's jobs by working for lower wages. Notions of skill had more to do with the sex of the workers than the nature of the work.[20]

The textile and clothing industries were a major source of employment (figs. 33 and 34). 'The great feature which differentiates the textile industries of Scotland from those of England,' wrote Margaret Irwin in 1895, 'is that, while in the latter country they are followed by both sexes, in this they are practically women's industries.' Elsewhere she noted: 'A manager of a large factory told me that he had once made an effort to introduce male labour into his weaving department, and that, after a few weeks' trial, the men gave it up being unable to stand the ridicule to which they were daily exposed for taking up women's work.'[21] In Glasgow, men were more attracted to highly skilled and paid jobs in the rapidly expanding heavy industries. This might also explain why female labour in the field of bookbinding was increased sooner in Glasgow than elsewhere in Scotland, a development fiercely resisted by the trade unions.[22]

Woven and embroidered textiles were the most important of the traditional crafts practised by women in rural areas of Scotland as an adjunct to their other domestic duties. Textiles were considered well suited to women's capabilities and character. By tradition women were associated more with pliant, soft, decorative fabrics than with harder, tougher materials like metal, wood or stone, even though the work could be as physically demanding. Physical and temperamental qualities were often confused in this way.

Women were rarely employed to work with either 'unfeminine' or costly materials, for instance cabinet-making or goldsmithing. Even in upholstery and embroidery the most expensive fabrics or metallic threads were usually worked by men. Women were also excluded from more 'intellectual' aspects of production such as designing and creating 3-D forms or structures. Their relegation to finishing skills such as ceramic and glass painting, or french polishing, was justified in terms of feminine neatness and dexterity or an affinity for surface pattern and applied ornament.

Work in a drawing office for women involved copying existing patterns rather than originating designs. Small numbers infiltrated the male-dominated locomotive industry in this capacity, though not without protest. In January 1866 the Glasgow locomotive manufacturing firm of Dubs and Co. took the highly unorthodox step of employing a lady tracer in their drawing office. By the end of the year she had been joined by two other ladies, and the three of them were installed in their own special department, separated by partitions to keep them from chattering. Mr Dubs justified this move on the grounds that the women had been extremely quick to learn; they worked 'with superior accuracy and industry,' had no ambition to make designs of their own, and the tracings were done at a very economical rate. He was accused in *The Engineer*, however, of trying to suppress the talents of his male apprentices out of jealousy, and of undercutting and robbing them of work. There was sufficient work for women, the writer went on, of a kind which did not threaten male jobs: 'the men, and especially the draughtsmen (mostly bachelors), have the greatest difficulty in the world to get their underlinen made, washed and mended, and their buttons sewn on.' In addition, women were physically unsuited for the job: 'it is well known that many young men have gone into consumption through stooping over or leaning on their drawing board; how much more trying then, must it be to the more delicate nature of a woman, particularly if she should happen to be somewhat full-breasted?' Undeterred by such op-position, Dubs and Co. gradually increased their staff of lady tracers (fig. 37).[23] In the 1888 International Exhibition both a tracing of a locomotive engine and drawings of machinery were included in the Women's Section.

The participation of women in the retailing of fine and decorative art mirrored the division of labour in its production. As dealers they were primarily involved in selling household goods such as glass, china, fabrics and furnishings, rather than the more prestigious fine art. Throughout the nineteenth century approximately half of the 'Furnishing Shops' listed in the Glasgow Trades Directories were run by women. These tended to be small-scale businesses aimed at the lower end of the middle class market. This type of shop was steadily eased out of business towards the end of the century by the huge, more lucrative warehouses and depart-ment stores, which were almost exclusively managed by men.[24]

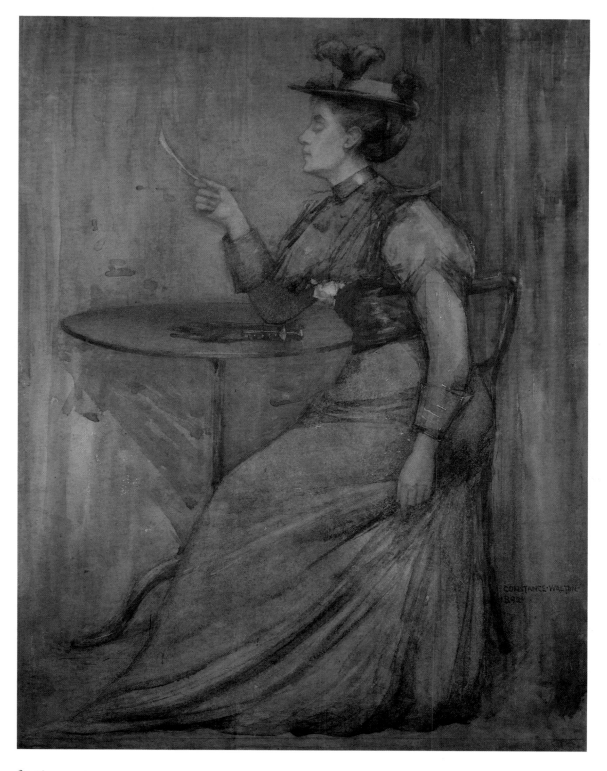

fig. 38
Lady Reading a Note, Constance Walton, 1892, watercolour on paper, 63.8 × 49.0. Tea at the Lady Artists' Club was an opportunity for women to share the same interchange of ideas and camaraderie that men enjoyed in their art organisations at the time. (Private Collection)

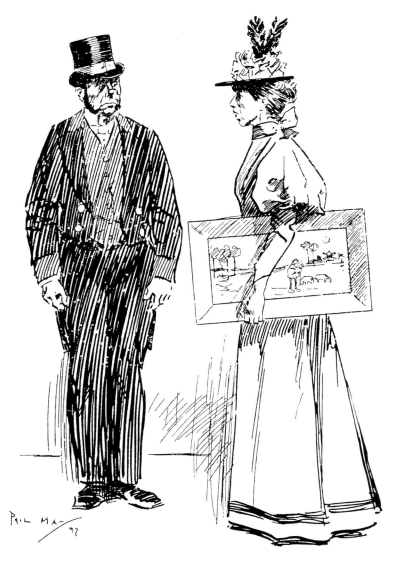

SENDING-IN-DAY AT THE R. A.

" But it is impossible for you to see the President. What do you want
to see him for?"

" I want to show him exactly where I want my Picture hung."

EPOCH IV. — 'THE NEW WOMAN'
(POSITIVELY HER FIRST AND ONLY APPEARANCE IN GLASGOW)

New Woman, 'gentle creature', is stern of mind and feature,
She's making ducks and drakes of man's most cherished whims,
She wears his hats and coats! she wants to share his votes!!
She wants an *equal* world, composed of 'hers' and 'hims'!

Herself Jim Maitland.
 and

Mr. John Leech's Ladies and Gentlemen of 1865, including Lord
Dundreary.

Mr. Barbour	Miss O. R. Smyth	Miss Mainds
Mr. Scott	Miss H. Paxton Brown	Miss Marion Orr
Mr. A. Reid	Miss May Buchanan	Miss Sybil Thompson

Verse from the Masque **The R(Evolution) of Woman)** by Fra Newbery.

THE 'NEW WOMAN' IN GLASGOW
by Jude Burkhauser

In the 1890s there was throughout Europe an intense interest in the cult of the 'new'. Magazines, news articles, and periodicals all spoke to their readers of new movements and ideas—the 'New Drama'—'New Realism'—'New Humour'—the 'New Art' (*L'Art Nouveau*)—and the 'New Woman'.[1] This 'New Woman' was challenging many areas of social convention, with demands for equal educational opportunities, open universities, sensible or so-called 'artistic' dress that would replace the constricting corset and laces of current fashion, women's suffrage, and equal rights in employment. In Glasgow, however, she was taking this movement one step further by challenging the *fin-de-siècle* image of woman that had been established by what Bird and Kinchin have demonstrated was a male-dominated Glasgow art world. Her posters in a Glasgow School of Art exhibition would stretch the prevailing visual iconography beyond the existing polarities of *femme fatale* or 'Pre-Raphaelite virgin' and in so doing create a 'New Woman' in art.

New and conflicting definitions of femininity were emerging from the social upheaval of the time. Ever-increasing changes in social systems and beliefs of Edwardian Britain, particularly those being won through the suffrage cause, were beginning to remove barriers to woman's self-determination. New laws regarding education in Scotland and increased employment of women in the teaching profession spurred on the reconstruction of the feminine. What had been constructed in Victorian society as the 'feminine' or 'womanly' arts (the decorative as opposed to the so-called fine or higher arts of painting, drawing and sculpture) based on an ideological separation of the perceived abilities of men and women according to their gender, was now being challenged, re-defined, and in some cases de-constructed (fig. 40).

The 'New Woman' made her first appearance in the 1850s with the first stirrings of dissatisfaction concerning the ingrained notion that: 'The home is the [only] sphere of woman.' Dissenters gained the derisive title 'emancipated' when they made modest demands that popular education for girls—'the contemptible, harmful, narrowing, sham-knowledge of things, be changed in favour of a more thorough education.'[2] Educational reform took half a century before effecting long-lasting change.[3] In an account in *The Young Woman* magazine from 1893 the contemporary 'New Woman' was defined as 'a creature fully awake to, conversant with, and interested in, the various phases of life of her time' and now had become what was approaching a major women's movement: '. . . whereas formerly she had only appeared singly, and was then regarded as a somewhat abnormal specimen.'[4] There was growing debate on who the 'New Woman' really was. Conservatives saw her as 'sweetly-womanly', not the 'Emancipated Woman' or 'Bluestocking' whom they derided for pressing for full employment opportunities and 'a voice and a vote in every blessed or unblessed political question. . . . '[5]

This controversy over the acceptable feminine persona—'The Woman Question'—raged across the pages of *The Young Woman* magazine and other periodicals readers would turn to for guidance.[6] In the October 1893 issue Hall Caine, a popular novelist, wrote an article which posited 'Are Women Inferior to Men?' Caine complained that the advanced woman ignored the 'absolute and essential inequality of the sexes,' which he claimed: '. . . began in the Garden of Eden, and will go on til the last woman is born. It is not an inequality of intellect but of sex. . . . Because the New Womanhood is not making its reckoning with the fundamental and natural inferiority of woman as a sex, it cannot permanently succeed.'[7] Letters and articles poured in to the defence of the 'New Woman' or to agree with Hall Caine's point of view. The following year Caine was the invited speaker on the occasion of the opening of the Scottish Arts Club's new Rutland Place home in Edinburgh.[8]

The debate would continue throughout the early part of the twentieth century with the term 'New Woman' frequently applied as insult to any female seen to be pressing too far the existing gender boundaries. When the Macdonald sisters exhibited unconventional poster work at the Glasgow Institute in 1894, their challenging use of the female form prompted letters and verse attacking the 'hags' in the pictures which, it was said, must be their version of the 'New Woman':

> Would you witness a conception
> Of the woman really New
> Without the least deception
> From the artist's point of view
> See the Art School Exhibition
> In the rue de Sauchiehall
> They don't charge you for admission
> (For they haven't got the gall)[9]

The strong reaction these posters provoked in the viewer's psyche was due in part to pressure for change which the 'New Woman' was exerting on various levels of Glasgow society, change that would eventually be effected by the suffrage movement.

No strangers to struggle for self-determination in their pursuit of a career, Glasgow women in the arts played a central part in the political campaigns of the

figs. 39 and 40
Phil May's cartoon of 'The New Woman' from *Punch Magazine*, 1898, lampoons the new assertiveness of women at the turn of the last century. The idea of a woman making demands was seen as humorous at the time. (Photo: Glasgow School of Art). Excerpt from the Masque 'The (R)Evolution of Woman'.

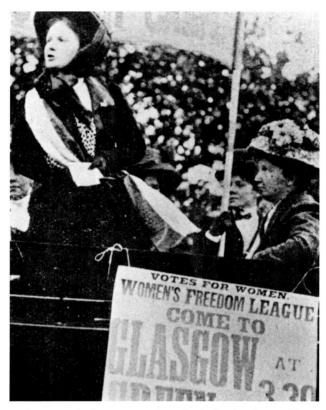

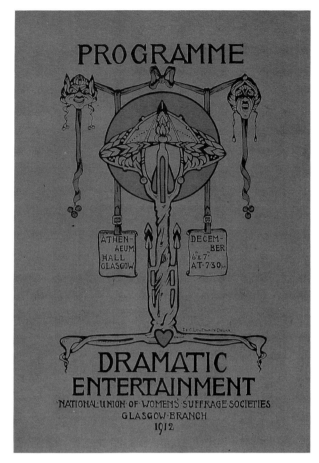

early twentieth century, particularly in the suffrage cause. In heavily industrialised Glasgow women of the artisan class, who were seen as a cheap source of labour, were excluded from trade unions as they were considered a hindrance to obtaining better pay and working conditions for men. In the textile industry particularly harsh conditions led to organised work actions by women which resulted in growing awareness of their collective power. Their involvement in the adult male suffrage movement and the temperance cause provided organisational experience which also helped them move collectively to enfranchise themselves. By 1903, when the WSPU (Women's Social and Political Union) was formed in Manchester by the indomitable Pankhurst family, the women's suffrage movement in Britain began to gather force and by 1906 a Scottish wing of the WSPU was set up in Glasgow.

School of Art students and staff, and many members of the Lady Artists' Club, took an active part in the suffrage cause with production of banners and fund-raising activities. De Courcy Lewthwaite Dewar, tutor of enamelling, designed programme covers for a number of events (figs. 1 and 42); one bears the motto: 'The Woman's Cause is Man's, They Rise or Sink Together, Dwarfed or Godlike, Bound or Free . . .' In her war diaries from the 1940s we see she was active in the National Council of Women, clipping news articles on the continuing victories of women in Scotland, including the right of women teachers to wed and retain their jobs. Another Glasgow artist from the turn

of the century whose life was radically affected was Helen Fraser, who is reported to have given up her art work entirely in order to work for suffrage, speaking throughout the country at meetings and rallies.[10] Jessie Newbery, wife of the director of the School of Art and a major figure in the evolution of the Glasgow Style, was an active member of the WSPU and organised the 'Arts and Curios Stall' at the Grand Suffrage Bazaar held in St Andrew's Halls in Glasgow in 1910. With the Art School director's wife so supportive, and with Ann Macbeth, then head of the Embroidery Department, involved in the design of banners, it is not surprising that the School of Art became a 'production source'. Students took turns between classes stitching up banners, and in 1908 there was a special exhibition of the work at the Fine Art Institute. It has been suggested that the Blythswood Square premises of the Society of Lady Artists' Club, might have served as a meeting place as the WSPU organiser for Glasgow, Janie Allan, conducted all business from that location.[11] Kate Cranston, the well-known tea-room proprietor, was also a staunch supporter.

The Representation of the People Act was passed in January 1918, granting suffrage to women over thirty. It was not until 1928, however, that all women in Scotland would be granted the equal right with men

At the Lady Artists' Club.

HER FRIEND - And I suppose you study Art a good deal?
THE LADY ARTIST - Art! You don't think I dare study Art.
It might spoil my style!

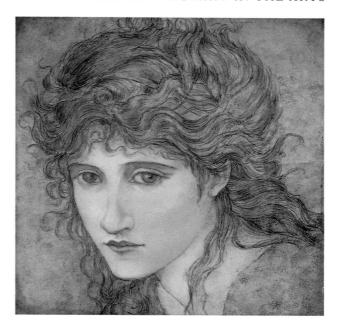

THE GLASGOW SOCIETY OF LADY ARTISTS

by Jude Burkhauser

for political representation. The life and work of the 'New Woman' in Glasgow, in the person of many of the artists and designers we examine here, was unquestionably influenced and informed by this ongoing struggle.

fig. 41 *(opposite left)*
Glasgow suffrage rally at Glasgow Green, *Votes for Women, Women's Freedom League*, 1914. In later years the campaign was to become militant and involved the burning of boat-houses and sports pavilions, bomb and arson attacks on university laboratories and grandstands, the cutting of telephone wires, bombing of railway trunk lines, damaging of artworks, acid attacks on pillar boxes in Glasgow and the physical assault of the Prime Minister in 1913 on the Lossiemouth Golf Course. Women who were caught and sentenced were treated as harshly in Scotland as elsewhere in Britain, tortured and forcibly fed while in prison, some never recovering after their release. (Glasgow Museums and Art Galleries)

fig. 42 *(opposite right)*
Programme cover for *Dramatic Entertainment for the National Union of Women's Suffrage Societies, Glasgow Branch*, De Courcy Lewthwaite Dewar, 1912, 15.5 × 25.6 approx. (Coll: H.L. Hamilton. Photo: Glasgow Museums and Art Galleries)

fig. 43 *(above)*
At the Lady Artists' Club, a cartoon showing the slightly risqué reputation of 'The Club' in Glasgow. (Mitchell Library, Glasgow)

These progressive ideas found an organised outlet in the Glasgow Society of Lady Artists.[12] The first women's society of its kind in Scotland, it was to play an important role in the artistic life of Glasgow. One early member remarked, '. . . we were in our small way pioneers, for as far as I have been able to find out we were the first women's art society in the country. We certainly were the first to have our own rooms, and to hold exhibitions in our own studio. . . .'[13]

Early in 1882 eight women—painters, teachers and art workers who had all been students at the Art School, decided to call a meeting in the studio of Robert Greenlees, former headmaster, who felt that opportunities for women artists in Glasgow were lacking. Greenlees, then over sixty, had recently resigned and the only two female members of the School's staff left with him; one, his daughter Georgina, became the second president of the Society. There would be no women on staff at the School again until 1888. It is unlikely that there was provision of life classes for women students. Perhaps for this reason, or because of his wish for his daughter and others to have outlet for their talents, Greenlees helped the women write a *Book of Rules* stating the object of the Society as: 'The study of Art, to be promoted by means of life classes and monthly meetings at which members will be required to exhibit sketches, and by an annual

fig. 44
A painted ceramic tile with a drawing of a head after Burne-Jones, Hannah More Walton, n.d., 20.2 × 20.2. The Walton Sisters were only one of a number of sister teams who set up production studios in Glasgow. (Coll: I. D. Lloyd-Jones. Photo: Glasgow Museums and Art Galleries)

exhibition of members' work.'[14]

The society offered women, then barred from the all-male Glasgow Art Club, a source of professional camaraderie, lectures by visiting artists, life drawing classes, studio space, and exhibition opportunities, as well as a centre for the exchange of ideas (fig. 45). At a time when suffrage was still being fought for, the notion of an all-women's residential club was considered very 'fast' and it was judged rather 'daring' to be a member: 'In fact when the proposal to form a lady artists' club was first mooted the idea was looked upon with disfavour as being dangerous and full of temptations.'[15] (fig. 43) The first exhibition was held in 1883, but by 1892 larger accommodation had to be found and it was suggested that the society be reformed into a club with membership open to non-artist members. By 1893 the Society moved to larger premises at 5 Blythswood Square. Many 'Glasgow Girls' were active members including Jessie M. King, Agnes Raeburn, Ann Macbeth, Katharine Cameron, and De Courcy Lewthwaite Dewar. In her series of letters to her parents in Ceylon, written 1903–06, Dewar provides a vivid account of the varied activities, meetings and rendezvous she and her contemporaries shared at the 'Club'. One letter reveals the close relationship between the two art clubs despite their physical barriers.

> . . . Yesterday, Wednesday, I went into the Institute in the forenoon as it was Varnishing Day and saw a lot of artists I knew. The ex. [sic] is really very good this year . . . in the evening we had our Varnishing dinner in the Club. . . . It was quite a TT dinner so we had no toasts but Miss Story who is Vice-President made a short speech welcoming our Edinburgh guests. After dinner we went into the gallery & had music and singing & conversation & Miss Gray read hands & told fortunes by cards. . . . The men were having a Varnishing dinner also; the two clubs stand back to back, ours enters from Blythswood Square, & the men's Club from Bath Street & there is just the lane between. . . . During the evening we got a note from the men's Club saying the toast of the 'Lady Artists' had just been drunk & that they hoped that at the next Varnishing Dinner the dividing lane might be bridged. Miss Story replied that we thanked them for their good wishes & that we also thought it a suitable occasion for bridge-building or at least something might be done in the way of a 'Channel Tunnel'.[16]

For many years the organisation flourished, offering annual and special exhibitions to its members with awards and prizes. Although the original intention of the society to provide a place for women to practise art was lost when the club became residential, the exhibitions continued. Despite the upheaval of the First World War, when allegiance of members was given to the Scottish Women's Hospitals and their work in Serbia and France, the society flourished and carried on until after the Second World War. Perhaps it was because women, now able to work in a variety of 'masculine' professions and entering into full-time employment, had less leisure time that after the 1940s the club never regained its momentum. Finally in 1971 the society was dissolved and eventually reborn in the Glasgow Society of Women Artists, but without premises for exhibitions or social events. The Society had provided women artists in Glasgow with a professional organisation with which they might associate to establish and further their careers. It provided a bridge from the past into the future. Many of the reasons the club was first formed—to provide life classes, lectures and workshop opportunities where none existed for women—were now available in the mainstream art establishments in the city. By 1987 the Glasgow Art Club, also finding itself in financial difficulty, voted to change its 'male only' membership rule and accept women into the organisation.

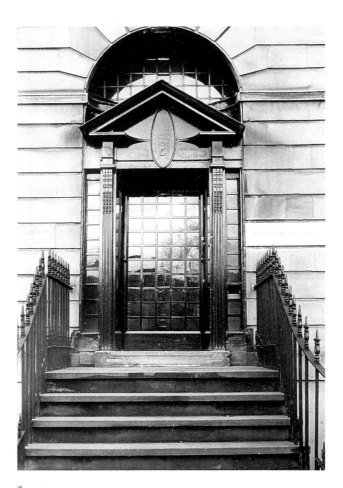

fig. 45
The Glasgow Society of Lady Artists' Club at 5 Blythswood Square, Glasgow. The door, designed by Charles Rennie Mackintosh, dates from 1908. (Glasgow Society of Women Artists)

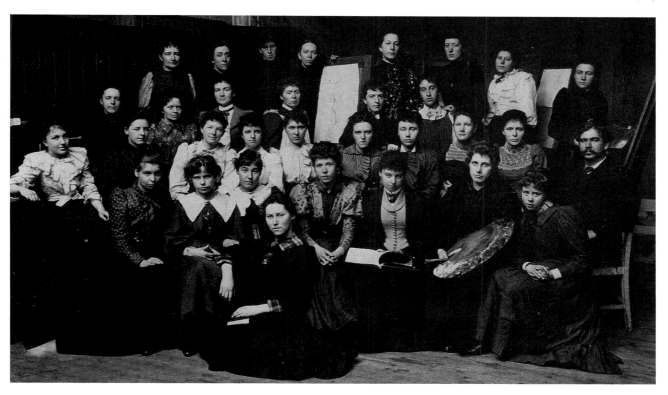

THE 'GIRLS' OF ROARING CAMP: 'THE IMMORTALS'

by Jude Burkhauser

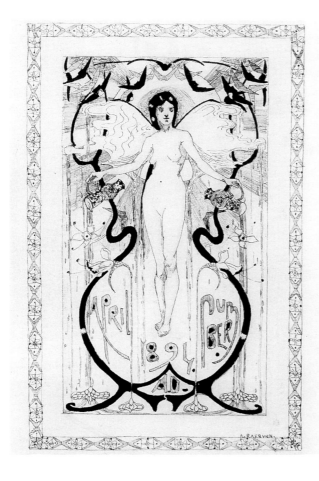

An interesting experiment for the 'New Woman' was the first commercially published ladies' magazine in Scotland, *The Lady's Review of Reviews* (1901), which urged support saying that 'Scottish women are not behind any more than Scottish men in everything that pertains to forward movements, and we think that the time has come for a country which has its own social customs, its own law and even its own religion, to have its own Ladies' Magazine. . . .'[17] The idea of young women publishing their own magazine was aimed at the 'new, educated and enquiring woman.'[18] One 'forward' thinking young 'lady', Lucy Raeburn, had already assembled her *Magazine* (1893–96) (fig. 47) seven years earlier, in April 1893, with contributions from her circle of friends at Glasgow School of Art, which included members of the Mackintosh circle. The

fig. 46
The Immortals, *c.*1894–5. Fra Newbery with his female students. The front row includes some of the women in the 'Mackintosh group'. From right to left: Frances Macdonald, unknown, Ruby Pickering, Margaret Macdonald, Agnes Raeburn, Katharine Cameron, Janet Aitken (in front). (*Scottish Field*)

fig. 47
Winged Woman frontispiece, *The Magazine*, Agnes Raeburn, April 1894. Lucy Raeburn's sister, Agnes, was one of the 'Immortals' who contributed watercolours, drawings, prose, and poetry to *The Magazine*. (Glasgow School of Art)

young women of the group, who called themselves 'The Immortals' (fig. 46),[19] were friends of Jessie Keppie, sister of John Keppie, Mackintosh's employer, whose weekend retreat they dubbed 'The Roaring Camp'. The designation—'Immortals'—has been an enigma as little information was available with regard to the young women of 'Roaring Camp'.[20] The phrase could refer to 'otherworldly' folk, fairies or sidhe, that figure in many illustrations by such Glasgow designers as Jessie M. King, that were the result of personal belief systems and Celtic heritage. Another explanation, however, may be found in an 1894 issue of *The Woman At Home: Annie S. Swan's Magazine*, a 'ladies' magazine probably read by the 'girls' of Roaring Camp. In the serial story *Confessions of a Royal Academician*, Nesbit, a rebel against established art canons (as were the Glasgow School painters and certainly the central figures of the Mackintosh circle), states:

> And further I wish it to be distinctly understood that it is not my intention . . . to interfere with the veil which enshrouds the mysteries of the Royal Academy of Arts. . . . My object is to set forth in a plain, unvarnished way—for I detest varnish in literature as much as I do in art—some of the more striking episodes in a life which has been rich above belief in strange experiences. *My brother Immortals* may therefore continue to possess their souls in peace. Their secrets shall not be exposed to the inquisitive gaze of the profane, neither shall the hand of the vulgar be laid upon their jealously guarded privileges, but for how long all this shall endure I utterly decline to say.[21]

The work that was produced from this period by two of the 'Girls' of Roaring Camp, Frances and Margaret Macdonald, certainly did not fit the art historical canons of the Royal Academy. Assumption of the 'Immortals' logo may have been commentary on the 'new women' of Roaring Camp who were challenging the all-male art establishment of the day not only with a new visual iconography, production of their own magazine, and the formation of their own art club but also, by impudently assuming the generally considered all-male claim to immortality in art.

On the editorial page of *The Magazine*, Lucy Raeburn, who signs herself the 'Editress', refers to future issues of the work which she hopes will continue if enough contributions are received. Lucy Raeburn's magazine stretched existing gender boundaries and documented what are some of the earliest known examples of the Glasgow Style in the work of the Mackintosh group. It is clear that Raeburn's journal—referred to on the title page as 'Her Magazine' and no doubt meaning more than a bookplate might in some other volume—was an idea ahead of its time.

> Go on and prosper my young friends, I expect to hear of you in wider circles soon. . . .[22]

'ARTISTIC' DRESS MOVEMENT IN GLASGOW

by Jude Burkhauser

The 'New Woman' in the Lady Artists' Club and in the Art School rebelled against fashions that would limit her activities, participation, or enjoyment of life, and affirmed her individuality and creativity through her dress. Speaking of Jessie Newbery, Head of Embroidery at Glasgow School of Art, Margaret Swain wrote: ' . . . she never wore a corset in her life . . . she deplored the tight lacing imposed by current fashion. . . . '[23] (fig. 48) Two trends in women's fashion had emerged in *fin-de-siècle* Britain. The first was the 'aesthetic' dress movement where Arts and Crafts figures such as Walter Crane and William Morris designed 'aesthetic' clothes which quoted from classical and medieval costume. Their influence was widespread and advocated a totality of approach which decreed that clothes be in harmony with interiors. In keeping with

fig. 48 *(above)*
Le Luxe, Un-aesthetic dress, fashion-plate from 1896. (Glasgow Museums and Art Galleries)

fig. 49 *(opposite lower left)*
*The Fiend of Fashion, c.*1900.

THE FIEND OF FASHION, FROM AN ANCIENT MANUSCRIPT. 43

this ethic, Morris had his fabric designs for upholstery translated into dress fabric. The second of these fashion trends was the 'rational' dress movement which promoted the freeing of women's bodies from restrictive laces of imposed fashion. This style was based in part on women's adoption of formerly male-only sports such as cycling and tennis and the resultant need for sensible, functional, and healthy dress. Articles appeared in journals such as *Scribners* at the turn of the century revealing the physical problems of women that were the result of the tight lacing of corsets and stays (fig. 49).[24]

Taking 'aesthetic' and 'rational' dress a step further

fig. 50 *(above left)*
Daydreams, Fra Newbery, *c*.1920, oil on canvas, 77.5 × 52.3. The colours of the 'rational' dress in which Newbery portrays his wife slumbering, are sympathetic to the interior, echoing the green altar-like background. The scene epitomises the ideal of a harmonious 'artistic' whole. (City of Edinburgh Art Centre)

fig. 51 *(above)*
'Rational' Dress, Jessie Newbery, silk-cut velvet with black design on jade-green ground, *c*.1920. A simple and comfortable day dress in which the 'new woman' could even slumber, exemplifies the free, loose-fitting fashions resulting from the 'rational' dress movement which rebelled against tight fitting corseted fashion. (National Museums of Scotland)

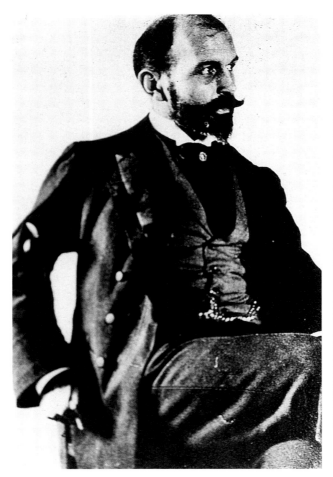

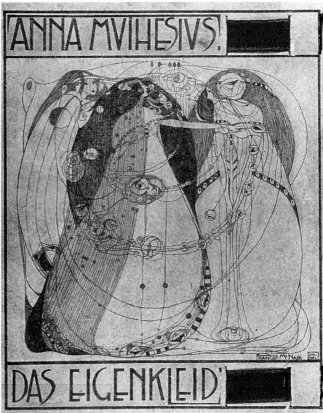

fig. 52
Hermann Muthesius, c.1900s, the noted architect who, with his wife Anna, acted as a connecting link between Glasgow and German 'Modern Movement' design theorists and played a major role in establishing the Deutscher Werkbund in Germany. *Qualitat*, the central idea of the group meant durable work and the use of 'flawless, genuine materials', as well as the attainment of an organic whole rendered '*sachlich*, noble, and . . . artistic by such means'. (Glasgow School of Art)

fig. 53 *(above right)*
Das Eigenklied der Frau, Anna Muthesius, 1903, book, 16.6 × 13.1. This commentary on the 'artistic dress' movement includes designs by colleagues and friends in Glasgow. Frances Macdonald's graphic design is featured on the cover; Newbery's daughters appear in dresses designed by her and Margaret Macdonald appears in a dress made to her design.

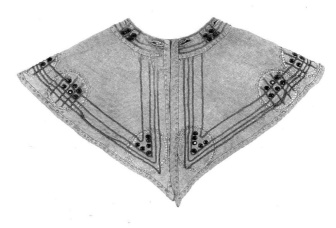

fig. 54 *(above)*
Embroidered collar with appliqué, Jessie Newbery, c.1900. Embroidered collars, cuffs and belts, often embellished with beads or imported metallic clasps, were designed and worn as part of an 'artistic' ensemble. (Glasgow Museums and Art Galleries)

fig. 55 *(opposite top left)*
Daisy McGlashan and daughters, in dress designed and made under Jessie Newbery's tutelage at Glasgow School of Art. Newbery advocated a democratisation of clothing where minimum surface embroidery of stylised organic motifs embellished simple inexpensive fabrics. (Glasgow School of Art)

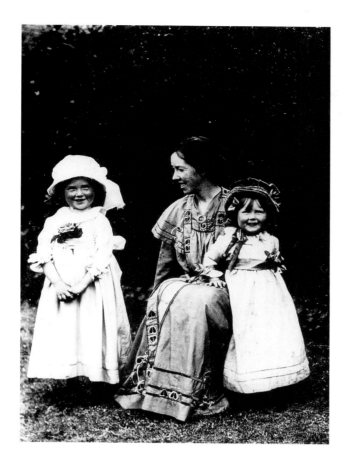

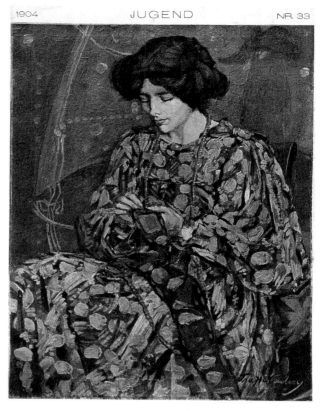

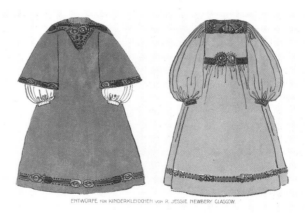

fig. 56 *(lower left)*
Detail of embroidered dress, Daisy McGlashan, green silk, appliqué with embroidery, 1910. The colours of the dress echo the colours of the women's suffrage movement, pale green, cream and lavender. (Glasgow School of Art)

fig. 57 *(above top right)*
Anna Muthesius Embroidering, Fra Newbery, oil, reproduced on cover of *Jugend*, 1904. The Newberys and Muthesiuses shared similar design ideals. Newbery's portrait portrays the 'artistic tout ensemble' in the Glasgow Style with Glasgow Rose motif on wall, dress and embroidery. (Private Collection, Photo: Glasgow School of Art)

fig. 58 *(above)*
Moderne Stickereien. Jessie Newbery's designs for embroidered children's dresses appeared in the periodical *Moderne Stickereien*, 1905, published by Alex Koch in Darmstadt between 1903–09. (Glasgow School of Art)

and abandoning historical references, the Viennese designers of the Wiener Werkstätte created 'dress-as-art', and produced clothing as part of a new concept which considered dress one aspect of an artistic whole. This *Gesamtkunstwerk* was not only emanating from the Continent; designers in Glasgow were also in the forefront of the modern design and dress reform movement. Their similarly evolved concept of 'feminine fashion' as part of a total design environment reached its zenith in Miss Cranston's tea-room interiors. A 1906 article 'Modern Decorative Art in Glasgow' in *The Studio*, focused on Miss Cranston's Argyle Street Tea Room and no doubt referred to designer C.R. Mackintosh in saying:

> Even feminine attire has not escaped the attention of the modern artist; with some recent schemes of decoration he has indicated the design and colour of the gowns to be worn, so that no disturbing element might mar the unity of the conception. [25]

The woman most involved in the 'artistic dress' movement in Glasgow, a fusion of the ideals of 'aesthetic' and 'rational' dress, was Jessie Newbery, who found popular fashion 'constricting, inartistic, and ugly.'[26] Newbery designed, embroidered and made her own (fig. 51) and her children's clothing (fig. 58) to exacting standards of comfort and beauty throughout her tenure as tutor of embroidery at Glasgow School of Art and after her retirement. She expressed her personal style in her clothing and her affirmation of Arts and Crafts ideals in rejection of mass-produced wear. This individual style of dress was an example to many of her students who adopted dress codes to their own design. Dresses Newbery designed for her daughters appeared in a book on the 'artistic' approach to dress written by Anna Muthesius, *Das Eigenkleid der Frau*.[27] Muthesius had come to Britain with her husband Hermann, an architect who was doing research for a book, *Das Englische Haus*. Anna and Hermann Muthesius were in contact with Fra and Jessie Newbery and many of the Glasgow Style artists and designers as a result of these projects. There were strong links between Scotland and Germany and a well-developed Germanophile sensibility existed in Glasgow at the turn of the century with prominent families such as that of Walter Blackie, the publisher and patron of Mackintosh, sending their children to German schools and employing German domestic staff as nannies.[28] Anna and Hermann Muthesius, warmly received in Glasgow, hosted many of the Glasgow artists at their home in London and took great interest in the Glasgow scene, even naming Newbery and Mackintosh godfathers of their son

Eckart. The cover of Anna Muthesius' book (fig. 53), for example, was designed by Frances Macdonald MacNair, and she and her sister Margaret, perhaps the most prominent female exponents of the Glasgow Style, appeared in the book in dresses of their own design. Fra Newbery painted a portrait of Anna Muthesius about 1902 embroidering a dark band with Glasgow Rose designs (fig. 57); her dress displays the characteristic stylised rose motif, and the wall behind shows a Glasgow Rose pattern similar to one which C.R. Mackintosh and Margaret Macdonald stencilled on the walls of their dining room. The painting is a statement of the 'artistic' *tout ensemble* in the Glasgow Style and was reproduced on the cover of *Jugend* (No. 33, 1904). In Hermann Muthesius' book, published in 1904, he would write of artistic dress in relation to Mackintosh's interior designs: '. . . the refinement and austerity of the artistic atmosphere prevailing here does not reflect the ordinariness that fills so much of our lives . . . an ordinary person . . . would look out of place wearing . . . simple working clothes in this fairytale world. . . .'[29]

Anna and Hermann Muthesius' role in promulgation of the ideals of William Morris, the Arts and Crafts movement, and the Glasgow Style to the continent was significant. In addition to their books, which linked continental and British design concepts, in 1907 Hermann Muthesius inspired the *Deutscher Werkbund*. This influential association of artists, industrialists and designers was concerned with returning dignity to manual labour by 'ensuring the concerted action of art, industry and craftsmen by a campaign of propaganda and education and by the assertion of a common will'.[30] These were goals not dissimilar to the socialist aims the Muthesiuses encountered in the ideals of their friends in Glasgow, Fra and Jessie Newbery, the Mackintoshes, the MacNairs, and many of the artists, designers and patrons of the Glasgow Style. The *Deutscher Werkbund* is seen by some to have carried significant influence from Britain to Germany whereby the 'basis was laid for the current of ideas which, by way of the Bauhaus and the declarations of faith of the *Esprit Nouveau* were to lead to the designs of the 60s'.[31] The Wiener Werkstätte developed similarly in Vienna and the effects of that important experiment are widely known. Although the early influence of Mackintosh is mentioned in many of these accounts, the contribution of the Glasgow movement as a whole to continental developments has never been fully explored. It is clear that there exists a strong link between Glasgow's unique brand of 'Scotto-Continental' Art Nouveau and the Modern Movement.

fig. 59
Cover of *Deutsche Kunst und Dekoration*, Margaret Macdonald Mackintosh, May 1902, halftone colour reproduction, 29.0 × 21.3. Women designers of the Glasgow Style movement were heralded abroad and their work appeared on the covers of important international art and design journals. (Hunterian Art Gallery)

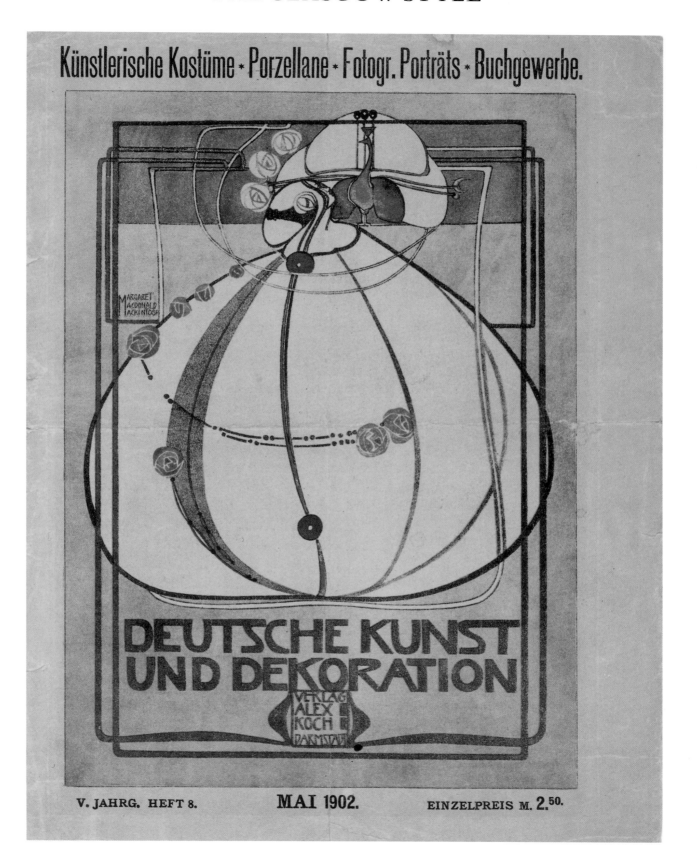

fig. 60
Portrait of Charles Rennie Mackintosh, *c.*1900 (T & R Annan and Sons, Ltd., Glasgow)

fig. 61 *(opposite)*
Portrait of Fra Newbery, Maurice Greiffenhagen, lithograph, n.d., 50.7 × 31.7, inscribed F.H. Newbery. The charismatic new Director established applied art studio courses which had wide ranging influence then hired 'efficient craftsmen' and craftswomen to teach them. (Coll: H.L. Hamilton. Photo: Glasgow Museums and Art Galleries)

INTRODUCTION:
SOME THOUGHTS ON CHARLES RENNIE MACKINTOSH, 'GIRLS'—AND GLASGOW
by Thomas Howarth

We may trace the antecedents of the Glasgow Style in the visual arts to William Blake, the Pre-Raphaelites, the Boys from Glasgow, the European Symbolists and Japan; through inspirational literature to Maeterlinck, Rossetti, Baudelaire, Gautier, Wilde and Geddes, and in the so-called minor arts to Morris, and the English Arts and Crafts Movement. But to Francis H. Newbery, headmaster of the Glasgow School of Art from 1885, must go the credit for bringing together and inspiring the group of extraordinarily talented students and teachers who created the Glasgow Style.

There can be no doubt that the centre of this constellation of young people was the architect Charles Rennie Mackintosh (fig. 60), who, from 1889 with his friend Herbert MacNair, worked at the office of John Honeyman and Keppie. Mackintosh and MacNair enrolled in evening classes at the school in 1884, some years before the Macdonald sisters, Margaret and Frances, arrived in Glasgow. Fra Newbery told me at our meeting in the summer of 1945 that he had introduced the two girls to the two young architects because he recognised a similarity in the style of their design work; they soon became known locally as 'the Four'. This significant event probably took place in, or about, 1893. Mackintosh had produced his important symbolic watercolour *Harvest Moon* in 1892 (fig. 63), an early essay in a new style—the Glasgow Style—and, with MacNair, he was designing furniture. In the nature of things MacNair, who never ventured seriously into the world of architecture, and the Macdonald sisters, who worked in the crafts, were quickly dominated by their dynamic friend, who in little more than a decade produced an astonishing variety of work of outstanding significance. Mackintosh joined forces with Miss Cranston, the Glasgow restaurateur, about 1896 to create the remarkably inventive series of four Glasgow tea-rooms which culminated in The Willow (1904–17) on which Margaret Macdonald collaborated. He won the competition for the new Glasgow School of Art (fig. 2) for Honeyman and Keppie in 1896, but to his chagrin he was not given credit for it publicly, either by the firm or by the media, as the building progressed through two stages of construction in 1897–99 and 1907–09.

In 1899 he designed Windyhill for William Davidson, and in 1902 The Hill House for Walter Blackie, his two most important domestic commissions, which, with the Willow Tea Rooms were given wide publicity in the European press, but little at home. He and Margaret married in 1900 and designed their own apartment at 120 Mains Street. They eventually found Mains Street too noisy and moved to a row house in Florentine Terrace, later renamed Southpark Avenue, near the University. It was the Southpark Avenue interiors (fig. 10) that were reconstructed in the Hunterian Art Gallery at Glasgow University in the early 1980s, some years after the demolition of the terrace itself.

Over the period 1896 to 1906, when he redesigned the west wing of the Glasgow School of Art, including the library, Mackintosh produced Queen's Cross Church of Scotland (now headquarters of the Mackintosh Society); designs for buildings for the Glasgow International Exhibition of 1901, including the well-known saucer-domed concert hall, and Scotland Street School (1904). He entered a design for the Liverpool Anglican Cathedral Competition (1903) but was unsuccessful—due, he always claimed with bitterness, to the opposition of Professor Charles Reilly, head of the Liverpool School of Architecture, who was a member of the jury. He, together with Margaret Macdonald and other representatives of the Glasgow School of Art, exhibited in 1900 at the Secession House in Vienna and in 1902 at the 'International Exhibition of Decorative Art', Turin. He submitted a design for the *Haus eines Kunstfreundes*

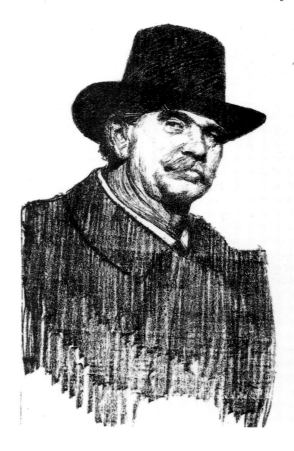

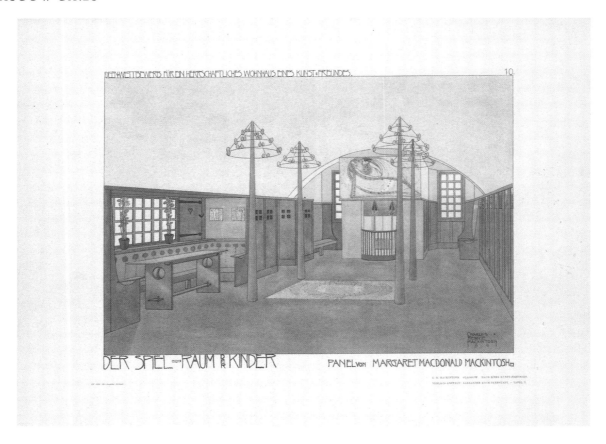

competition organised by Alexander Koch, of Darmstadt, in 1901 (fig. 62). A first prize was not awarded, but Mackintosh's submission, to which Margaret made a major contribution, was given a special award. All their drawings were published in a splendid portfolio with an appraisal by the distinguished German architect Hermann Muthesius. Thus, Mackintosh's position as one of the most significant figures in the modern movement was firmly established abroad.[1]

In addition to all this work, comprehended in little more than a single decade, and other commissions that need not concern us here, Mackintosh produced some four hundred designs for furniture and craft work. However, he did not take kindly to the formal constraints of architectural practice. Few seemed to share his vision of a new architecture which, as he had demonstrated, could be based firmly on Scottish traditional building. In view of his enthusiastic welcome in Europe and especially in Vienna, he felt that he was not receiving the recognition he deserved from his architectural colleagues at home. Although in 1906 he was elected a Fellow of the Royal Institute of British Architects, the Royal Incorporation of Architects in Scotland did not choose to recognise him as a Fellow until 1908. The School of Art was finished in 1909 and thereafter Mackintosh became increasingly intractable, alienating his partners and their clients. Despite the care lavished on him by Margaret he was

unable to continue working in the office; he resigned from the firm in 1913.

The Mackintoshes left Glasgow in 1914, and settled in England where wartime conditions greatly limited opportunities for practice—to this phase belongs the work for W.J. Bassett-Lowke of Northampton, and the fabric designs. In 1923 they moved to the south of France where Charles developed to a high degree his skill as a watercolour painter and produced work that placed him among the leaders of contemporary artists in this medium. For health reasons Margaret returned for a time to their London studios where she did little creative work—the correspondence in the Hunterian collection belongs to this period. In the autumn of 1927 Mackintosh became seriously ill with cancer and returned to London where he died in 1928; Margaret survived him for five years.

Over and over again in the Glasgow story we return to the key figure, Newbery, whom I met at Corfe Castle, Dorset, in the 1940s. Students were always Newbery's main concern and he continually sought ways and

fig. 62
Design for *Haus eines Kunstfreundes* competition, Charles Rennie Mackintosh and Margaret Macdonald Mackintosh, 1901, decorative panel in Music Room, 38.8 × 52.3. (Glasgow School of Art)

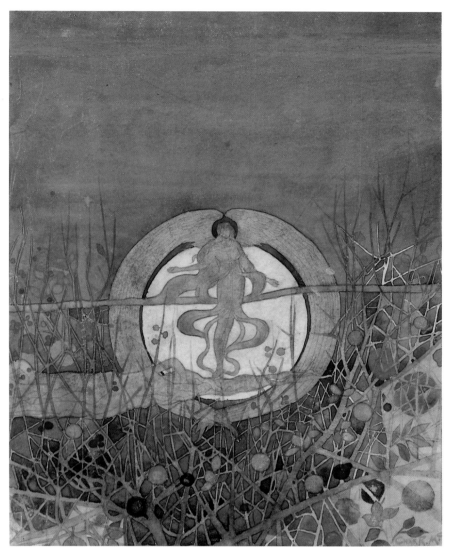

means of improving their educational and professional opportunities. Like all good teachers, he delighted in their achievements and used his influence to introduce them to potential patrons and clients.

'Newbery', said Agnes Raeburn at a meeting with me in September 1946, 'had the ability of sizing up his pupils at once, and was able to develop their latent talents. . . . A strict disciplinarian, he took an interest in individual pupils and did not direct them into set channels but persuaded them to adopt the art form for which they had most inclination. . . . His was a commanding presence; there was always silence when he entered the room.' He maintained that design should come as easily as writing: 'Folk art', he said, 'was evolved by simple, untrained people.'[2]

In 1892, Newbery opened new workshop-studios to provide his students with skills essential to the successful execution of their practical craftwork (fig. 68). As Jude Burkhauser points out, the jury of the annual National Competitions organised by the South Kensington Museum to which Newbery submitted his

students' work, had commented repeatedly on the high quality of design, but very poor execution.[3] The opening of the Decorative Arts Studios occurred therefore at a propitious time, and had a profound effect upon technical presentation in the School. Mackintosh, however, seems to have done very well as a student without them: he received his first award from South Kensington—a bronze medal—in 1888 and for five years thereafter, his name appeared on the awards list (with the exception of 1891 when he was on his scholarship tour of Italy). But, of course, his work was mainly architectural.

The names of Margaret and Frances Macdonald appeared first in the School records in 1891 and they used the new studios until 1894 when they left to set up their own professional studios in the city. Jessie Rowat, one of Newbery's students, whom he married in 1889, rapidly distinguished herself as an embroideress of

fig. 63
Harvest Moon, Charles Rennie Mackintosh, 1892, pencil and watercolour, 35.2 × 27.7. (Glasgow School of Art)

outstanding originality, and she joined the teaching staff which, in the 1890s, included a number of women—thanks to the headmaster's enlightened policy.

Other women students at this time who were to become very well-known in the art world were, in addition to the Macdonald sisters, Janet Aitken, Katharine Cameron (Kay), De Courcy Lewthwaite Dewar, Jessie M. King (Taylor), Ann Macbeth (who succeeded Mrs Newbery as head of the needlework section), and Agnes Raeburn. Jessie Keppie, sister of John Keppie, Mackintosh's employer, also attended classes at the school, but did not emerge as a significant figure. I met all of these individuals and others, with the exception of the Macdonalds and Janet Aitken, in the 1940s.[4]

These, then, were the leading women proponents of the Glasgow Style, a generic term that emerged in the mid-1890s. However, by no means all the artists subscribed to the grotesque conventionalisation of the human figure that earned for Fra Newbery's institution the sobriquet, 'Spook School', which should really be applied only to the work of 'the Four'. For example, the elegance and child-like charm of Jessie King's illustrations which, it could be argued, most clearly represent the Glasgow Style, although sharing the linear characteristics of Beardsley's drawings, have none of his sinister malevolence and sexual overtones. Hers is a gentle symbolism, imaginative and beautifully executed, but none the less safe and conservative. Similar observations could be made of work by the other 'Glasgow Girls'—especially of Annie French—which at times is almost indistinguishable from Jessie King's.

Through the medium of *The Studio* and its perceptive editor Gleeson White, the Glasgow designers received extraordinary publicity, and, during the late 1890s, the Glasgow Style was universally recognised as an important, provocative, and somewhat puzzling phenomenon. What has been described in modern language as 'the relative visibility'[5] of its women artists was noted everywhere—relative, that is, to the neglect of the female component by most contemporary educators, writers and art historians.

This, then, was an exciting time at the School with its progressive educational policy, liberal administration, mixed (co-ed) classes and shared studios. The confidence of staff and students was reflected in their marvellously prophetic, self-adopted title, 'The Immortals'. Immortal they may be, but how do we account for the marked contrast between the work of 'the Four' — 'The Spook School' — and the others?

As I have pointed out elsewhere, the Mackintosh group were captivated by the disquieting dream world of Maeterlinck, Rossetti, Gautier and other men of letters, and by publications such as *The Yellow Book*, and Patrick Geddes' *The Evergreen*. They were immersed in what has been described as the Celtic Twilight and found visual stimulation, for example, in the work of the symbolists—Jan Toorop, Carloz Schwabe, Aubrey Beardsley and others who were breaking new ground.

All these were challenging influences, but there was also a powerful undertow, a turbulent emotional conflict that found expression in the work of 'the Four'. It represented the age-old struggle of youth seeking to free itself from the shackles of tradition, of moral and religious repression in a world of rapid change where old values were being challenged and new ones were not yet established. The exotic symbolism of the rose, the thorn, the passion flower, the lily and the peacock's feather, and the erotic, explicit drawings by Beardsley's incisive pen, opened up a new world for those adventurous spirits who had the courage to defy convention—and 'the Four' were nothing if not adventurous!

It is significant that when John Keppie, Mackintosh's employer, invited his sister Jessie's friends from the School of Art to spend working weekends at Dunure on the Clyde Estuary where he rented two bungalows for them, he named the place 'The Roaring Camp'. We do not know what went on there, but we do know they acquired a reputation as 'Bohemians'.[6] Mackintosh broke off his engagement to marry Jessie at about this time.

The emotional turmoil that disturbed the lives of 'the Four' was clearly reflected in the extraordinary watercolours they produced at this time. Although we were very well aware of the sensual nature of this work, we are indebted to Timothy Neat, of Fife, and to Janice Helland of Memorial University, Newfoundland, for drawing our attention to the powerful sexual symbolism that informs them, and to Jude Burkhauser for emphasising the significance of the Macdonald sisters' new portrayal of the 'feminine' in the 1988 Exhibition 'Glasgow Girls'. Professor Neat's careful analysis of the watercolours has revealed skilfully camouflaged figures and symbolic content that had escaped previous observers. He relates these works to the developing love affair between Margaret and Charles, as she and Jessie Keppie contended for the young architect's affection; and Frances Macdonald and Herbert MacNair were inevitably involved. One of the most poignant of Neat's images is that of Frances Macdonald's painting *Ill Omen, Girl in the East Wind with Ravens Passing the Moon* (1894) (fig. 153). There are three trees behind the girl, and one in front of her. Neat suggests that the three trees represent Frances, Margaret and MacNair; the one in front, Mackintosh. The Girl in the East Wind is imploring Mackintosh the single tree, to join the group of three, in other words, to make up his mind about Jessie. This he did, of course, and left her heartbroken.

We might well ask what sort of a man was Mackintosh at this point in his career? And what of Margaret? During the course of my research they were

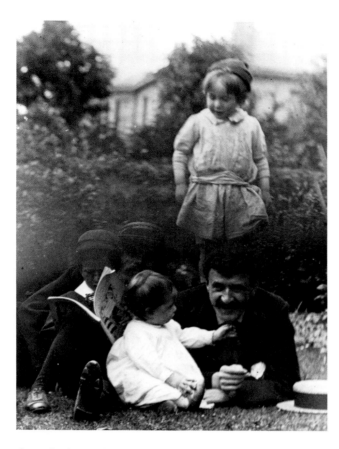

described vividly to me by people who knew them well—but no one would admit to knowledge of the Bohemian life 'the Four' were reputed to have led. Apparently Mackintosh was generally quiet and somewhat morose, but short-tempered and capable of violent fits of rage—'a satanic personality' according to Jessie Newbery; but, on the other hand, he could be extremely kind, well-mannered and chivalrous. He was also described as alert and intelligent; firm and outspoken; simple and direct. Very well informed on general topics, he had a wide knowledge of architecture and art—but he was no scholar. 'His mouth betrayed caution, timidity, probably mockery.' Although quite unpretentious, he sometimes wore a monocle and affected unusual clothes—later in life a cape and 'Sherlock Holmes' deerstalker caps with earflaps. He smoked a pipe, and was fond of the theatre, less so of music, and he did not play any instrument.

Unlike Jessie Keppie, who was a modest, homely girl, Margaret was tall and stately and had great personal charm. She had a fresh complexion with strong, almost masculine features and glorious auburn hair which she washed in distilled water. Her hair created a sensation when she travelled in Europe and it remained beautiful to the end of her life. Her clothes were always made by a dressmaker and she embroidered or modified them herself to give special character.

Despite her strong personality she was mild and

gentle of manner. She is described as having great courage and fortitude—and endless patience, a necessity in dealing with her volatile and somewhat paranoidal husband. As one of her friends observed, 'all her energy was given to Mackintosh'. The late Sir William O. Hutchison, formerly head of the School of Art, told me that Margaret once confided to him some of her personal problems and he said tritely, 'Trust in Providence'. She replied: 'I do—that's me!' We are told that Mackintosh was fond of children—Margaret was not! They had no family.

One of my greatest regrets in writing on Mackintosh in the early days was the paucity of correspondence that might have thrown more light on the man's character and relations with others. We had the fragmented diary of his Italian tour, and the lecture notes, but there seemed to be a conspiracy of silence when questioning his contemporaries about his personal life and relationships. The legacy of Victorian propriety dies hard and his heavy drinking, which Mrs Newbery said became a serious problem when he left the School (and which William Davidson, his friend and client of Windyhill, Kilmacolm, denied!) and his never-defined 'Bohemian way of life', greatly inhibited research in this area. To give a memorable example, I dined one evening with the Davidsons at the Mackintoshes' former house in Southpark Avenue and mentioned the correspondence issue. William Davidson quietly left the room and returned with a bundle of letters tied with faded blue ribbon, correspondence, he said, between Charles and Margaret. I asked if I might study the letters and he said no, of course not, they were love letters and only he, as trustee of their estate, could have access to them. Eventually these important documents were released some time after William Davidson's death to the Hunterian Museum under strict conditions, as part of the Davidson family's generous bequest of drawings, furniture and artefacts. They reveal, among other things, the largely unsuspected depth of the personal relationship between Charles and Margaret and their dependence on one another, especially during the last decade of their lives. Timothy Neat now maintains that the Mackintosh relationship is one of the great love stories of the twentieth century. We are pleased that Neat has been persuaded to contribute to this book and eagerly await the publication of his complete work, along with the publication of documents held by the University of Glasgow. This material, supplemented by research into the life and work of other contemporaries, will enable the threads of the Mackintosh story to be woven into a rich fabric in which the Girls of Glasgow, their contemporaries and successors, will be given their rightful place.

fig. 64
Charles Rennie Mackintosh with Hamish Davidson, c.1898, taken at Gladsmuir, the home of William Davidson who commissioned Windyhill. (Hunterian Art Gallery)

fig. 65
The Glasgow School of Art, J. Alix Dick, n.d, watercolour, 59.7 ×47.6. View from Scott Street of the second completed phase of the building with the library windows. Jessie Alexandra Dick (1896–1976), followed a full teaching career in art, as well as a painting one. She joined the staff of Glasgow School of Art in 1921 after her years as a student from 1914 to 1919, and taught in the school of drawing and painting until she retired in 1959. As well as drawing she taught still life painting, a favourite subject of her own, landscape and portraiture. An active member of the Lady Artists' Club, in 1960 she was elected ARSA. (Private Collection. Photo: Glasgow Museums and Art Galleries)

fig. 66 *(inset)*
Glasgow School of Art Library, May Reid, *c*.1915, watercolour, 66.0 × 33.0. A view of Mackintosh's library interior by student May Reid who studied from 1914–20. (Dr. Mabel Tannahill)

FRA NEWBERY, JESSIE NEWBERY AND THE GLASGOW SCHOOL OF ART

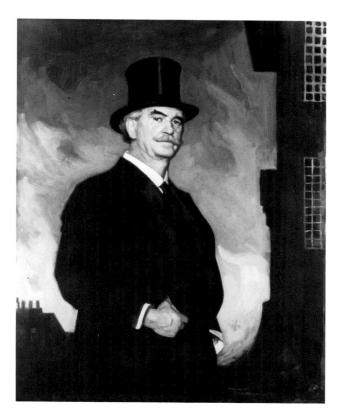

THE VISIBLE WOMAN VANISHES!
by Jude Burkhauser

Any reappraisal of the avant-garde movement which occurred in Glasgow from about 1880 to 1920 in the design arts must focus on the central role played by Francis H. (Fra) Newbery and the Glasgow School of Art (fig. 67). Although there have been numerous appraisals, stemming from interest in Mackintosh, evaluations of the period have neglected the influence of the entry of women into education in Scotland generally; their entry into the Glasgow School of Art specifically as both students and teachers; and the role played by women from the School in the development of the progressive art movement that was labelled 'Scotto-Continental' Art Nouveau[1] and which evolved locally as the Glasgow Style. Liz Bird, in 'Threading the Beads' (1983),[2] opened up this line of enquiry for the first time when she examined the Glasgow Style from the perspective of the women of the School during the brief period they achieved prominence in the decorative arts and the factors which brought about reversal in their fortunes. Bird drew attention to '. . . the relative visibility of these women' compared to previous and subsequent development of the visual arts in Scotland noting here they were recognised as artists, and were able to earn their living through their art by

working as teachers and selling their designs.[3] Yet despite high visibility in journals, reviews, publications and exhibitions, the women who made a significant contribution to avant-garde developments interacting as students and tutors in the School, vanished from most accounts. Even on a 1955 commemorative scroll representing the history of the School and its distinguished graduates (which still hangs in the foyer of the Mackintosh designed building and is visited by thousands of tourists and architectural scholars annually), the visible women of the early history of the School—who so often appeared in the pages of *The Studio* and continental magazine accounts through which it achieved international recognition—had vanished.[4]

With university education denied to women in Scotland until 1892 the Art School had provided one of the earliest opportunities for further study. In 'rich, raw, Glasgow' in the mid-nineteenth century there was a healthy respect for the value of art in design. The Glasgow School of Art was 'founded with a view to the improvement of . . . National Manufactures,' and initially funded by local industry. The first committee of management included: '. . . a Calico Printer, an Engineer, a DeLaine Manufacturer, two Shawl Manufacturers, an Upholsterer . . . [and] a Sewed Muslin Manufacturer. . . .'[5] Speaking in 1850 one of the Governors, Sheriff Alison, said:

> The reason why we in this country are so inferior to foreigners in the Arts of Design is from our remote and insular situation which prevents us enjoying their opportunities of studying from the best models. On the Continent . . . objects in the very highest style are brought under the notice of the people every time they walk the streets, which was not the case in this country, and this was one of the reasons of our inferiority to Continental nations in the Arts. . . .[6]

French-manufactured designer shawls had challenged the Paisley shawl industry and with the Paisley depression of 1841–42 the manufacturing community learned that they would need to improve the design of their products to keep pace with their continental competitors. Manufacturers in Glasgow realised they would need trained designers and qualified teachers to replace traditional methods of handing down knowledge. They joined with local merchants and the government in support of a government school of Art

fig. 67
Portrait of Francis (Fra) Newbery, Maurice Greiffenhagen, 1913, oil on canvas, 132.1 × 102.2. Newbery was the charismatic Headmaster of Glasgow School of Art, the creative centre from which the Glasgow Style would emerge. (Glasgow Museums and Art Galleries)

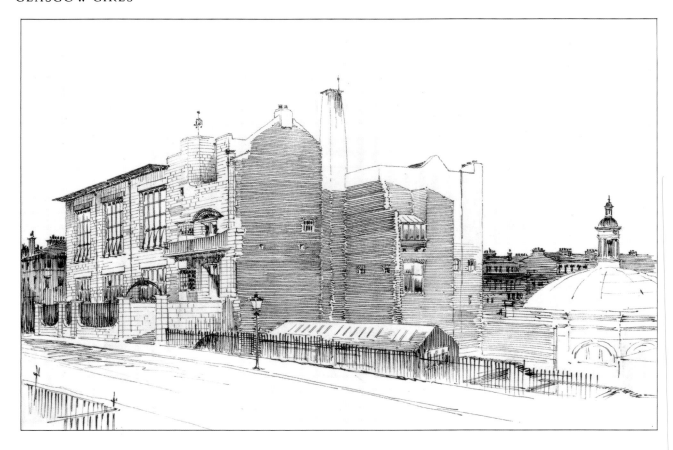

and Design that would train both men and women of the 'artisan' class, the only women then considered acceptable as workers. This division of labour and class contributed to the fact that many (middle class) women could not obtain equal educational opportunity in Scotland until the late 1800s.

Ironically, it may have been the dominant ideological view as expressed by Humphrey Ewing Crum in an 1841 speech at the awards ceremony of the Glasgow Mechanics Institute that 'females would be found to excel in works of fancy [design], as their taste is more delicate than that of the other sex'[7] which first led to the local manufacturers' support of the School and an opening up of educational opportunities for women in the industrial arts. In an attempt to capitalise on this perceived superiority of women as designers, coupled with the fact that women could be paid a lower wage, the merchants and manufacturers of Glasgow provided support for a technical school that would train 'females' and prepare them for employment in the design of patterns for industry.

By the late 1850s with the emergence in Great Britain of the 'destitute gentlewoman' phenomenon, a growing number of middle class women were forced to earn their own living despite the social stigma attached to it. Since art was viewed as a 'ladylike' area of accomplishment and since women in Scotland could then qualify as teachers in special subjects such as art, without

the university training denied them, large numbers of middle class women or 'ladies' sought further education in the Art School. Their entry into the School was generally approved of by 1849, although it was seen to endanger the trade of the private drawing masters, once a woman's only source of training.[8]

In 1852, the School came under the control of the Science and Art Department, South Kensington, and in 1882 earned the greatest number of awards of any school in Scotland and gained the largest government grant of any school of art in the country. There was a firm policy of acceptance for women students by 1885, as demonstrated in the Chairman's statement at an annual meeting in which he said: '. . . in the Fine Arts, women . . . will take a distinguished place, as has been done by many, such as Rosa Bonheur, Elizabeth Thompson, Clara Montalba, Alice Havers, and others, and will [be taken] by many of our Lady Students here.'[9]

A far-reaching development under Newbery was the establishment of Technical Art Studios in 1892. The

figs. 68 *(above)* and 70 *(opposite right)*
Glasgow School of Art, attributed to Alexander McGibbon, 1907–08, pen and ink. This sketch of the School shows the completed first phase from the northwest. The sketch appeared in the Prospectus of the School (fig. 70) and shows the technical design studios to the right of the lamppost. (Glasgow School of Art)

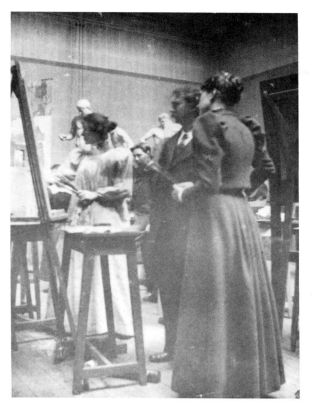

THE:GLASGOW:
SCHOOL:OF:ART.
Director: FRA:H:NEWBERY.

EVENING:SCHOOL.

SPECIAL:TECHNICAL:CLASSES:
To meet the Artistic and Commercial.
Requirements of the following Crafts:

METAL CRAFTSMEN.	COPPERSMITHS.
SILVERSMITHS.	BRASSFOUNDERS.
BLACKSMITHS.	JEWELLERS.
CHASERS.	ENGRAVERS.
ENAMELLERS.	PATTERNMAKERS.
GLASS STAINERS.	LEAD WORKERS.
MANUAL INSTRUCTORS.	

GENERAL SYLLABUS.
Designing in the Material; Repousse in all
its Branches; Fine and Exclusive Chasing
in Gold and Silver; Chain Making; Saw
Piercing; Hammered Work; Jewellery;
Soldering; Pattern Making; Finishing;
Bronzing and Colouring; Tool Making;
Enamelling: The various Methods; Tools and Appliances; Champleve; Cloisonne; Limoges; Plique à Jour; Basse-taille.

TIME TABLE: (see School Calendar).

FEES: for Session September 8th, 1910, till June 9th, 1911, - - - 21/-

Students attending these classes are eligible for the Bursaries granted by the Secondary Education and other Committees.

JOHN:M:GROUNDWATER, SECRETARY.

intention was 'to offer a complete cycle of Technical Artistic Education applicable to the Industrial Arts of the City of Glasgow,' and to employ practising craftsmen as instructors. There were strong links with Glasgow and West of Scotland Technical College, which offered training with the same practical bias.[10] Largely through the opportunities offered in these studio courses, by 1897 women were making their presence in the schools felt in the National Competition awards where Glasgow was seen as the most successful school in the country and the growing strength of the 'sisterhood of art' was eliciting comment:

It is interesting, in glancing over the prize lists, to notice the numerous honours gained by what Sir Wyke Bayliss, in his speech to the South Kensington students, called 'the sisterhood of Art'. The women competitors . . . managed to secure four gold medals (three of which were for original designs), twenty-five silver medals, and ninety-six bronze medals.[11]

By the turn of the century, Glasgow School of Art provided an overlap of industrial design and fine arts training in which draughtsmen, architects, and artists (both male and female, 'artisan' class and middle class) all interacted. This provided a great cross-fertilisation

fig. 69
Ann Macbeth and Fra Newbery in a drawing and painting class at Glasgow School of Art, c.1911–12. Newbery's 'adventurous' hiring of women supported the 'New Woman' in the arts in Glasgow. (Glasgow School of Art)

of ideas, creating a 'hot house' environment for experimentation in all areas of the arts. Women excelled particularly in the area of Decorative Arts where more opportunities had been created for them by Newbery, who, with his wife, Jessie Newbery, played a key role in the development of the Glasgow Style.

A confirmed socialist with strong convictions on the role of the arts in society, Newbery added to the debate in his talk on 'The Place of Art Schools in the Economy of Applied Art' at the Edinburgh Art Congress in 1889. While arguing that any art school should meet the needs of the local population, he maintained that they existed 'not for the immediate production of designs, but of designers. They are not commercial but artistic institutions . . . whose efforts should be directed, not to supplying the demands of a public taste, but of endeavouring to educate that taste.'[12] Newbery's defence of the innovative helped foster the development of young designers such as C.R. Mackintosh, the Macdonald sisters, Jessie M. King, and others in whom he encouraged independence of vision. The Studio review of King's illustrations reported her early work bore 'no hallmark of an established tradition' and was thus rejected by judges who 'believe[d] that a student's business was to be neither individual nor artistic.' The Studio credited Newbery indirectly by saying of King that: 'she was encouraged in her attitude [italics added] by those directly responsible for her education. . . . Better a gold medal lost than an artist spoiled and good it is that in Glasgow, at least, gold medals are no longer to appraise artistic value.'[13]

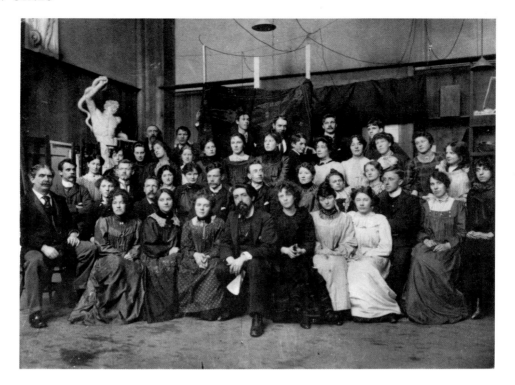

This nurturing of originality was an important factor in the advent of the Glasgow design movement.

From 1885 the dynamic new headmaster publicly avowed equal encouragement of male and female students and set the pace for a continued broadening of educational opportunity for women. By 1908, when the School had risen from relative obscurity to the 'forefront of the modern movement', the number of female staff had risen from none to ten.[14] Under his tutelage there was consistent growth in the number of women students who were free to enrol in most classes and worked side by side with men in all the studios, except the life class. This was not the case in all art schools at the time when timetables, curriculum and architectural space often segregated male from female students.

Francis H. Newbery (fig. 67), who preferred to be called 'Fra' by his students, was born in Membury, Devon in 1853. A competent painter who studied at South Kensington and later taught there, he was the most charismatic figure to have served as director of the Glasgow School of Art. Generally considered the catalyst for the avant-garde movement which emerged, Newbery, at age thirty-two, brought an enlightened, energetic leadership to the school. The special regard in which he was held by most of his associates carried on long after his retirement. One of Newbery's former students, De Courcy Dewar, wrote shortly after the appointment of a new director: '. . . attended the opening of a Greek exhibition at Kelvingrove Galleries specially to see what the new Head of the School of Art was like. . . . He looked nervous and sad. None have been like Fra.'[15]

Although respected and admired by many, Newbery did not enjoy a trouble-free tenure. His support of the 'new' art of the Glasgow Boys and the controversial design movement embodied in the work of his students, in addition to the perception by some of his associates that he was an 'outsider', caused conflicts with his Glasgow contemporaries. In an 1897 letter to E.A. Hornel, the well-known Glasgow Boy painter, written by Bessie MacNicol, another female student of Newbery's, we see a side of the Headmaster seldom revealed:

Poor old Newbery is complaining bitterly about all the best men leaving Glasgow—'Johnny is gone & won't come back I'm sure'. 'Jamie has the idea in the balance & Teddy has gone & is doing well'. I sympathised with him & thought to ask him if he felt lonely here, but thought it might pass for 'MacNicol cheek'. He has some good work—with more distinction than anything he has done. I asked him if he was going to send 2 to the Institute. 'Oh I don't know—there is still a good deal of bad feeling in Glasgow—I am still looked on as too much of a damned Englishman!' I said 'The best men do not think so'. 'Oh no—just the "moles" but they have some power!!'[16]

Under Newbery's direction, the Art School was brought to international attention and the forefront of

figs. 71 *(above)* and 72 *(opposite)*
Newbery in Drawing and Painting Studio with tutor Jean Delville; montage of drawings for the masque, *c.* 1904. *(Glasgow School of Art)*

UNIVERSITY.

🦋🦋🦋🦋🦋🦋🦋🦋

A MASQUE of the CITY ARMS;
OR,
THE SAINT; THE RING;
THE FISH; THE
TREE; THE BIRD;
THE BELL.

By FRA. H. NEWBERY.
(Dedicated to J.R.N.)

Produced at the Glasgow
School of Art (by permis-
sion of the Governors) on
Tuesday, December 22, &
on Wednesday, Decem-
ber 23, 1903 and Played
by the Students of the
School.

The Proceeds are to be devoted to the
Scottish Artists' Benevolent Fund.

🦋🦋🦋🦋🦋🦋🦋🦋

THE BOOK.

. Music .

PROLOGUE.
BY THE DOCTOR.

Good friends! sweet guests! gather-
ed within this House of Art.
Glad welcome to you, one and all, from
out our hearts,
LET GLASGOW FLOURISH!
Dark Daughter of the North, whose
fame in these our days,
Sounds through the World with voice
that clang'rous marks Thee out
As Second in the Circle of the Cities
bound
Round Britain's Brow of Empire,
Glasgow all hail!
Grey hive of men! Thy rain swept
streets and fogs of gloom,
Thy noisome smells, Thy whistles and
Thy uncouth cries,
Give Life an added burden 'neath an
atmosphere of smoke,
And realise in facts, the visions Dante
saw!
These make Thee byword in the
mouths of men who live,
In climates more attuned to pass the
hours of Life
In ease and rest. To such their jeers!
To us Thy joys,
Though these be ever sad, where Man
sweet Nature kills.

Honorary Secretary to the Masque.
Mr. JAMES J. F. X. KING, F.E.S.
Honorary Treasurer to the Masque.
Mr. JOHN M. GROUNDWATER.
The Masque is produced (by permission of the
Chairman and Governors of the School), by the
Headmaster,
Mr. FRA H. NEWBERY.

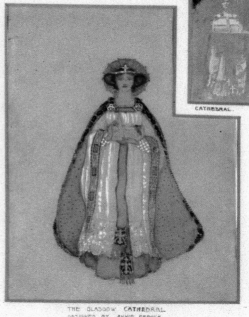

CATHEDRAL.

THE GLASGOW UNIVERSITY.
DESIGNED BY ANNIE FRENCH.

THE GLASGOW CATHEDRAL.
DESIGNED BY ANNIE FRENCH.

KING RODERICK THE BOUNTIFUL.

KING REDDERCH OF STRATHCLYDE.
DESIGNED BY D. CARLETON SMYTH.

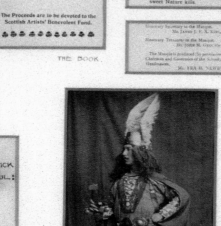

KING REDDERCH.

QUEEN AND MAIDENS.

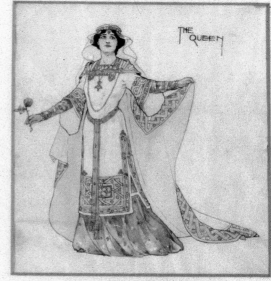

THE QUEEN

QUEEN LANGUETH OF STRATHCLYDE.
DESIGNED BY D. CARLETON SMYTH.

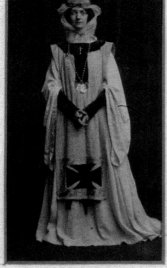

NOVICE OF THE BLOOD ROYAL.

NOVICE OF THE BLOOD ROYAL.
DESIGNED BY D. CARLETON SMYTH.

NOVICE OF THE BLOOD ROYAL.

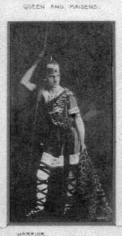

WARRIOR.
DESIGNED BY ALLAN D. MAINDS.

QUEEN'S LADY.

QUEEN'S LADY.
DESIGNED BY DECOURCY LEWTHWAITE DEWAR.

MASQUE CHARACTERS.— DRESSES DESIGNED BY STUDENTS OF THE GLASGOW SCHOOL OF ART.

"THE:(R)EVOLUTION:OF:WOMAN"!!

EPOCH I.—"EDEN."

See primal woman! free and glorying in her bravery,
To her, crawls savage man, intent to set up slavery,
She, as usual, taken up with housework and the cooking,
Gets nabbed for squaw, or wife (?), just when she isn't looking.

Mme. Eve et Cie	Miss M'Laren.	Miss Robertson.
M'Adam & Co.	Stewart Orr.	Y. G. Ap. Griffith.

EPOCH II.—"THE IDEAL WIFE"
(FAR ABOVE RUBIES).

In sad woeful plight, now her lot it has cast her,
See woman compelled to let MAN be her master!
While she works and she slaves, HE is drinking and eating,
And if things do not please him, why—she's in for a beating.

The Wife	Miss A. Urquhart.	The Mann M.P.	Mr. Urquhart.
The Maiden	Miss Sorley.	The Elder	Mr. Workman.

EPOCH III.—"THE AGE OF CHIVALRY."

Let trumpets blow and shouts proclaim the Victor's feats of arms!
Him, Chivalry has fired with zeal, for woman's lovely charms,
He risks his life in knightly strife, with courage heaven sent.
His brows shall bear the crown, placed there by Queen of Tournament.

The Queen of Beauty	Dr. Everett M'Laren.
The Damsel with the Garland	Isabelle Livingstone.
The Damsel with the Fan	Agnes Halley.
The Damsel with the Roseleaves	Dorothy Fraser.
The Page	Master Earnie Aspin.
and Ladies	
The Victorious Knight	Robert Mitchell.
The Esquire	Master Chris. Hird.
The Page	Master Jim Aspin.
The Falconer	Miss Turner.
and Knights	

EPOCH IV.—"THE NEW WOMAN"
(POSITIVELY HER FIRST AND ONLY APPEARANCE IN GLASGOW).

New Woman, "gentle creature," is stern of mind and feature,
She's making ducks and drakes of man's most cherished whims,
She wears his hats and coats! she wants to share his votes!!
She wants an *equal* world, composed of "hers" and "hims"!

Herself	Jim Maitland.
and	

Mr. John Leech's Ladies and Gentlemen of 1865, including Lord Dundreary.

Mr. Barbour.	Miss O. R. Smyth.	Miss Mainds.
Mr. Scott.	Miss H. Paxton Brown.	Miss Marion Orr.
Mr. A. Reid.	Miss May Buchanan.	Miss Sybil Thompson.

EPOCH V.—"THE BAR OF JUSTICE," 1950 A.D.

Oh! Goddess blind! to Thee for mercy, cry some guilty males,
Do not, so please Thee, deem their prayers "mere fudge,"
Pause in Thy vengeful work, put up Thy sword and scales,
And think Thee of the Woman in the Judge!

His Honour the Judge	Miss D'Courcy L. Dewar.	
The Counsel	Miss Susan Crawford.	Miss Isa Wright.
The Clerk of Court	Miss Cathcart.	
The Jury	Miss Collins.	Miss Marion Orr.
	Miss Jennie Gunn.	Miss Bettie MacPherson.
	Miss Jeanie Sellars.	etc.
The Macer	Miss Ina Campbell.	
The Constabulary	Miss Elsie Carruthers.	Miss Jean Corrie.
	Miss Sandford.	etc.
Press	Miss Hogg.	
Defendants	Mr. Neaves.	Mr. Conacher.
	Mr. A. Reid.	Mr. Roy Orr.
	Mr. Gray.	Mr. Jack Wilson.
	etc.	

EPOCH VI.—"THE UNIVERSITY OF GLASGOW," 2000 A.D.
(ZOOLOGICAL DEPARTMENT).

See "Homo" become both in form and in pedigree,
As extinct as the Dodo; unknown to Zoology.
Recovered from strata, fine in figure and face
He to museum goes, to be put in glass case.

The Professor	Miss Conacher.	The Students ?
The Specimen	Mr. Harold Halley.	

Recently discovered, and
as yet unclassified

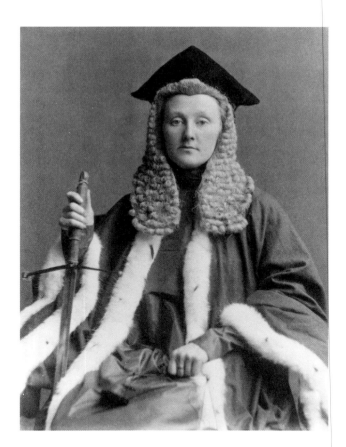

the modern movement. He initiated important changes in the curriculum, focusing on the practical applications of design. This was done in response to the call from manufacturing industries in Glasgow for designers, and to the criticisms from such judges as Walter Crane and William Morris in the South Kensington competitions who said that, while innovative in concept, the practical application and construction was lacking in his students' work. He promoted, staged, and involved his students in important art and design exhibitions abroad in Turin, Vienna, and Liège, encouraging interaction with the Continent and going so far as to employ a continental tutor, Jean Delville (fig. 71), in drawing and painting when few other British art schools would dare to do so. In addition, Newbery envisaged and promoted a new school building in Glasgow which provided a base for his ambitious plans for the expansion of the School's programme. Perhaps most importantly, he gave equal encouragement to male and female students providing an atmosphere of equal opportunity in education that was somewhat rare at the time.

Despite Newbery's raised consciousness with regard to women students and staff, he maintained the 'equal but different' view of equality held by the leaders of the Arts and Crafts movement such as Crane and Morris with whom he was in professional contact. In an article for *The Studio*, 'An Appreciation of the Work of Ann Macbeth', Newbery wrote: 'The association of the needle is with the woman's hand. . . . As the plough to

fig. 73
The (R)Evolution of Woman was performed at the Bellefield Sanatorium, Lanark, c.1900. In delightful rhyme Newbery related the evolution of woman, 'free and glorying in her bravery' (Epoch I—Eden), to her 'sad woeful plight' as the ideal wife (Epoch II), who then passes woefully through the age of chivalry (Epoch III), to make 'positively her first and only appearance in Glasgow as the 'new woman' in (Epoch IV). (Glasgow School of Art)

fig. 74
De Courcy Lewthwaite Dewar dressed as 'His Honour The Judge'. Dewar appeared as 'His Honour the Judge' in (Epoch V): The Bar of Justice, AD 1950. Newbery was not far off with his prediction of the New Woman's entry into such 'masculine' occupations as The Bar. Whether his (Epoch VI), the University of Glasgow—2000 A.D. sees the 'Homo' become 'both in form and in pedigree, as extinct as the Dodo', we shall have to wait and see! (Coll: H. L. Hamilton. Photo: Glasgow Museums and Art Galleries)

the peasant or the pen to the writer, so the needle lives in our sentiments as a personal effect of the woman . . . [and] embroidery—the art by instinct of the woman . . .'[17] Although he advocated open admissions and course offerings that prepared men *and* women for teacher certification and work in industry, the Victorian belief that there existed separate spheres of ability prevailed, and the courses in architecture were closed to women until about 1905. When Glasgow did admit women into its architectural programme it appears that it was the first art school in Great Britain to do so.[18]

Newbery believed in close interaction with his students past and present and initiated a number of programmes which would provide a vehicle for contact. One, the Glasgow School of Art Club, a vacation sketching scheme, became an important exhibiting outlet for students including Charles Rennie Mackintosh and members of his circle. He was interested in the writing of light verse and amateur dramatics and initiated, wrote and directed a number of masques which were produced and performed by Art School staff and students in locations throughout Glasgow. The popularity of masques or *tableaux vivants* stemmed from a nineteenth-century renewal of interest in medievalism. One indication of the scale of these productions is seen in a news clipping from Edinburgh *c.*1911 which announced that a 'much advertised' production by Mr Geddes, entitled 'Learning', recently presented in the city, was now to appear at London University with over 500 performers![19] In Glasgow masques were frequently presented at the School as a result of the infectious enthusiasm of Newbery, who wrote and directed many of the pageants himself.[20] A number of the *tableaux*, with groups of characters in elaborate costumes assuming varied poses accompanied by verse and full orchestral accompaniment, were designed, staged and performed by staff and students as costume design and drawing was an important part of the curriculum and the masques provided an excellent showcase (figs. 72–73). In her letters, Dewar gives a behind-the-scenes glimpse of one masque and it is obvious from her account that Newbery was a perfectionist:

In the afternoon we had our first Dress rehearsals in the School, which lasted from 3 to 9 p.m.! Fancy we were so tired that a man and a girl fainted; Mr Newbery sent out for tea and after a great fight most of us managed to procure a cup of tea and a slice of bread. Fra took a tremendous amount of trouble over it. Really the dresses looked beautiful and the smell of incense from the acolyte's censer gave quite an ecclesiastical feeling to the procession. . . .[21]

Dewar, who studied and later taught enamelling at the School, provides insight into Newbery's sometimes domineering and contradictory nature as Headmaster.

In November 1903 she had asked Newbery for a rise in her salary. The Board of Governors decided to raise it by only one shilling. Outraged, Dewar resigned her position as teacher in the enamel class saying 'they could not have offered me less.' She writes of her subsequent meeting with Newbery:

I wondered what tack he would take whether a bullying one or one of reconciliation. . . . He asked what it was all about. I told him I did not think I had been offered enough, etc. Then he said he was not pleased with my designs in the class, I said . . . that was an argument on my side not his; if he and the Governors did not think my work good enough all the more reason why they should . . . appoint someone else. He said he did not want to loose [sic] light [sic] of me; that this might be the Scotch [sic] way of suddenly cutting off a friendship but it was not his way . . . & he also told me I was conceited & self confident & I told him if you had not some self confidence you would not get on . . . eventually he asked me how much I wanted, so I said 7/6 a lesson . . . so he is going to speak to the governors. . . . He is simply a mass of contradictions, as when I asked him for a rise he told me to write him a note; I just reminded him of that. He gets more and more impertinent until there is a regular row and then he gets polite again. Nearly everyone has had a row with him at one time or other & then he is quite nice again.[22]

Yet despite their differences, Dewar and Newbery worked closely together as part of a team in the planning and production of the masque held at the School of Art the following month (fig. 74). Dewar's affection for Newbery despite the exasperation is clear:

We had the bagpipes and all the music that day and Fra of course went on changing everything. After getting the book of the masque printed he changed the order of the pageant & some of the pictures a little. He has got such a fertile brain that he could go on changing them for ever if he could.[23]

Fra Newbery remained in his post at the Glasgow School of Art from 1885 until 1918 when, after a series of breakdowns, ill health forced him to retire to Corfe Castle where he was cared for by his wife until his death. His close relationships with several of his students, most prominently Charles Rennie Mackintosh and Margaret Macdonald, carried on into those final years. A full investigation of Newbery and his contribution to the Glasgow Style is long overdue.

Fra Newbery's devoted partner, Jessie Newbery, (née Rowat) (fig. 75), was first a student and later Head of Embroidery at Glasgow School of Art. Identified by Anthea Callen in *Angel in the Studio* as one of an 'extremely important group of women designers and embroiderers although only indirectly connected to the Arts and Crafts movement proper . . . [who] had a

crucial impact not only on design for embroidery, but on methods of teaching it,' and who, with Margaret and Frances Macdonald and Ann Macbeth, were 'central to the evolution of the Glasgow Style'[24] in the decorative arts, Newbery is an important figure in the development of the Scottish Art Needlework movement at the turn of the century. Her influence as teacher, designer, and initiator of 'Glasgow School of Art Embroidery' has been acknowledged, but the extent of her influence on the Glasgow Style has not been as well understood. Liz Arthur fully investigates Newbery's life in the Designers chapter of this book.

In 1889 she married Fra Newbery and assisted in social and fund-raising activities of the Art School, including masques, 'At Home' programmes and teas which provided interaction between staff and students. Fra and Jessie Newbery shared a personal and professional relationship that was profound and long-lasting and which provided an important influence to the many students from the Art School who saw them as role models.

Newbery's importance to the history of women in the arts generally comes less from her own art work and more from the philosophical approach with which she initiated and taught the 'art' rather than the 'craft' of embroidery to a new generation of women. Through this new 'artistic' consciousness she loosened the hold of what Rozsika Parker calls 'enforced femininity' on embroidery and was the first to advocate that needlework be reconsidered as an art form and not merely as an 'extension of the embroiderer.'[25] Newbery's design style, her use of innovative lettering and geometric motifs with its 'distinctly modern feeling' was a major influence on her students (fig. 194). Most importantly her philosophical stance as a self-defined artist demonstrated clear commitment to self-determination, an attribute of woman that was beginning to re-emerge after centuries of repression. Newbery stated: 'I believe in education consisting of seeing the best that has been done. Then, having this high standard thus set before us, in doing what we like to do; *that* for our fathers, *this* for us. . . .'[26] Jessie Newbery, although marginalised by many of the 'official histories' of the era made a major contribution in design education, theory and application along with her successor Ann Macbeth. Through holistic reappraisal of the movement we see that she was a major influence along with Fra Newbery to the early development of the Glasgow Style.

fig. 75
Jessie Newbery and Fra Newbery in 'fancy dress', c.1900. The Newberys' influence took the form of equal encouragement of male and female students and in promotion of original design rather than slavish copying. (Glasgow School of Art)

WOMEN AND ART EDUCATION

by Liz Bird

The ability of women to succeed as artists and designers was crucially influenced by access to training in the fine and applied arts. Prior to the nineteenth century women were excluded from most forms of artistic training. Women artists whose work did achieve recognition usually gained training by being related to male artists and thereby having access to studios. From the seventeenth century, the establishment of art academies opened up another route for the professional artist and many had training schools attached to them.[27] Women were generally excluded from such schools and were reliant upon instruction from privately employed drawing masters. During the nineteenth century a further development took place in Great Britain with the establishment of government schools of design.[28]

The access of women to training in the fine and applied arts in the second half of the nineteenth century is a complicated story as during this period there was considerable debate over what should be taught, to whom, and for what purpose. Firstly, there was training in the fine arts in order to qualify as a professional artist. As Pamela Gerrish Nunn argues in her book, *Victorian Women Artists*, women were considered to be excluded from such a profession by virtue of their sex and much of the energy of the early feminists concentrated on challenging these assumptions, in particular by gaining access for women students to the Royal Academy in London which was partially achieved in 1861. Some women chose to study abroad, either in Paris or Germany, where private schools accepted women students. The Slade School which opened in London in 1871 adopted the French system and men and women were accepted on equal terms.[29]

Both the Royal Academy and the Slade were officially offering training in the fine arts. The second form of training was in the applied arts and here the government schools of design, including the Glasgow School of Art, were set up in the 1840s in order to promote good design for the benefit of manufactures.[30] All the government schools of design were also open to women, and, as the records of provincial schools show, they were rapidly taken over by middle class women in search of a means of livelihood and eager to secure an education which was otherwise denied them. In London, this had been recognised by the setting up of a Female School of Design in 1842, one of the objects of which was to 'enable young women of the middle class

fig. 76

Tristan and Isolde, Dorothy Carleton Smyth, 1901, leaded stained glass window, 152.5 × 122.2. Large scale productions in metal, gesso, glass and mosaic by women emerged from Newbery's Decorative Arts Studios; the window was exhibited at the Glasgow International Exhibition in 1901. (Glasgow School of Art)

to obtain an honourable and profitable employment.'[31] This school had a varied history. It moved many times and lost its government grant in 1859, but was saved by an appeal and royal patronage in 1861.[32] Other ventures, such as the Royal School of Art Needlework, founded in London in 1872 with royal patronage, also addressed the plight of needy gentlewomen. The emphasis on needlework can be seen in Glasgow in the Scottish Industries exhibitions.

The government sponsored schools of design were co-educational, although the numbers of women attending varied according to local circumstances and attitude.[33] The fortunes of women students at Glasgow School of Art (figs. 77–78) seem to have been relatively good compared to elsewhere. They could follow all courses offered, and were educated alongside the men, with the exception of the life class. Registers exist from

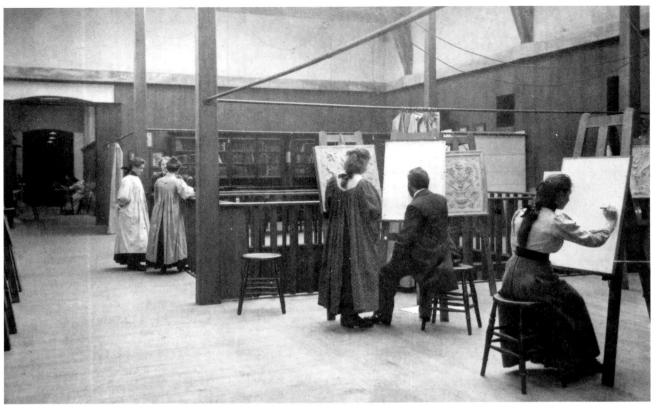

1881 until the present day which enable us to calculate the numbers of female students. In 1881–2 women made up about 28 per cent of the student body. This increased steadily to 35 per cent in 1892–3 and to 47 per cent in 1901–2. About 1904 a change was made in the register, following a transfer in 1899 of the School from the control of South Kensington to the Scottish Education Department. After 1904, students taking the Saturday morning classes for teachers were recorded separately and the proportion of female students dropped to 33 per cent in 1907–8, but by 1911–12 it had risen again to 47 per cent. The war disrupted normal recruitment, but by 1920, the proportion of female students was roughly half, while if those attending the teachers' classes are included, the proportion is much higher.[34]

The presence of female students at the Art School did not often occasion much comment, and the School seems to have maintained a firm educational policy of offering professional training to anyone who wished to benefit. In 1885 Sir William Fettes Douglas, then President of the Royal Scottish Academy in Edinburgh, made a speech in which he poured scorn on the work of women artists—'why is a woman's work like a man's only weaker and poorer', to which the chairman of the Glasgow School responded at the School's prizegiving by praising the work of the Glasgow lady students and claiming that women were quite capable of being artists if they applied themselves.[35]

In 1890, after a particularly good year for the School in the South Kensington competitions, the *Mail* commented:

> The success of the female students has been very marked, no fewer than six national prizes and twenty third-grade prizes being taken by them this year, and the gaining of the Haldane Scholarship by a lady student would point out that the higher education of women is being attempted in the school with some success.[36]

In 1895 Fra Newbery, when asked about the 'dilettante young lady who would decorate tambourines and milking stools with impossible forget-me-nots and sunflowers', replied that she 'has been entirely weeded out. She got no encouragement, and is now, so far as the School is concerned, non-existent.'[37]

The choice made by women students in the period 1890–1920 was to specialise in painting and drawing or the applied crafts. Posts obtained by female graduates of the School were usually as teachers of crafts, in particular embroidery, at either elementary school level or within the Art School itself, or as professional designers. All students had to follow the basic course initiated by Newbery which taught the skills of modelling, drawing and painting. The post-basic course could be pursued in one of four sections of the School—Drawing and Painting, Modelling and Sculp-

fig. 77
Women in the museum, Glasgow School of Art, in a drawing class, c.1900s. (T & R Annan and Sons, Ltd., Glasgow)

ture, Architecture, and Design and Decorative Art. The women designers, whose work was such an important part of the Glasgow Style, specialised in design and decorative art, and many of them moved from being students to teachers of these subjects in the Art School itself.

When Fra Newbery was appointed in 1885 there were no female staff at the Art School. There had been two women teaching drawing, Miss Patrick and Miss Greenlees, but they left with the latter's father when he resigned as Headmaster of the School in 1881. The first woman appointed by Newbery was Miss Dunlop in 1892 and the annual report for that year refers to 'artistic needlework taught by a lady'. Miss Dunlop was joined in the following year by Newbery's wife, Jessie. Jessie Newbery and later Ann Macbeth, were to make the School internationally famous for its 'artistic needlework' (see Chapter 4). Along with the innovation of needlework as a subject of study Newbery introduced a series of craft subjects and, by 1895, a separate section was set up in the School, the Applied Art Studios, which were intended to provide '*practical* execution of studies in design, applicable to the industrial arts of the city.'

The establishment of the Studios marks a further stage in the development of art education. Although intended to promote industrial design, the majority of the government schools of design had tended to gravitate towards the fine arts and there was a renewed attempt in the 1890s to re-establish the connections between art and industry. Newbery had taken up this cause early in his career at Glasgow, and the setting up of studios, using local designers as instructors, was based on the work of Walter Crane at South Kensington in the 1880s. The Central School of Arts and Crafts, headed by another craftsman/designer William Lethaby, was set up in London in 1896 and was the first school to be established on specifically craft-training principles.

Where Newbery differed was in the encouragement he gave to women designers. Through Lethaby the Central School was closely linked to the Art Workers' Guild which excluded women from membership.[38] In 1908 the Female School of Design was amalgamated with a reluctant Central School and women were admitted to the craft classes. The method of teaching applied crafts through studio instruction proved attractive to women designers, and the Central School and Birmingham School of Art which also adopted this method were, along with Glasgow, to produce 'many of the bolder, well-known and most successful craftswomen.'[39]

This shift in the principles of art education thus had a significant effect on the part played by women in the Art School. A number of factors had resulted in increasing numbers of women students, now the new arts and crafts emphasis had given women a specific role, where their traditional interests could be de-veloped in the creation of a coherent decorative style. The emergence of applied arts also resulted in more women gaining teaching posts within the Art School. The feminist movement of the 1860s and 1870s had drawn attention to the difficulties faced by women gaining employment in art education. An article in the *Art Journal* of 1872, 'Art Work for Women I', referred to 117 art schools in Great Britain training 20,133 pupils, only three of which had lady superintendents, and 338 art night classes, five of which were taught by women.[40] The Applied Art Studios in the Glasgow Art School were to be dominated by female teaching staff. Between 1892 and 1920, twenty-seven women appear on the staff lists of the School, and, of these, seven worked in the painting and drawing division. The other twenty were in the applied or decorative arts. These women included most of the Glasgow Style designers whose work was exhibited abroad and who achieved international recognition.

Jessie M. King, famous for her work as a book illustrator and jewellery designer, began her career as a student in the School and then taught book illustration, ceramic decoration and design until her departure for Manchester in 1908. Ann Macbeth, the embroiderer, also entered the School as a student in 1897. She became Head of Embroidery in 1908, succeeding Jessie Newbery and, in this position, was the only woman to reach the upper levels of the School hierarchy. As head of a section she was at professorial level although she was never given that title. Margaret and Frances Macdonald were both students at the Art School in the 1890s, leaving in 1894 and setting up their own studio in the city. Margaret was to merge her career with that of Mackintosh, and never taught in the School, but Frances taught design for metalwork, repoussé and embroidery between 1908 and 1910, after her marriage to Herbert MacNair and their return from Liverpool. Agnes Bankier Harvey taught metalwork, enamelling and goldsmithing, and De Courcy Lewthwaite Dewar, also an enameller, taught a whole range of applied arts at the School from 1900 until 1928.

Other women designers who achieved international recognition and also taught in the School during this period included Susan Crawford, who taught etching; Helen Muir Wood—enamels and block cutting; Norah Neilson Gray—fashion plate drawing; Annie French—ceramic decoration; and in the school of embroidery and needlework, Helen Paxton Brown, Margaret Swanson, and Anne Arthur. Perhaps the most versatile and long-serving of the women teachers were the sisters Dorothy and Olive Carleton Smyth. They joined the staff in 1900 and 1902 respectively, and between them, taught sgraffito, gesso, wood blocks, printing in colours, metalwork, gold and silver smithing, repoussé, mosaics, miniature painting, lithography, block cutting, black and white, the history of costume and armour and fashion plates. Thus the crafts taught by women correspond closely to

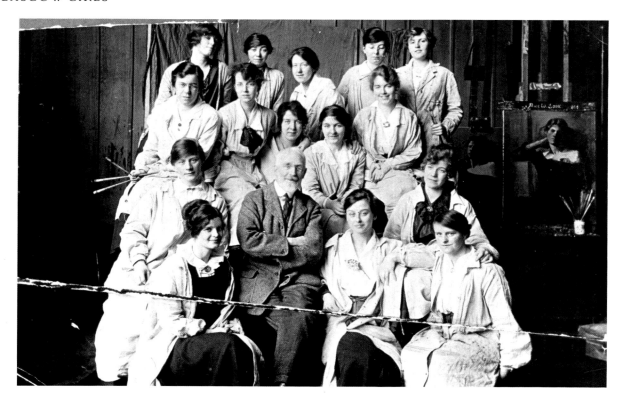

those in which, according to Callen, women in the Arts and Crafts movement specialised.[41]

Of all the crafts taught and practised at the Glasgow School of Art, embroidery was to become the most renowned (fig. 79). The development of art embroidery as part of the Arts and Crafts movement was taken in a specific direction by the Glasgow Style. Firstly, the embroidery produced by the Glasgow women was designated as *art* embroidery and its place as an art form was quite clearly accepted. Jessie Newbery's contribution to the origin of the Glasgow Style was recognised in the first article on their work which appeared in *The Studio* in 1897. In that article, the philosophy which underlay the Glasgow Style is articulated by her: 'I believe that the design and decoration of a pepper pot is as important in its degree as the conception of a cathedral.'[42] Secondly, as has been seen, Jessie Newbery had quite radical views about the execution and the teaching of embroidery. She used simple, cheap and easily available materials, and through the extension of embroidery teaching from the School of Art into all schools in Glasgow, she hoped to demonstrate the relevance of art to all classes of people. The *His Majesty's Inspector's Report* on the work of the School in 1906 made special mention of the embroidery continuation classes, taken by Jessie

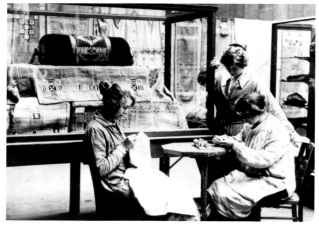

Newbery and Ann Macbeth, where clothes were made which were 'suitable for and useful to the class of pupils they teach'. The report also mentions classes for workers in the threadmills, where 'the girls may be helped to the artistic development of the material they work amongst'. This tradition was carried on by Ann Macbeth who pioneered a new method of teaching embroidery, where the needle was to determine the nature of the design. It was reported that 'in giving the instruction in this new form they [student teachers from the Art School] have found it of great value as an outlet in the Elementary Schools for the artistic

fig. 78
Glasgow School of Art Painting Studio with tutor Maurice Greiffenhagen, *c.*1920s. Mary Armour is in the right rear of the photograph. Drawing and painting students who wished to qualify as teachers were required to take embroidery classes. (Glasgow School of Art)

fig. 79
Glasgow School of Art embroiderers in the Museum, *c.*1920s, Mary Armour, Honorary President of Glasgow School of Art is on the left. (Glasgow School of Art)

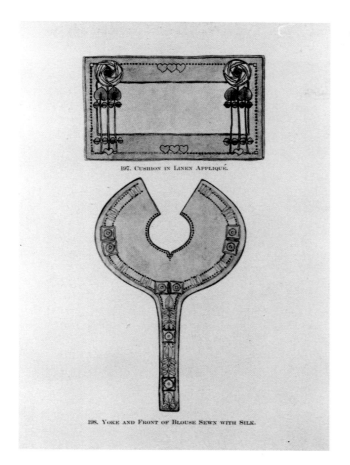

197. CUSHION IN LINEN APPLIQUÉ.

198. YOKE AND FRONT OF BLOUSE SEWN WITH SILK.

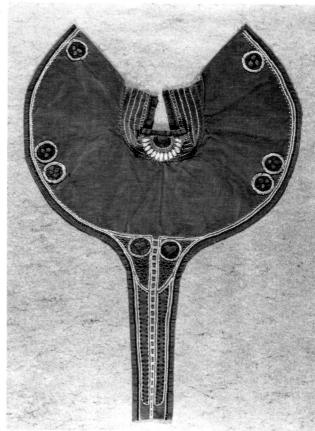

training.' Ann Macbeth was to disseminate her new method in a series of textbooks published between 1911 and 1929 (fig. 80). The character of the Glasgow Style of embroidery was recognised in an early article in *The Studio*:

> Look to the Glasgow School of Art if we wish to think of today's embroidery as a thing that lives and grows and is therefore of greater value and interest than a display of archaeology in patterns and stitches.[43]

Although the Glasgow Style came to an end about 1920, many women designers continued to exhibit their work in the city, particularly at the Lady Artists' Club's annual exhibitions. New and influential women joined the staff of the Art School, such as Grace Melvin who taught illumination and Goldie Killin who taught ceramics and design. By the time Olive Carleton Smyth was replaced in 1937 by Tom Purvis, the applied studio arts section had been re-named Commercial Art. The move towards a more business-orientated curriculum in the School signified by this change of name also saw a steady decline in the numbers of women on the teaching staff although embroidery was to remain a

female domain and, as late as 1970, was a compulsory subject for 'all girls who intend to qualify as teachers of art'.

(Despite the fact that from 1880 to 1920 there was a significant increase in the number of women staff and a corresponding increase in the number of women from the School of Art pursuing careers in art and gaining recognition for their work, women who sought a career were faced with a difficult choice: marriage *or* a career. For, up until 1945 married women were not permitted full-time employment as school teachers.[44] Many talented and dedicated women were directly affected by this ruling which effectively removed married women artists as role models in education.

Rising generations of women art students had been given a clear message: marriage or profession.[45] It was not until the 1945 Education (Scotland) Act that the 'marriage bar on women teachers'[46] was ended by an amended clause which provided that no woman shall be disqualified for employment as a teacher or be dismissed from any such employment, by reason only of marriage.[47] Despite the removal of marriage as a disqualifier for women in art education, there are still few female staff at the Glasgow School of Art.—Ed.)[48]

fig. 80
Illustration from *Educational Needlecraft* showing front of blouse sewn with silk and a linen appliqué, examples of Glasgow Style work, Ann Macbeth, 1911. (Glasgow School of Art)

fig. 81
Embroidered orange velvet yoke close to that illustrated in *Educational Needlecraft*, designed by Ann Macbeth, c.1910–11. (Glasgow School of Art)

THE MAGAZINE (1893–1896)

by Ian Monie

15 March, 1949
Dear Mr Bliss,

I have found this magazine made by Mrs Spottiswoode Ritchie and containing contributions from C.R. MacIntosh [sic] and other students of that time. . . . I thought you might like to have it . . . in memory of very interesting and wonderful days at the Glasgow School of Art when we were all there, working very hard in—I can't remember what year—so long ago. . . . !! Katharine Cameron Kay[49]

Cameron's donation was a publication of original writings and designs by students from the School and their friends. Appearing in four volumes between November 1893 and Spring 1896, *The Magazine* (fig. 47) contains text from contributors handwritten by Lucy Raeburn, editress, accompanied by original illustrations. These volumes are the only known copies of *The Magazine*. In addition to rare, early watercolours and designs by Mackintosh (fig. 154), the volumes contain early designs by Frances and Margaret Macdonald, at the stage of their development which has been labelled 'Spook School', and two sets of photographs by James Craig Annan, when he was beginning to establish a reputation at home and abroad. Amongst other female contributors were Janet Aitken, Katharine Cameron, Agnes Raeburn and Jessie Keppie, all of whom enjoyed lengthy careers in art and design.

The Magazine is similar to an *album amicorum* such as those which originated in the middle of the sixteenth century among German university students, who collected autographs of their friends and notable persons, sometimes adding coats of arms and illustrations.[50] *The Magazine* resembled the *album amicorum* in that the contributions were by a close group of students and their friends and is all the more interesting because the illustrations were produced by young people who had a common social background, were trained at the same art school, and subjected to the same artistic influences. The contributors were closely linked, some by family, some by romantic attachments and had close social connections. There were three sets of sisters; Agnes and Lucy Raeburn, Frances and Margaret Macdonald, and Jane and Jessie Keppie. Charles Rennie Mackintosh broke off a romantic relationship with Keppie and married Margaret Macdonald. D.Y. Cameron and Katharine Cameron were brother and sister.

John Keppie, a junior partner in the architectural firm which employed Mackintosh and MacNair, often invited Mackintosh to his home at Ayr when competitive designs were being prepared and at weekends Keppie rented two bungalows, christened 'The Roaring Camp', at nearby Dunure to house additional guests. Usually the women of the party were Frances and Margaret Macdonald, Agnes Raeburn, Katharine Cameron, Janet Aitken, and John's sister, Jessie Keppie. With the exception of MacNair, Keppie's guests at 'The Roaring Camp' were Lucy Raeburn's major contributors. From a population of over 500 students, the persons who were persuaded to contribute to *The Magazine* were a small clique, many living in the same fashionable area of Glasgow. Some designs and theoretical essays may have been stimulated by the vacation work for the School of Art Club. Two of the four volumes were produced in November, the month of the Club exhibition, and Lucy's article 'Round the Studios', dated October 1893 and published in the first issue of *The Magazine*, is a criticism of some of the work to be shown a month later at the exhibition.

Lucy Raeburn (1869–1952), did not pursue a career in art. She enrolled for only one session, 1894–1895, in the School, by which time she had already edited the first two numbers of *The Magazine*. The only substantial piece by her on record is a hammered brass panel which she designed and executed, which was exhibited by Charles Rennie Mackintosh at the 'Arts and Crafts Exhibition Society' in 1896. Hammer work she exhibited at a 'Glasgow School of Art Club Exhibition' was good enough to be commended in a local press notice. It is, however, Raeburn's documentation of some of the early drawings and watercolours by the members of the Mackintosh circle in *The Magazine* which has proved her lasting contribution to Glasgow Art and Design.

Her sister, Agnes Middleton Raeburn (1872–1955), was an active artist for many years studying at Glasgow School of Art from 1887 until 1901 when she was elected to the Royal Scottish Society of Painters in Watercolours. Raeburn exhibited landscapes and flower studies in this country, in Paris, the USA, and Canada. Her early work in *The Magazine* includes several unremarkable drawings of fairies, and some full-page illustrations incorporating text which are pleasing designs. The work does show certain features common to the Glasgow artists—women with flowing hair, birds with large combs and flowing tail feathers, mist swirling across the sun, swallows in flight, and long thin flower or tree stems growing from entwined roots or bulbs.

The bookplate (fig. 82) by Frances Macdonald (1873–1921) for the November 1893 *Magazine* is one of the earliest of her surviving works. It is an interesting example of how elements of designs were re-worked to become part of the regular vocabulary of the Glasgow Style. The bottom half is almost a replica of Frances' design for the Glasgow School of Art Club programme for 25th November, 1893; the top half weds the tree of that design and the central angel in Margaret's invitation card for the same event (figs. 83–84). The framework of flowing hair, wings, and branches with

shoots terminating in a single fruit, became features used by several artists, including Mackintosh. Photographs of Frances Macdonald's design for a mural decoration *The Crucifixion and Ascension* (*c*.1893)[51] (fig. 85) appeared in the April 1894 issue of *The Magazine*, one of which was reproduced by Pevsner in 1950 and wrongly attributed to Margaret. This work may have been partly inspired by the Symbolist Jan Toorop, whose *The Three Brides* was reproduced in the September 1893 number of *The Studio*. His *L'Annonciation du Nouveau Mysticisme* (1893) includes an elongated angel with clasped hands, and in the foreground a group of flowers on the point of opening. In her design, Frances creates a repeat abstract pattern incorporating elongated angels with hands clasped in prayer, some of whom in profile resemble her female figure in *Ill Omen* (1893) (fig. 153) and groups of flowers, some forming an *espalier*-type pattern. Another ingredient in her design is an abstract tree which has been more usually associated with Mackintosh. And is it merely a coincidence that in the background of *L'Annonciation du Nouveau Mysticisme* Toorop depicts trees with branches bearing a single fruit?

In her watercolour, *A Pond* (fig. 95), which appears in the November 1894 issue, emaciated figures from earlier designs are even more attenuated. Insect women with sharply tilted heads resemble Charles Ricketts' work, *Dog-faced Anubis*. It is possible Frances Macdonald was drawn to Ricketts' illustrations, and his figures may have influenced her designs. In the Spring 1896 issue however, the two sisters, who had been collaborating to produce an illustrated version of the Christmas story, are represented by Margaret's *Annunciation* and Frances' *Star of Bethlehem*, better calculated to satisfy a commercial market, albeit heavy with religious symbolism, but each with less skeletal figures, and with positively chubby renderings of the infant Jesus. Despite their modified style, the book was not published.

In addition Margaret Macdonald (1864-1933) contributed three designs to *The Magazine*; two are photographs of stained glass designs, published in April 1894. The Hunterian Art Gallery, Glasgow University holds the original ink and watercolour design of *Summer* (fig. 138), a thin female form growing from a bulb or large seed, and standing on tiptoe to kiss a male sun. The female drops rose-like flowers from an expressive hand, while a flight of Glasgow Style swallows passes across the sun. *The Path of Life* (fig. 151) is a photograph of an undiscovered design, depicting a realistic figure of a woman flanked by two stylised angels and two anguished Toorop-type females. Margaret's watercolour *November 5* (fig. 94), of two extremely attenuated female figures leaning towards one another with long yellow hair and yellow tears falling to the ground, which is in the form of a long, sad, sensuous face, has long been thought to symbolise a firework display. In Britain, Guy Fawkes' Day is celebrated on the fifth of November and it is customary to have bonfires and fireworks to commemorate the occasion.[52] It may be worth noting that the fifth of November was also Margaret's birthday, and that in her tour round the studios in October 1893, Lucy Raeburn saw a stained glass design *Despair* by Frances Macdonald 'representing two figures whose sorrow has worn them to shadows and whose tears have watered their eyelashes and made them grow to rather an alarming extent.'

Katharine Cameron (1874-1965) was the younger sister of Sir D.Y. Cameron. In contrast to the Macdonald sisters, she had a successful career in book illustration, most titles being children's stories. She drifted into book illustration because she was asked to, continued illustrating for as long as she was invited, and then returned to her first and real love, landscape and flower painting. Her drawings for *The Magazine* are not at all in the Glasgow Style, and the only motif to appear regularly was the butterfly. Apart from a fine watercolour sketch of hens in a farmyard, her most noticeable contributions were two humorous ink and watercolour drawings of young ladies with impossibly large hats which become ruined in the rain, and seven humorous ink drawings of a girl on a butterfly chase.

Janet Macdonald Aitken (1873-1941) studied at Glasgow School of Art from 1887 until 1902 and later at the Atelier Colarossi, Paris. A portrait and landscape artist, she exhibited art metalwork as a student and during her early career. Her designs in *The Magazine* incorporate flowing lines of hair (fig. 97), dresses and feathers, and flowers growing from large bulbs. Her patterns are bold, employing much black, with hints of the oriental in a hair style and in bare sharply twisting branches which feature in several of her contributions. A member of the Society of Lady Artists and the Scottish Guild of Handicraft, her skill in composition became admired locally, particularly in her street scenes and architectural subjects. Her black and white drawings of Glasgow were strongly executed and at least four of her Glasgow etchings were reproduced as postcards. In 1930 she exhibited forty watercolour landscapes of views in Majorca, Spain and Scotland at the Beaux Arts Galleries.

Jessie Keppie (1868-1951) won a silver medal in the National Competition in 1889 for her design for a Persian carpet while a student at Glasgow School of Art from 1889-1900. She was a member of the Scottish Society of Art Workers, and during her early career submitted a wide range of objects and designs to various exhibitions. Her later exhibits were mainly watercolours of flowers and architectural subjects. She never married, and at the time of her death it was reported that many young artists were indebted to her for her assistance. Jessie Keppie's designs and drawings for *The Magazine* are all of flowers (fig. 295), without any of the motifs shared by some of her fellow contributors. She also wrote 'A fairy tale', which appeared in November 1893.

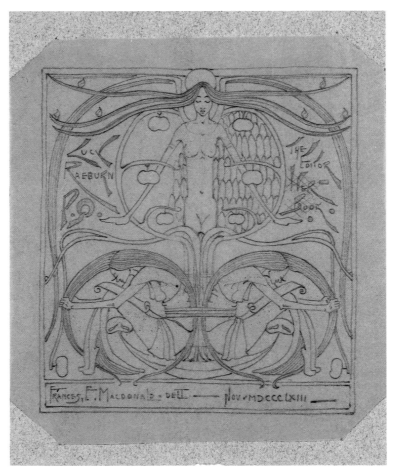

fig. 82
Eve, design for a bookplate for Lucy Raeburn, Frances Macdonald, from *The Magazine*, November 1893, pencil on cream paper. (Glasgow School of Art)

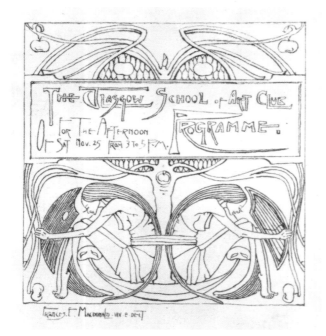

fig. 83
Programme for a Glasgow School of Art Club 'At Home', 25th November, Frances Macdonald, lithograph or line block, *c.*1894, 11.8 × 13.1. (Glasgow School of Art)

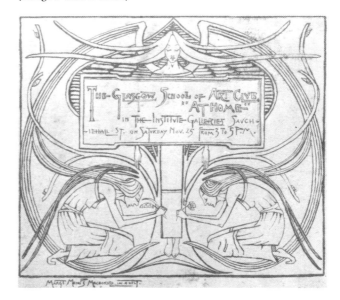

fig. 84
Invitation card for a Glasgow School of Art Club 'At Home', 25th November, Margaret (Memps) Macdonald, lithograph or line block, *c.*1894, 13.1 × 15.6. (Hunterian Art Gallery)

The contents of Lucy Raeburn's *album amicorum* described here are the major items by its female contributors. These young women helped to set standards in art and design locally. Jessie Keppie, Janet Aitken, Katharine Cameron and Agnes Raeburn were all life-long members of the Lady Artists' Club, and the Society's Lauder Prize, for the best work of art exhibited each year, was being won in the 1920s and 1930s by Keppie, Aitken and Raeburn. The work of the Macdonald sisters was displayed locally in their own Glasgow studio and was given wider exposure. As a group they would contribute not only to *The Magazine*, but also to the development of what has become known internationally as the Glasgow Style.

fig. 85
The Crucifixion, Frances Macdonald, from *The Magazine*, April 1894, pencil and watercolour. (Hunterian Art Gallery. Photo: Glasgow School of Art)

fig. 86
Zon der Tijden - Without Times, Jan Toorop, 1893, ink and coloured pencil, 32.0 × 58.5. This work by Toorop demonstrates many affinities with Frances Macdonald's *Crucifixion* including a composition based on stable verticals activated by flowing lines, angularity and elongation of figures, and incorporation of the cross into the design structure. (Rijksmuseum Kröller-Müller, Amsterdam).

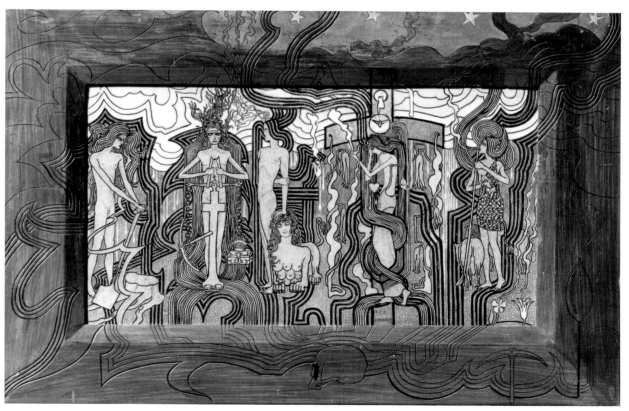

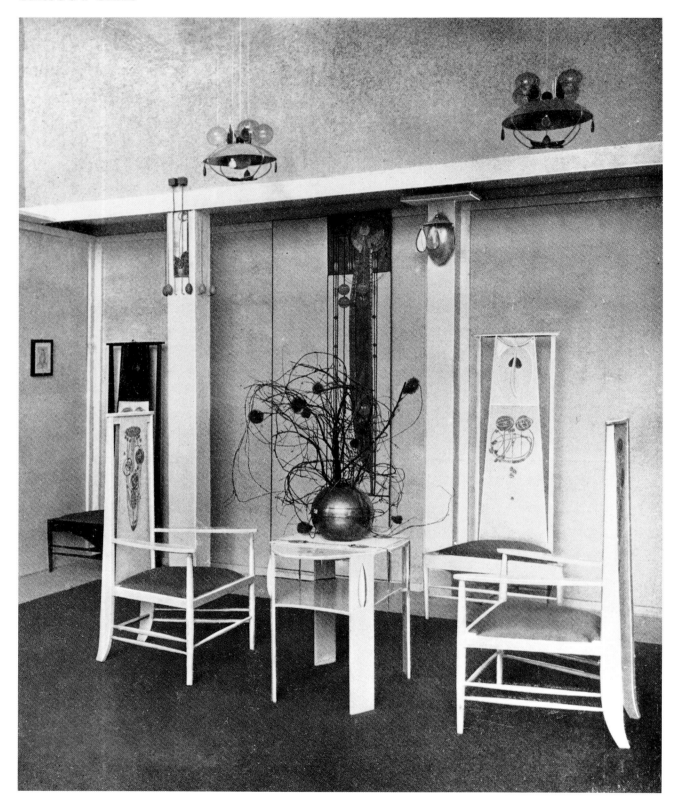

fig. 87
Rose Boudoir, 'Turin International Exhibition' 1902, Charles Rennie Mackintosh, 1902. *The Rose Boudoir* designed by Mackintosh in collaboration with Margaret Macdonald was seen as the 'clou' of the Scottish section. Macdonald contributed gesso and metal panels, graphics, textiles and decorative art objects to the room setting. (Illustrated in *The Studio*, 1902)

THE GLASGOW STYLE

by Jude Burkhauser

With the transformation from Victorian to Edwardian society underway, Glasgow, an important industrial manufacturing centre with trading connections world-wide, provided an international, cosmopolitan atmosphere with wealth, density of population, intensity of social change and a buoyancy of economy which allowed an avant-garde movement in the visual arts to flourish at the turn of the century. *The Studio*, then an important channel for the international exchange of ideas in art, reported in 1906:

> Nowhere has the modern movement of art been entered upon more seriously than at Glasgow; the church, the school, the house, the restaurant, the shop, the poster, the book, with its printing, illustrating and binding, have all come under the spell of the new influence.[1]

Stimulated by international exhibitions in Glasgow resulting in increased commissions for local artists and designers, the Glasgow Style was encouraged by the activity of art dealers who catered to the new wealth in the city and fostered by the energetic vision of the new Art School Director Newbery. It was expanded when increased travel by artists resulted in interaction with continental trends particularly in Vienna, France and Germany. The new movement was enriched and individualised by the contribution of a substantial number of local artists, designers, and craftworkers, many of them women, who worked in collaborative studios:

> In studying the history of decorative art, it becomes evident that the most original and lasting work has been more often than not the outcome of a well-defined local movement. Sometimes a single artist initiated the whole school; at others a few working in familiar intercourse acted and reacted on each other, so that a distinct character was imparted to their work and that of their successors.[2]

As a result of these factors the unique Scottish variation of Art Nouveau design originated at the School and spread its influence to the Continent. Having little in common with the 'whiplash' style of 'new art' in France and Belgium, the Style, labelled 'Scotto-Continental' Art Nouveau,[3] had strong links with Viennese and German Secession movements where the asymmetrical, rectilinearity of the designs corresponded most closely to their own (figs. 90, 104).

Despite an early conceptual base with socialist educational aims and a collective studio approach, the Style developed more, perhaps from a shared design vocabulary than as a movement which cohered as a result of strong ideological or organisational affiliation.

Overall it was based on an individual design approach, strongly encouraged by Newbery, which may best be summed up in Mackintosh's comment that their ideal was to work for the best type of individual and others would follow.[4] The resultant design style—individual, innovative, and unique to Glasgow—manifested itself in a variety of forms in the work of a large number of designers from around 1895 to 1920.

Characteristics most distinctive are stylised, elongated, organic motifs including the geometricised Glasgow Rose, birds in flight—particularly the raven; plant forms drawn from early herbals; and an attenuated and conventionalised human (female) form that gained for the artists who employed it the derisive title of 'The Spook School'. Through frequent exposure in *The Studio* and international journals such as *Ver Sacrum* and *Deutsche Kunst* (fig. 59), the Glasgow Style was influential in Vienna and Germany where it found the acceptance it never enjoyed in Britain.

The Style initially derived from creative interaction of 'the Four', Charles Rennie Mackintosh, Margaret Macdonald, Frances Macdonald and Herbert MacNair, the artists most associated with its international renown. It achieved international prominence at the 'VIIIth Vienna Secession Exhibition' (1900) and the 'Turin International Exhibition of Decorative Art' (1902), where collaborative interiors of 'the Four' affirmed the importance of *Gesamtkunstwerk*—the con-

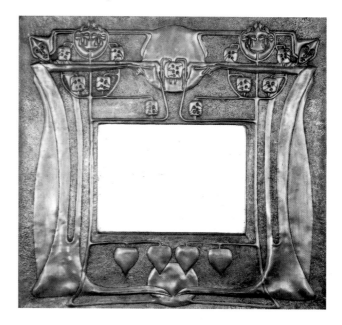

fig. 88
Honesty, Frances Macdonald, 1896, mirror frame, beaten tin on wood frame, 73.0 × 73.6. Attenuated, grotesque female forms were used on metal, in posters and watercolours by Frances Macdonald. (Glasgow Museums and Art Galleries)

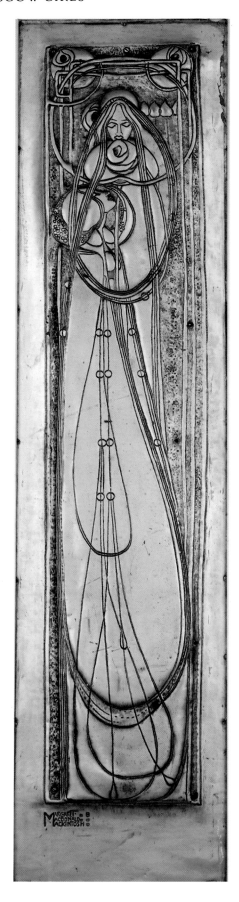

sideration of the interior as part of an aesthetic whole.

In her foreword to the catalogue of the '1933 Mackintosh Memorial Exhibition', Jessie Newbery affirmed the international status afforded the movement. Confirming the centrality of Mackintosh, Newbery stated that the Vienna exhibition not only established his reputation as one of the first of modern architects, but also affirmed that he 'gave new life to a group of brilliant young architects, decorators, sculptors, and metalworkers, who at once acknowledged him as their leader. . . .' She noted that some of the foremost Viennese architects of the day, including Albrecht [sic], Josef Hoffmann and Koloman Moser, had shared in spreading the new style throughout Europe. However, crediting the other members of 'the Four' she added:

> The rooms in the Turin International Exhibition of 1902, designed and decorated by Mackintosh, were very rich in the work of 'the Four', adding to the European reputation of Mackintosh, and also lustre to Glasgow which possessed such artists and also to the Glasgow School of Art.[5]

Although the Glasgow Style's current renown stems from rediscovery and recognition of the work of Mackintosh, it is clear his 'genius' was fed by and infused with the creative spirit of what has come to be known as the Mackintosh group or circle. It is found in the work of a large number of talented designers, craftsmen—'and particularly craftswomen'[6]—from Glasgow whose work 'in familiar intercourse' at Glasgow School of Art acted and reacted on each other so that a distinct character was imparted to their work and to that of their successors'.[7] In praising the Glasgow Style *The Studio* noticed in particular the 'Misses Macdonald', Mackintosh and Herbert MacNair, along with Jessie Newbery and Talwin Morris as those Glasgow artists who were working in the 'newest and most individual manner'[8] but remarked upon the collective aspect of the movement:

> . . . it is not the personal expression of any one artist which is here commended, but the systematic conventionalisation of form, the use of bright colours, and the absence of hackneyed motives which mark the experiment.[9]

fig. 89
The Dew, Margaret Macdonald Mackintosh, 1901, silvered lead in repoussé, 122.5 × 29.8. (Glasgow Museums and Art Galleries)

fig. 90 *(opposite)*
Poster for the *Jung Wiener Theater zum Lieben Augustin*, 1901, Koloman Moser, displays a rectilinear verticality of the Viennese Secession movement which found affinity with many Glasgow Style designs. Other shared motifs are the characteristic checkerboard often found on Glasgow Style furniture and textiles particularly in the interior design schemes of Charles Rennie Mackintosh and the attenuated human female form used by the Macdonald Sisters in their watercolours, posters and metalwork.

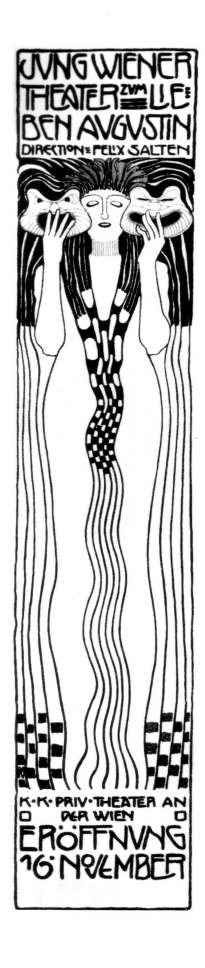

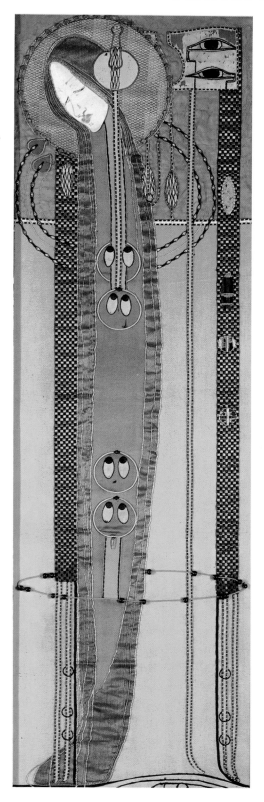

fig. 91
Embroidered Panel, Margaret Macdonald Mackintosh, 1902, linen with silk braid, ribbon, silk appliqué, and bead decoration, 182.2 × 40.6. The characteristic checkerboard and attenuated female form is found in the designs of Vienna Secession artists such as Koloman Moser. (Glasgow School of Art).

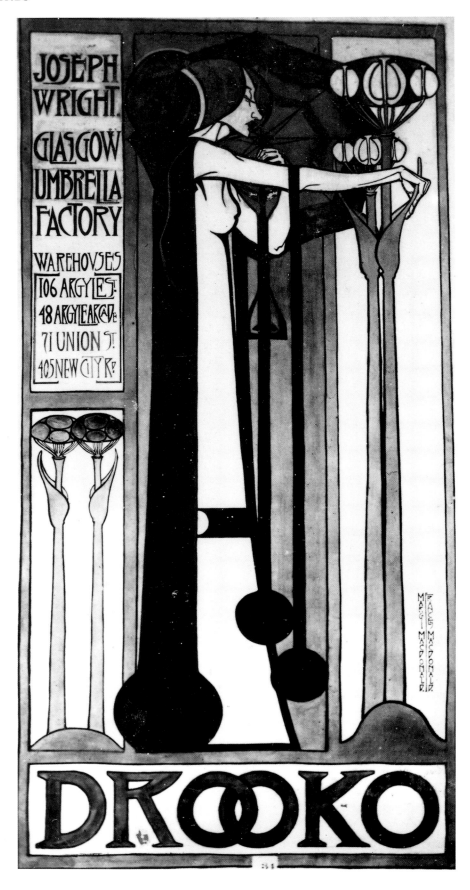

'THE SPOOK SCHOOL':
A NEW VISUAL ICONOGRAPHY

The 'Misses Macdonald', Margaret (1864–1933) and Frances (1873-1921), are the two women most widely recognised today as proponents of the Glasgow Style. Students from 1890–94, we know Newbery's introduction of the sisters to evening students Mackintosh and MacNair (because he found great similarity in their style of work) led to their collaboration. In November 1894 when 'the Four' exhibited together in the 'Glasgow School of Art Club Exhibition' at the Institute Galleries, Sauchiehall Street, the poster work of the 'Misses Macdonald' in particular caused a stir in the press and was the start of what would thereafter be known as 'The Spook (or Ghoul) School' of Art in Scotland.[10] 'The Spooky School' was actually the derisive epithet hurled at the 'ghoulish' images on the students' posters, and although we do not know precisely which works were shown, it is clear from others produced by the women at that time (fig. 92) and from descriptions in the press that they were an entirely new departure which outraged critics because of their use of a distorted and conventionalised human (female) form:

Why conventionalise the human figure?, said one critic.

Why not? replied another of the group.

Certain conventional distortions, harpies, mermaids, caryatids, and the rest are acceptable, why should not a worker today make patterns out of people if he pleases?[11]

Adverse reaction to the startling new iconography portrayed on the posters appeared in two local satirical periodicals, *Quiz* and *The Bailie*, and in the *Glasgow Evening News*. The works which had caused the furore were most probably variations of/or the watercolours *A Pond* (1893) (fig. 95) by Frances Macdonald, *November 5* (1894) (fig. 94) by Margaret Macdonald, and *The Fountain* (1893-95) (fig. 155) by both women or posters such as *Drooko* (c.1898) (fig. 92). One critic turned to verse, comparing the 'hags' in the pictures to the 'New Woman':

As painted by her sister
Who affects the realm of Art
The Woman New's a twister
To give nervous man a start
She is calculated chiefly
To make him really think

That he's got 'em and that, briefly,
It's the dire result of drink.

For if Caliban was mated
With a feminine gorilla
Who her youth had dissipated
O'er the book yclept the Yellow
The daughters of the wedding
Would be something such as these –
Sadly scant of fleshly padding
And ground-spavined at the knees.[12]

The images of what the critics derisively referred to as the 'Woman New', described as 'human beings drawn on the gas pipe system' were, as Thomas Howarth has said: ' . . . an entirely new departure and positively impinged upon the public consciousness . . . the grotesque, half-human, half-vegetable entities . . . [were] . . . a peculiar choice of subject for a young lady of the 1890s!'[13]

Alexander Roche, the Glasgow School artist who

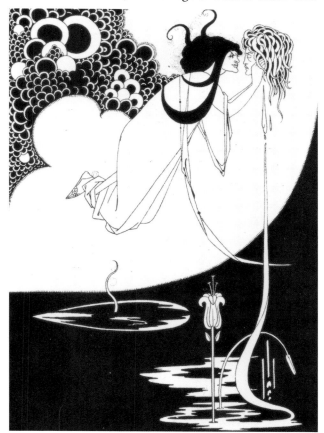

fig. 93
Salome, Aubrey Beardsley, c.1894, illustration for Oscar Wilde's book of the same name. *The Studio* was said to have been an influence on the group, particularly through publication of Beardsley's illustrations for *Salome*. Beardsley's flowing, simple, structural use of line provided stylistic influence and his irreverent abandon of Victorian morality challenged accepted forms of representation such as those evolved from the 'puritan' spirit that had informed the work of the Pre-Raphaelites and served as a model to be emulated by the young artists. (Photo: Glasgow Museums and Art Galleries)

fig. 92 *(opposite)*
Drooko Umbrella Poster, Margaret and Frances Macdonald, 1898, lithograph, (untraced), illustrated in *Dekorative Kunst*, November 1898. The Drooko umbrella was the patent design of Joseph Wright, Glasgow. It was probably posters similar to this which earned the 'Misses Macdonald' and their partners the label of 'The Spook School'. (Photo: Hunterian Art Gallery)

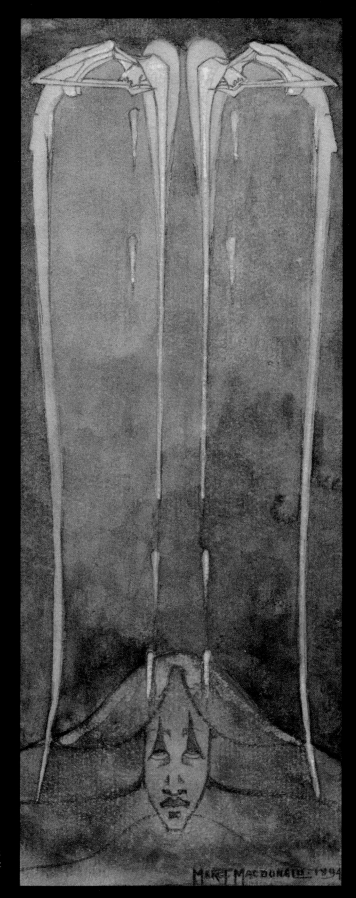

fig. 94
November 5th, Margaret Macdonald,
1894, watercolour, 31.5 × 19.0.
Critics compared figures in 'Spook
School' work, 'ground spavined at
the knees', to 'feminine gorillas'.
(Glasgow School of Art)

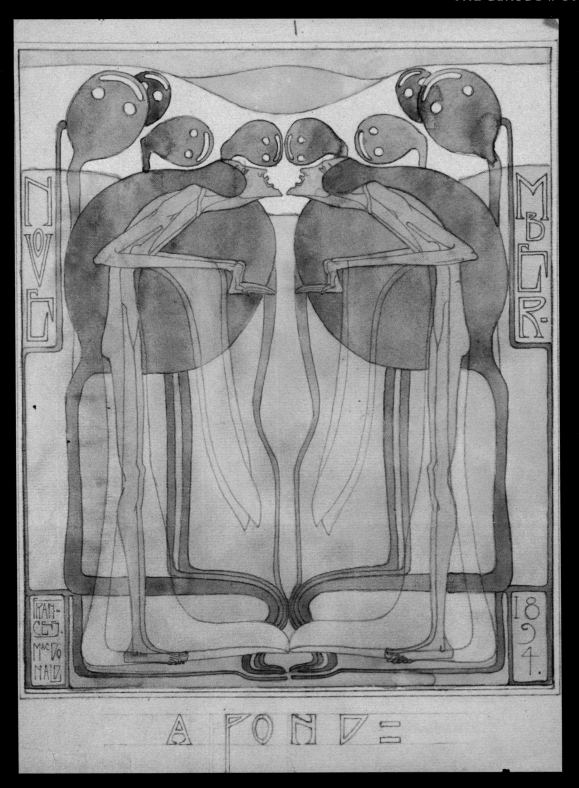

fig. 95
A Pond, Frances Macdonald, *The Magazine*, November 1894, pencil and watercolour on grey paper, 32.0 × 25.8. The grotesque, androgynous, and sexually self-contained female persona portrayed here had little in common with images of woman seen in the work of the Pre-Raphaelites. (Glasgow School of Art)

87

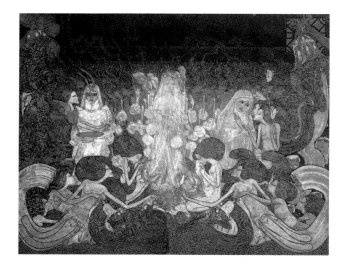

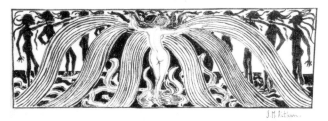

judged the School of Art Club Exhibition, had started the controversy in the press by suggesting in his awards speech that future judges should 'put down that sort of thing', referring to work exhibited in the middle room of the Institute including posters by Mackintosh and MacNair, and to the 'chief perpetrators' who had offended the prevailing accepted female imagery: 'As to the ghoul-like designs of the Misses Macdonald, they were simply hideous, and the less said about them the better. . . . '[14] Fra Newbery came under attack for the controversial work, both its imagery and form, as poster-work itself was a subject of debate, focusing public attention on the School. Newbery's affirmation that he 'encouraged that sort of thing' was followed in a letter to the press by a student confirming the aims of the new movement:

> For our school, then, I claim that it has thrown overboard the old conventions and is bravely struggling to uphold a new standard in Art—originality even at the expense of excellence. . . . (I)t is in the pursuit of ideals, however mystic or erratic they may seem, that the future of art is assured.[15]

The 'decadent' black and white work of Aubrey Beardsley (the 'book yclept the yellow' or *The Yellow Book* referred to in the poem) (fig. 188) and the 'Nouveau Mysticism' in the work *The Three Brides* (fig. 96) by Dutch artist Jan Toorop, recently published in *The Studio*, most certainly influenced the group. There were, however, other influences at work at the time,

not least of which was the re-perception of definitions of 'femininity' going on in the public consciousness which affected the portrayal of the 'New Woman' in the poster images of Margaret and Frances Macdonald.[16]

By the late 1890s British Arts and Crafts ideals had narrowed to the introspective search for 'some lost secret of human life' which was frequently represented by a 'wraithlike female figure with flowing hair and trailing clothes, her arms outstretched towards the ineffable substance of a dream.'[17] 'The Spook School' work of the Macdonald sisters went beyond this existing canon and it was precisely because their visual representation of woman was unlike any accepted form that it was so vehemently denounced in the local press: 'To disguise mediocrity by the assumption of the extraordinary is a cheap way to pass as a genius.'[18] Even Gleeson White, in his review of the Glasgow Style designers, noted the sisters' controversial and 'daring' approach:

> The small poster of the Nomad Art Club is calculated to exasperate those who dislike the work of these clever sisters. . . . It is just because . . . the naïveté and daring of these designs controvert all well-established ideas that it is very hard to be quite just in criticising them.[19]

There were certain accepted images in late nineteenth-century Britain used to represent the *fin-de-siècle* woman. Although recent research has shown there were female artists working within Pre-Raphaelitism, accepted representations of the 'female' were determined almost exclusively by male artists. Iconography used in the portrayal of woman limited 'her' to polarities. She was, *femme fatale* as seen in Aubrey Beardsley's *Salome* (1893) (fig. 93), Franz von Stuck's *Eve* (1893), and the 'Fallen Magdalens' of the Pre-Raphaelite painters; or in sharp contrast, she was the

fig. 96
The Three Brides, Johannes Toorop, 1893, pencil, black and coloured crayon on brown paper, 78 × 98. In addition to work by Beardsley, the reproduction of pictures by Dutch artist Jan Toorop, especially *The Three Brides*, and the architectural and decorative work of C.F.A. Voysey were cited as influences by Jessie Newbery who said that: 'These artists gave an impetus and a direction to the work of "the Four" . . . and in their section (at the 1894 exhibition) was seen the first blooming of a new style in architecture, internal decoration and in varied crafts.' (Rijksmuseum Kröller-Müller, Amsterdam)

fig. 97
The Witches, Janet Aitken from *The Magazine*, April 1894, pen and ink. Aitken's use of repeated female figures in a rhythmic patterning has similarity to Toorop's *The Three Brides* and *Delftsche Slaolie Poster*. (Glasgow School of Art)

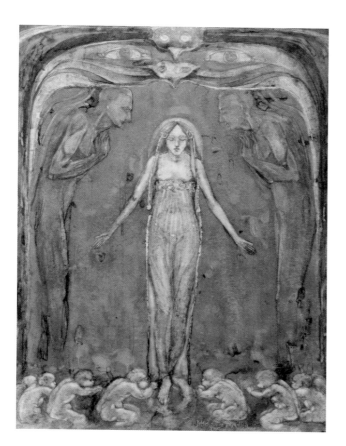

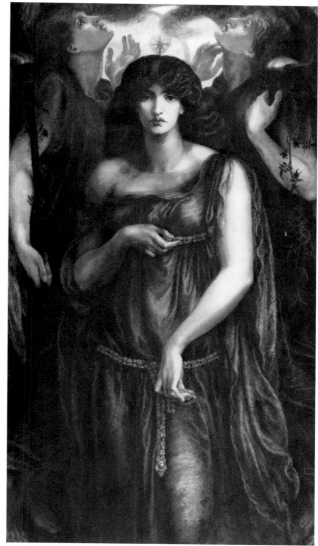

fig. 98 *(a)*
Ysighlu, Herbert MacNair, 1895, watercolour, portrays the 'ped-astalled woman' who was 'worshipped' rather than related to by men. (University of Liverpool Art Gallery)

pedestalled 'virgin', or 'nubile maiden' of Dante Gabriel Rossetti's *Regina Cordium* (1866) and Edward Burne-Jones' *King Cophetua and the Beggar Maid* (1884) the 'enthroned mother' of Ford Madox Brown's *Take Your Son, Sir* (1851-7) (fig. 125) and the allegorical representation of the eternal 'female' principle exemplified in Dante Gabriel Rossetti's *Astarte Syriaca* (1877) (fig. 98)[20]. Despite the fact that women *were* painting, for a woman artist to portray a self-image in late nineteenth-century Britain, which ventured beyond the accepted canon or demonstrated creative disregard for the prevailing iconography of 'virgin/whore' was revolutionary.

The Macdonalds' 'Spook School' images moved beyond these existing parameters presenting a self-contained and androgynous 'female' in works such as *A Pond* (1893), and an unacceptably conventionalised female 'grotesque' in others such as *November 5* (1894), which met with disapproval not only in Glasgow but were also denounced the following year when 'the

Four' exhibited at the London 'Arts and Crafts Exhibition'.[21] In a review by an anonymous critic we learn there were no other works which had 'provoked more decided censure' yet the critic was incisive enough to recognise that the artists would eventually emerge as leaders of a 'school of design peculiarly their own' and eulogies would await them a 'few years hence'.[22] Although Mackintosh, and 'the Four', are considered the progenitors of 'Scotto-Continental' Art Nouveau and 'The Spook School' episode is seen as its beginning, there has been lack of recognition of the 'creative leap' taken by Margaret and Frances Macdonald in their portrayal of a 'female' persona who was visually self-defined.

fig. 98 *(b)*
Astarte Syriaca, Dante Gabriel Rossetti, 1877, oil on canvas, 182.9 × 106.7. The stereotypical personification of woman as 'nature' is exemplified in such works as *Astarte Syriaca*. Use of flanking figures around a central form, similar to early *Tree of Life* symbolism, is employed by 'the Four' in a number of their designs. (City of Manchester Art Galleries)

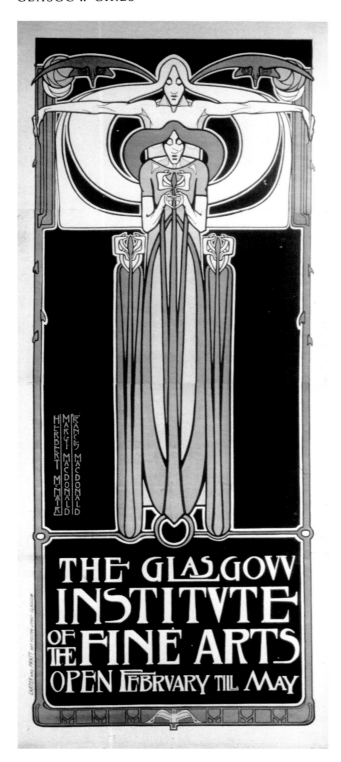

fig. 99
Poster for the Glasgow Institute of the Fine Arts, Margaret Macdonald, Frances Macdonald and Herbert MacNair, colour lithograph, *c.*1896, 236.0 × 102.0. Printed in four sections by Carter and Pratt, Glasgow, probably for the 1896 exhibition. The Macdonald Sisters and MacNair collaborated on this poster, one copy of which is held in the collection of the Museum of Modern Art, New York City. (Glasgow Museums and Art Galleries)

THE 'MISSES MACDONALD' AND 'THE FOUR'

From 1895 Margaret and Frances Macdonald collaborated with Herbert MacNair, and their work received critical notice through reviews of the Liège Exhibition 'L'Oeuvre Artistique', which included 110 items from the Art School. Not surprisingly the 'individuality' of their work was praised. One poster collaboratively designed for the Glasgow Institute of the Fine Arts (1896) is now in the collection of the Museum of Modern Art in New York City (fig. 99). The July 1896 issue of *The Yellow Book* published two works by each of the artists putting them in the company of Aubrey Beardsley and the Glasgow Boys. It was not the first time, however, they had been in such company. Posters by the Macdonald sisters were exhibited at La Société des Beaux Arts, Alexander Reid's gallery in Glasgow, in 1895 with designs by Lautrec, Beardsley, Steinlen and Dudley Hardy.

In October 1896 Mackintosh joined the Macdonalds and MacNair to exhibit in the 'Fifth Arts and Crafts Exhibition' in London. The negative reaction of critics to this work ironically led to international recognition through two articles in their defence by editor Gleeson White in *The Studio*. White travelled to Glasgow to interview the artists and described the Macdonald sisters as 'clever' with designs of 'naïveté and daring', which 'controvert all well-established ideas'. He wrote supportively of their work and that of 'the Four' in an effort to counter its dismissal on the grounds that it lacked 'historical basis':

> If you throw over precedent there need be no limit to experiment: except that to be accepted it must justify itself. Without claiming that the method of the new Glasgow is the best or that it is impeccable, its very audacity and novelty deserve to be encouraged . . . there is method in its madness . . . in spite of the nickname of 'the spook school', there is a distinct effort to decorate objects with certain harmonious lines . . . 'jewelled effects' of colour, which may . . . evolve a style of its own, owing scarce anything to precedent. [23]

It was, precisely, this 'throwing over of precedent', in an age when most 'decorative' art had been based on an established style, which made the Glasgow design movement appeal to the Vienna Secession artists who had been brought together by similar aims. Rejecting historicism, the Secession was formed in 1897 under the leadership of Gustav Klimt (1862–1918) and the Secession group, including, Josef Hoffmann, Joseph M. Olbrich, Kolo Moser and Carl Moll. The Secessionists had defected from the conservative establishment of the 'Kunstlerhaus' and embraced the philosophy 'To Each Time its Art, To Art its Freedom'. Pre-eminently modern, they accepted no fixed canons and declared international intentions. At

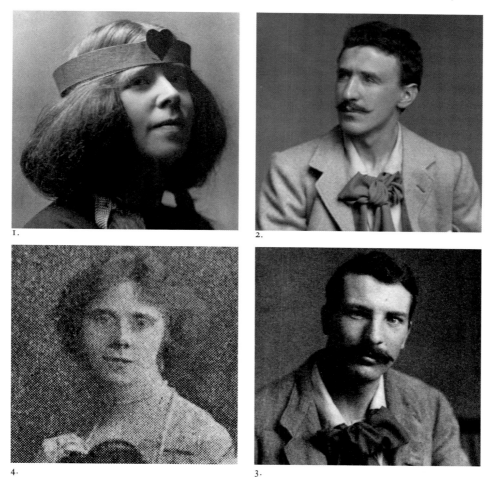

1. 2.

4. 3.

the urging of the art critic Ludwig Hevesi, they brought the modern art of other countries to Vienna.[24] The first editorial in their journal, *Ver Sacrum*, invited the 'art of abroad' to act upon them as influence and stated their intention to bring foreign art to the city. From the first Secession Exhibition there were links with Scottish artists and the 1898 exhibition included paintings by Glasgow Boys, including John Lavery and E.A. Walton. It was in the 'IVth Secession Exhibition', however, where we find the strongest representation of Scottish painters and along with paintings by the Glasgow Boys including Hornel, Henry, Stevenson, Gauld and Mann, was work by 'Glasgow Girl', Bessie MacNicol (fig. 270), a fringe member of the group. The first of the Secession exhibitions to be devoted primarily to applied arts was the 'VIIIth' where the work of 'the Four' was featured. As with other international avant-garde artists of the early twentieth century, the rejection of easel painting in favour of dedication to applied arts was considered by the Secessionists as a revolutionary challenge to established ideology and the accepted 'high arts'. Later, in Russia, women designers Alexandra Exter, Liubov Popova, and Varvara Stepanova, part of the revolutionary group who met at the Moscow Institute of Artistic Culture, would explain, when announcing their entry

into industrial design: 'We recognise self-sufficient easel art as outmoded and our activity as mere painters as being useless . . . we declare productional art to be absolute. . . .'[25] Although stereotypes surrounding the applied arts and 'femininity' place women's participation in these areas of art production within what was seen as woman's traditional role in the 'minor arts', as Ann Sutherland Harris and Linda Nochlin point out in *Women Artists: 1550-1950*, 'advanced women artists involved in the decorative arts in the early twentieth century were contributing to the most revolutionary directions—both social and aesthetic—of their times.'[26]

How did the Vienna/Glasgow connection solidify? According to Jessie Newbery, Josef Hoffmann, the organiser of the 'VIIIth Vienna Secession Exhibition', reportedly had seen illustrations of the work of 'the Four' in a journal, probably *The Studio*. The Austrian artists invited Mackintosh and 'Monsieur M. Macdonald' to take part, according to Desmond Chapman-Huston, 'being perhaps unable to realise that

figs. 100–103
'The Four': 1. Margaret Macdonald Mackintosh, (H.L. Hamilton); 2. Charles Rennie Mackintosh, (T & R Annan and Sons, Ltd., Glasgow); 3. Herbert MacNair, (T & R Annan and Sons, Ltd., Glasgow, Photo: Glasgow School of Art); 4. Frances Macdonald MacNair, (Hunterian Art Gallery).

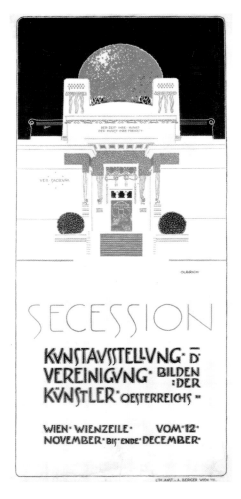

fig. 104
Secession Kunstausstellung der Vereinigung Bildender Künstler Österreichs, Joseph Maria Olbrich, 1898, colour lithograph, 73.6 × 31.8. (Fischer Fine Art)

the pictures signed with that name could be by a woman.'[27] Viennese art patron, Fritz Wärndorfer, representing the Secession group, travelled to Glasgow to meet the young designers and at Wärndorfer's urging Margaret Macdonald and Charles Rennie Mackintosh travelled to Vienna, where they stayed for six weeks and gave their first joint Continental exhibition. As a result of this exchange, the artists sold all of the work that had been exhibited and received several important commissions. Gustav Klimt's work and the work of the Glasgow artists appear to have been an influence upon each other from this Vienna connection. In the *Beethoven Frieze* (1902) (fig. 110) by Klimt, there seem to be quotes from an earlier work by Frances Macdonald entitled *Eve* (1896) (fig. 157) and some affinity with Margaret Macdonald's *Opera of the Sea*, (1902) (fig. 106) one of a series of twelve panels commissioned by Wärndorfer for his music room. In *Art Nouveau*, Mario Amaya discusses the Mackintoshes' interior commission by the Wärndorfers, 'in whose house all the avant-garde of Vienna met', for a music salon. Amaya records:

> The music salon was the most talked about room of the time and its influence on contemporary architecture cannot be measured fully . . . certain generic ideas which first appeared there were used throughout the next decade by Austrians and Germans alike, before the founding of the Weimar Bauhaus after the war. What is more, a series of decorative panels by Mackintosh, designed with his wife for the Wärndorfer salon, and based on a Maeterlinck poem, had far reaching effect on the decorative murals of Gustav Klimt, whose style became more geometric and schematic after their installation. Klimt's broken up cubist patterning owed an indirect debt to Mackintosh just as his murals themselves had some bearing on the cubist abstractions of the next decade.[28]

A contemporary critic in Vienna related that the room 'which is the delight of every connoisseur, and which serves as a place of pilgrimage for lovers of art, and for strangers coming to the city . . . is perhaps their greatest work' giving credit to both Mackintosh *and* Margaret Macdonald.[29] In Vienna both 'Mr and Mrs Mackintosh' were held in high esteem; Mackintosh was regarded as one of the chief founders of modern art. Carried through the streets of Vienna with flowers strewn at their feet by admiring art students, there seems little question, as Hugh Cheape and Jane Kidd conclude,[30] that the attitude and response of the Viennese to the 'Scotto-Continental' artists was that of disciples. Despite the fact that their work was rejected in Glasgow and in London, an article appeared in *Dekorative Kunst* in praise of the Scottish artists:

> Mackintosh, both Macdonald sisters, and G. Walton, amongst others, gave in a very short time a new face to Glasgow, which was only known in Germany through the Munich successes of the dreamy Scottish painters. They exerted a fresh influence which had nothing in common with the Pre-Raphaelite movement and which was able to give new blood to the sluggish veins of the Londoners. . . .[31]

A special issue of *The Studio* in 1901, entitled *Modern British Domestic Architecture and Decoration*, featured the work of 'the Four'. An extensive series of photographs showed the domestic interiors they had designed as collaborators. By 1902 when their work was exhibited in the 'International Exhibition of Decorative Art' in Turin (figs. 124 and 148), a selective invitational array of the best examples of contemporary international design, the work of Mackintosh and Macdonald was perceived as 'the "clou" of the Scottish Section . . . an epitome of the work of an architect and an art-worker, labouring together as co-partners in the same scheme, and to whom the "House Beautiful" is an edifice built and adorned by the one handiwork . . . standing as an

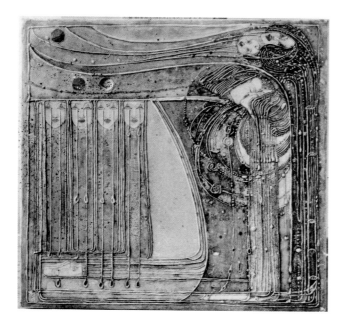

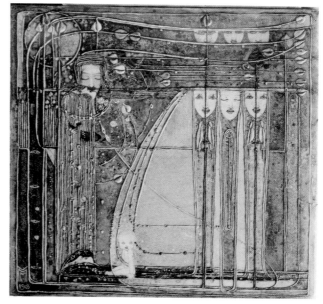

expression of thought in art.'[32] Writing in his 1978 exhibition catalogue in *Charles Rennie Mackintosh and the Glasgow Contribution*, Thomas Howarth affirmed the mutuality of the designers' work:

> . . . together they designed and furnished their first home, an apartment at 120 Mains Street, Glasgow. The drawing room is one of the most important interiors in modern design history. It represents a complete departure from contemporary practice in its whiteness and lightness and freedom from superficial decoration. Every single piece of furniture was designed by the architect in collaboration with his wife, as indeed were the light fittings and other details. [33]

The work of Frances Macdonald (fig. 111) and Herbert MacNair exhibited adjacent to the Mackintoshes' display in Turin in 1902 was also praised for its ability to show 'in what manner the necessities and beauties of life can be brought together in one harmonious whole . . . '

and their joint efforts, seen as 'united brains through helping hands', were particularly commended.[34]

The 'Turin Exhibition', organised to prove the evolution of a modern style in design which had replaced cold and lifeless repetition of academic motifs from the past, was considered the official stamp of recognition for the modern movement in design. Turin claimed to be the first of the international design exhibitions to exclude what were 'purely mechanical productions' in decorative art based on historic styles and to require each object to be an 'original work showing a decided effort at renovation of form.'[35] In addition to the rooms set aside for 'the Four', a room full of work from the Glasgow School of Art Embroidery section was presented along with a special display of Glasgow bookbindings, one by Jessie M. King gaining a gold medal. In praising the contributions of the varied countries represented, *The Studio* reviewer said that, 'brilliant in its young strength was that of Scotland.'[36]

fig. 105
The Opera of the Winds, (untraced), Margaret Macdonald Mackintosh, 1901–3, one of twelve decorative gesso panels designed for the Wärndorfer Music Salon, Vienna. Nikolaus Pevsner in *Pioneers of Modern Design* quoted Ahlers-Hestermann: 'the aristocratically effortless certainty with which an ornament of enamel, coloured glass, semi-precious stone, beaten metal was placed, fascinated the artists of Vienna who were already a little bored with the eternal solid goodness of English interiors'. (Photo: Hunterian Art Gallery)

fig. 106
The Opera of the Sea, (untraced), Margaret Macdonald Mackintosh, 1903, painted gesso panel. The panel was one of twelve commissioned by the Wärndorfers for their music salon in Vienna in 1901 based on Maeterlinck's *The Seven Princesses*. Two years later Fritz Wärndorfer contributed money for the founding of the Wiener Werkstätte. (Photo: Hunterian Art Gallery)

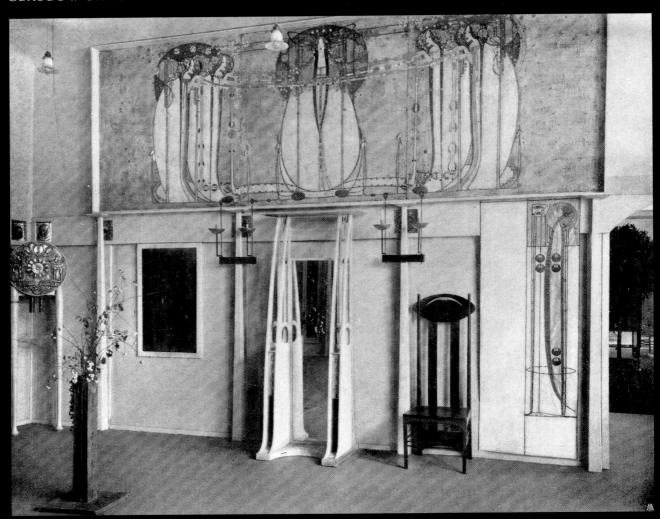

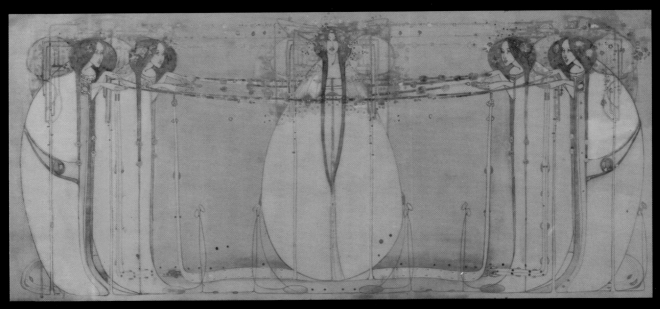

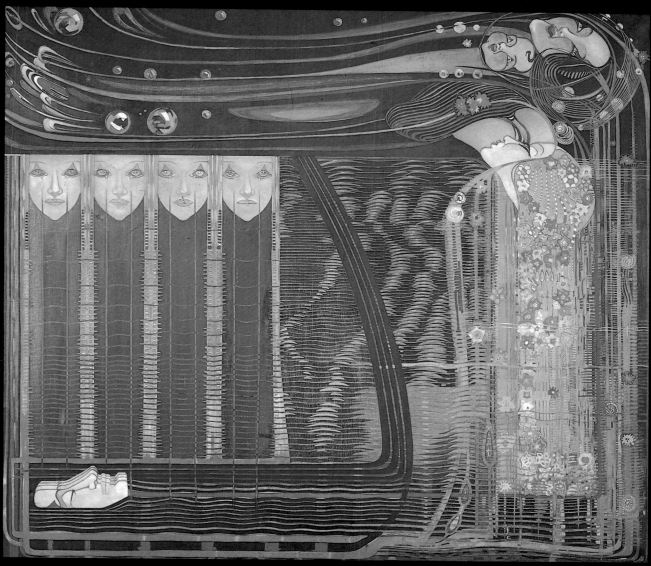

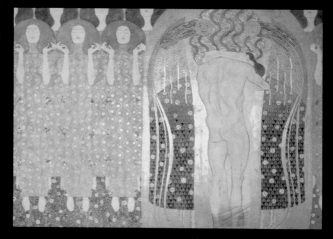

fig109 *(above)*
The Opera of the Sea, Margaret Macdonald Mackintosh, *c.*1915–21, oil and tempera with papier collé, 144.0 × 160.0, (after the now-lost gesso original). (Hessisches Landesmuseum, Darmstadt)

figs. 107 and 108 *(opposite)*
'Vienna Secession Exhibition, 1900', the Scottish Section showing *The May Queen* panel by Margaret Macdonald Mackintosh in situ. In many art historical accounts this room is referred to as 'The Mackintosh Room' despite the fact that many of the objects in the photo are by Frances and Margaret Macdonald. (*The Studio*)
Sketch for *The May Queen*, Margaret Macdonald Mackintosh, *c.*1900, pencil on watercolour on brown tracing paper, 32.4 × 68.0. Sketch for a gesso panel set with twine, glass beads and tin inlay designed as one of two facing panels for the walls of the White Dining Room, Ingram Street Tea Rooms, Glasgow and exhibited in the Vienna 1900 Secession Exhibition. (Howarth Collection. Photo: Glasgow Museums and Art Galleries)

fig. 110 *(left)*
The Beethoven Frieze, Gustav Klimt, 1902. Klimt's figures in the frieze bear an affinity to those found in works by both Frances Macdonald and Margaret Macdonald pre-1902. Nikolaus Pevsner stated in *Pioneers of Modern Design*: (p. 174): 'From . . . the obvious similarity between Mackintosh's earliest interior designs—or rather one should say the interior designs of Mackintosh and Margaret Macdonald—and the (*change in*) style of the Viennese Secession, . . . one can safely conclude that the change of taste in the artists of the Secession was at least partly caused by impressions received by Mackintosh's (*and Macdonald's*) work.' (Österreichische Galerie, Vienna)

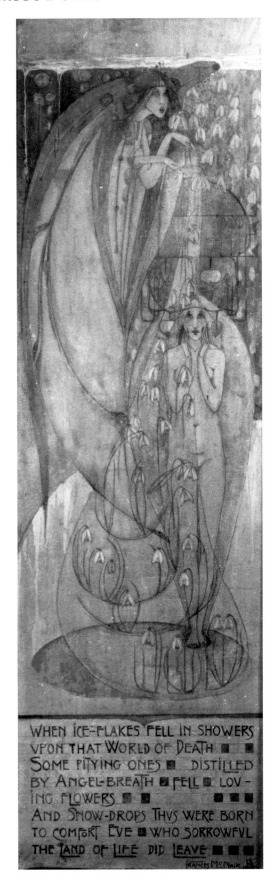

WHEN ICE-FLAKES FELL IN SHOWERS
VPON THAT WORLD OF DEATH ▪ ▪
SOME PITYING ONES ▪ DISTILLED
BY ANGEL-BREATH ▪ FELL ▪ LOV-
ING FLOWERS ▪ ▪ ▪ ▪ ▪ ▪
AND SNOW-DROPS THVS WERE BORN
TO COMFORT EVE ▪ WHO SORROWFVL
THE LAND OF LIFE DID LEAVE ▪ ▪ ▪

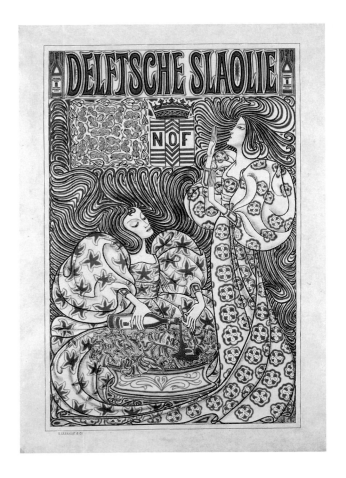

INFLUENCES

In addition to interchange between Glasgow and the Continent, there were other important influences to the Glasgow Style. The first of these included the **Celtic Art Revival**. With roots in manuscript illumination employing ribbonlike lines, spirals, whiplash curves, and abstract and interlacing zoomorphic and human forms, Celtic Art has been credited as an influence on the Glasgow Boys painters, who in turn reinforced the Celtic tendencies in Glasgow Style art. A collaborative painting by Hornel and Henry, *The Druids—Bringing in the Mistletoe* (1890) with its ceremonial figures is credited as an early influence on the work of Mackintosh and 'the Four', who conventionalised the hierarchic human form in their poster design (fig. 99).[37] Agnes Raeburn's design for a Glasgow Lecture Association poster (fig. 115) employs the interlaced and entwined serpent. Frances Macdonald's early drawings for *The Magazine* and her 'Pond' women bear an

fig. 111 *(left)*
When Iceflakes Fell in Showers . . ., Frances MacNair, *c.*1900, gouache painting from Dunglass Castle, exhibited in Turin, 1902. 185.0 × 55.0. (National Museums of Scotland)

fig. 112 *(above)*
Delftsche Slaolie Poster, Johannes Toorop, 1895, lithograph. (Stedelijk Museum, Amsterdam)

angular, humorous, and attenuated resemblance to figures seen in details on the pages of illuminated manuscripts such as the *Book of Kells*. Owen Jones' *Grammar of Ornament* and the work of Christopher Dresser is thought to have promoted a use of organically inspired forms which derived from Celtic sources. Elongated figures, crescents, disc and bars, the comb, natural forms, asymmetry and variation are all identified as Celtic elements which appear in the Glasgow Style (fig. 114). The Celtic Revival in Edinburgh, embodied in Patrick Geddes' publication *The Evergreen* (1895-1897), was a parallel movement which both infused and helped to disseminate the Celtic influence.

Another important influence was **Japonism**. A thriving commercial port, Glasgow was linked closely with industrial trading routes including those to and from the Orient. International awakening to the art and design of Japan in the 1880s, in particular the Japanese print with its flat surface, emphasis on line, outlining, and highly developed use of negative space, spread through numerous prints which found their way into tenements and public buildings. The Glasgow Art Club obtained a set of prints which were hung along their staircase. Knowledge of 'things Japanese' had also come via Whistler's paintings, Christopher Dresser's visit to Japan and his subsequent gift to Glasgow Art Gallery of ceramics, textiles and paper,[38] through *Le Japon Artistique* (produced in Paris by S. Bing) as well as through the Glasgow Boys who travelled to Japan. The *mon* tradition, where objects are adopted as crests, was also influential and a book containing *mon* designs was

fig. 113
Endpiece, *The Magazine*, April 1894, pen and ink. (Glasgow School of Art)

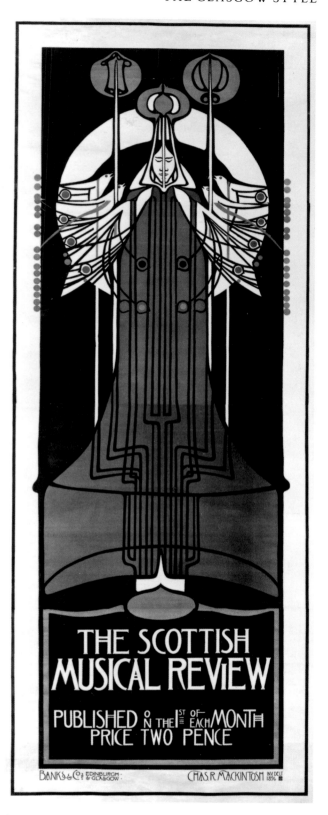

fig. 114
The Scottish Musical Review Poster, Charles Rennie Mackintosh, 1896, colour lithograph printed in four sections by Bank and Co., Edinburgh and Glasgow, 246.0 × 101.5. (Glasgow Museums and Art Galleries)

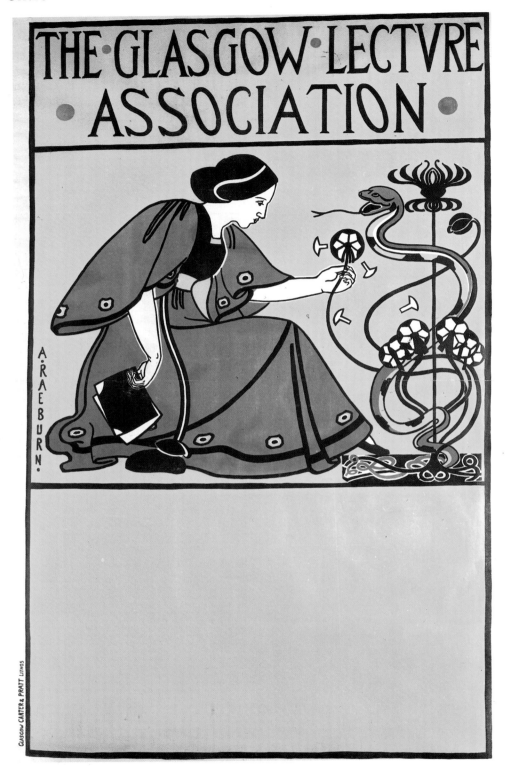

fig. 115
The Glasgow Lecture Association, Agnes Middleton Raeburn, *c.*1897, colour lithograph poster, 93.5 × 57.4.
(Hunterian Art Gallery)

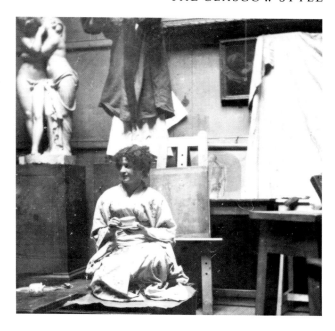

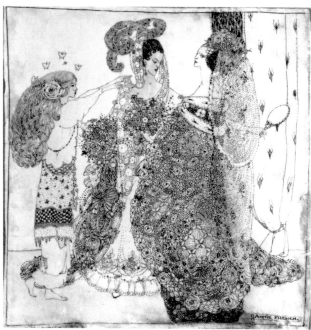

fig. 116 *(above right)*
Life model in kimono, drawing and painting class at Glasgow School of Art, *c*.1900. (Glasgow School of Art)

fig. 117 *(above left)*
Sketch of the model in kimono, De Courcy Lewthwaite Dewar, from her student sketchbooks, *c*.1900. (Coll: H.L. Hamilton. Photo: Glasgow Museums and Art Galleries)

fig. 118 *(lower left)*
The Ugly Sisters, Annie French, *c*.1900, watercolour over black ink, highlighted with gold, on parchment, 22.5 × 20.7. French made use of Japanese conventions such as patterned clothes, back views and quarter face techniques in portrayal of figures such as *The Ugly Sisters*. (National Galleries of Scotland, Edinburgh)

an early addition to the School library. Mackintosh and Margaret Macdonald, who adopted *mon*-like emblems in textiles, metalwork and furniture, displayed two Japanese prints which had been given to them by their German friends Anna and Hermann Muthesius (Gototei Kunisada, *Girl Acting the Arigato Part of Ashahina Saburo*, *c*.1825 and Yanagawa Shigenobu, *Girl Practising Her Samisen*, *c*.1825). Japanese stencils were also an influence (fig. 148). Mackintosh's stylised design on a set of impromptu banners (fig. 148) to modify the exhibition space at the 'Turin Exhibition of 1902' shows Japanese concern for the 'essence' of an object conveyed in economy of line and form. Alexander Reid's links to France and to the Impressionist painters introduced Japanese-inspired artistic devices such as pattern-making, narrow formats, unconventional points of view and odd colour combinations that were taken up by Glasgow Boy painters Hornel and Henry. The influence of patterned textiles and kimonos appears in numerous works (fig. 116), for example Bessie MacNicol painted *A Japanese Robe* (*c*.1900) and a portrait of Hornel which has affinity with Van Gogh's *Le Père Tanguy* employs Japanese imagery on a background frieze,[39] and Annie French's work *The Ugly Sisters* (fig. 118) using stylised surface ornament shows the influence of Japanese patterned textiles.

Of major significance to the development of the Glasgow Style was the **Arts and Crafts Movement** in Britain. Initiated by William Morris, 'the aesthetic apostle of the Victorian era' who corresponded with Fra Newbery and, with Walter Crane, lectured to students from the Glasgow School of Art (fig. 119), this movement and its aims was a precursor to the Glasgow Style. Morris affirmed the unity of the arts and, with John Ruskin, advocated the study of nature for use in art and design. Arts and Crafts architect, J.D. Sedding,

particularly recommended drawing inspiration from reference to early herbals. Glasgow School of Art Library owned an early illustrated herbal which has been linked to some of the first work of the Glasgow Style in design at the school.

The **Symbolist Aesthetic** was also influential in that it replaced Victorian historical references in form and pattern with exotic symbols such as lilies, birds, peacocks, and the rose which conveyed specific ideas. Symbolist theory, not limited to the visual arts, advocated that barriers between the arts be removed—gouache panels by Frances Macdonald and Herbert MacNair from Dunglass Castle (fig. 111) exemplify a synthesis of poetry and art. Jessie Newbery's embroidered designs were a manifestation of this concept in the medium of embroidery. Newbery's use of distinctive lettering was an early influence on younger designers who employed variations on her characteristic style in graphic designs, posters, textiles, book illustrations and book covers (fig. 193).

Another movement which contributed to the philosophical basis of the Glasgow Style was the **Spiritualist Revival** which brought leading lecturers such as Professor Max Müller, the specialist in Far Eastern philosophy, to Glasgow and inspired artists to address spiritual and poetic values in their work (fig. 106). Maurice Maeterlinck's ideals, used as references for Mackintosh and Macdonald's gesso panels, were also embodied in the interiors of their residence. They were praised by Desmond Chapman-Huston for their otherworldly aspects: '. . . the surroundings were, in the full meaning of the word, unique . . . an oasis, a revelation . . .'[40] Hermann Muthesius saw their

interiors embodying significance in every aspect and stated: 'their severe and at the same time subtle atmosphere cannot tolerate an intrusion of the ordinary . . . An unsuitably bound book on the table would be a disturbance. People of today are strangers in this fairy-tale world.'[41] The Belgian Symbolist painter, Jean Delville, an influential tutor in drawing and painting at the School of Art, published his book, *The New Mission for Art* (*c*.1913), which included a chapter on the significance of spiritualism as a basis in art.

Another possible influence is that of the substance **laudanum**, a tincture of opium in spirit of wine. The drug was quite commonly used at the end of the nineteenth century, as the long-term effects were not fully realised at the time. Laudanum was known in Glasgow's local history to have been used by some of the artists of the Glasgow Style and the attenuation and contortions of the human figures which emerged in their work might have been partially influenced by such mind-altering experiences. Although first-hand experience may be one of the ways that laudanum's effects entered into the art, the same effects may have come through secondary sources. Illustrations from *The Mangwa* (fig. 122) a collection of Japanese drawings, and such contemporary books as Thomas De Quincey's *Confessions of an English Opium Eater* (first edition 1822),[42] represent figures in the process of using laudanum or opium, and show the same kinds of distortions and elongations as are found in some of the illustrations from *The Magazine* (fig. 121). Such illustrations of the effects of mind-altering substances may have been an influence on some early work of the Glasgow artists.

fig. 119
Glasgow School of Art Third Annual Re-union of Past and Present Students' Programme, Tuesday, 12th February, 1889, cover for lecture by William Morris on the Arts and Crafts, 21.4 × 16.0. (Coll: Barclay Lennie Fine Art Ltd. Photo: Glasgow Museums and Art Galleries)

fig. 120
Use . . . and Beauty, cover for *The Studio*, 1893, 30.8 × 25.0. One of the main tenets of the Arts and Crafts movement was summed up in the title on the first cover of *The Studio* magazine and adopted by the artists of the Glasgow Style movement.

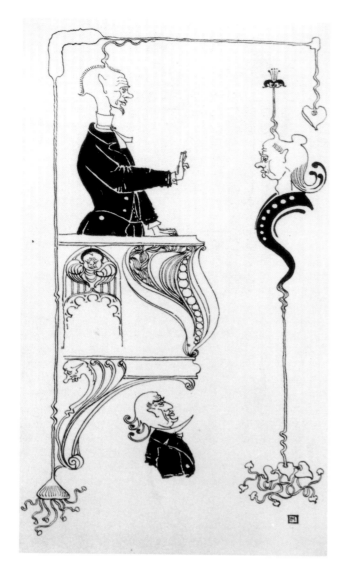

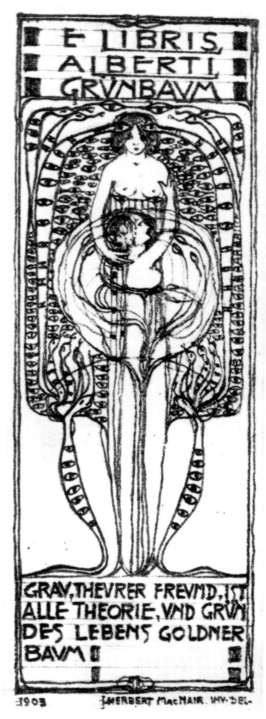

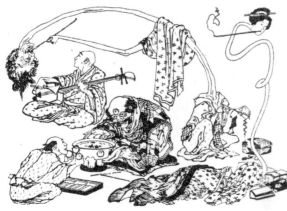

fig. 121 *(upper left)*
Untitled Drawing from *The Magazine*, Henry Mitchell, black and white, Spring 1896. (Glasgow School of Art)

fig. 122 *(lower left)*
An Impression of an Opium Takers Dream from *The Mangwa* of Hokusai, a collection of Japanese nineteenth-century drawings.

fig. 123
Alberti Grunbaum bookplate, Herbert MacNair, 1903. MacNair's use of the mystic eye, the serpent and the figures in the rose in this bookplate exemplify the symbolism employed in many works by 'the Four'. There was a Rosicrucian community in Glasgow and the well-regarded Professor of Eastern Philosophy Max Müller gave a series of lectures on esoteric issues which were published in the local press. Jessie Newbery credited Zola's novel, *Le Rêve*, with illustrations by Carloz Schwabe (a Belgian artist closely associated with the idealist-mystical salon de la Rose + Croix), as a special influence to 'the Four' and a copy of *Le Rêve* was owned by the Newberys. (Hunterian Art Gallery)

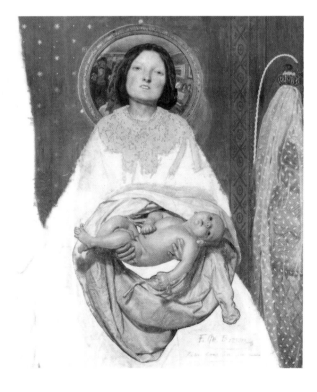

ON SYMBOLISM: THE GLASGOW ROSE

The most distinctive decorative motif to be used by Glasgow Style artists, the 'Glasgow Rose', was frequently employed in the furniture and interior design schemes of Mackintosh. 'Glasgow Rose'-as-icon may be seen to have reached its apotheosis in *The Rose Boudoir* installation in Turin (1902) (fig. 87), and its extensive use is generally attributed to Mackintosh. However, as Germaine Greer states in *The Obstacle Race*: 'It is not always the woman who follows the man's influence. She is often the innovator, but it is the man who recognises the innovation for what it is, commandeers it, and establishes it as his own. . . . '[43] The use of the Glasgow Rose may be attributed to appliquéd flower imagery introduced at the Glasgow School of Art by Jessie Newbery, an avid gardener, in her early textile designs and is documented in her early sketchbooks (fig. 128). 'The characteristic Glasgow Rose is believed to have evolved from her circles of pink linen, cut out freehand and applied with lines of satin stitch to indicate the folded petals. . . . '[44] This geometric stylised flower form (fig. 126) which became a feature in much of the Glasgow Style work was adopted by Newbery's students in the studios and carried into international exhibitions in Turin, Vienna, and Glasgow on a variety of objects. Today, along with the heart, it is the most recognisable element of the Glasgow Style (figs. 129–132). It was applied to articles ranging from metalwork, gesso, illustration, furniture design, stained glass windows in tea-room décor and the tenement close (common stair) to metal candle sconces and lockplates for the home, embroidered domestic and ecclesiastical textiles, and on enamelled jewellery. In addition to its use on decorative objects,

fig. 125 *(left)*
Take Your Son, Sir!, Ford Madox Brown, 1851–7, oil on paper, 70.5 × 38.1. The painting's format bears a striking similarity to that used by Margaret Macdonald in her gesso panel *The Heart of the Rose*. Pre-Raphaelite influence may be found in the work of 'the Four' and other women of the Glasgow Style Movement. (Tate Gallery, London)

fig. 124 *(top left)*
The Heart of the Rose, Margaret Macdonald Mackintosh, c.1902–03, painted gesso panel, 96.9 × 94.0. The panel was incorporated above a fireplace at 3 Lilybank Terrace for R. Wylie Hill, 1901. A duplicate was exhibited at Turin 1902 International Exhibition of Decorative Art in 'The Rose Boudoir' installation of the Mackintoshes, where The Glasgow Rose was brought ro international attention in design. (Glasgow School of Art)

fig. 126 *(above opposite)*
Rose tea cosy, Jessie Newbery, grey linen with pink linen appliqué shapes embroidered with floss silk thread in two shades of green and in pink using satin stitch, early 1900s, 40.8 × 29.4. The unfinished tea cosy designed and worked by Jessie Newbery in appliqué technique shows the geometricised Glasgow Rose she is said to have originated in her work at Glasgow School of Art. (Glasgow Museums and Art Galleries)

fig. 127
Cushion cover, designed and worked by Jessie Newbery, *c*.1900, linen with linen appliqué, embroidered in coloured silks in satin stitch, with a border of needleweaving. Inscription reads: "Sensim Sed/Propere Fluit/Irremeabilis/ Hora Consule/Ne Perdas Abs/Que Labore Diem", 55.9 × 64.7. (Victoria & Albert Museum, London)

fig. 128 *(right)*
A page from Jessie Newbery's sketchbook, 'Glasgow Rose' design, *c*.1900, pencil on paper, 26.0 × 21.0. (Glasgow Museums and Art Galleries)

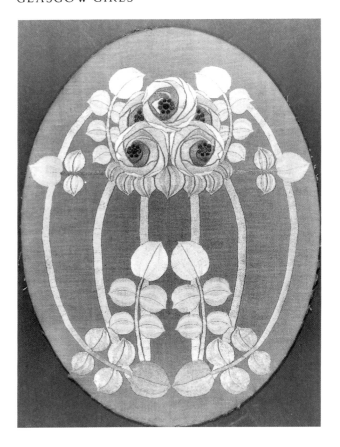

fig. 129
Fire Screen Panel, Johann McCrae, n.d., dark red linen embroidered with floss silk threads. 57.3 × 41.5. (Mrs Sheena MacBryde)

fig. 130
Leather tooled bookcover with rose motif, anonymous, n.d., 14.1 × 10.1. (Coll: Brian and Liz McKelvie. Photo: Glasgow Museums and Art Galleries)

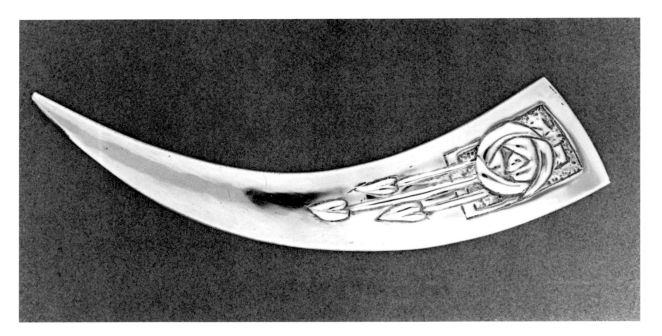

fig. 131
A white metal paper knife, Margaret Gilmour, c.1910, length 19.4. (Coll: Brian and Liz McKelvie. Photo: Glasgow Museums and Art Galleries)

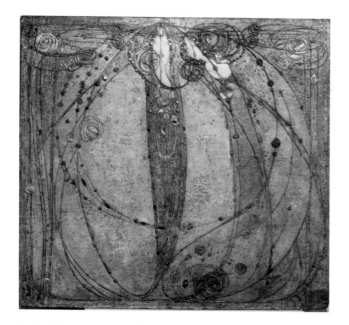

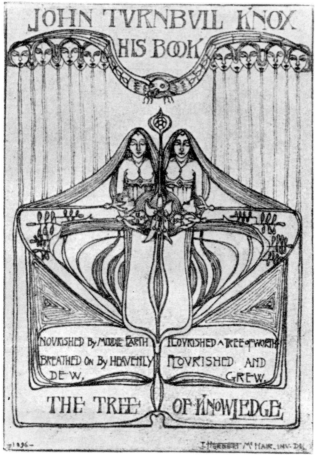

the rose appears in many of the paintings of the women artists of the period.

The choice of rose-as-icon in Glasgow decorative art is an interesting one to pursue. Newbery singled out the Belgian Symbolist artist Carloz Schwabe (1866-1926) who was closely associated with the *Salon de la Rose + Croix* as a 'very special influence' on the work of the artists from the Glasgow Style.[45] Art Nouveau historian, Stephan Tschudi Madsen, reported that a copy of *Le Rêve* illustrated by Schwabe and Luc Métivet originally belonged to the Newberys and was probably well known in the 'Glasgow Circle'. Jessie M. King created an embossed leather cover for the Newberys' edition of *Le Rêve*. The symbolic meaning of the rose has been variously interpreted over the ages demonstrating whatever religious or secular ideology was currently dominant. In Christian symbolism the rose was particularly associated with the Virgin. However, there is an alternative reading of the icon's significance which may have informed the work of the Glasgow Style designers. Pre-Christian records show the rose as a flower with unmistakably 'feminine' significance. Sacred to Venus, the Goddess of Love, the rose was the badge of Venus's priestesses and things spoken 'under the rose (*sub rosa*) . . . part of Venus's sexual mysteries, not to be revealed to the uninitiated'.[46] Christianity transferred the rose-as-icon to the Virgin. Similar goddess/rose symbolism is found in India where the Great Mother, called Holy Rose, was represented by a scarlet China rose. Mystics generally regarded the rose as feminine in gender and one medieval scholar, Pierre Col, cited the Gospel of Saint Luke in stating that the Holy Rose was a sign of the vulva.[47] Vaginal imagery may be read in some Glasgow Style works, for example, in Margaret Macdonald's gesso panel, *The White and The Red Rose* (*c.*1902) (fig. 132) and similarly in Frances Macdonald's *A Pond* (1893) In these works, and in similar ones by MacNair, the body of woman, herself, bends or contorts or flowers to create the reference (fig. 133).

In addition to the single geometricised rose, the elongated rectilinear rose tree became a frequent motif, for example, in Marion Henderson Wilson's repoussé metal triptych (fig. 134). In early Eastern iconography the 'World Tree' was sometimes envisioned as a rose tree—'a female Tree of Life and Immortality' as opposed to later masculinised readings of the genesis. With its 'feminine' signification, the rose-as-icon was especially appropriate for what evolved as a predominantly 'feminine' design style in Glasgow and it is not surprising to find international art historian Julius Meier-Graefe's declaration in his *Encyclopedia of Modern Art* that in Glasgow 'English Art was no longer hermaphrodite but passed entirely into the hands of women.'[48]

fig. 132 *(top)*
The White Rose and the Red, Margaret Macdonald Mackintosh, *c.*1902, painted gesso set with string, glass beads and shell, 99.0 × 101.5. (Private Collection. Photo: Hunterian Art Gallery)

fig. 133
Bookplate for *John Turnbull Knox*, Herbert MacNair, 1896. Based on the Biblical 'Tree of Knowledge', vaginal reference may be found in this design for a bookplate. (Hunterian Art Gallery)

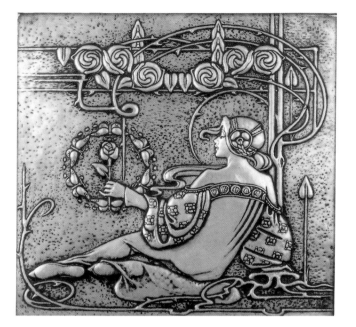
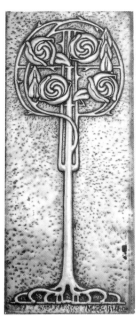

fig. 134
Rose Trees, Marion Henderson Wilson, *c.*1905, repoussé tin triptych of a girl seated in a rose arbour flanked by rose trees, centre panel: 59.0 × 59.0, side panels: 59.0 × 27.0 each. (Glasgow Museums and Art Galleries)

fig. 135 *(opposite)*
Spring, Frances Macdonald, 1897, pencil and gouache on vellum with beaten lead frame, signed by the artist, 43.8 × 13.0. (Glasgow Museums and Art Galleries)

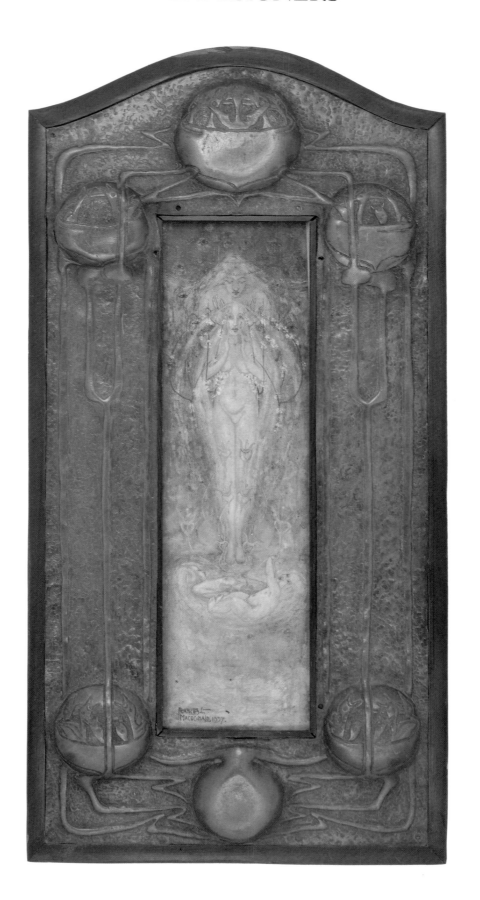

fig. 136
Portrait of Margaret Macdonald Mackintosh, *c.*1900. (T & R Annan and Sons, Ltd., Glasgow)

MARGARET MACDONALD MACKINTOSH (1864–1933)

by Pamela Robertson

Margaret Macdonald Mackintosh (fig. 136) was one of the most versatile, imaginative and successful women artists working in Glasgow at the turn of this century. Between 1895 and 1924 she contributed to more than forty exhibitions throughout Europe and America. Articles featuring her work appeared in leading art periodicals of the day, including *The Studio, Dekorative Kunst, Deutsche Kunst und Dekoration* and *Ver Sacrum*. Her work was bought by Fritz Wärndorfer, a leading patron of the Wiener Werkstätte, and won a diploma of honour at the 1902 Turin 'International Exhibition of Modern Decorative Art'; with her husband, C.R. Mackintosh, she also won a special prize in the international 'House for an Art Lover' competition of 1901. Yet on her death in 1933, brief notices only appeared in *The Times* and *Glasgow Herald*, and subsequent art historical criticism has largely denigrated her significance. This must in part be attributed to her limited output, the creative infertility of her final years, and to changing taste. But it is also due to a persistent tendency to view her work in the shadow of that of her husband. An independent assessment is long overdue.

Little is known of Margaret Macdonald's early years. She was born on 5th November, 1864 in Tipton near Wolverhampton, but the family moved frequently with her father's changing career as colliery manager, estate manager/agent and consulting engineer. By 1890 they were in Glasgow. There Margaret and her younger sister Frances registered as art students at the Glasgow School of Art. Given the maturity in style and execution of their work from the early 1890s, it is probable they had received some formal training south of the border. The following years at the School were to be of central importance. Director Fra Newbery's committed belief in the importance of design and the decorative arts, and his keen personal interest in talented students must have provided valuable encouragement for the development of the sisters' work. His role became more than that of mentor, for the association developed into a valued friendship.[1] Above all, it was at the School that the Macdonald sisters met the evening class students Charles Rennie Mackintosh and James Herbert MacNair. This must have taken place by November 1894 when they exhibited together in the 'Glasgow School of Art Club Exhibition' at the Institute Galleries, Sauchiehall Street. MacNair and Frances married in 1899, while Mackintosh and Margaret married the following year. Apart from the personal significance, their work during the 1890s as 'the Four' was to be of great importance. For even though their output was small, it received relatively wide coverage in the British and Continental artistic press, and though there were few direct imitators, its

originality provided substantial impetus for the development and recognition of a distinctive Glasgow Style.

From the beginning the sisters' work was regarded as unusual. An entertaining, if somewhat patronising, review was given in 1893 by their fellow student Lucy Raeburn in a piece entitled 'Round the Studios' in *The Magazine*, an album of students' work:

To begin with the brilliant sisters Macdonald have some work which ravished my artistic 'Soule' by its originality of idea, tho' perhaps in execution something is to be desired. The younger's colour schemes made me ask myself tenderly, 'Is it possible your eye for harmony is out of tune?' I never could abide crude blues, they always make me think of the wash tub. A very much woe-stricken soul would no doubt feel its grief embroidered in her clever stain-glass window design, 'Despair' representing two figures whose sorrow has worn them to shadows and whose tears have watered their eyelashes, and made them grow to rather an alarming extent. Her *Children blowing dandelions* was very cheering, the bright effects made me dry my eyes, while *Reflections*—well on reflection I will not say anything about it; too original for me to get the hang of. The elder sister trotted out her productions next. *Soldier, Sailor, Tinker, etc.* is very charming in its unfin-

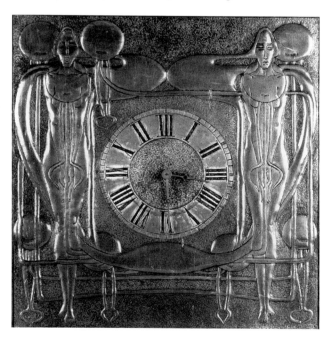

fig. 137
Clock face (untraced), Margaret and Frances Macdonald, 1896, beaten tin with enamel on wood frame. (Photo: Hunterian Art Gallery)

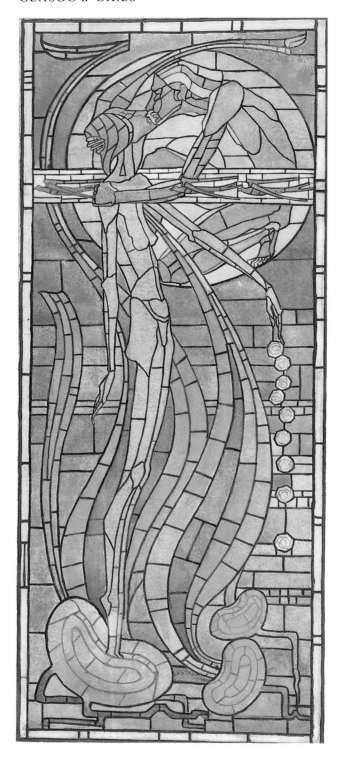

fig. 138
Summer, Margaret Macdonald, probably 1894, watercolour, pencil, pen and ink, probably a design for a stained glass window, 51.7 × 21.8. (Hunterian Art Gallery)

fig. 139 *(right)*
Morning, Margaret and Frances Macdonald, 1903, one of a pair of wall sconces in beaten brass, 77.0 × 25.5. (Glasgow Museums and Art Galleries)

ished condition, and to me is the nicest thing she has ever done, showing great improvement and promise of better to come. 'Go on and prosper my Young Friends, I expect to hear of you in wider circles soon.'[2]

By 1896 the sisters had opened a studio at 128 Hope Street, Glasgow. Over the next three years they worked closely together, occasionally in collaboration with MacNair with whom they had begun to work by 1895. Though at times whimsical and weak in design and execution, their productions were often of considerable originality. Gaunt human forms and stylised plants appeared in a variety of media—watercolour, metalwork, and graphics—in a style which had little historical derivation (fig. 139). Abstract themes such as 'Time' or obscure legends such as 'The Birth and Death of the Winds' were developed. Even with a work such as the *Drooko* umbrella poster (*c.*1895–98) (fig. 92), a commission from a commercial business, the Macdonald sisters created their own imagery. An inscription on a contemporary photograph partially explains, 'Poster for Umbrellas/Invention showing the Umbelliferae, the source of its construction,' a witty allusion to umbellifers such as cowslip and hemlock whose flower-stalks spring like umbrella ribs from a central stem. Their work provoked hostility and ridicule from many observers. Of the 1896 'Arts and Crafts Exhibition' in London, undoubtedly in reference to the exhibits of 'the Four', *The Magazine of Art* claimed, 'there is much in the exhibition that is the outcome of mere juvenile enthusiasm, of the passion for originality-at-any-price which is willing to sacrifice all claim to beauty and revel in absolute ugliness, if novelty can by that means be obtained.'[3] Although their exhibits were, on the whole, dismissed, their work prompted two supportive articles in the influential *The Studio* magazine. In the first of these, while expressing some misgivings, the editor Gleeson White cautioned against over-hasty dismissal, saying, 'In their own way, unmoved by ridicule or misconception, the Glasgow students have thought out a very fascinating scheme to puzzle, surprise and please.'[4]

White was intrigued enough to visit Glasgow. His subsequent article defended once more the Glasgow designers' original style: 'Eccentricity is often enough the first title given to efforts, which, later on, are accepted as proofs of serious advance.'[5] His articles were of great significance for they undoubtedly introduced the work of the Glasgow designers to the Continent, leading to an article in *Dekorative Kunst* in 1898 and, in 1900, to an invitation to exhibit at the 'VIIIth Secession Exhibition', Vienna. In Glasgow, however, their work met with derision, particularly its most public face—posters. The examples exhibited at the Glasgow Institute of Fine Arts in 1894 were hastily dismissed:

As to the ghoul-like designs of the Misses

Macdonald, they were simply hideous, and the less said about them the better. Decidedly the authorities should not halt till such offences are brought within the scope of the Further Powers.[6]

The latter were additional police powers introduced to curb unruly and drunken behaviour on the streets!

By the late 1890s, Margaret Macdonald's style had moved away from 'The Spook School'. In her watercolours she began increasingly to use muted colour to achieve more atmospheric effects. Narrative and romantic themes such as *The Christmas Story* (1896) or William Morris's *Defence of Guinevere* (1896-1899) were now preferred. The 1894 stained glass design *Summer* had been a disturbing composition of attenuated, naked human forms and stylised plants which used intense greens, blues and yellows (figs. 138, 140). In comparison a work of the same title painted in 1897 presented a more romantic celebration of the fertility of Summer, depicted now as a rounded female form swathed in flowing robes, flowers and seeds, and attended by plump putti. Forms are less crisply delineated, and a wider tonal range of soft greens and yellows is used.

The broad-ranging experimentation of the late 1890s helped to define Margaret Macdonald's style and preferred media. Though she continued with watercolour and some graphics and textile designs, only a

fig. 140
Summer, Margaret Macdonald, 1897, pencil and gouache on vellum with beaten lead frame, 45.1 × 20.5. (Glasgow Museums and Art Galleries)

few pieces of metalwork after the 1890s are known. Instead she turned to gesso and to embroidery. These media with their greater potential for including a wider range of materials and colour compared to metalwork better suited developing her decorative style. In particular she concentrated on gesso, and between 1900 and 1909 over a third of her known works were in this medium, ranging from panels little more than two feet square to friezes three yards long. Panels such as *The White Rose and the Red Rose* (c.1902), *Heart of the Rose* (c.1902) and *O Ye That Walk in Willow Wood* (1903) (figs. 132, 124, 31) demonstrate her technical skill and draughtsmanship in working an awkward plaster medium into highly-finished, complex compositions. In all of her work till 1909 she continued with romantic themes such as *The Flowery Path* (1901), *The Sleeper* (c.1903), *The Youngest Princess* (c.1909), *The Dead Princess* (c.1909), and, in the main, the use of muted colour schemes. Her few embroidery designs (fig. 147), such as the 1905 Hill House antimacassar, however, show a bolder colour sense. Though stylistically different, these designs share certain common principles with the work and teaching of Jessie Newbery in their imaginative use of ordinary materials, and the understanding and development of the abstract elements of design.

From 1910 her output, never large, declined. She produced only a small group of watercolours, some graphics and textile designs, and a few oil paintings. While works from the early 1900s such as *A Rosebud* (c.1900), *St Dorothy* (1905) or the Maeterlinck-inspired subjects had been primarily decorative treatments of titles often drawn from literary sources, the later watercolours (figs. 141–142), such as *The Mysterious Garden* (1911), *The Three Perfumes* (1912) and *The Pool of Silence* (1913), became less clear in meaning and source though still following the decorative atmospheric style of the earlier works. At the same time she was capable of producing a design such as *The White Cockade Menu* (1911) (fig. 25) menu whose boldly-delineated and strongly-coloured composition relates it to contemporary Viennese Secession graphics.

In 1914, with Mackintosh's architectural career in decline, the couple closed their Glasgow home at 78 Southpark Avenue and moved to London after spending several months painting at Walberswick. Only a dozen or so works are known from the London period, but these constitute some of her boldest designs, incorporating primary colours and geometric motifs in skilful textile designs and certain of the late watercolours (fig. 146). Her last work, *La Mort Parfumée* of 1921 (fig. 142), highly stylised and dramatically coloured, is one of her most challenging pieces.

Following Mackintosh's failure to establish an architectural practice in London, the couple moved in 1923 to the south of France. There Mackintosh devoted himself to watercolour painting but no work by Margaret is known. In 1927 they returned to London,

fig. 141
The Mysterious Garden, Margaret Macdonald Mackintosh, 1911, watercolour and ink on vellum, 45.7 × 48.3. (Private Collection. Photo: Hunterian Art Gallery)

where Mackintosh died of cancer the following year. The next five years for Margaret were lonely and restless, divided between France and the south of England. In January 1933 she died in her Chelsea studio. Brief notices appeared in *The Times* and *Glasgow Herald*. It was a quiet end.

In her lifetime and subsequently, Margaret Macdonald's work has puzzled and intrigued. As early as 1897 Gleeson White struggled to categorise the Macdonald sisters' work:

> With a delightfully innocent air these two sisters disclaim any attempt to set precedence at defiance, and decline to acknowledge that Egyptian decoration has interested them specially. 'We have no basis.' Nor do they advance any theory. [7]

Few external sources can be confidently cited. Only in the work of the early 1890s can a direct stylistic influence be identified, in the work of the contemporary Dutch artist Jan Toorop whose work was published in *The Studio* in 1893 (fig. 143). *The Studio* also made available the work of Aubrey Beardsley and nineteenth-century Japanese prints. While little direct borrowing can be demonstrated, an awareness of Beardsley is seen in the large-scale stylised figures for the Glasgow Institute and *Drooko* posters. These illustrations presented in an unconventional manner stylistic elements which were to be fundamental to Margaret Macdonald's style. Her work was founded on a serious and imaginative attempt to rework traditional images. 'Certain conventional distortions, harpies, mermaids, caryatides and the rest are accepted

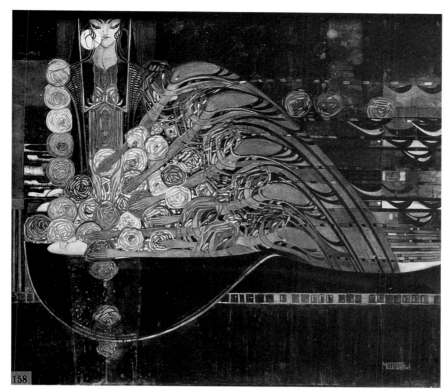

fig. 142
La Mort Parfumée, Margaret Macdonald
Mackintosh, 1921, watercolour,
63.0 × 71.2. (Private Collection,
Photo: Hunterian Art Gallery)

fig. 143 *(below)*
Fatalisme, Jan Toorop,
ink and coloured pencil,
60.0 × 75.0. (Rijksmuseum
Kröller-Müller, Amsterdam)

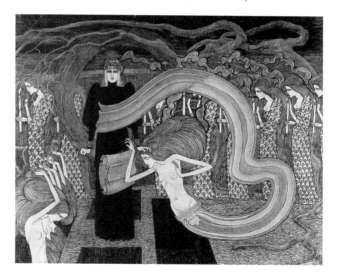

but why should not a worker today make patterns out of people if he pleases?'[8]

She drew on a limited number of sources for her subject matter: the *Bible*, the *Odyssey*, the poems of Morris and Rossetti and, in particular, the writings of the contemporary Belgian Symbolist author and playwright Maurice Maeterlinck. The literary symbolism of her work had a potency for her contemporaries which has now lost its resonance, a resonance expressively described in a *Dekorative Kunst* article of 1905:

> Mrs Mackintosh is outstanding for her illustrations of mystic poetry. Maeterlinck's imaginative writing, and the visions of Dante Gabriel Rossetti echo profoundly in her soul, and under their influence her hand creates drawings, paintings and reliefs whose unusually meticulous and delicate execution never hampers their spiritual clarity. I know no plaster relief by any living artist which can be compared with hers.[9]

Surprisingly, given the emphasis in contemporary avante-garde teaching and design, she did not work directly from Nature. No sketchbooks exist. No portraits, landscapes or still-lifes are known. In the main she drew on her own imaginative resources.

Collaboration seems to have been essential for Margaret Macdonald's creativity. More than two-thirds of her output was collaborative, though she worked only with three other artists, all personally close to her: Frances Macdonald, MacNair, and Mackintosh. In the 1890s the majority of her work was designed and executed with Frances, occasionally working also with MacNair. This collaboration comprised either designing separate works under a collective title, such as *The Four Seasons* (*c.*1896) or, as with the screen *The Birth and Death of the Winds*, (*c.*1896–99) the joint conception and execution of a single piece.

113

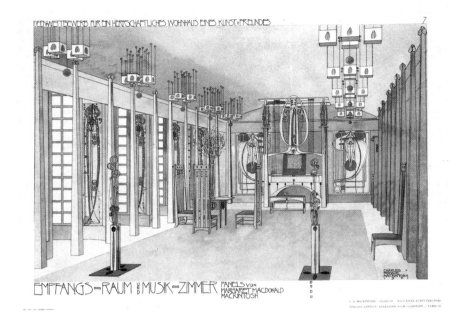

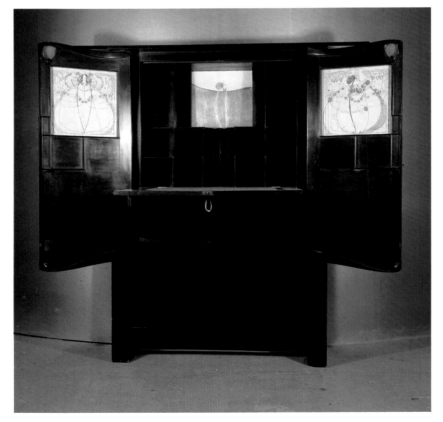

fig. 144 *(bottom)*
Writing cabinet, Charles Rennie Mackintosh with panels by Margaret Macdonald Mackintosh, 1902, five metal and painted gesso panels by Margaret Macdonald, 34.0 × 34.0. Two gesso panels *The Dreaming Rose*, (l.), and *The Awakened Rose*, (r.), were inside the doors, the three gesso and metal panels were placed on the front doors and the back panel. (Coll: Austrian Museum of Applied Art, Vienna, Photo: Eric Young)

fig. 145 *(top)*
Design for *Haus eines Kunstfreundes* competition, Charles Rennie Mackintosh and Margaret Macdonald Mackintosh, Music Room, 1901, 38.8 × 52.3. (Glasgow School of Art)

Margaret's collaboration with Mackintosh was not as wide-ranging and took a different form, comprising chiefly panels for his furniture and interiors (fig. 144). Their collaboration, begun in 1898, lasted for nearly twenty years, their last joint production being an untraced series of panels and candlesticks, *The Voices of the Wood*, (*c.*1915) for the 'IX Arts and Crafts Exhibition', London, 1916.

A fair assessment of Margaret Macdonald's achievement has inevitably been complicated by her marriage to Mackintosh. In 1933, for instance, the architectural critic P. Morton Shand wrote to the organisers of the 'Mackintosh Memorial Exhibition' in Glasgow:

> I hope that the exhibition may not be so arranged or announced as to give the impression that Mrs Mackintosh was in any sense considered her husband's equal or alter ego. Outside of circles of loyal friends in Glasgow and Chelsea her work is either unknown, or long since forgotten; and the future is scarcely likely to see her rather thin talent restored to a place of honour.[10]

Equivalent views have, unfairly, been expressed by subsequent critics.

It cannot be disputed that Margaret Macdonald's best work was done in association with Mackintosh. Three outstanding projects with her husband brought the greatest successes of her career: the exhibition room at the 'VIIIth Vienna Secession Exhibition', 1900; the 'House for an Art Lover' competition designs (1901); and *The Rose Boudoir* (1902) (fig. 148) at Turin. The gesso and embroidery panels for the Ingram and Willow Tea Rooms, the Turin exhibition, Hill House, the Wärndorfer Music Room and Hous'hill Card Room are among her finest achievements. But her role was neither peripheral, nor submissive, nor second-rate. At the Willow *Room de Luxe* her panel *O Ye That Walk in Willow Wood* provided the centrepiece of the jewel-like, silver and purple interior. Her influence is apparent in a number of Mackintosh's interiors from 1901–04. In the Art Lover's Music Room (fig. 145), for instance, the elaborate panels by the piano, the scheme of white, silver, and pink, and the unusual flower arrangements must derive in part from her. Her panels for this room demonstrate how effectively she could design for Mackintosh's schemes. A series of identical upright panels, either stencilled or embroidered, showing a stylised figure, were created for the window bays, their design closely related to the architecture and the interior decorative scheme. The panels hung against the wall from rail height to the skirting. The elongated upright form of the figures continued the predominant vertical emphasis of Mackintosh's furnishings and fitments while the curvilinear details offset the rigid geometry of the square window panes and reiterated the curves of the window bays, ceiling, piano, and flanking panels. The colours followed the silver, pink, green and purple of the overall scheme. Designs by

Mackintosh for five pieces of furniture incorporating panels by his wife survive. While these specify the precise panel proportions, they indicate their design content in broad terms only, suggesting that, with the exception of size, the conception and execution was wholly Margaret's. Mackintosh himself had great respect for his wife's gifts, allegedly declaring, 'Margaret has genius. I have only talent.' He worked with no other designer.

While it is questionable whether Margaret Mac-

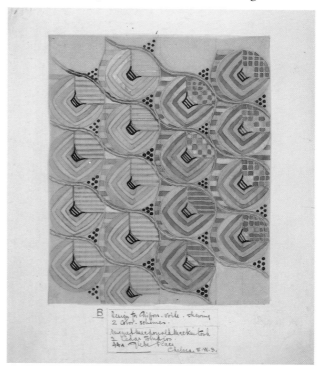

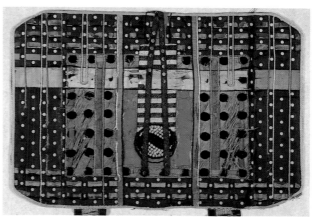

fig. 146 *(top)*
Textile Design, Margaret Macdonald, 1915–23, gouache and watercolour, 35.5 × 28.1. (Hunterian Art Gallery)

fig. 147 *(bottom)*
Antimacassar from the Hill House, Margaret Macdonald, *c.*1904, cotton and silk knot with appliqué cotton tacked over card, satin and velvet, paper, silk and satin ribbon, silk braid, one plastic ring, 27.0 × 38.7. (Coll: The National Trust for Scotland, Photo: Glasgow Museums and Art Galleries)

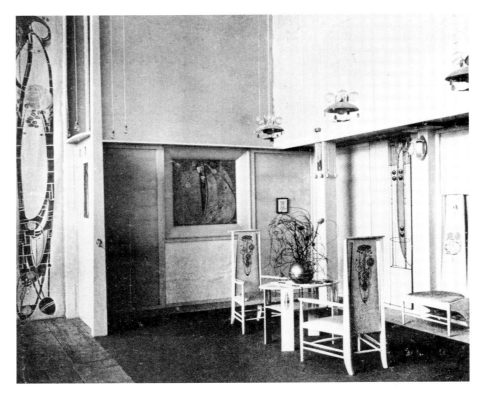

donald's influence diminished Mackintosh's work, it is clear that marriage restricted her own career. Throughout the 1900s Mackintosh was deeply affected by the hostility with which his work was received in Glasgow. As early as 1903, he wrote to Hermann Muthesius of 'antagonisms and undeserved ridicule . . . feelings of despondency and despair.'[11] Throughout this period Margaret must have acted as a support and reassurance. Jessie Newbery later paid tribute to these qualities: 'Margaret's gifts were a great asset to Toshie—as advisor, appreciator, collaborateur.'[12] The debt is acknowledged by Mackintosh himself. In a letter written from France in 1927, when Margaret was temporarily in London, Mackintosh stresses that she had been half, if not three-quarters, in his architectural efforts.[13] Margaret's declining output can be directly related to Mackintosh's declining career as an architect and designer. From 1910–19, the date of his last interior, his total output comprised only four small projects for Catherine Cranston and the commissions from W.J. Bassett-Lowke for his homes in Northampton. In this professional hiatus Mackintosh turned to textile design and to watercolour painting, which increasingly preoccupied him from 1914. In his watercolours he drew inspiration from plants, and the rural landscape and architecture of Dorset and the south of France, working directly from Nature. Margaret seems to have been unable to find the same inspiration or to work at a sustained level on her own. Undoubtedly, declining health and her preoccupation with Mackintosh partially explains this. Jessie Newbery recalled, 'She could only work in tranquillity

and that, even before 1914, was denied her.'[14] But it would seem that her art could not, like Mackintosh's, adapt to a new artistic climate.

This must not, however, diminish the significance of her earlier contributions as an innovative artist of impressive technical versatility. The work of the 1890s was of central importance for the development and recognition in Britain and on the Continent of a distinctive Glasgow Style. In the Preface to the published folio of the Mackintoshes' 'House for an Art Lover' designs, Hermann Muthesius perceptively outlined the importance of that movement:

> Whatever one's individual attitude to the Glasgow Style may be, one thing cannot be denied: it has brought new values into the turmoil of the artistic manifestations of our time. It is independent to a high degree and bears the stamp of breeding and character. More than that it has a contagious effect. The stimulus it has given is felt not only in Glasgow, it has penetrated deep into the Continent and certainly as far as Vienna where it found fertile soil.[15]

With her early work, the gesso and embroidery panels of 1900–10, and certain of the late watercolours, Margaret Macdonald developed a distinctive decorative style which establishes her as one of the most individual and gifted women artists of the Glasgow School.

fig. 148
Rose Boudoir, 'Turin International Exhibition', 1902, Charles Rennie Mackintosh in collaboration with Margaret Macdonald. (Illustrated in *The Studio*)

TINKER, TAILOR, SOLDIER, SAILOR:
MARGARET MACDONALD AND THE
PRINCIPLE OF CHOICE

by Timothy Neat

An apparently casual remark by Mackintosh about Margaret Macdonald has become famous: 'I had talent, Margaret had genius.' What does it mean? It is not an isolated statement, on various occasions he said that Margaret had been half, if not three-quarters, of his architectural efforts, and that his two interests were Margaret first and then his work.[16]

Was Mackintosh a besotted old flatterer? Or did he speak and write the truth—a truth perhaps coloured, but not altered by his gentlemanly good manners? This short article will begin to show the extent to which Margaret Macdonald was not just a marvellous wife and friend to Mackintosh—but also his artistic collaborator, his muse, his touchstone in all moral and intellectual matters related to his vision as a man and as an artist.

What was this vision? What did Mackintosh, what did 'the Four' seek? What was their creative relationship one to another? The clearest statement about the underlying aims and methods of the group comes from Herbert MacNair in conversation with Thomas Howarth, '. . . not a line was drawn without purpose, and rarely was a single motif employed that had not some allegorical meaning.'[17] Mackintosh made similar, cryptic statements which at once suggest, but do not reveal what his art was about. He was concerned, he wrote: 'not so much with the technical as with the ethical, the indefinable side of Art.'[18]

Practically no writings by the Macdonald sisters exist, but their paintings and designs are full of allegorical and symbolic images which reinforce (and predate) these rare but revealing statements made by the two men. And it seems certain that it was the women, particularly Margaret, who conceived, promoted and most loyally affirmed the central poetic ideas—the sacred ideals—which lie at the heart of the work of 'the Four'. It was Margaret who transformed the prize-winning student, working for a firm of successful business architects, into an artist at the helm of the Modern movement; Margaret, who encouraged and inspired the ambitious Glasgow policeman's son—to the point where, in his lecture 'Seemliness' (1901), Mackintosh could assert—with all the authority of the great artist he had, by then, become—that :

The man with no convictions—no ideals in Art, no desire to do something that will leave the world richer—his fellows happier—is no artist. The artist who sinks his personal convictions—who lives not up to his ideals—is no man. . . . All artists know that the pleasure derivable from their works is their life's pleasure—the very spirit and soul of their existence. But you must be Independent,

Independent, Independent—don't talk so much but do more—go your own way and let your neighbour go his.[19]

These thoughts are essentially Margaret Macdonald's. She sought meaning and spiritual truth in Art and Life—and expressed both symbolically—in her work and in her lifestyle. Her symbolism is at once personal and universal. She attached supreme importance to the ethical content of any work of art, but knew its expression must be individual and contemporary. There is plenty of evidence that Margaret had an exceptional natural authority—and that both sisters were compelling characters of vivid imagination and high seriousness. Both goaded and encouraged their two lovers to truly 'become' themselves—they made them *choose* what they would do with their lives and their talents, made them attempt to be masters of their destinies, not victims of their circumstance or weaknesses.

For Margaret and Frances Macdonald *choice* and the *idea of choice* were primary issues that everyone must address. One of Margaret's earliest, and now lost paintings, was entitled *Tinker, Tailor, Soldier, Sailor* (c.1893). It is, almost certainly, a painting which makes reference to the children's Marriage Rhyme which continues 'Richman, Poorman, Beggarman, Thief'. In the context of Margaret's complete *oeuvre*, it is fair to assume that this painting was about choices, symbolised a predicament, and threw out a challenge. What does fate hold for me, for you? Whom will we marry and why? What values do we hold and why? How important is Love? What effect is social ambition and worldly success likely to have on those who hope to become artists? At this time, Mackintosh was, of course, engaged to Jessie Keppie, his employer's sister—so the questions were almost too real, and too close for comfort, for many of those who would have viewed this painting when displayed in the Glasgow School of Art in the Summer of 1893. These youthful questions are also fundamental questions; they vexed 'the Four', and fuelled their art. As avid readers of *The Studio*, they would have been struck by a ditty in the first issue, April 1893, of that influential magazine; of Scots and Scotland it speaks:

Land o' careful cunning bodies
Foes to a' ungodly fun;
Land that sums up man's whole duty.
Heaven, the de'il, and Number One![20]

Margaret was totally opposed to such a philosophy of life; and she had undoubtedly shaped Mackintosh's thinking by the time he set out the poles of his artistic

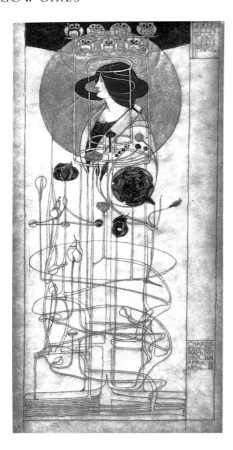

fig. 149
Part Seen, Imagined Part, Charles Rennie Mackintosh, 1896, 39.0 × 19.5. (Glasgow Museums and Art Galleries)

principles a decade later—in his heroic lecture 'Seemliness', in which he asks his fellow artists to show:

> . . . greater strength and courage, to present a braver front, a more determined opposition, in the great struggle that must always, I am afraid, be waged by the advocates of Individuality, Freedom of Thought, and Personal Expression on the one hand and the advocates of Tradition and Authority on the other. The men of our profession . . . in high and exalted positions . . . who imagine they are helping on the cause of art, whereas they are (in fact) feebly imitating some of the visible and superficial features of old and beautiful works and neglecting the spirit, the intention of the soul that lies underneath. . . . Art is the flower. Life is the green leaf. Let every artist strive to make his flower a beautiful living thing, something that will convince the world that there may be, there are, things more precious, more beautiful than life itself.[21]

It was the Episcopalian Margaret who particularly nourished these high thoughts in Mackintosh—and such thoughts provide the springboard for all of his outstanding artistic successes, and, of course, her own.

In Frances Macdonald's late watercolour, *The Choice* (1909–15) (fig. 150), we see the younger sister making a clear statement about the kind of choices that had been shaping the lives of 'the Four' for two decades. Does one pursue conventional success, or risk public failure to be true to personal visions and ideals? In *The Choice*, Frances gives visual form to ideas, almost identical to those expressed by Mackintosh above, and recurrently by Margaret. The painting shows two pairs of lovers. The two pairs are strongly contrasted. On the right and slightly in the background, we see a shadowy, half-naked couple. The man stiffly cringes and hides his nakedness with hands that close around his genitals. (The image is iconographically like many traditional representations of Adam when first expelled from Paradise.) From the woman's left hand spill golden coins—symbols of worldly success and hoarded wealth. The couple rise from an ill-defined base; their feet are hidden, they seem to drift, there is no sense of this couple being well-rooted, or that they are growing and thriving. Their heads are 'scalped' by a cloud that wipes the horizon: the minds of these lovers are blanketed in unknowing, they have no spiritual existence. Their heads turn and look toward the other pair of lovers: the man's expression suggests envy, the woman's—a self-satisfied superiority, coupled with contempt. Frances thus creates an image of a couple who chose the worldly path, and who have harvested material success. Perhaps, secretly, the man, at least, now regrets his choice. But it is too late. Whatever money or comforts they might have, it is clear that the choice this couple made, has left them barren custodians of a spiritual desert. If they were ever artists, they are now no more. The base life they chose has led, and always will, to spiritual suicide, to a kind of living Hell.

The other couple, on the left of the picture, are very different. They, too, are more or less naked, but they do not cringe introvertedly; their hands are open and conjoined and hold, or reveal, roses in bloom. Their bodies are not shaded as those of the other couple, but lighted, almost illuminated, from within. The man's face suggests pain, suffering, hardship, the tragic disappointment of the true poet, but he is not bitter—he looks towards the other (lost) couple with a gentle pity. The woman stands bare-breasted, open-faced, innocent, vulnerable, but strangely content and self-contained. Their two bodies are an almost integrated pair—and they seem to grow up, spring out of the great bud of a bulb-*cum*-flower bursting into new life. This bloom-bestrewn couple embody an organic, natural and very physical life. And this couple's life is not just physical, it is also spiritual. The heads of these two lovers are not draped with fog, or scalped, but free in the fresh air. This is a pair who have risked all in the pursuit of True Love, uncompromised Art—and Common Humanity. This couple may be poor, may feel the pricks of the rose briars that bind them but they are free

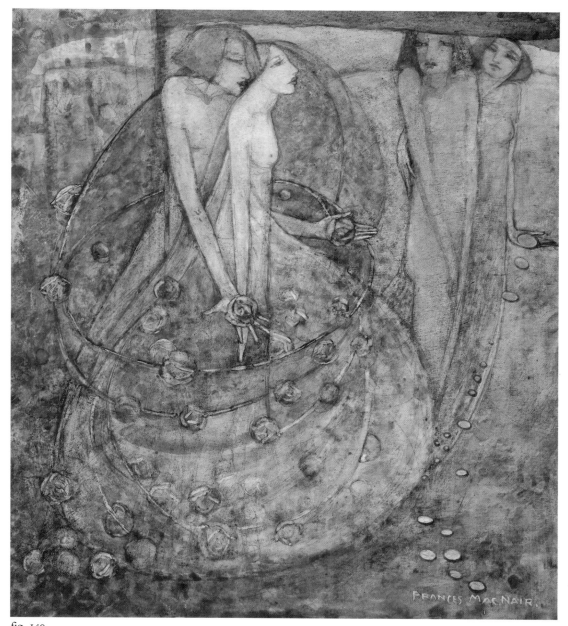

fig. 150
The Choice, Frances Macdonald, n.d., watercolour, pencil and gold paint on paper, 35.0 × 30.6. (Hunterian Art Gallery)

beings in contact with a cosmic surge of forces far greater than themselves. By being prepared to give up their lives, they have found their lives—and, despite hardship and unhappiness, it is worth it! (In this painting, one is much more aware of the 'flower of Art' than of 'the green leaf of life'—and there is no doubt that this painting documents a tragic low-point in the actual lives of 'the Four'—but none of them ever renounced their principles.)

Margaret Macdonald creates similar polarities in her little known watercolour, *The Path of Life* (1894) (fig. 151), illustrated in Lucy Raeburn's *Magazine* No. 2, Spring 1894. In the *Magazine*, it appears just after two designs by Frances entitled *The Crucifixion* (1894) and

The Ascension (1894): it has clear religious overtones. In *The Path of Life*, we see a nude woman standing between two clothed maidens with wings; outside them are two more young women—naked and seen in profile. The large central woman is in movement forward—like images of Pharoahs in Egyptian sculpture (which were carved to await, and then to embody, the living spirit of the person who has 'temporarily' died). She has one leg forward and her hands by her sides, as was also traditional in ancient Egypt. She is 'everywoman' (and Margaret)—on the Journey of Life. The two clothed and winged maidens (spiritual guardians, angels) are representations of the different spiritual paths that 'everywoman' might

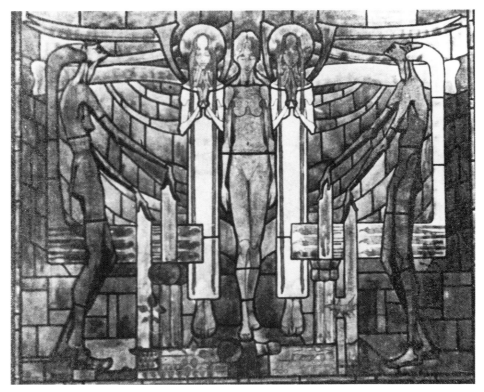

fig. 151
The Path of Life, Margaret Macdonald, 1894, watercolour, appeared in the April 1894 volume of *The Magazine*, untraced. (Photo: Glasgow School of Art)

follow. They have haloes, their hands are together in prayer, their feet side by side in stillness. They both have high, strangely egg-shaped foreheads—indicative of spiritual potentiality. The forehead of one maiden glows with light and illuminating knowledge. The forehead and face of the other maiden is dark with unknowing. (The visual structures look back to Rossetti's *Sanct Grail*, and anticipate the elongated forms that Mackintosh would later use in many designs — particularly for his chairs.)

The wings of the angelic maidens link them to two other figures—standing in profile at the sides of the design. These figures are naked, and look up towards the large central figure; they grasp with both hands, pillars which, like the corner supports of a throne, surround the central figures. The naked figure to the right grasps with her right hand a pillar which has the root, stalk, leaves and flower of a rose. This pillar represents the force of Nature in mankind. With her left hand, this figure grasps the other pillar and its form is based on an Abstraction of the five-leaved, five-petalled form of the rose plant. This pillar represents Creative Power; mankind's ability to imaginatively respond to, shape, and use Nature. Like God, mankind has powers and sacred duties. The composition of *The Path of Life* is strongly symmetrical, and on the left side of this design, we see another, almost identical, naked woman. With her right hand she grasps the pillar of 'Natural Force': this pillar has the form of a thistle.

With her left hand, she grasps the other pillar, of mankind's Creative Power (but here the destructive aspect of that power is symbolised) and its form is an abstraction of a thistle. (These thistles are not, however, I believe, emblems of the Scottish nation, but rather universal symbols of barrenness, envy and aggressive self-interest.[22] If it does represent Scotland, it represents narrowness, introversion and greed—but nowhere else do 'the Four' represent Scotland in such a light—so there is no solid reason to think they do so here.)

Thus, on the *The Path of Life*, we are confronted with choices: one can choose to walk with the rose or the thistle; love, or hate and envy; creative beauty, or barren defiance. To further emphasise this line of reasoning, Margaret has painted behind the woman-of-rose, a flight of swallows—symbols of Isis, Venus, summer, embodiments of all that is beautiful and good in Life. Behind the woman-of-thistle, she paints a flight of crows or ravens, with ugly drooping beaks—these black, carrion-eating birds are emblems of greed, darkness, winter and death: they are symbols of those who will not return, symbols of those without hope of regeneration or resurrection.

To Margaret, the choices in life were clear. And she knew that the right choice was important for everyone—but for anyone with the potential to be a great artist, the choice was truly and absolutely crucial. She loved, even at this time, Charles Rennie

Mackintosh; and she, even more than Fra Newbery, had recognised the genius lying dormant in the young architect. And she knew if he were to succeed as a great architect, he must first become a great artist, and to be that, Mackintosh needed a direction, an encouragement, a belief, that neither his family background, nor his education, nor the offices of Honeyman and Keppie, could give him. She knew that she could give Mackintosh much, and she did. Margaret Macdonald is the spiritual key to Mackintosh's greatness—the importance of her role in his personal and intellectual development cannot be over-emphasised. Mackintosh recognised this.

Various public works of art by Mackintosh pay Margaret Macdonald the same kind of compliment that he paid her in his private correspondence from Port Vendres. (The kind of compliments quoted at the start of this article.) In *Part Seen: Imagined Part* and in the *Ladies Room of the Buchanan Street Tea Rooms*, we can see stylised portraits of Margaret Macdonald (fig. 149). Those works show that Margaret not only fired Mackintosh with aims and ideals but was also the physical and ideological starting point of what one can only call a new 'Order of Architecture'. As the Greeks constructed their 'Orders' on the forms and proportions of Doric Men, Ionian Maidens, Corinthian Courtesans—so Mackintosh constructed a 'Modern Scottish Order' inspired by the woman he honoured and loved. Perceptive contemporary critics were aware—not only of this fact, but also of the extent to which Margaret was in every sense an integral part of the Mackintosh phenomenon. Richard Muther describes the Mackintosh room at the 'Vienna Secession Exhibition' of 1900 in these words:

> You see thin, tall candles, chairs and cupboards thrust up in pure verticals, pictures with slender elliptical figures whose outlines are governed by the linear play of a unifying thread. You have seen Mrs Mackintosh herself, standing in the room like a Gothic pillar. Her hat was the capital, the perpendicular folds of her long mantle providing the fluting. Just imagine Mrs Mackintosh standing in blouse with wide, bulky sleeves, in a jacket that exaggerated the hips; imagine the pictures on the walls replaced by others by Macarb, the rectilinear flower basket, the delicate, vertical lines of the light fitments by an overhanging Baroque chandelier; and it will feel like a slap in the face. The stylistic unity of the room has become manifest to you![23]

The truth of Muther's perception is reaffirmed by study of Mackintosh's sketch from 1904, (fig. 152), in which the very naked and splendidly hirsute body of Mrs Mackintosh can clearly be seen mildly disguised in a gridded drawing of a plant. This sketch was the basis of the stencilled design which decorates the dining room at Hous'hill, Nitshill; and in modified form is

used again much later at Derngate. It is surprising that this naked woman has not been pointed out before! But in such drawings and in such rooms, constructed around clear, yet secret, schema and ideals—art and life become one: form and function, one—as in all great architecture—and the function mentioned here, understood not as mere material fact but as part of a much wider human, spiritual and aesthetic phenomenon. No wonder the Viennese toasted—'Mackintosh: the greatest since the Gothic!' No wonder Mackintosh described Margaret as 'half if not three-quarters' of all he did. They were two individuals who made choices. They chose each other and they gave each other aspects of the genius that separately they hadn't.

fig. 152
Sketch design for stencil decoration for the dining-room, Hous'hill, Nitshill, Glasgow, Charles Rennie Mackintosh, 1904, pencil, 39.0 × 11.5. (Hunterian Art Gallery)

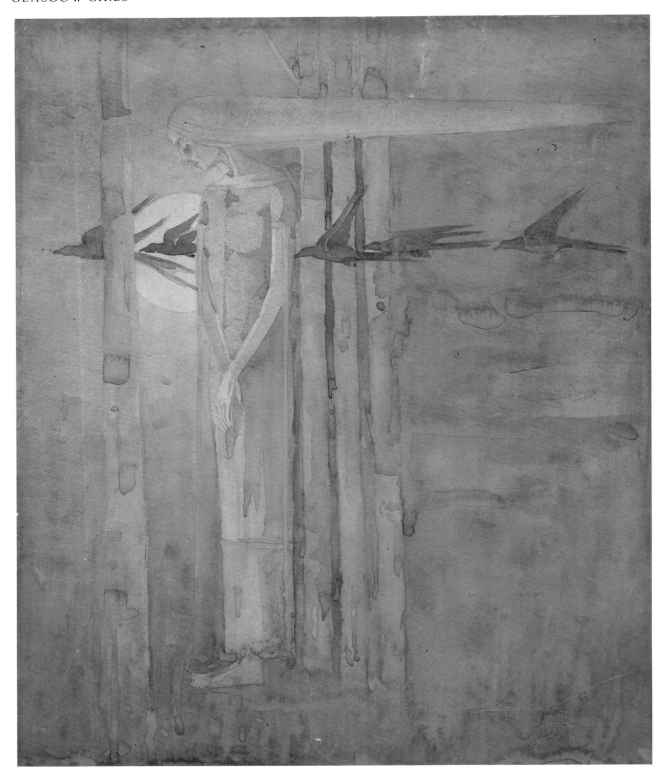

fig. 153
Ill Omen, Frances Macdonald, 1893, watercolour, 51.8 × 42.7. (Hunterian Art Gallery)

fig. 154 *(opposite left)*
Winter, Charles Rennie Mackintosh, dated 1895, appeared in *The Magazine*, Spring 1896. Even in 1895, the year after the 'Spook School' images first appeared and caused a furore in the local press, Mackintosh's female was still the more conventional representation of woman. (Glasgow School of Art)

FRANCES MACDONALD (1873–1921)

by Jude Burkhauser

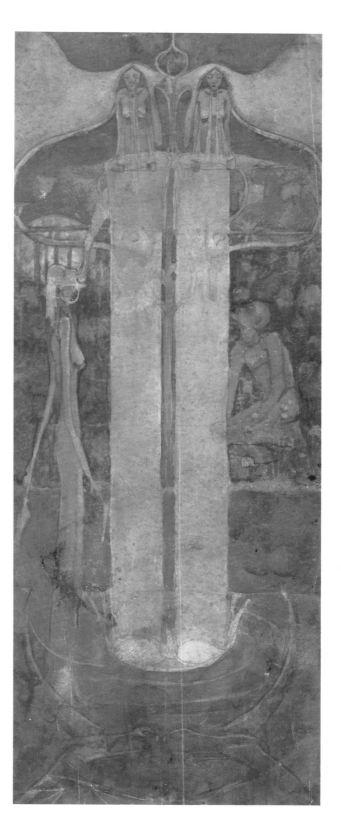

Innovative and gifted, Frances Macdonald MacNair (fig. 156), a talented metalworker, watercolourist, and embroiderer, was central to the evolution of the Glasgow Style in design. Born in 1873, she and her older sister, Margaret, studied at the Glasgow School of Art from about 1890 until c.1894. Macdonald's avant-garde tendencies as a student won her a bronze medal in the National Competition organised by South Kensington, when her design for a tapestry hanging was praised as 'bold and clever in conception.'[1] As discussed previously, in her earliest work she collaborated with Margaret and a number of these works were mutually signed. *The Studio* critic Gleeson White noted this collaboration:

> It is with some relief that one finds the Misses Macdonald are quite willing to have their work jointly attributed—for actuated by the same spirit, it would be difficult, if not impossible . . . to distinguish the hand of each. . . .[2]

A comment on the collective ethos which animated the early work of 'the Four', White perceptively saw that it was an 'actuating spirit' even more importantly than an applied style in design that the sisters shared and he praised their work as part of a distinctive 'group' emerging in Glasgow. This 'actuating spirit' is what sets the work of Frances and Margaret Macdonald apart from their female contemporaries, and what sets Frances, in her later watercolour work, apart from 'the

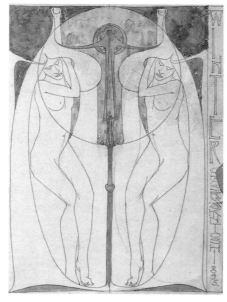

fig. 155 *(right)*
The Fountain, Margaret or Frances Macdonald, 1893–1895, watercolour, 41.2 × 16.4. One of the most enigmatic of the early works of the 'Misses Macdonald'. (Hunterian Art Gallery)

Four'. The Macdonalds' poster work, as discussed in Chapter 3, challenged the existing visual iconography of its day by providing a radical new representation of the 'feminine persona'.[3] Their images provided an alternate reading of 'femininity' to that of the dominant discourse and created a female who was visually self-defined (fig. 153). This acuity of 'spirit' or creative risk taking is no doubt what Mackintosh referred to in the controversial quote about Margaret Macdonald's 'genius'.[4] Although Mackintosh, unquestionably a creative genius, may have had a broader vision and applied the 'creative leap' beyond the narrower limits of the Macdonalds or MacNair, it may be argued that the sisters, especially Frances, and MacNair in the early days of 'the Four', were the 'actuating spirits' in 'The Spook School' work. Early critics acknowledged that it was the work of the 'sisters'—the main perpetrators—that 'controverted' all existing forms[5] and it has been documented elsewhere that Mackintosh's representations of women were portrayals of the more conventional 'female' icon (fig. 154).[6] Although the Macdonalds initially shared studio space and exhibited together, marriages—that of Frances to Herbert MacNair and of Margaret to Mackintosh—and the MacNairs' move to Liverpool, separated the sisters and their work evolved independently. One wonders what the two might have continued to produce had they not been separated at that time.

Frances Macdonald's work, both unconventional and unpopular, was as Howarth pointed out, an unusual statement for a woman of the 1890s.[7] We can see in one of her early symbolist watercolours, *Eve* (1896) (fig. 157),[8] a representation of woman-by-woman that is a departure from existing iconography of the 'Fall'. Eve (the feminine), clothed in a cocoon-like casing and sexually unavailable to the viewer sees no evil, there is no serpent, no apple, her hands are clasped protectively to her head while on a separate plane, Eve and Adam (the Yang or masculine) are merged into an androgynous unity (the self). Set on a spiral path, we see the transformation of Eve (the Yin or Great Mother or feminine principle) now separated from this union (the self or balance), as she is led by a devil-like figure (separation or lack of balance) backwards along the spiral toward another plane, casting a final rueful look behind. The work bears similarity to and may have been quoted by Gustav Klimt in one section of his mural design for the 1901–2 *Beethoven Frieze* (fig. 158) while it also has affinity with contemporary New Age 'transformation' art. We know that Klimt and the Secessionists were looking to Glasgow at this time[9] and it is possible that Macdonald's work may have been taken to Vienna by her sister Margaret Macdonald. All of 'the Four' had been invited to exhibit at the 'Vienna Secession Exhibition' of 1900, but the recent birth of their only child, Sylvan, is recorded as having prevented the MacNairs from travelling with the Mackintoshes to Austria, although they sent along some of their design work. This missed opportunity may have been an important loss to Frances Macdonald's career, for the two months stay in Vienna in close contact with Klimt and the Secession artists could possibly have further informed her work.

While continuing to exhibit with 'the Four', in important international exhibitions such as Turin in 1902, Frances Macdonald evolved her own symbolic content in her painting which was more personal, intense, and confrontational than any of 'the Four' but which she was unable to consistently sustain as Janice Helland demonstrates in the subsequent essay. From 1909 to 1915 her watercolour images of woman such as *Man Makes the Beads of Life; But Woman Must Thread Them* (c.1909–15) (fig. 162) or *'Tis A Long Path Which Wanders To Desire* (c.1909–15) (fig. 164) can be seen as directly related to both the reported domestic difficulties of the MacNairs' married life; the loss of Herbert MacNair's financial security and his alcohol dependence, but more importantly, directly to her experience of negotiating the conflicts and challenges of the turn-of-the-century 'feminine'. Macdonald's 'creative leap', her atypical representations of woman reflect a creative response to the obstacles she negotiated in an attempt to define herself as artist and to 'write her own history' as woman—which was a radical *Gestalt* at the time.[10]

fig. 156
Photograph of Frances Macdonald MacNair with Sylvan as an infant, c.1900. (Private Collection, Photo: Roger Billcliffe)

Along with Herbert MacNair (fig. 102), Frances Macdonald taught at the School of Architecture and Applied Art at University College during their time in Liverpool. After MacNair resigned, he taught at the independent Sandon Studios, but then suffered the loss of his inheritance. The artists returned to Glasgow c.1908. Their timing was unfortunate. The Glasgow Style, of which they had been so significant a part, was

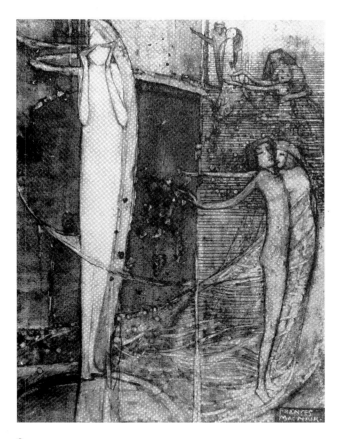

fig. 157
Eve, (untraced), Frances Macdonald, 1896, watercolour. (Photo: The Herbert Press)

in decline and no large architectural or interior commissions were forthcoming. Herbert MacNair had given up architecture as a profession, and although his early design work was innovative, it remained static while Mackintosh's had evolved. 'The Four' had never been popularly accepted in Glasgow although their design style was heralded abroad. Perhaps because it was socially unacceptable for wives to work to support their husbands, the Macdonald sisters, whose careers had diverged and merged with those of their respective spouses, never resumed their collaborative studio work although Frances taught design briefly in the Enamelling and Embroidery Departments at Glasgow School of Art from *c.*1908–11. The stress this set of circumstances placed on Frances Macdonald and Herbert MacNair's marriage was significant enough to warrant the Macdonald family sending Herbert MacNair across to Canada with a one-way fare. He returned to Glasgow and to Frances but was never recognised again, it is said, by the Macdonald family. Herbert MacNair himself deserves a comprehensive study, for despite his role as understudy to Mackintosh it seems clear that his early 'actuating spirit' may have played a key role in the genesis of the 'Scotto-Continental' Art Nouveau movement.[11]

fig. 158 *(below)*
The Beethoven Frieze, detail from *'Poetry' (Choir of the Angels of Paradise* and *This Kiss for the Whole World)*, Gustav Klimt, 1902, casein, gold leaf, semi-precious stones, mother of pearl, gypsum, charcoal, pastel and pencil on plaster, 216.0 × 981.0. (Österreichische Galerie, Vienna)

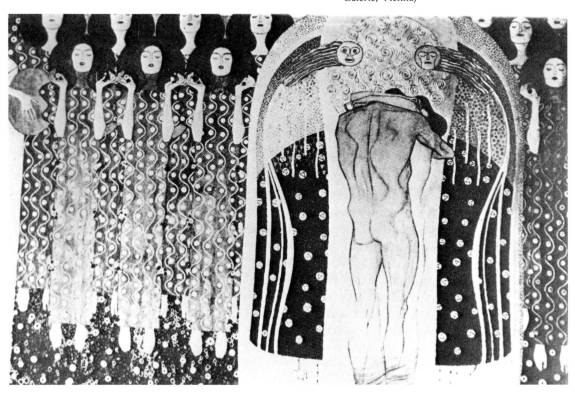

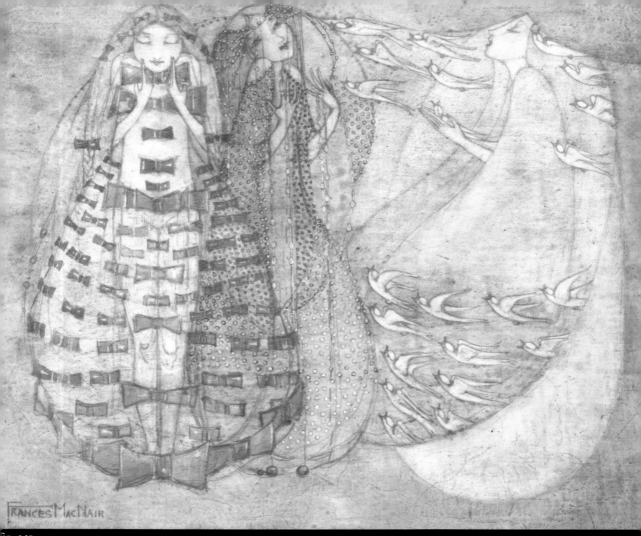

Fig. 159

Bows, Beads and Birds, Frances MacNair, n.d., watercolour, 30.0 × 35.0. (Private Collection, Photo: Sotheby's)

Undoubtedly one of the most gifted artists of the Glasgow Style era, with a talent that looked forward to modern representation, Frances Macdonald was also perhaps the most tragic figure from the perspective of woman's struggle to sustain a creative life in the face of marital, familial, and societal pressures. As one of the women closest to the centre of the Mackintosh circle her beaten metalwork, graphic designs and water-colours had been exhibited in Vienna, Turin, Liverpool

and London. While her earliest work challenged prevailing feminine iconography, leading critics to dismiss it for its lack of historical basis, today it is recognised as one of the earliest manifestations of the Glasgow Style in 'Scotto-Continental' Art Nouveau and one of few statements made by a 'New Woman' in a self-determined visual vocabulary. Her work had featured prominently in the important international art journals in *The Studio* and *The Yellow Book*, yet

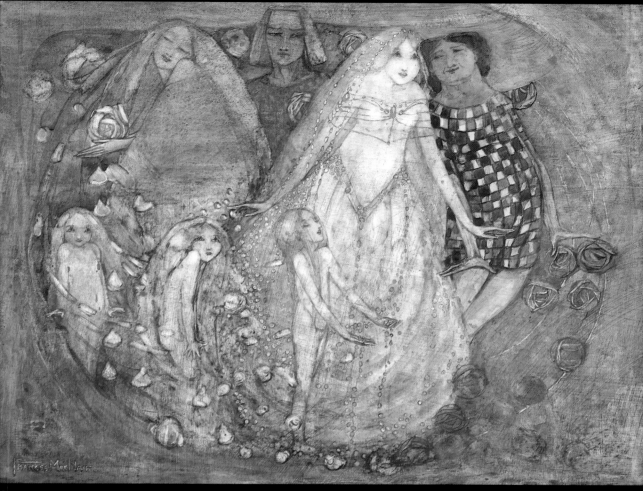

fig. 160
A Paradox, Frances Macdonald, *c*.1905, watercolour, 35.0 × 44.0. (Victor Arwas, London)

was largely forgotten even in Glasgow. Although a retrospective exhibition of her sister Margaret's work was presented by the Hunterian Museum, University of Glasgow, in 1983, Frances Macdonald's work was only marginally included. The reason may be that after her untimely death in 1921 at the age of forty-seven, reportedly of a cerebral haemorrhage, although allegedly having taken her own life, Herbert MacNair destroyed most of her work as well as his own. The little work of Macdonald's that does survive shows a talent that never, perhaps, reached its full potential and was, of all the 'Glasgow Girls', the strongest commentary on the conflicts to be negotiated as a woman in the arts at the turn of the century—a conflict to be more fully examined in the following essay.

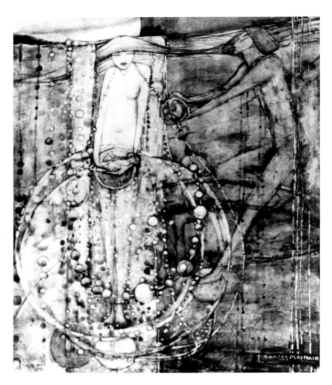

GENDER AND OPPOSITION IN THE ART OF FRANCES MACDONALD

by Janice Helland

In July 1908 the London Salon of the Allied Artists' Association opened the doors on its first exhibition. The foreword to the catalogue announced a 'new art society' with its primary objective to permit artists '. . . to submit their work freely to the judgment of the public.' The Association, unlike the Academy, accorded: '. . . the same treatment to all artists, irrespective of their positions and their reputations.' Anyone who made application prior to 1st June, 1908 was accepted; up to five works would be hung.[12] Frances Macdonald MacNair sent five paintings to the 'new art society'. This was not the first time she had exhibited with new associations that propounded a break with tradition. She exhibited with that most British of secessionist organisations, the International Society of Painters, Sculptors, and Gravers in 1899, with the Vienna Secession artists in 1900 and with the Sandon Society of Artists in Liverpool after 1905 when they set up independently of the University.[13]

This pattern of involvement with independent organisations, with the new and innovative, began when Macdonald was a student at Glasgow School of Art. Even as a student, her work commanded attention and criticism for its eccentricities, as discussed in 'The Spook School' (Chapter 3). Her unusual treatment of the female form elicited vitriolic responses from the Glasgow public.[14] A Glasgow critic wrote about her 'weird designs' with their 'impossible forms, lurid colour and symbolism;'[15] another considered the work, 'fearfully, wonderfully and weirdly "new".'[16] Although there are no catalogues for the student exhibitions held annually at the School (Chapter 3), it

was probably watercolour drawings like Macdonald's *A Pond* (1894) (fig. 95) and *The Fountain* (1894) (fig. 155) that attracted such attention.[17]

Macdonald's posters also attracted adverse attention, while being recognised as innovative and exciting. At the School of Art, Fra Newbery encouraged the making of posters which, at the time, were controversial. In an 1895 interview Newbery defended poster-making, stating: 'The possibilities of the poster are great. Our early efforts . . . met with a shower of adverse criticism. We expected that, and we're not cast down.'[18] Indeed, by this time, Macdonald's posters were considered accomplished and advanced. For example, when exhibited early in the year at La Société des Beaux Arts, a critic commented that, '. . . the Misses Macdonald [are] the only "new" poster designers who have yet arisen in Glasgow, and [their] rather weird adaptation of the human form to decorative purposes at the recent exhibition of the School of Art will be remembered.'[19]

Shortly after this, two of Frances Macdonald's paintings appeared in the controversial London publication, *The Yellow Book*, July 1896: *Girl in the East Wind with Ravens Passing the Moon* or *(Ill Omen)*, (1893) (fig. 153), and *The Sleeping Princess*, (c.1895–6)

fig. 161
Frances Macdonald with her son, Sylvan MacNair, c.1904. (Private Collection, Photo: Roger Billcliffe)

fig. 162
Man Makes The Beads of Life But Woman Must Thread Them, Frances Macdonald, c.1915, watercolour, 34.3 × 29.2. (Private Collection, Photo: Hunterian Art Gallery)

(fig. 163). That year when *Ill Omen* hung in the annual 'Autumn Exhibition of Modern Art' at the Walker Art Gallery in Liverpool,[20] it was called a 'Yellow Book Madness'; its artist was labelled 'decadent'.[21] Certainly, Macdonald's 'decadent' combination of greens, mauves and blues conveys a pervasive sense of aloofness, coolness and distance. Her female figure enhances this mood with her own self-containment. She is elongated; her hands stretch down past her hips and cross in front of her pubic area; her facial features are heavy and powerful; she is closed off. This strong, independent woman is unavailable to the voyeuristic viewer and although she does not remain a feature of Macdonald's work, woman as subject is her consistent theme. The non-compliant female disappeared from Macdonald's art, but she, as an artist, consistently showed with innovative, slightly rebellious exhibiting organisations.[22] Even her early success in the 'Arts and Crafts Exhibition' of 1896, in the form of coverage in a major art journal, *The Studio*, came at a time when the Arts and Crafts movement itself was still somewhat suspicious.[23] Review articles focused on the art rather than the craft;[24] they also '. . . aimed at presenting the stronger-flavoured specimens of work of the better-known men.'[25] Given the emphasis put upon the well-known artists in the large exhibition, unknowns were fortunate to receive any attention at all. In addition to the laudatory review Gleeson White gave the Macdonald sisters, it was quite likely that, although not named in the article, it was her jointly produced *Clock in Beaten Silver* (1896) that was given special attention by a reviewer in *The Artist*.[26]

If Macdonald was in the company of 'better-known men' when she exhibited with the Arts and Crafts Society, she was that and more when she exhibited with the 'International Society of Painters, Sculptors and Gravers'. Members of ISPSG included J.M. Whistler and John Lavery;[27] 1898 exhibitors included 'the most anti-Academical names', Manet, Degas, Hans Thoma and Puvis de Chavannes.[28] The Society held its first council meeting in December 1897 and opened its first exhibition in 1898. In 'the chronic revolt against the Academy', the new Society was seen as 'an insurrection in force', one that might even be using its first exhibition as a celebration of the 'jubilee of '48— that year of revolution.'[29] A large contingent of Scottish artists, all painters, were invited to exhibit in the 'jubilee of '48': David Gauld, D.Y. Cameron, A. Roche, G. Henry and E. Hornel.[30] Francis Newbery, Macdonald's friend and teacher, was on the list of Guarantors for the 1899 exhibition. Macdonald's own painting, *Spring* (1897) appeared in the second exhibition of the ISPSG and, although it hung in this 'Secessionist' exhibition, conservative critics considered it more acceptable than her earlier work.[31] The London correspondent for the *Glasgow Evening News* wrote:

> . . . among the prints and drawings [there are] a
> number by the Misses Macdonald, C.K. [sic]

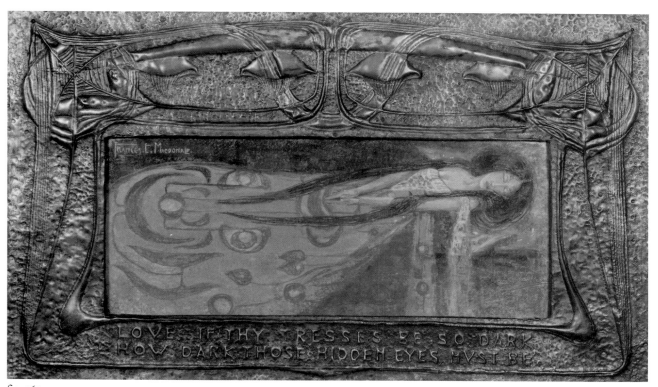

fig. 163
The Sleeping Princess, Frances Macdonald, 1895–6, illustration for *The Yellow Book*, July 1896, pastel, 19.0 × 46.4. (Glasgow Museums and Art Galleries)

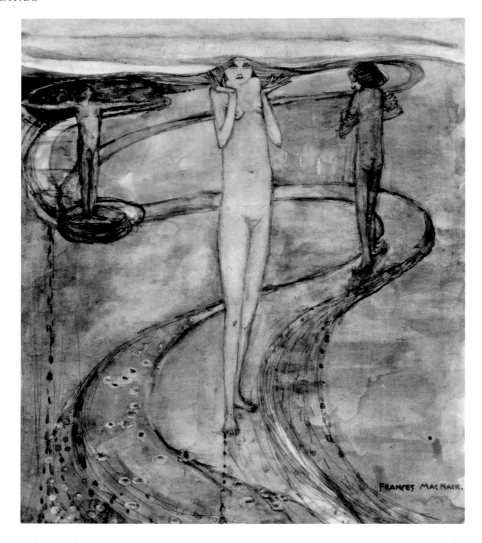

Mackintosh and Herbert MacNair, which quartette, if I mistake not, were responsible for such extraordinary poster work on the Glasgow hoardings. The pictures of each of them [Margaret and Frances Macdonald] represent a vast improvement on anything I have previously seen of theirs. The desire to startle for startling's sake has passed away, and they now produce honest mature work of which *The Rose Garden* (Margaret Macdonald) and *Spring* (Frances Macdonald) may be taken as types.[32]

If startling for startling's sake had passed away, the tendency to exhibit with Secessionists continued. After the '1900 Vienna Secession' and in the '1902 Turin Exhibition' Macdonald's associations became more exclusively Liverpool based, first with the Sandon Studio and next with the London Salon.[33] Both of these, as exhibiting organisations, were more radical than her previous choices. For example, Sandon '. . . organised in a sort of revolt . . . when the University School was absorbed by the Municipal School [was] virtuously progressive.'[34] Macdonald

exhibited four paintings in the 'Exhibition of Modern Art' organised by the Sandon Society of Artists in 1908.[35] Her 'fantastic compositions', wrote one critic, were 'in a very different vein.' Macdonald's *A Panel* (*c.*1908) and *Sleep* (*c.*1908), he continued, 'are quite beautiful inventions, with a musical rhythm of line and colour, and there is charm too, in her eerie and quaint *Waves Kissing the Faces of the Rocks.*' (*c.*1908)[36] A second critic wrote that her art was a 'symbolic study'.[37] The London Salon opened its doors soon after the Sandon exhibition closed. The Salon was radical and independent: 'As opposed to all other existing art societies in this country, the Association is based upon co-operation instead of competition.'[38] Macdonald added two new paintings to the London show, *The Rose* (1908) and *The Birth of the Rose* (1908). *The Birth of the Rose*, also called *The Sleeping Princess*,[39] is one of Macdonald's images of sleeping women, which have generally been relegated to 'fairy-tale status'.[40] For

fig. 164
'Tis A Long Path Which Wanders to Desire, Frances Macdonald, 1909–15, watercolour and pencil on vellum, 35.2 × 30.1. (Private Collection, Photo: Hunterian Art Gallery)

example, recent research refers to Macdonald's 1895 *The Sleeping Princess* (fig. 163) as a '. . . fairy tale of the sleeping beauty . . . seen as symbolic of woman in her virginal state of sleep—her state of suspended animation and, as it were, death-in-life.' The somnolent death-in-life interpretation continues as *Sleeping Princess* becomes Ophelia: '. . . this princess seems to be floating in a watery grave rather than to be merely sleeping.'[41] However, one must consider the frame, designed and executed by Macdonald, part of this picture and, on it, is a spider's web. The 'princess' is not in a watery grave like Ophelia, but in a deep sleep like Sleeping Beauty. When Macdonald placed her female figure in water, for example in *The Birth of the Rose*, the woman is care-worn rather than in a 'virginal state of sleep'. She has given birth; the child sits on her stomach. She looks drawn and tired; she is not a fairy-tale subject.[42]

Given the explorations of recent feminist thought, particularly among French feminists such as Hélène Cixous, entirely new meanings of Macdonald's art could be constructed.[43] Cixous, as well as other French theorists, write about the female experience and its multiplicities. She suggests that woman's psychology and woman's body do not conform to the oppositions with which we are familiar: submissive/dominant, inferior/superior, passive/active. Cixous claims that, in addition to women being unable to function within these rational categories, the oppositions are always 'against woman'.[44] Often when analysing Macdonald's art we are thrown back upon these oppositions: she created non-conformist art, then she created fairy-tale art; she was castigated as 'weirdly "new",' then credited with 'quite beautiful inventions'; she was too eerie, then too mysterious. She is inconsistent.

Art like this requires fresh views and new insights. Traditional patriarchal discourse fails to illuminate multiplicities of meanings in female art. The relegation to the realm of fairy-tale has effectively removed Macdonald's work from the mainstream (not that it ever constituted part of the dominant discourse) and given her art second, if not third, rate status in the established art historical hierarchy.

Certainly, Macdonald's last paintings that were not exhibited, *'Tis a Long Path Which Wanders to Desire*, (*c*.1909–15) (fig. 164) and *Man Makes the Beads of Life But Woman Must Thread Them*, (*c*.1909–15) (fig. 162) reveal an insight into woman's psychology, woman's role and woman's place in society. If we combine Macdonald's commitment to exhibiting with non-mainstream organisations with an analysis of her work that incorporates feminist theory, a fresh view of her art emerges. She can be seen as painting the female experience in its many forms. For example, *Girl in the East Wind* is powerful, self-contained and independent; 'Princess' in *The Prince and the Sleeping Princess*, (*c*.1895) is in relation to a male Other;[45] the young woman in *'Tis a Long Path Which Wanders to Desire*,

stands naked, exposed and indecisive, between two other figures, one male, the other ambiguously sexed; her 'pond women' in *A Pond*, are shrill and aggressive; her mother, in *Birth of the Rose*, is mature and weary.

Macdonald's paintings posit many different women and suggest that women have many different voices. Discussed within such a context—a context that includes the location of women in society at the time Macdonald was painting—clarifies her images for the viewer. Her women are sometimes closed off, sometimes available and sometimes ambivalent. During the 1890s and the first decade of the twentieth century, most European women were silent. Ambivalence and silence can be seen in Macdonald's painting and in order to obtain a clear understanding of it we must abandon hierarchical art historical thought and begin to rely more extensively upon less rigid structures. Static closures[46] must be replaced by more flexible organisations that allow an artist and a viewer to move and change, to analyse images, not fixed, but changing. Macdonald's turning 'away from the eerie world of "The Spook School" to paint fairy-tale scenes', or her painting of 'mysterious works given philosophical titles,'[47] are much better understood within the process of feminist theory.[48] She painted woman and woman's experience—it is within the gender issue that her work must be discussed.

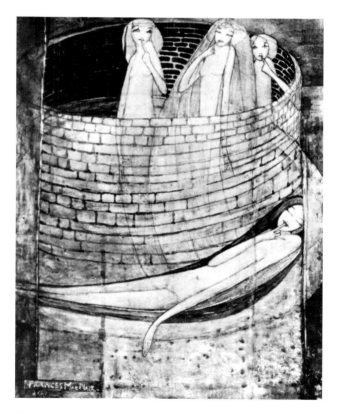

fig. 165
Truth Lies At The Bottom Of A Well, Frances Macdonald, watercolour, 35.5 × 28.6. (Private Collection, Photo: Hunterian Art Gallery)

fig. 166
Portrait of Jessie M. King, *c.*1920, shown in her trademark attire of wide brimmed black hat with a batik scarf designed and made by herself. (National Portrait Gallery)

fig. 167 *(above opposite)*
Album von Dresden und Sachische Schweitz, Jessie M. King, 1899, bookcover, 27.5 × 35.0. (Coll: Barclay Lennie Fine Art Ltd. Photo: Glasgow Museums and Art Galleries)

fig. 168 *(below opposite)*
Neugealtach, bookplate for E.A. Taylor, Jessie M. King, *c.*1900, pen and ink heightened with silver on vellum, 14.5 × 6.5. (Coll: Barclay Lennie Fine Art Ltd. Photo: Glasgow Museums and Art Galleries)

JESSIE M. KING (1875–1949)

by Jude Burkhauser

One of the most individual and successful Glasgow Style designers in her lifetime, Jessie Marion King (fig. 166), had a long and productive professional career. The body of work she has left in a wide-ranging, rich and varied *ouevre* is astonishing. King was the daughter of Mary Ann Anderson and the Revd James W. King of New Kilpatrick parish (now Bearsden). Although her father tried to discourage her from art, she maintained her 'child-like' vision throughout a prolific career as book illustrator and designer of Glasgow Style jewellery, ceramics, interiors and textiles. As a student she was encouraged by Fra Newbery to maintain her style of drawing. She stated that she saw her imaginative pictures vividly with her 'internal eye' before setting pen to paper.[1] In a handwritten lecture on design which was to be delivered to the women of the Rural Institute on a tour of Arran, King wrote of her strong belief in following one's individual vision rather than copying. In asking the women, 'Why not draw out of our head?' she related an anecdote about a foreign visitor to one of her first exhibitions whose design theory was based on literal translation of plant forms:

> One Frenchman who came to Glasgow School of Art said: 'I hate her work—she draws things God Almighty never made! She puts tulips on chrysanthemum leaves and makes chrysanthemums have tulip leaves—I hate her work. But it fascinates me!'[2]

Remembering the strength of will it often takes to maintain one's own course despite what others think she said: 'I also remember falling foul of a design master because I would not copy designs . . . but insisted on drawing out of my head.'[3] During these early art school days, Jessie M. King and Helen 'Nell' Paxton Brown, who would become a noted Glasgow Style embroiderer, were closest friends and the pair shared a studio at the top of 141 Bath Street adjacent to fellow artist Ernest Archibald Taylor, who was King's future husband. From about 1903 to 1906 the two women were part of a circle of friends, most of whom would become long-time tutors in the decorative arts studios at the School, which included De Courcy Lewthwaite Dewar, Dorothy and Olive Carleton Smyth, Ann Macbeth, Agnes Raeburn and her sister Lucy Raeburn. Dewar writes, in letters to her parents, of King's preparations for her exhibition in Berlin, of her sometimes unsettling relationship with E.A. Taylor; of her bout with appendicitis; of her growing success as an illustrator (fig. 167), and of her working visit to Kirkcudbright in 1903. King eventually bought property in Kirkcudbright, the artists' 'colony' in the south of Scotland, and Dewar documents her involve-

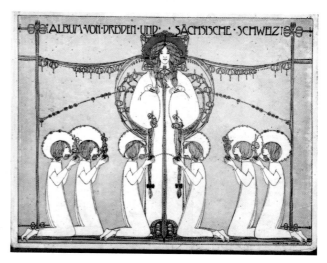

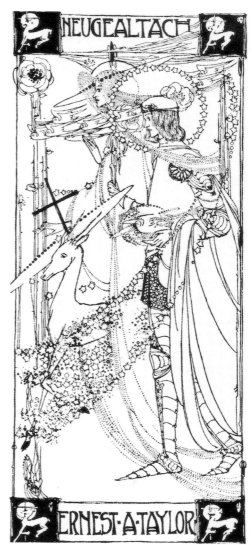

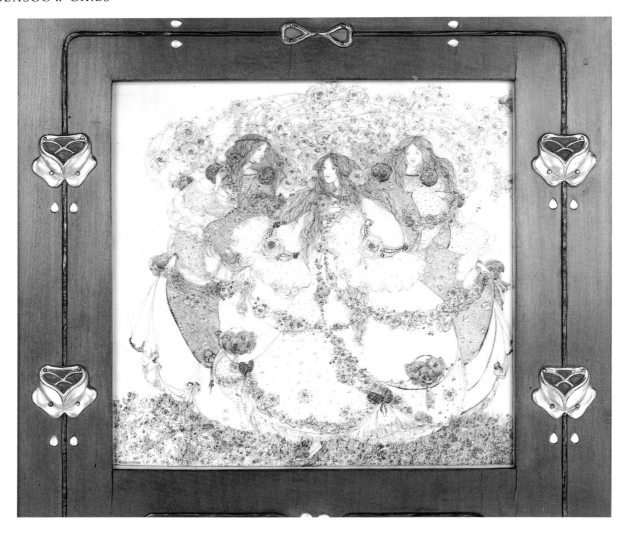

fig. 169
Detail of screen with pen and ink inset drawing, *Princess of the Red Rose*, Jessie M. King, 1902. (Glasgow Museums and Art Galleries)

ment with one of the resident Glasgow Boys saying: 'Jessie has got to know the famous artist Hornel, who stays in Kirkcudbright, although he is looked upon as one of the Glasgow School of Painters.'[4]

Over the years the young women taught classes together at the School of Art, made frequent studio visits, sketched each other in their masque costumes, travelled to the country on sketching excursions together, visited Milton of Campsie where King stayed for a time with her devoted lifelong companion Mary McNab and shared the inimitable 'tea' at Miss Cranston's Room de Luxe. Dewar records their day-to-day interaction and shows us the close-knit relationship of the group:

All yesterday forenoon I was cutting out dresses [for the masques], & had lunch in Miss Cranston's with Nell [Helen Paxton Brown] & Dorothy [Carleton Smyth] who had been busy in the same way. Then I took my books up to Jessie's studio & got her to put her valued autograph on them, which you will note on the frontispiece of your copy.[5]

Although her earliest success and major focus was book design and illustration, King also wrote books, and designed exquisitely wrought silver and jewellery for Liberty and Co's 'Cymric' line, in addition to wallpaper, fabrics, posters, bookplates (fig. 172), and costumes for the many masques. Her long and successful commercial career began in 1899 when Newbery's contact, Georg Wertheim, whose family owned a large department store in Berlin, commissioned her to design a range of items in the 'new Scottish Style.'[6] King's earliest designs for book-covers such as *Album von Dresden* (fig. 167) were done in characteristic 'wirework style' with pronounced attenuation of figures not found in her later work. As noted by Howarth, this work bears little resemblance to 'The Spook School' designs of 'the Four' yet does share distinctive motifs and linear affinities with the Glasgow Style as a whole. In meticulous and intricately designed

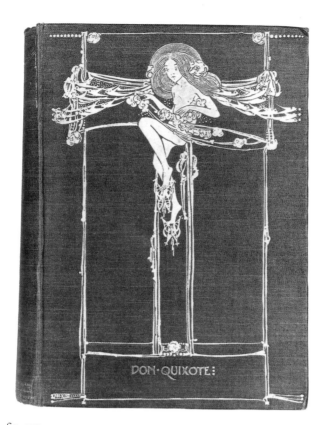

fig. 170
Don Quixote bookcover, Jessie M. King, 1905. (Coll: Brian and Liz McKelvie. Photo: Glasgow Museums and Art Galleries)

pen and ink drawings (fig. 169) King employed a nib pen with ink on vellum (animal skin), a material frequently used in the middle ages for illumination work. This so called 'fantasy' work was often illustrated in *The Studio* which helped to spread King's name abroad. Her accomplishment in book-cover design was recognised when she won a gold medal in the 'International Exhibition of Decorative Arts in Turin' in 1902 for the book *L'Evangile de l'Enfance (c.*1900).

King taught book illustration and ceramic decoration in Newbery's Decorative Art Studios until her marriage to E.A. Taylor in 1908. In a somewhat unusual fashion for that era, Jessie M. King retained her maiden name after her marriage, no doubt because she had successfully established her career internationally through exhibitions in India, Germany, and Italy by that time. In 1910 King and Taylor moved to France where he was appointed professor in the Studio School of Drawing and Painting with Tudor Hart in Paris. Once settled, they ran the Shealing Atelier, a studio gallery for fine and applied art, up to the outbreak of the First World War. While there, King continued to illustrate books but was significantly influenced by the innovative colour and design work of Leon Bakst whose costumes for the Ballet Russes were creating an international sensation. Formed in 1909, the Ballet Russes had commissioned a number of artists and

designers including Nicholas Roerich and Bakst to design costumes for their debut that year in Paris. Audiences were dazzled by the colour and splendour of Bakst's exotic designs for *Sleeping Beauty* followed by *Cléopâtre* and *Schéhérazade* and he was soon hailed internationally. Their influence on the aesthetics of Europe at that time is epitomised in the change it effected on the work of the young King. Bakst's 'orgiastic', 'voluptuous' and 'brilliant' use of colour and his 'painter's' approach to the creation of harmonious ensembles of thematic costume and decoration helped to change the course of modern theatre design and created a ripple effect in many areas including book illustration and textile design.[7] Jessie M. King's exposure to Bakst is reflected in her work where we see her style change from 'linear fantasy' to a broader line with brightly coloured washes.

Through Frank Zimmerer, an American she met in Paris, with whom she worked in the atelier, King experimented with batik, a wax-resist technique then new to Britain. From this time she continued to work in the medium, applying it to curtains and clothing (fig. 175), and wrote and illustrated a 'how-to' book on the subject entitled *How Cinderella Was Able to Go to the Ball*. Although based in Paris, King and Taylor also spent time on the Isle of Arran where they ran a summer sketching school, which attracted participants from throughout Europe and other continents. When the First World War forced their return from France to Scotland, the pair settled in the village of Kirkcudbright, reported to be 'the most artistic town in the United Kingdom.'[8] The artists lived together at the 'Green Gate Close' until King's death in 1949.

Kirkcudbright, especially the 'Green Gate Close', became an important centre for women artists. So strong was their artistic presence in the 'close' that a writer for the *Glasgow Evening News* reported that it was the 'centre of the women artists' coterie,' noting that: 'Artists and art lovers of all sorts find their way to the Green Gate, and . . . it is here . . . in the Close women artists have settled down or come as birds of passage with the spring and summer.'[9] Jessie M. King was recognised as a source of inspiration for the others. She maintained a studio in the close where she painted her ceramics, although she kept a separate large studio perched on a roof near the harbour where she worked and for a number of years also maintained the atelier in Paris. During the years in Kirkcudbright, King continued her successful career as illustrator, *par excellence*, in pen and ink and wash, produced linear pieces that were an evolution of her early 'fantasy' style, and worked both by herself and in collaboration with Taylor on furniture and interior design. In addition, she expanded the range of media, subject-matter, and style in which she worked, increasing her use of batik, and producing a series of bold and vividly coloured landscapes in oil and watercolour. Her first exhibition of this new departure took place in Glasgow

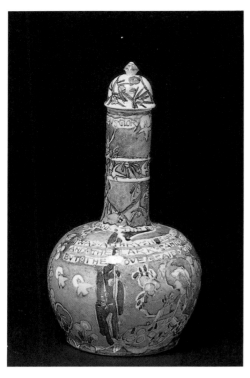

fig. 171
Vase and cover, Jessie M. King, c.1905, earthenware painted with words and decorations of the first verse of *One Morning, Oh so early!* by Jean Ingelow (1820–1897). (Glasgow Museums and Art Galleries)

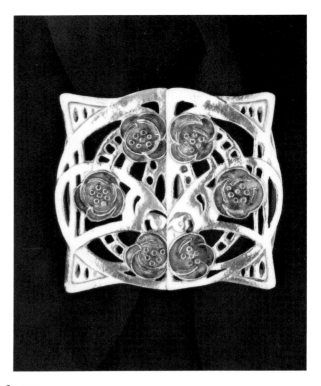

fig. 172
Waist buckles, Jessie M. King, c.1907, silver and enamel with stylised birds and flowers, hallmarked Liberty & Co., Birmingham. (Glasgow Museums and Art Galleries)

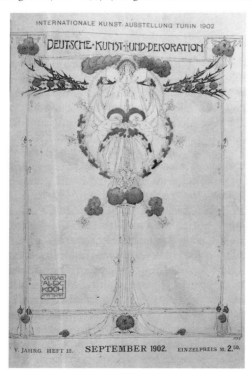

fig. 173
Cover for *Deutsche Kunst und Dekoration*, September 1902, designed by Jessie M. King. Glasgow Style work by King and other women was featured on the covers of the most prestigious international art journals of the day.

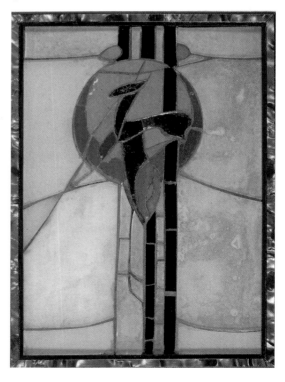

fig. 174
The Enchanted Faun, Jessie M. King, a lead, mirror and stained glass mosaic panel, 1904, 23.0 × 17.0. (Coll: Barclay Lennie Fine Art Ltd. Photo: Glasgow Museums and Art Galleries)

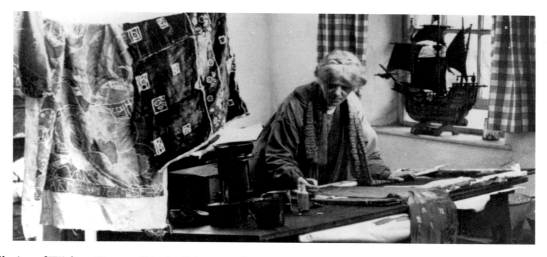

at the galleries of Wishart Brown (Limited) in 1927. In a contemporary interview King referred to the brightly coloured works as her 'strong drink', ascribing their strong colour and bold execution to the effects of working directly from nature. There is great looseness and freedom of application in these paintings attributed by the artist to her 'short-sightedness' and the fact that when she sketched from nature she saw 'broad outlines and broad colour.' King explained that the rapidity required in working outdoors from the motif produced a very different effect from her 'fantasy' pieces, the carefully rendered pen and ink and watercolour drawings she produced in her studio. This work was not well received by critics when first exhibited, as it was such a departure from the well accepted notions of her style and it was said 'her flamboyant colours were extremely distasteful to many people.'[10] In a later installation of adventurously coloured furniture, for example, King showed a bright green bed with an orange rabbit painted at either end!

Throughout her life, Jessie M. King was an individualist who set her own course. Her special affinity for children was demonstrated in more than seventy books and in her fantastic watercolours and drawings. In addition to the smaller scale commissions she received throughout her life, in 1927 King and Taylor worked on a commission of large-scale brightly coloured murals for the Lanarkshire Education Authorities (Scotland) in Drumpark and Larkhall schools. This was the 'first time the experiment had been tried in this country.'[11] This forward-thinking and innovative expenditure by the local authorities on original art for school classrooms prompted some angry comments from ratepayers who opposed the new schemes and had clearly defined opinions on what were suitable areas of study for a girl.

Sir,—I cordially endorse the letter from 'Ratepayer' which appeared in your issue of yesterday. Instead of attempting to economise, the Lanarkshire Education Authority seem to go out of their way to devise new schemes for spending the ratepayers' money. Is 'art' going to give bread and butter to those who are expected to admire the colour scheme of a classroom! I was surprised to learn from the mother of a girl of thirteen, who is attending a Higher Grade school in the area administered by the Lanarkshire Education Authority, that she does not get a single lesson in sewing or cooking. The girl in question is normal in every way. Surely instruction in these fundamental domestic duties will do more good than spending money on 'art' on school room walls.—I am, etc. . . . [Signed] Ratepayer No. 2.[12]

This must have been an important issue for Jessie M. King, who kept the clipping, as her earliest efforts at drawing had to be hidden from a disapproving father. Her personal papers are full of quotes on the value of art and on individualism. Her sketchbooks and notebooks contain lectures prepared for the Scottish Women's Rural Institutes stressing the importance of fostering and maintaining one's creative vision and on the value of art as a profession for women.[13] King was dedicated to spreading an understanding of her values wherever and whenever an occasion presented itself whether in serendipitous exchanges with village children who saw her as a 'friendly witch' in her black hat and cape and silver buckle shoes, or in lectures to the women of the Rural Institutes, or via her many professional associations.

As Jessie M. King's illustrations demonstrate, she had a deep love and respect for nature and as a young woman she had a psychic experience that influenced her work. When lying in the grass in a field one summer, she felt a pricking sensation on her eyelids. King maintained and wrote in one of her red school notebooks that she believed she had been 'chosen' by the fairies to communicate their world to others.[14] King believed there was in nature an abiding presence that she portrayed in her illustrations such as *Kilmeny*

fig. 175
Jessie M. King at work in her batik studio in Kirkcudbright 1934. (Photo: Barclay Lennie Fine Art Ltd)

by James Hogg (1911) and *At the Gate of the House of Dreams* (*c.*1909) or the much later watercolour *Magic* (*c.*1937). Writing of this affinity for the 'fantastic' in King's work a reviewer noted that: 'Some of the recent drawings look as though her gift of sight were bringing her farther on her own way. They are more expressive of a real possession of vision in life than anything by her that I remember to have seen.'[15]

King found she was able to visualise clearly with her 'third eye' and developed a 'magico-mystical' base to her artwork. This spiritual approach to art was one both King and Taylor shared and in a lecture Taylor gave to the Royal Glasgow Institute of the Fine Arts at Kelvingrove Art Gallery, he stressed the importance of the 'inward eye in art' and said that 'he hoped the modern artist would never forget the necessity of spirituality in his work.'[16] In the Rural Institute lecture mentioned earlier, King spoke of her design 'vision':

I, personally, see all my designs at the back of my head—at the right side—and I remember once falling down a flight of stairs (not at the New Year!) and hitting the back of my head on a step and the first thing I did when I recovered was to rush upstairs to my studio and draw a design to see

if the bump had upset my . . . vision. This is the same visualising which makes one see halos or auras round people's heads—this may not be very universal but it exists.[17]

This inner vision and spiritual approach was the mainstay of King's entire career in art and design and was reflected in practically everything she produced from her early illustrations of *Siddhartha* (1898) for *The Light of Asia* to the final years in Kirkcudbright filled with freely executed renderings of figures in woodland or underwater scenes encountering 'visions' of the 'wee folk', sprites, mermaids or anthropomorphic beings. There was, in every work, an appeal to the viewer to pay attention to detail in life, to look more closely at 'what the road passes by' and to suspend one's disbelief in the miraculous, if only momentarily.

Jessie M. King's 'fantastic' world did not end at the edge of the canvas or the border of the page, it was also reflected in textile hangings such as *Morgiana* (1939) (fig. 177), and in her painted ceramic work, done primarily in the latter years of her life, which was

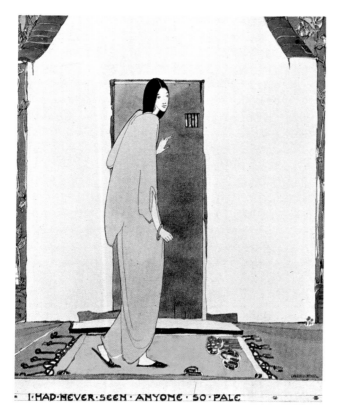

fig. 176
I had never seen anyone so pale, Jessie M. King, illustration for *A House of Pomegranates* by Oscar Wilde, 1915, 25.8 × 19.5. (Coll: Barclay Lennie Fine Art Ltd. Photo: Glasgow Museums and Art Galleries)

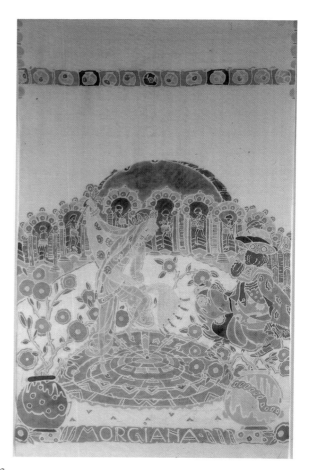

fig. 177
Morgiana, Jessie M. King, *c.*1920s, batik on silk wall hanging, 137.5 × 80.0. (Coll: Barclay Lennie Fine Art Ltd. Photo: Glasgow Museums and Art Galleries)

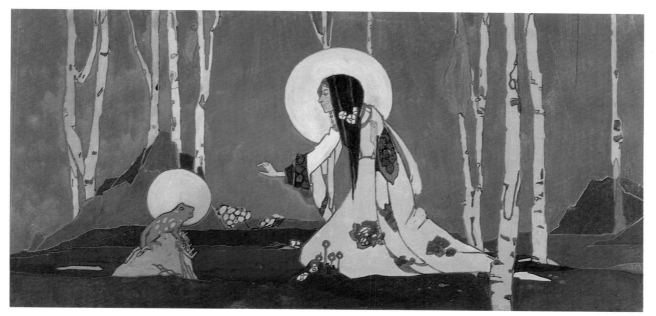

the simple bright decoration of pre-made ware by Minton's or other factories. She signed the vases, tea pots, cups and plates she produced with the characteristic symbol of 'Green Gate Close' and sold them to tourists at Paul Jones' Tea-rooms in Kirkcudbright for which she had designed the interior. King's propensity for 'life as art' in Kirkcudbright was demonstrated not only in decoration of tableware and tea-room interiors but also in her changing decoration of the steps of the 'Green Gate Close' with painted designs.

While opportunities for women in architecture and interior design were limited, King was one of the few women from this period to involve herself with interiors to any scale. In addition to her Kirkcudbright tea-room interior she also designed a fireplace surround, stained glass windows for interiors, and had been commissioned to design a nursery room which was done for the Musée Galliera Exposition de l'Art pour l'Enfance, c.1912. In this design for a child's room, with the *Gesamtkunstwerk* ethic evident in the design of even the toys and with King's typical attention to detail united with uniformity of vision, we find her strongest interior scheme. The panel insets are well designed and each individually and brightly painted, as in the case of *The Frog Prince* (c.1913) (fig. 178), employing the less conventional use of a strong 'blue and green' typical of King's Glasgow-bred disregard for conventional colour concepts. King's design for the child's rocking horse, *Brightling*, and for the doll's house display the organic but restrained curves found in Mackintosh's Glasgow School of Art building design. The toys and doll's house were probably prototypes but it was not until the 1940s that King began designing children's furniture and toys, which she considered manufacturing in collaboration with Dumfries artist, J.G. Jeffs.[18] She designed several rabbits and a doll's house over a canal taken from her book *The Little*

White Town of Never Weary (1917). One of King's only other recorded interior schemes was done in collaboration with her oldest friend Helen 'Nell' Paxton Brown in the 1930s. The two artists exhibited an interior for three rooms in an installation entitled *Spring in Three Rooms* at the Glasgow Society of Lady Artists' Club. King and Brown attempted unsuccessfully to wake up the sombre taste of their contemporaries with three galleries transformed by employing colour drawn from art deco influence.

Jessie M. King, individualist, worked in a distinctive manner throughout her long and prolific career. A recent monograph on her is the first and only to date which attempts full documentation of the life and work of any woman who contributed to the Glasgow Style. It is a commentary on the fickleness of the art market as well as verification of the changing perception of women in design, that in a Sotheby's sale at Queen's Cross, Glasgow (1977) from the collection of their only daughter Merle, King's work commanded more attention than that of her husband. Her legacy—a 'fantastic world' created in the body of her collected works and in the example of her life in all of its originality and unconventionality—are gifts only now regaining the recognition they deserve. Although her work was illustrated on the cover of the important international journal *Deutsche Kunst und Dekoration* in 1902, the same year she achieved international recognition at the 'Turin International Exhibition' with her gold medal book-cover from a competitive field that included most of the major international figures in decorative art at the time, King's work was largely forgotten along with that of her female contemporaries.

fig. 178
The Frog Prince, Jessie M. King, 1913, oil on panel in white painted frame, 35.5 × 67.7. From a child's room designed for the Musée Galliera Exposition de l'Art pour l'Enfance, Paris. (Coll: Barclay Lennie Fine Art Ltd. Photo: Glasgow Museums and Art Galleries)

ANNIE FRENCH (1872–1965)

by Louise Annand

Annie French (fig. 179) best known for her black and white illustration work, followed Jessie M. King and the Mackintosh group of designers at the Glasgow School of Art, where she became a tutor. French did not have to struggle to go to art school; her father, she once said, would have liked all his children to be artists. He had seven, and three had attended schools of art before her. Writing in her letters of her earliest memories of art she recalled that she and her brother Jamie made paint brushes from matchsticks and then: '. . . cut off tufts of Jamie's hair . . . later I fell heir to Lyle's paint box.'[1]

French's father was a metallurgist who had to travel—and move his family about—as he found work. This family attitude of acceptance toward her early aspirations in art is as important as the attitude of Newbery toward his women students. Before the development of the modern art schools, a painter was apprenticed or simply learned from others, and unless there were painters in the family, girls were not likely to be taught. Watercolour sketching was an admirable accomplishment—Queen Victoria was in fact good at it—but earning a living would be something else.

French was presumably encouraged by Newbery to pursue her own style, as Jessie M. King was, and there is some similarity in their preference for line drawing, and for 'romantic' figures and subjects, but Annie French was to stick firmly to this one mode of expression throughout her life, rather than to expand her range as King did, perhaps because her supportive family left her free of the pressure to earn, which partly accounts for the greater variety of Jessie M. King's output.

The Studio magazine, which appeared from 1893 on, carried reviews as well as articles. It paid attention to the Glasgow School of Art Club exhibitions and picked out exhibitors in galleries in London and elsewhere. French received her share of commendation in this influential journal. There was perhaps a tendency to perceive that what she was doing was suitable for a

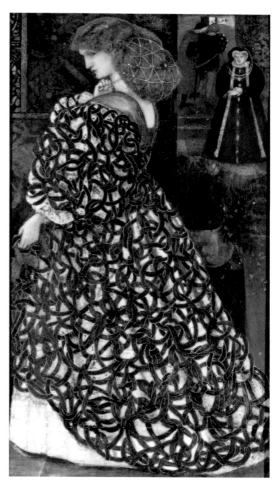

fig. 179 *(opposite)*
Annie French, c. 1900. (Glasgow Museums and Art Galleries)

fig. 180 *(opposite inset)*
Daisy Chain, Annie French, 1906, black ink drawing, 18.2 × 37.3. (Coll: Victoria & Albert Museum, London. Photo: *The Studio*)

fig. 181 *(above right)*
The Picture Book, Annie French, illustrated in *The Studio*, 14th July, 1906, Vol. 38, No. 160, black and white, 14.8 × 13.5.

fig. 182 *(right)*
Sidonia von Bork, Edward Burne-Jones, 1860, watercolour with bodycolour, 33.0 × 17.1. Less sinister in content than Beardsley or Burne-Jones' Sidonia, French's working style was similar to both. (Tate Gallery, London)

fig. 183
The Plumed Hat, Annie French, *c.*1900, pen, sepia and black ink with watercolour, 20.0 × 12.7. Possibly a greeting card design this work has affinity with Beardsley's bookplate for *Olive Custance* in its use of stippling. (Coll: Jacqueline McColl. Photo: Sotheby's)

woman. The terms 'quaint' and 'fanciful' are used, fairly enough; 'charming' and 'dainty' condescend; but the derogatory remark 'cloying sentimentality' is a judgment that only appears much later[2] when her work, like that of many others, had gone out of fashion and not yet been reappraised as very good of its kind and of historic interest.

What then was she producing? Annie French seldom departed from the theme of delicately pretty ladies among flowers or woods—brides or maidens. There are many excuses for the ladies—*The Lace Dress* (1902), *The Garland* (1906), *The Forest Beloved* (1905) or

Scottish ballads like *Can Ye Sew Cushions?* (*c.*1900). The ladies are generally clad in bouffant skirts, tight low-necked bodices, with flowing full sleeves, possibly a veil or scarf or train to make agreeable curves (fig. 181). The floating garments are decorated with flower patterns and can be very elaborate; not, in fact, very likely to survive well a forest walk or pulling roses, but reality was not French's province. The faces are idealised and of two types, round and pretty with small features, or profiles recalling the Pre-Raphaelite style with full lips, delicate jaw line and tendency to swan neck. Sir Edward Burne-Jones' 1860 work *Sidonia Von Bork* (fig. 182) in watercolour with bodycolour, now in the collection of the Tate Gallery, has some affinity with Annie French 'ladies'. French was one of many artists from this period to borrow some of the conventions of the Pre-Raphaelites.

fig. 185
The Bower Maidens, Annie French, 1906–14, watercolour, pen and ink, 24.0 × 25.8. (Private Collection. Photo: Glasgow Museums and Art Galleries)

fig. 184 *(left)*
Woman and Boy, Annie French, n.d., watercolour, pen and ink from a late sketchbook, 30.0 × 20.0. (Glasgow Museums and Art Galleries)

fig. 186 *(below)*
The Five Princesses, Annie French, n.d. watercolour in glazed and natural wood frame, 27.5 × 38.5. (Private Collection. Photo: Glasgow Museums and Art Galleries)

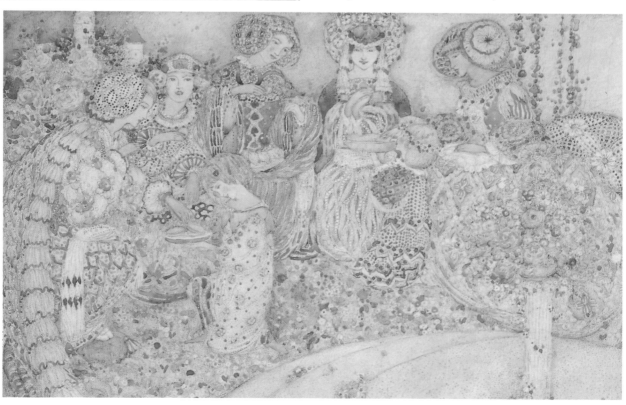

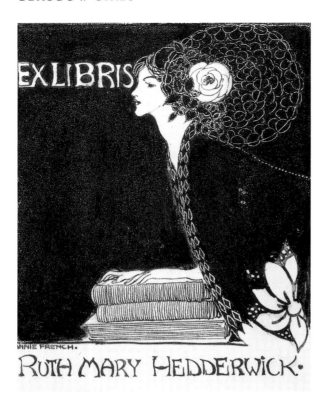

fig. 187
Design for a bookplate for Ruth Mary Hedderwick, Annie French,
c.1900s, pen and ink, 12.5 × 10.0. (Coll: Mrs R.M. Hedderwick.
Photo: Glasgow Museums and Art Galleries)

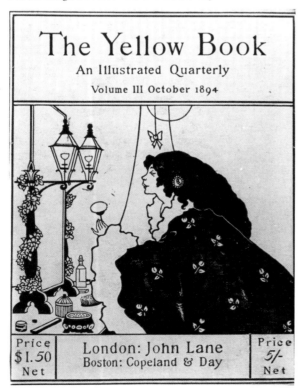

fig. 188
Cover design for *The Yellow Book*, Aubrey Beardsley, October 1894,
Volume III. (Coll: Jude Burkhauser. Photo: Jessica Russell)

The hair styles, puffed up, or full and flowing, which feature prominently in her designs, such as the bookplate, (fig. 187) were a convention also, but not so far from contemporary reality as may seem to the present-day viewer. People did wear their hair like that if it could be persuaded to stay in position, perhaps with a bandeau or ornament on the forehead as can be seen in photographs of the artist's contemporaries, for example, Katharine Cameron Kay (fig. 297).

The full-blown rose shapes in French's picture patterns recall Mackintosh and 'the Four', but a 'Spook' Annie is not. Her backgrounds are extremely detailed, full of flowers, green swards, plants, trees. Mechanisms and industry do not appear. There is considerable variation in tone, which is achieved by fine and finer pen lines, dots and dotted lines, hatching. The darkest patches are usually complex hatching, not plain solid black. It is a style requiring time, patience, and considerable invention. Where colour is used it is generally applied decoratively, with an eye to pattern. The work is a line drawing with colour, not a watercolour with lines, although sometimes lines are used over the colour again. Very often the base of the work is a brown paper, which may of course become browner with exposure to light.

The works are not usually very large. *The Bower Maidens*, (fig. 185) for example, is approximately ten inches square, on a smooth ochre paper, showing the use of a very fine pen line, some dotted lines, some hatching, giving a variety of tone—there is some gouache-like watercolour. The maidens are in the preferred costume and hair styles—medieval/romantic —with beautifully indicated hands. *The Daisy Chain* (1906) (fig. 180), now in the collection of the Victoria and Albert Museum in London, is different in that there is a panel of female figures in more chemise-like garments, with a background of open country seen through tree-trunks. The figures walk on the flowery sward and detailed path, and carry an improbably thick daisy chain and wands wreathed with daisies. The viewer tends to admire the drawing and not wonder too much what the children are doing marching about the edge of the forest with their harvest of daisies. They seem innocently employed in a game.

Comparisons of her work with Beardsley are based on her use of dots and dotted line. Many people have used dots when making pen drawings, and apart from the technique, which Beardsley did use when he passed into his second phase of design work c.1896 using stippling effects,[3] there is no great similarity between Beardsley's strong clear line, black and white contrast patterns, sinister atmosphere, and Annie French's gentle fantasies (fig. 181). *The Studio* critic noticing French's work in 1906 recognised a distinction: 'Making from what might be termed the Beardsley convention fanciful schemes of her own, her work has individual charm in its highly decorative quality and elegance of design.'[4]

French's work first appeared in a public exhibition while she was still a student, in the Brussels Salon of 1903, presumably under the patronage of her tutor, Jean Delville. Her work was accepted thereafter in the two main exhibitions open to her in Scotland, the Royal Scottish Academy and the Royal Glasgow Institute of the Fine Arts. From the titles in their catalogues it is clear that she held to her themes—*Proud Maisie* (1907) and *Homage to the Bride* (1914). She continued to send to the RGIFA until 1924.

The catalogue entries also let us know where she was living: 1 Kelvinside Place in 1904; 227 West George Street in 1906, where she shared a studio with Bessie Young and Jane Younger; 'Oberlea', Clarkston in 1914, a family home—she records later having rushed down to the garden in the dark on her return from a holiday in France with her sister Margaret in order to touch the flowers, so it is no wonder flowers play a large part in her designs. After her marriage in 1914 she is at 'Eaglesmere', Trinity Road, Tulse Hill, London. After a gap, we know she was living in Kenley, Surrey at 1 Oaklands, Hayas Lane, with Margaret; Agnes, another sister, retired to No. 2. From there Annie retired to Jersey, c/o a Mrs Le Sueur, presumably to be near her sister-in-law, Jasmine (Lady French) and her favourite nephew Eric. When a neighbour on Jersey remarked to her of the pair's (fig. 184) close relationship, 'How is it you two are "aye thegither"?', French recalled: 'I said in a stage whisper — We're ARTISTS!'[5]

For several years Annie French taught at the Glasgow School of Art, succeeding Jessie M. King, teaching the design element in the ceramics class and possibly other decorative art studio classes. She is also shown in a 1913 photograph with Ann Macbeth (fig. 14) as instructor in a drawing class. She married George Wooliscroft Rhead RE, also from an artistic family, in 1914 and went to London with him. Unfortunately, Rhead died some six years later.

French is known to have produced many postcards which, although an example is in the Victoria and Albert Museum, otherwise seem to have disappeared. Some did surface at a sale in 1981, attributed to 1924–27, with a calendar cover of 1948. Other relics and documents of Annie French's private life are equally scarce. There is a postcard to a relative in 1954, when she was packing up and selling both flats in Kenley—for Agnes had come by an accident from which she never fully recovered and Margaret had died in 1952—that suggests she was going through and burning the accumulation of letters and business papers: 'The God of Fire of the Ancients knows me quite well by now.'[6]

A few letters to relatives in the late 1950s from Jersey give some idea of her personality, for she had time to write and recall the pleasures of warm family companionship. She was interested in ancestral connections with Gordons, evidently dispossessed Cavaliers; she did not much approve of what is now called 'Women's Lib'; she felt out of place in a society devoted to the game of bridge; and disapproved of the gambling which went on, including the pools. She liked reading books, especially biography; her eyes were becoming weaker; she did not say anything about drawing.

An album exists, retrieved from a dustbin in Australia and now in the Glasgow Museums and Art Galleries, Kelvingrove, a fat little five-and-a-half by four inches, of fifty-two pages in hard covers. Each left-hand page has an elaborate border, possibly a space for a title or poem. The right-hand page has a picture, usually a female figure in her usual style, often with 'Ex Libris Annie French' added. Most of the drawings are densely decorated, with myriad variations on flower forms: fine pen line, hatching and perhaps gouache. There are, however, one or two pages in a bold simple style, e.g. *The Procession is in Sight* (fig. 189), (like a Hannah Frank) and the occasional sketchy lively line drawing like *The Despaired-of Letter*, a little figure (female) skipping in joy. There are some weak patches which look as if she had got bored with repetitious flowers or loops, but other pages are of richly-coloured careful patterning—black and gold, purple, pink and gold. Many pages have pieces stuck on, and the album is in fact a composite with extra pages glued in. There is one date on a drawing, 1948, which may suggest that the album was put together then or later when she had time. The date appears on *Woman in a Tram from Recollection*, so cannot be taken as proof positive.

Writing from Jersey in the late 1950s she made no reference to work in hand, although she described people with an artist's observation and mentioned difficulties with her eyesight. She was obviously alert, recalling family histories and approving or disapproving of local and national happenings. French died in Jersey in 1965. Perhaps now that interest has reawakened in the 'Glasgow Girls' more of her work will be retrieved.

fig. 189
The Procession is in Sight, Annie French, n.d., sketchbook design, watercolour, pen and ink, 30.0 × 20.0. (Glasgow Museums and Art Galleries)

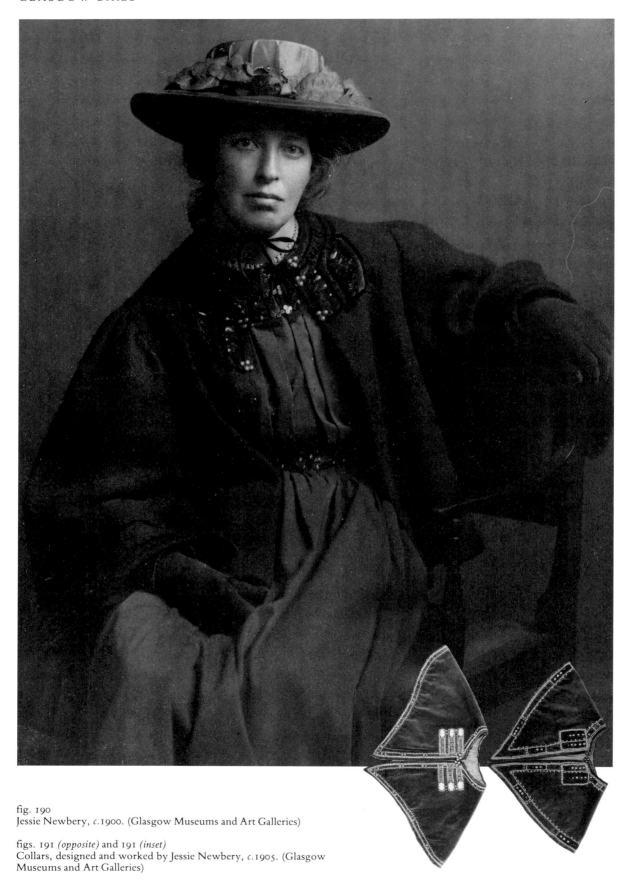

fig. 190
Jessie Newbery, *c.*1900. (Glasgow Museums and Art Galleries)

figs. 191 *(opposite)* and 191 *(inset)*
Collars, designed and worked by Jessie Newbery, *c.*1905. (Glasgow
Museums and Art Galleries)

JESSIE NEWBERY (1864–1948)

by Liz Arthur

Jessie Newbery's (fig. 190) great achievement was that she established a Department of Embroidery at the Glasgow School of Art in which the teaching took a revolutionary new form, with embroidery seen as a specialist subject linked to the other arts. Her main aim, to encourage and develop the individual skills of each student, was a complete break with the prevalent belief that laborious execution was more important than originality which had resulted in stereotyped work of little artistic merit.

During the late nineteenth century embroidery was enjoying a revival, but by the 1870s most of that produced in Britain was machine made. Hand embroidery was limited to the decoration of ceremonial garments and to Berlin woolwork, which was sold as ready printed designs on canvas to be worked in brightly coloured wools. In reacting against this division between designer and worker, William Morris created a revival in secular embroidery in the form of Art Needlework. Art Needlework was encouraged by the Royal School of Needlework, founded in 1872, although staff still executed designs by architects and other designers rather than producing their own as Morris advocated. Similarly, after 1885 when May Morris took over the embroidery work-shops from her father, they also produced ready-traced designs on fabric, which were supplied with threads in appropriate muted colours for working the designs. There was considerable interest in Art Needlework in Glasgow; a branch of the Royal School was set up in St Vincent Street.

Glasgow had a long involvement with the textile industry through the manufacture of cotton, a wide variety of woven and printed fabrics, carpets, and a strong needlework tradition through the production of embroidered whitework. Therefore, it is not surprising that the School of Art should have established embroidery classes, nor that Jessie Newbery should have been instrumental in shaping a highly successful new approach to embroidery. She grew up in Paisley where her father William Rowat and two uncles had been successfully involved in the Paisley shawl industry (fig. 35). Her father's radical views included a belief in education for women, and after school in Edinburgh she had a thorough training in drawing, painting, and anatomy, and followed the design course in textiles and stained glass at the Glasgow School of Art.

What is most significant is the way she developed the classes within the framework of the school and created new aesthetic standards for embroidery through honest simplicity of design and good craftsmanship, which resulted in highly acclaimed work of a very distinctive character (fig. 193). Art Needlework classes were already taught in the school's premises at 3 Rose Street, but in 1894 they were re-organised. Jessie Newbery taught design one afternoon and two evenings each week, with Miss Dunlop responsible for teaching technique. These classes were open to members of the public, who were charged a fee, but were free to students. Needlework became part of the School diploma course in Applied Design, but students first had to reach a required standard in drawing, still-life, painting and modelling. The classes consisted of 'Foliage in Outline; Study of Flowers from Nature; Design and Application; Technique and Study of Old Examples'[1] and showed the strong influence of John Ruskin and William Morris in the emphasis on nature and respect for technique and the work of earlier generations.[2] But, this was not a slavish devotion to realism or the past, rather a foundation on which to base creativity and self-expression.

Initially, she continued to use crewel wools on linen favoured by Morris and the Royal School of Needlework, but gradually extended this to include silks as well as cheap fabrics such as hessian, calico and flannel. She was adamant that embroidery was an art form available to all social classes and was as effective worked on cheap materials as on expensive ones. She supported the Arts and Crafts view expressed by her husband, Fra Newbery, that, 'Picture painting is for the few but beauty in the common surrounding of our daily lives is or should be an absolute necessity to the many.'[3] To this end most of her own work and that of her students, particularly in the early years of the department, was utilitarian. They made cushions, table centres, curtains, bags and mantel borders, using simple stitches appropriate to the design and materials.

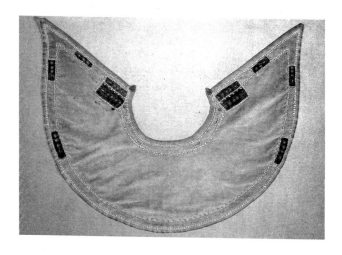

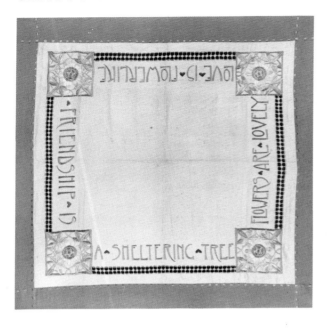

fig. 193
Friendship tablecover, Ellison Young, linen tablecloth, floss silk thread embroidery, motto: 'Friendship is a sheltering tree, Flowers are lovely, Love is Flower like', 1907-08, 116.5 × 116.5. (Glasgow Museums and Art Galleries)

She reacted against the prevalent laborious execution, preferring instead simple stitchery, and tried '. . . to make most appearance with least effort, but insist that what work is ventured on is as perfect as it may be.'[4] To help achieve this end she introduced appliqué, the method of applying pieces of fabric to a ground fabric to form a design, which became such a favoured technique that by 1901 the department was referred to as the 'Department of Needlework, Embroidery and Appliqué'.

Jessie Newbery was an enthusiastic teacher and encouraged a strong sense of design in her pupils' work, fostering an essentially linear style which was, no doubt, rooted in her studies and designs for stained glass, enamels and mosaics.[5] She held classes in mosaics from 1896 to 1898, enamels from 1895 until 1899 and taught book decoration in 1899. In 1890 she had won a bronze medal at South Kensington for a stained glass window design *Tempestas*. She had also designed a silver repoussé chalice and paten (fig. 195) and a repoussé alms plate which were shown in the 'Fourth Exhibition of the Arts and Crafts Exhibition Society' in 1893.[6]

For her, design was of primary importance. She said: 'I believe that nothing is common or unclean: that the design and decoration of a pepper pot is as important, in its degree, as the conception of a cathedral.'[7] Colour, too, was important. She rejected the predominantly dark colours used and introduced instead lighter purples, greens, blues and pink. Her early work is less restrained and more elaborate than later examples. Her embroidery with a quotation from Blake, *c*.1900 illustrates her pleasure in '. . . the opposition of straight

lines to curved; of horizontal to vertical. I delight in correspondence and the inevitable relation of part to part. I specially aim at beautifully shaped spaces and try to make them as important as the patterns.'[8] Gradually she evolved a more simplified style based on her life-long interest in botany and plants. These she used in stylised, almost geometric forms which, reduced to their essential elements, formed a satisfying harmonious design combining the natural and the abstract, yet still retaining the essence of the plant (fig. 194). She used many motifs, such as pea-pods, pea-flowers and roses, which recur throughout the history of embroidery, but her treatment gives them a distinctive quality which makes them unmistakably of their time. These botanically inspired designs were invariably worked on linen, the appliqué motifs secured using Pearsall's Mallard Floss silk thread in satin stitch which gave a strength and solidity to the design. This was often combined with a needlewoven border, a technique she had seen used on local crafts in Italy.

Functional elements were often used as an integral part of her designs, for example, the fastening of cushions, but this is best seen on her collars (fig. 191). The buttonholes by which the collar was fastened to the neck of the dress have been emphasised by being stitched boldly, so that together with the buttons they form an essential element of the overall design. Similarly, hems, instead of being worked unobtrusively, have been turned to the right side of the work and secured with bold decorative stitches, usually French knots or simple straight stitches. She added texture in the form of couched thread and fine braid as well as flat beads of glass and shell.

Just as she expressed her creativity and individuality in her embroidery and teaching, she also adopted her own distinctive form of dress, as did so many other women in artistic circles. At first, her dresses had a Renaissance flavour and show the influence of the Pre-Raphaelites. Her design for her wedding dress was based on that of St Ursula in the paintings by Carpaccio in the Accademia in Venice. The long sleeves with puffed insertions of white chiffon became a distinctive feature of her dresses, which were frequently described in the press. In November 1900, at one of the School's 'At Homes', she is reported as being :

> . . . dressed in the quaint and becoming style she always affects. Her black merve [sic] gown was slightly trained and had the long sleeves puffed at intervals to correspond with the simply fashioned bodice which was finished with a narrow collar of old lace, and on the shoulders bows of reddish gold velvet. [9]

Green silk or velvet with slashings of white were her favourite for evening wear, and one dress was worn for fifteen years. But it was not until 1905 that she was reported as wearing embroidered garments to these functions.

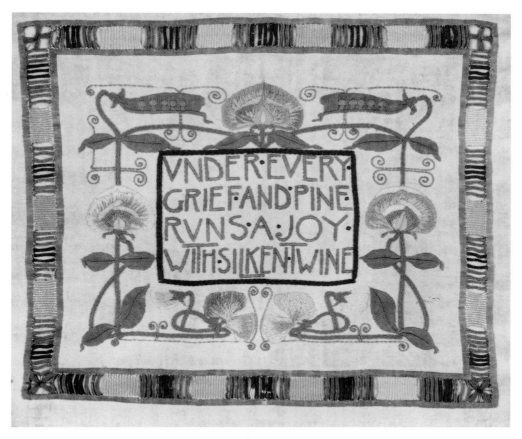

fig. 194
Cushion cover, Jessie Newbery, c.1900, linen embroidered with woollen threads, with inscription: 'Under Every Grief and Pine Runs a Joy With Silken Twine', William Blake, 48.8 × 55.8. (Glasgow Museums and Art Galleries)

Newbery appreciated and was fastidious in the use of fine materials, particularly silk velvets and lightweight wools, and in the early 1900s made embroidered collars, belts, yokes and cuffs for herself and her two daughters (born in 1890 and 1892) (fig. 58). She also taught her students to embroider their own clothes, and many copied this type of collar. In 1906 she bought the distinctive metal clasps she was to use on her collars and belts from an exhibition of Russian crafts at the Doré Gallery, Bond Street, managed by Madame Pogosky.[10] Later, in the 1920s and 1930s, she made loose velvet or wool garments consisting of gathered skirts attached to sleeveless bodices, covered by a simply cut tunic decorated with braid and a more simplified form of appliqué or green woollen bobbles. In winter she wore a knitted jumper underneath.

By 1900 the department was well established, gaining increasing recognition, and the students' work featured regularly in *The Studio* magazine. In a review of the 'Glasgow International Exhibition' of 1901, the work of Jessie Newbery and her students is further cited as being 'worthy of examination on account of the qualities of design combined with workmanship of rare excellence.'[11] Their work was also well represented in the Turin exhibition the following year, including an embroidered bedspread by Jessie Newbery and an Axminster carpet worked to her design by Alexander Morton and Co.

In 1901 special classes were instituted for the in-struction of teachers under Article 91(d) of the Scottish Code of Regulation for the Further Training of Teachers of 1899. This was a three year course after which a certificate of proficiency was issued by the Scottish Education Department. The fee for a course of twenty-four lessons was ten shillings (fifty pence). In 1906 the code was redrafted, the fees were abolished, and the classes became known as 'The Article 55 Classes'. Ann Macbeth, a student of Jessie Newbery, was invited to join the department, at first to help with these Saturday classes which were for both primary and secondary school teachers, but after 1904 she took charge of them.

The work of the department was further recognised in 1907 when the Scottish Education Department authorised the Governors of the School of Art to grant a certificate for Art Needlework and Embroidery. The course for this certificate lasted two years, at the end of which the student submitted a satchel of work, a portfolio of drawings and designs, and a design drawn and executed under given conditions. The certificate was awarded to any student attending the weekly or Saturday morning classes provided they reached the required standard. The course was about the same as

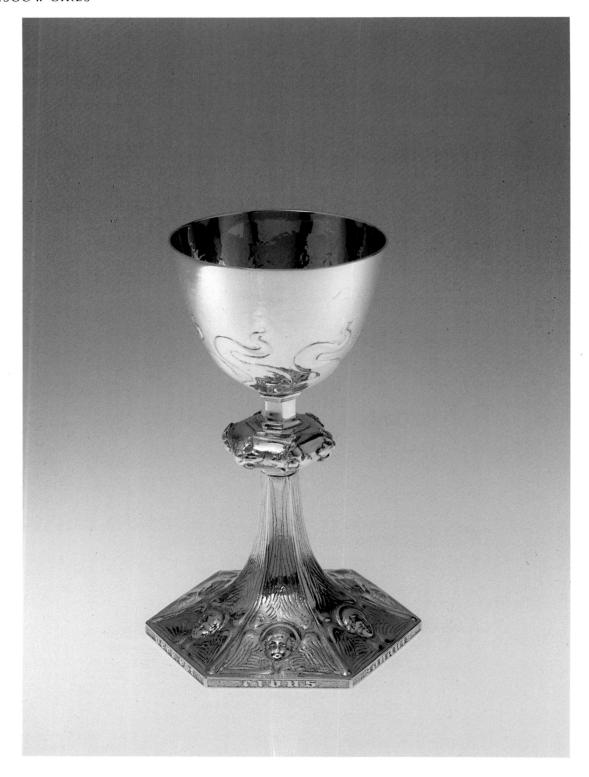

fig. 195
Chalice and Paten, designed by Jessie Newbery, executed by Kellock Brown, hallmarked Thomas Stewart, Glasgow, 1892, silver with repoussé decoration, chalice h. 19.0, dia. 8.3, paten dia. 12.7. Metal working was one of the decorative art studio areas in which the women of the Glasgow Style movement were to excel. The designers found commissions for their work in a bouyant economy. (St. Bride's Scottish Episcopal Church, Glasgow, Photo: Glasgow Museums and Art Galleries)

that followed by the diploma course students and gave many who could not be full-time students a professional qualification in embroidery. It is significant that the embroidery department was the only one in the school to award an individual certificate and to have a separate entry in the annual report.

In 1908, after an illness, Jessie Newbery retired from the department but continued her contact through the award of an annual prize for embroidery which she had instituted in 1906.[12] She was also very much involved in the organisation and arrangement of a major exhibition, 'Ancient and Modern Embroidery and Needlecraft', held in 1916. She supported her husband very actively and was remembered by De Courcy Lewthwaite Dewar as a 'charmingly gentle artist and a strong backbone. She had a remarkable sense of colour and design and managed her mercurial husband to perfection.'[13] She also continued to embroider, exhibiting with the 'Scottish Guild of Handicraft' and with the 'Arts Décoratifs de Grande Bretagne' exhibition held in the Louvre, Paris, in 1914. Fra Newbery retired in 1918 and they moved to Corfe Castle, Dorset. Jessie died in 1948.

For a long time she gave honorary service to the School as mistress of its needlework department, and it was not until this was satisfactorily established, and its daring, its originality, and its brilliant talent recognised that she handed the charge over to her able auxiliary, Miss Ann Macbeth.[14]

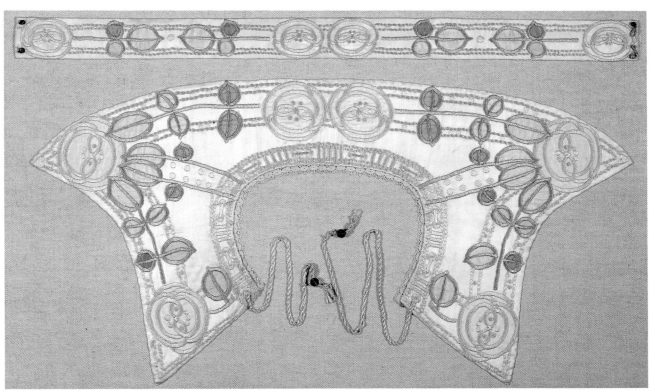

fig. 196
Collar and belt, designed and worked by Jessie Newbery, appliquéd and embroidered in pale greens and pink. (Victoria & Albert Museum, London)

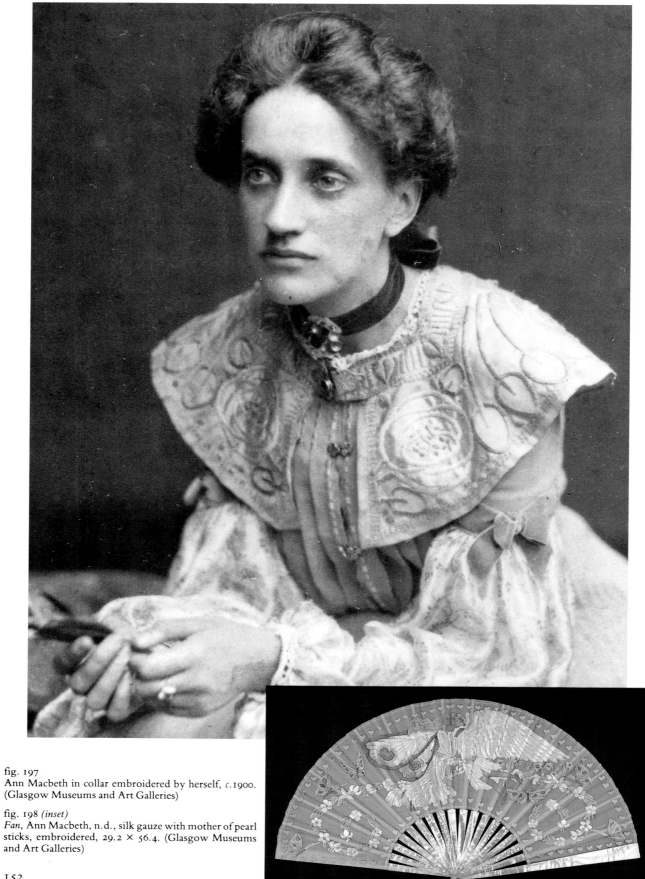

fig. 197
Ann Macbeth in collar embroidered by herself, c.1900.
(Glasgow Museums and Art Galleries)

fig. 198 *(inset)*
Fan, Ann Macbeth, n.d., silk gauze with mother of pearl
sticks, embroidered, 29.2 × 56.4. (Glasgow Museums
and Art Galleries)

ANN MACBETH (1875–1948)

by Liz Arthur

As Jessie Newbery's 'most talented and subsequently most influential student', Ann Macbeth's life and work exerted a wide-ranging influence on education in Great Britain and abroad. Overcoming her parents' objections to her pursuit of a career in art, Macbeth (fig. 197) was a successful student at the Glasgow School of Art. Born in Bolton, Lancashire, the eldest of nine children of a Scottish engineer and granddaughter of a Royal Academician, she enrolled in the Glasgow School of Art in 1897, won a prize for needlework two years later and in 1901 was appointed assistant instructress to Jessie Newbery.

Her embroidery was highly regarded and given regular coverage in *The Studio* magazine, (fig. 34) including an appreciation of her work written by Fra Newbery.[1] In 1901 she designed and worked the Glasgow Coat of Arms on one side of the banner presented to Professor Rucker of the British Association for the Advancement of Science, which was exhibited at the International Exhibition. (Jessie Newbery designed and worked the other side.) The following year she won a silver medal at Turin. She also worked a silk cushion with the floral attributes of the four countries of Britain which was presented to Queen Alexandra in commemoration of the coronation.[2]

Ann Macbeth was a gifted teacher and during 1904, when Jessie M. King temporarily took over for Jessie Newbery, she took sole charge of the classes for the teachers. In 1906 she extended her teaching to include metalwork and in 1907 bookbinding, which she continued until 1911. She produced several designs for jewellery which were either executed by Peter Wylie Davidson or used as illustrations in his books.[3] She also began teaching ceramic decoration in 1912, designed carpets for Alexander Morton and Co. and also designed for Donald Bros. of Dundee, Liberty's and Knox's Linen Thread Company.

When she became chief instructress she became a member of the Staff Council. In the three years that followed she consolidated the work of the department and by 1910 the classes were conducted on two distinct levels. The elementary class dealt with stitchery and constructional decoration with design limited to simple geometric and floral forms. The advanced class was for students who had studied in the life and figure composition classes and they were encouraged to develop more elaborate designs involving figures, animals and plant motifs.

Following a successful exhibition of the work of the Saturday classes for teachers in 1909 there was increased interest from abroad. In 1910 work was sent to the 'Thirty-sixth International Exhibition of German Art Workers and Teachers' in Hanover and the students also exhibited at the Beith Art Workers' Society, in the

Education Offices of the London County Council and in Chester. A number of samples were presented to the Canadian Royal Commission on Education who visited the School. The reason for international interest was the unique method of teaching needlecraft to school children being promoted in the Saturday classes. This method had been devised by Margaret Swanson, an Ayrshire teacher with experience of instructing children, with the help of Ann Macbeth.[4] Jointly they published *Educational Needlecraft* in 1911 (fig. 80). The book emphasised the practical aspect of embroidery without losing sight of creativity. The aim was to develop craftsmanship in parallel with the child's improving co-ordination and eyesight, without repressing imagination or enthusiasm, with each stage progressing logically from the previous one with an increasing degree of difficulty. It is worth noting that this method of teaching continued in Scottish primary schools into the 1950s.

Parcels of examples of the work illustrated in the book were sent to interested schools in 'Yorkshire, Lancashire, Cumberland, Wales, Dorset, Bedford, London, Africa, America, West Indies and India.'[5] Of course there was a great deal of Scottish interest in these developments and a two week exhibition of the 'Art and Craft Work done in schools of the Western Division of Scotland for Primary Schools', held in the School of Art in December 1911, attracted 14,000

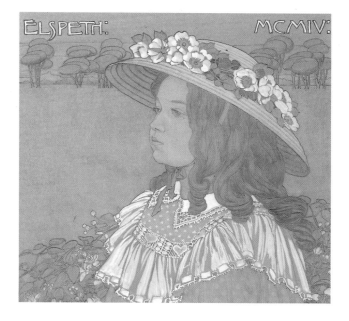

fig. 199
Elspeth MCMIV, Ann Macbeth, watercolour on paper, 1904, signed. 24.4 × 23.6. Elspeth Currie aged eight, sister of Marie Currie and friend of Ann Macbeth. (Coll: Mrs M. E. Inglis. Photo: Glasgow Museums and Art Galleries)

fig. 200
Detail of Curtain, Ann Macbeth, n.d., blue silk curtain with black silk border edge and beige silk appliqué shapes embroidered with floss silk threads and black, green and cream using satin, straight, running and stem stitches with couching, 364.9 × 78.6. (Coll: Glasgow School of Art. Photo: Glasgow Museums and Art Galleries)

fig. 201
This photograph of Grace Melvin's work, exhibited at the School of Art in 1912, includes practical embroideries based on Ann Macbeth and Margaret Swanson's teaching programme, items of jewellery and examples of lettering. She taught lettering and illumination at the School from 1920–27 and in 1927 became head of the design department in the School of Art, Vancouver, Canada. (Coll: Glasgow School of Art. Photo: Glasgow Museums and Art Galleries)

visitors. As further response to the interest shown, Ann Macbeth, Margaret Swanson and later Anne Knox Arthur, organised lectures and summer schools throughout Britain. At the same time, a new course, approved by the Scottish Education Department, was devised for students attending the West of Scotland College of Domestic Science, and in 1914 Ann Macbeth was asked by the National Froebel Union to draw up a programme of work for their proposed diploma course in handiwork. Representatives from various educational bodies visited the School of Art to study the scheme at first hand. In 1912 these included visitors from Chicago University, South Africa and the English Board of Education.

By this time Needlework was the most important section of the applied arts in the school and in 1914 had the distinction not only of exhibiting the work of staff and former students in the 'Arts Décoratifs de Grande Bretagne et d'Irlande Exposition', in the Palais de Louvre, (fig. 202) but also in the Lyon exhibition where in a pavilion reserved for the Glasgow exhibits the School of Art was 'represented by photographs of the building and certain examples of Needlework and Embroidery.'[6] The students showed their work in a wide variety of exhibitions ranging from the 'National Economy Exhibition' in London to various arts and crafts exhibitions. More than 100 specimens were sent to York in 1917. The work continued to be illustrated regularly in *The Studio* and one review reported:

> Throughout the various exhibits of elementary and advanced pupils were to be found many charming designs and essays in craftsmanship in which the character and personality of the worker had not been lost in extreme technicalities and with them some remarkable examples of work by their chief instructress Ann Macbeth.[7]

Students were sought after and appointed to posts abroad and throughout Britain. Some of the advanced class students also taught in schools, factories and the guild classes of the co-operative societies.

Despite her busy teaching commitments Ann Macbeth continued to be a prolific worker, producing not only her own pieces but designs for relatives and friends to work and for commissions worked by the students (fig. 201). Among these were the embroidered coronation robe worn by Lady Pentland in 1910 and suffrage banners which students took turns stitching during their breaks.[8]

fig. 202
Panel of silk satin embroidered with floss silk and silver metal threads with glass beads and seed pearls, Muriel Boyd, 1910, 38.3 diameter. Exhibited at Palais de Louvre, Arts Décoratifs de Grande Bretagne et d'Irelande Exposition, October, 1914. (Private Collection. Photo: Glasgow Museums and Art Galleries)

Ann Macbeth's early embroidery was very much influenced by Jessie Newbery whose views she shared, particularly in her stress on the interdependence of purpose and design. She made many functional items and, like Jessie Newbery, preferred artistic dress (fig. 197). Despite distinctive metal clasps and the rose and heart motifs which became Ann Macbeth's hallmarks, her collars show a greater exuberance and elaboration of design than those by Jessie Newbery[9] (fig. 51). Although essentially a very practical woman, Ann Macbeth produced many embroideries which were purely decorative.

She was a fine draughtswoman and this underpins all her work. Although best known for embroidery, Ann Macbeth frequently exhibited pen and wash drawings and portraits. Fra Newbery said: 'Miss Macbeth kept her design aspirations in the background until she made herself a competent draughtswoman, and had mastered the art of drawing, without which design is as lifeless as a body without a soul.'[10] This ability is particularly obvious in her figure panels which she regarded as the supreme challenge for the embroiderer. She recommended that her students use white silk satin as a ground for small figure panels because the design could be transferred easily to the smooth surface. *The Sleeping Beauty* is an early work; her later figures became more stylised, although not to the extent of Margaret Macdonald's attenuated figures, and are more earthbound than Jessie M. King's ethereal ones. Among several examples is the altar frontal she designed for the Trinity Church of St Mary the Virgin in Glasgow (fig. 203). The work, which took two years to complete, was done by student Agnes E.P. Skene and shows a much wider colour range than was used in her earlier work. Simple stitches continue to be used but the colour and design are enhanced by the play of light on the floss silk threads and the directional arrangement of the stitches worked in solid blocks.

Mary Sturrock (the Newberys' younger daughter) believed that the most beautiful work produced in the department was the result of the influence of Frances MacNair, who worked as Ann Macbeth's assistant from 1908 until 1911. During this time Ann Macbeth produced several designs containing magnificent winged figures and more striking colours.

In 1914 she was asked to represent the school in the Student Careers Association for Women and after the resignation of Margaret Swanson in 1913 she was appointed Lady Warden in the School of Art. She continued to extend her interest in teaching, publishing *The Playwork Book* in 1918, *Schools and Fireside Crafts* with Mary Spence in 1920, *Embroidered Lace and Leatherwork* in 1924, *Needleweaving* in 1926 and *The Countrywoman's Rug Book* in 1929. In recognition of her work she received honorary diplomas from Paris, Tunis, Ghent, Budapest and Chicago. Although she moved to the Lake District in 1920 she continued as a visiting instructress until 1928 with Anne Knox Arthur as head of the department. In retirement she continued to promote needlework. In her foreword to Anne Knox Arthur's *An Embroidery Book*, she expressed her belief that people should use their increased leisure time in pursuit of embroidery and advocated that men in particular could contribute greatly to the craft if they took up the needle. From her books, her infectious enthusiasm for embroidery is clear, and through her writing and work as a teacher she continued to assert that 'Beauty must come back to the useful arts and the distinction between fine and useful arts be forgotten.'[11]

In Patterdale she held embroidery classes and through the Women's Institute organised handicraft classes. The most important of these was rugmaking, which she began in an effort to alleviate the hardship caused by the depression after the First World War when local farmers were unable to sell their stocks of wool. She had the wool spun in the Tweed Mills at Wetheral and it was then woven into hard-wearing rugs by local women on the simple loom she devised.

Although a very direct, slightly forbidding character Ann Macbeth was also very kind and generous. She had a kiln in which she made a christening mug or plate for each child in the parish and teapots for anniversaries. A woman of strong Presbyterian conviction with a firm belief in the work ethic, her nieces remember that on visits during school holidays they were not allowed to be idle and were kept busy sewing. Ann Macbeth set them a good example as she continued her prolific output, exhibiting regularly with the Glasgow Society of Lady Artists' Club and winning the Lauder prize in 1930 and 1938. It was this singlemindedness and dedication, together with a gift for teaching, which made the School of Art Embroidery Department an international centre for needlework education and produced embroidery of outstanding quality.

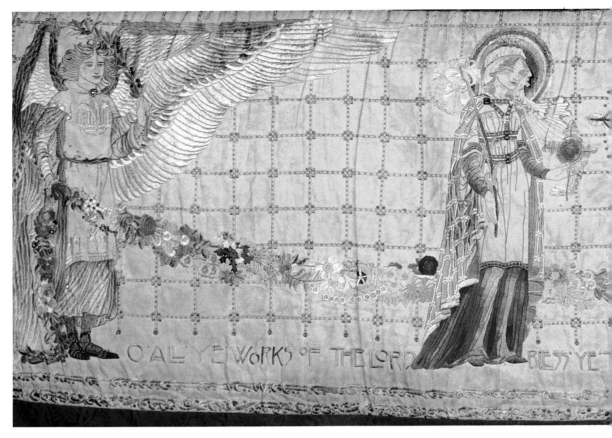

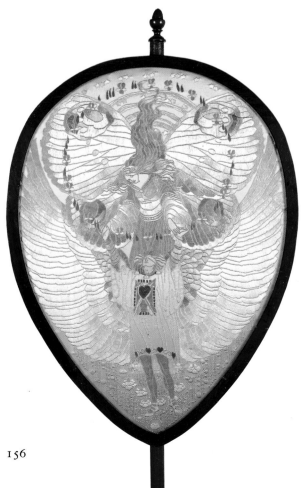

fig. 203 (above)
Altar Frontal for the Cathedral Church of St. Mary the Virgin, designed by Ann Macbeth and worked by Agnes E. P. Skene, c.1909–10, 80.5 × 276.0. Cream coloured corded silk embroidered with gold and silver metal threads and silk threads of varied colours. Worked in satin, knot, chain, stem, straight, long and short, running and daisy stitches with french knots and couching; decorated with seed pearls, green beads, and semi-circular glass beads. Inscription: *O all ye works of the Lord . . .* (Glasgow Museums and Art Galleries)

fig. 204 (left)
Oval Fire Screen, designed by Ann Macbeth and worked by Madge Maitland, c.1915, silk embroidered, 61.5 × 43.4. Possibly exhibited in 1916 at the GSA 'Exhibition of Ancient and Modern Embroidery and Needlecraft', cat. no. 575. J. Taylor, 'The Glasgow School of Embroidery', *The Studio*, Vol.L, 1910. (Coll: Mrs Margaret Briscoe. Photo: Sotheby's)

fig. 205 (opposite)
The Sleeping Beauty, designed and worked by Ann Macbeth, beige silk with appliqué shapes in cream, pink and fawn. Embroidered with gold metal and silk threads, 48.4 × 106.8. Exhibited Turin 1902. (Glasgow Museums and Art Galleries)

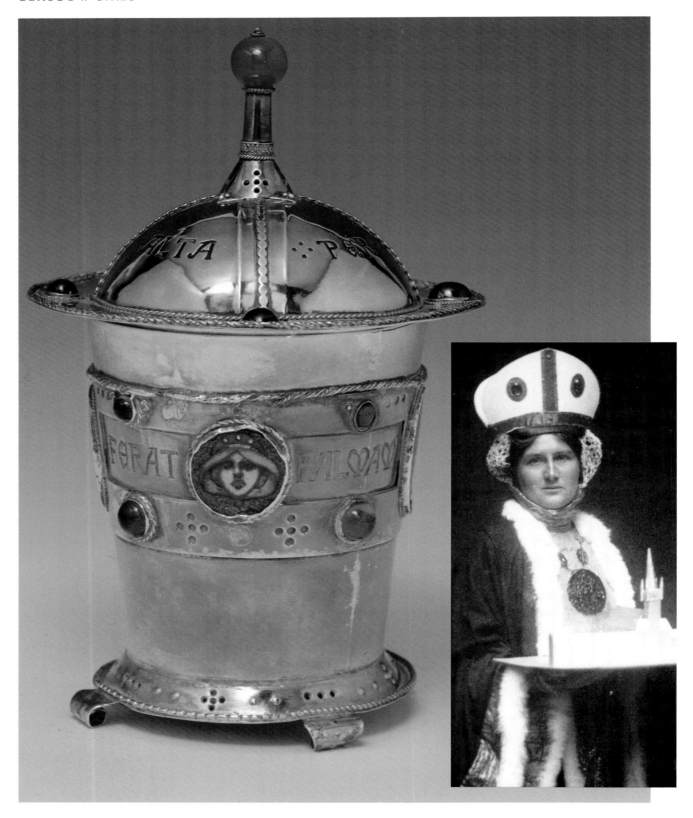

fig. 206
Cup and cover in silver with enamel plaques and cabochon stones, De Courcy Lewthwaite Dewar, dated 1912, 17.6 high. Impressed signature below cup. (Glasgow Museums and Art Galleries)

fig. 207 *(inset)*
De Courcy Lewthwaite Dewar in masque costume as the University of Glasgow, *c*.1904. (Coll: H.L. Hamilton. Photo: Glasgow Museums and Art Galleries)

DE COURCY LEWTHWAITE DEWAR (1878–1959)

by Jude Burkhauser with Susan Taylor

I had a letter from some one called John Wilson, Highbury, London saying he heard I did enamels & that a friend of his wanted some done. . . . Fancy sending to Glasgow to get enamels done when such heaps of people do them in London.[1]

De Courcy Lewthwaite Dewar (fig. 207) was born in 1878 in Kandy, Ceylon (Sri Lanka), daughter of tea planter, John Lewthwaite Dewar and Amelia Cochrane. Her unusual name had been handed down in the Dewar family for several generations although she was always called *Kooroovi*, the Tamil word for small bird.[2] Dewar had two sisters, Margaret, the eldest and Katie, with whom she lived in Glasgow most of her life. From 1891 until after the 1908–9 session, she studied at Glasgow School of Art.

Dewar's main contribution to the Glasgow Style was enamel and metalwork frequently illustrated in *The Studio*. In addition to design and production of enamelled jewellery, plaques, mirror surrounds, sconces, clocks, caskets and buttons she was a prolific graphic designer, painter and engraver. Her graphic design output included bookplates, programme covers, calendars, cards, and tea-room menu covers. In addition, she designed costumes for the numerous masques in which she took an active part (fig. 74). A review of her work in *The Studio* from 1909, although succumbing to the patronising language applied to reviews of the work of women at that time, placed her with the best of her contemporaries:

In the ever-widening circle of artistic workers in Glasgow, Miss De C. Lewthwaite Dewar takes a deservedly high position; her work showing imaginative charm and executive ability . . . her studio is rich in water colour and illuminated drawing, beaten metal work, enamelling, engraving, [and] dainty work in jewellery—for which the fingers of woman seem specially fashioned. . . .[3]

A competent draughtswoman, Dewar's sketchbooks from c.1895–1910 are filled with studies for metalwork (figs. 209–210), in which she and many Glasgow women, such as the sister teams of Gilmour and Macdonald, excelled. This distinctive metalwork was well known through contemporary art journals and major international exhibitions. In the first half of the nineteenth century, rigidly-defined roles established dividing lines between Arts and Crafts practice, separating those products and tasks appropriate for men from those appropriate for women. Metalworking was a trade primarily closed to women as a result of these boundaries, and few opportunities existed for

training. Men generally were seen as makers of furniture, wood and metalwork while women were confined to weaving, rug-making, and the sewing crafts. Change in 'socially accepted' division of labour created an opening in metalworking distinct from what was still restrictive commercial production, which resulted in an influx of women into the profession, primarily as jewellers. In Glasgow this manifested in a variety of forms not limited to the brooches or pendants that Arthur Lasenby Liberty and Company, for example, commissioned from Glasgow artists, such as Jessie M. King, for its 'Cymric' line or that women, such as Rhoda Wager, would produce independently to earn their livelihood well into the next century. A 1910 review commented on female metalworkers in Glasgow:

. . . in regard to metal work, however, the male craftsmanship seems to be dying out. . . . In picture galleries in the future the work of women may be more in evidence, and in metalwork the field seems to be already theirs. It is true that the lady metal worker has occasionally erred on the side of mere daintiness. She has produced mirrors, picture frames, and ornate fireplaces merely pretty without being useful which is bad art. But the merely dainty touch is passing away. In this exhibition there are productions which, while being artistic, are also useful.[4]

Dewar and her contemporaries created both ornamental and useful items including clock faces, candle sconces, fire surrounds, jardinières, vases, caskets, panels for tea-room interiors, as well as furniture insets. Most of these items were both designed *and* made by the hand of women themselves. Glasgow School of Art was one of a growing number of British schools that equipped women with professional expertise to establish their own craft studios and earn their living by design, teaching or production of craft metalwork. Part of this movement, Dewar had her own studio on the sixth floor of Central Chambers, 93 Hope Street, Glasgow where she worked independently from 1900 until 1926. After 1926, she continued to work in a studio at 15 Woodside Terrace, Glasgow.

Her earliest notices in *The Studio* appear in conjunction with School of Art Club Exhibitions of 1899[5] and 1900,[6] in which her candle sconce and white metal casket were praised as 'excellent in design and execution, and worthy of study.' In 1902 an enamelled plaque drawn on copper, entitled *Vanity*, appeared in 'Studio Talk'.[7] Dewar was appointed instructor in enamels at the Art School by Fra Newbery as part of his adventurous employment of female staff in the decorative arts studios. In one day in Dewar's schedule

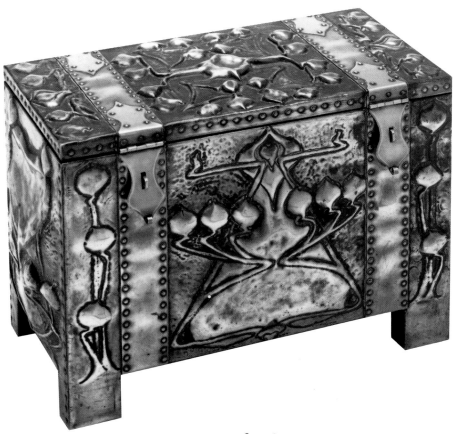

fig. 208
A Casket in repoussé metal by De Courcy Lewthwaite Dewar,
c.1900, 38.0 × 17.0 × 25.0. Illustrated in *The Studio* in 1900. (Coll:
John Jesse Gallery. Photo: Sotheby's)

we find her interacting professionally with other female tutors Ann Macbeth, Jessie M. King and Dorothy Carleton Smyth, and with several influential male figures from art and design: Jean Delville (the Belgian Symbolist, then tutor in drawing and painting), Fra Newbery, the dynamic Headmaster, and sculptor Kellock Brown.

Another of her associates at the School who would have an influence on her career was designer/craftsman Peter Wylie Davidson (1870–1963) (fig. 211), who had earlier studied drawing at the School, and was a silversmith for James Reid and Co., Glasgow. A part time instructor of metalwork in 1897, Dewar had been one of his first students. In 1905 he left Reid and Co. to join his brother, W. A. Davidson, also a silversmith, whose studio at 93 Hope Street was in the same building as Dewar's. The pair produced a variety of commissioned objects in repoussé and silver. Davidson, who had served a seven-year apprenticeship, was highly skilled in his craft and was able to introduce techniques to Dewar's class which would improve the quality of their work. Most importantly, Dewar saw his help as a way for her students to gain the

expertise needed to become completely self-sufficient in their craft. She wrote: 'Mr Davidson has been getting a lot of tools, blow pipes etc. so we hope to start better equipped this year, as we want to make up all our jewellery boxes etc, all ourselves.'[8] Over a period of thirty-eight years Davidson's skill and technical expertise was to influence the many students of metalwork who would pass through the School. From 1910 he became a full-time instructor, working in collaboration with Dewar, a position he was to hold until his retirement in 1935. In the 1920s he wrote two important books on metalwork for the Longman's Technical Handicraft Series, *Applied Design in the Precious Metals* and *Educational Metalcraft*, which were major texts used in craft education throughout Great Britain. Dewar and Davidson continued their association from this time and remained colleagues and friends until Dewar's death in 1959.[9]

Fra Newbery initiated important contacts for his students with key working artists and designers and some of the major figures of the Arts and Crafts movement in Britain travelled to Glasgow to lecture at his request, including Walter Crane and William

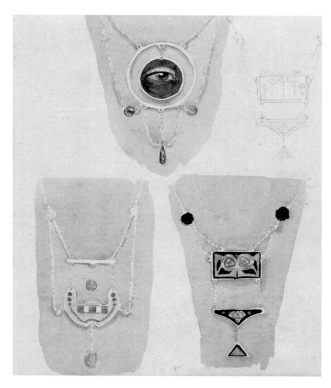

fig. 209
Designs for enamelled pendants, the Mystic Eye, Glasgow Rose and Glasgow square motif, De Courcy Lewthwaite Dewar, sketchbook page (1), 8th March, 1908, black sketchbooks with folio leaves, watercolour and pencil throughout. 25.0 × 15.0 approx. (Coll: H.L. Hamilton. Photo: Glasgow Museums and Art Galleries)

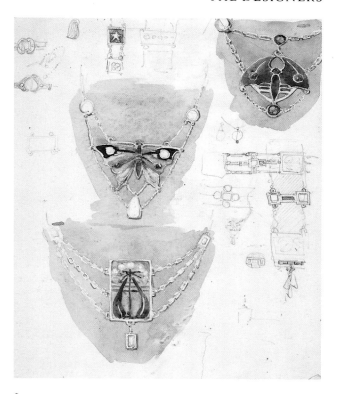

fig. 210
Designs for enamelled pendants, bat and butterfly designs, De Courcy Lewthwaite Dewar, sketchbook page (1), 8th April, 1908, black sketchbooks with folio leaves, watercolour and pencil throughout, 25.0 × 15.0 approx. (Coll: H.L. Hamilton. Photo: Glasgow Museums and Art Galleries)

Morris. In 1903 Newbery invited Alexander Fisher, the prominent enamelling artist trained at South Kensington, then lecturing in Glasgow at the Royal Philosophical Society, to visit the School. Newbery arranged for Fisher to visit Dewar's class probably with the intention of obtaining help from Fisher in an effort to expand both the equipment and scope of the enamelling and metalwork departments. Dewar, who attended Fisher's lecture and found it 'very poetic but not much of the practicall [sic] side . . .' was introduced to Fisher and the next morning he attended her enamel class at the School. He stayed for two hours observing, answering questions ('I must say he really did tell us something!') and criticising the students' work. He was favourably impressed by the standard of work produced, considering the paucity of supplies, particularly for silversmithing. When Dewar explained that the Governors of the School did not want to spend too much money, 'Then,' Fisher replied, 'they cannot expect you to do good and well made up enamels.'[10] The visitor promptly delivered a list of items required to improve the class to Fra Newbery and he also determined to speak to one of the Governors about the situation, no doubt Mr Burnet (the well-known architect) who had accompanied him to the class.[11] The results of the visit were to benefit Dewar and her students for she

wrote: 'Fra gave me a copy of Mr Fisher's report on the enamel class, it was good on the whole but he insisted on our getting more tools as he said it was impossible to work so short handed as we are.'[12] By September of that year the progress occasioned by Fisher's report was evident and not only had new tools, vices and blow-pipes been secured, but changes were also initiated in the department. Dewar noted: 'Our technical rooms have all been lined with wood which will make them much warmer than they were before with just the plain corrugated iron.'[13]

Later that year, Dewar met Alexander Fisher again when she visited him at his studio in South Kensington. He was working on a large commission for a Volunteer Corps in London. Writing to her parents she described the piece saying: 'It is like a huge door with wooden pillars at the side, it is to be covered in the centre with the names of those who fell in South Africa, in beaten copper, there are to be large enamelled shields at the sides, and a crest at the top. . . .'[14] Showing something of her forthright personality, Dewar did not hesitate in criticising the design of the woodwork on the piece despite the possibly intimidating situation:

I did not like the woodwork, neither did Mr Fisher, it was so commonplace although Walter

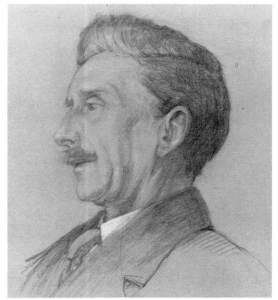

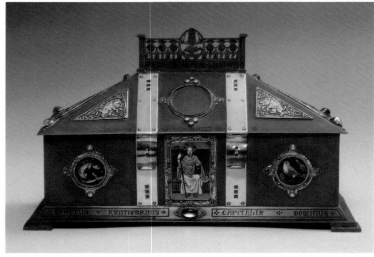

Crane was the designer of it. Mr F said he wished they had given the woodwork to a Glasgow man to do. Of course he meant Mr McIntosh [sic].[15]

The true measure of Dewar's stalwart and determined nature comes to light in the incident later that year when she realised other women teachers at the School were being paid at a higher rate and asked Newbery for an increase in salary. On being offered only one shilling more she resigned her position. In the ensuing confrontation with Newbery he said he did not want her to leave but also told her she was 'conceited' and 'self-confident'. To which Dewar replied: 'If you had not some self-confidence you would not get on.'[16] Newbery claimed the lower salary was due to the fact he was not entirely pleased with the standard of design in the class, but agreed to speak to the Governors for her; Dewar retracted her resignation. Whether or not Newbery's criticisms were justified, Peter Wylie Davidson thought highly enough of Dewar's work to include a piece in his book *Applied Design in the Precious Metals*,[17] which illustrated her *Presentation Casket* (c.1910) (fig. 212) in zinc and silver with moonstones and enamel panels as an example of good design in his chapter on 'Misapplied Ornament'. The casket gained for her the Society of Lady Artists' Lauder Award in 1935. It is in this work, and in her *Silver Cup and Cover* (c.1913) (fig. 206) that we see perhaps the best example of her life-long interest in heraldic art and Celtic design. The works have more affinity with Arts and Crafts

fig. 211
Portrait of Peter Wylie Davidson, De Courcy Lewthwaite Dewar, inscribed: 1st Feb. 1937, pencil, 35.0 × 24.0. (Coll: The Family of P. Wylie Davidson. Photo: Sotheby's)

fig. 212
Presentation Casket with the Arms of Glasgow, c.1910, zinc with enamel plaques, 24.2 × 38.1 × 17.3. (Glasgow Society of Women Artists, on loan to Glasgow Museums and Art Galleries)

metalwork than the designs of her earlier Glasgow Style enamelling and repoussé (figs. 208–210).

In a review of the 1915 'Glasgow School of Art Annual Arts and Crafts Exhibition', we are given an insight into the methods and production in the metalwork department under Dewar and Davidson's collaborative direction:

. . . the teaching is directed towards encouraging the artistic feeling of the worker and provides an outlet for individuality in contrast to the monotony so often found in trade work. The work . . . is executed by the students from start to finish, each distinct operation being the work of one individual student engaged in the production of any object. Sometimes one or more students are associated in the execution of a . . . piece.[18]

Dewar was an astute observer, and her letters to her parents in Ceylon (1903–6) provide documentation of her colleagues, some of whom shared studio premises near her own. Jessie M. King and Nell Paxton Brown were frequent visitors; Dorothy and Olive Carleton Smyth were her principal comrades in design and production of masque costumes; Ann Macbeth, then tutor in embroidery, was helping her with a 'China' silk dress she was making. Macbeth had cut the round yoke of the bodice and drawn on a design of fuchsias to be embroidered in 'green & cream & perhaps a little purply pink.' Dewar wrote: 'Won't it be swagger[?]'.[19] Her account confirms the camaraderie and creative interaction with regular studio and gallery visits, shared exhibitions, group projects, as well as vacation sketching trips and the inevitable tea at Miss Cranston's or at the Society of Lady Artists' Club:

In the afternoon we went to the Fine Art Institute . . . afterwards we went to . . . tea at Miss Cranston's new tea-rooms . . . to the Salon de Lux [sic], which is a beautiful room designed of course by Mr & Mrs Mackintosh.[20]

Dewar's passport is testament to extensive travel; her three journeys round the world with several visits to Ceylon stimulated and influenced her work. She exhibited internationally oil paintings, watercolours and drawings as well as metalwork and enamels.[21] In Italy at the important 'Turin International Exhibition of Decorative Art' in 1902 she was represented with the Scottish Section, where Glasgow's most prominent designers, 'Mr and Mrs Mackintosh and Mr and Mrs MacNair' had been offered their own rooms along with 'the Edinburgh embroiderer, Mrs Traquair'.[22] We know that a piece of her work from this exhibition, an enamelled and decorated panel, was sold, as she refers to it in a letter of 5th April, 1903:

> I have got a notice re the Turin Exhibition, the thing I sold there last summer. I have not been paid for it yet! Now this note is to say the . . . [exhibition] was a financial failure & they are going to take 15% off the price of everything that was sold, isn't it cool? I think no place seems able to run exhibitions successfully except Glasgow.[23]

Meanwhile, in Glasgow she received frequent commissions for her work, and was represented at the Scottish Guild of Handicraft, a labour co-operative association, at 414 Sauchiehall Street,[24] made up of artists 'chiefly of the house and the book' who had banded together to sell their own work 'on their own common account cutting out the middle-man.' A juried organisation, the Guild managed its own workshop for metalwork and their exhibitions featured artists from the whole of Britain including as noted by *The Studio*: 'Ruskin ware and leadless glaze pottery of W. Howson Taylor; and charming . . . lamps by Mr Garrod, London; and of Scottish Artists . . . works by Annie France [sic], Jessie M. King, Helen P. Brown, E. A. Taylor.'[25] Other female members of the Guild included Jessie Newbery, Phoebe Traquair (needlework), Jessie Keppie, J.M. Aitken (jewellery), Agnes Harvey, Ann Macbeth, and Jane Younger.[26]

Dewar's enamel and graphic work is characterised by strong colour and vigorous outline and the Glasgow Style designs from her student and tutorial phase gradually evolved to a more geometric and boldly coloured Czechoslovakian folk-art influenced style that lasted from the 1920s. During the Second World War she was influential in establishing a Scottish-Czechoslovak Club in Glasgow. This involvement is evidenced in her change of style and informed her work. In 1924 she painted one of twenty-three panels for the Forestry Hall at the 'Wembley Exhibition'. Most were done by Edinburgh artists in a general scheme under the direction of Robert Burns. A reviewer noted: 'It is good to know one has been painted by a Glasgow woman—Miss De C. Lewthwaite Dewar, whose exquisite colour work and fine designs are widely known.'[27]

De Courcy Dewar contributed also through her documentation of the Society of Lady Artists' Club. She was the Society's President and in 1950 published its history.[28] Her faithfully maintained journals and letters provide a rare account of a woman designer from the Glasgow Style era. Dating from the early 1900s, her work shows a concern for women's issues and an involvement in the suffrage movement and she designed bookplates, programmes and calendars for suffrage organisations (fig. 42). Committed to documentation of women in the arts throughout Great Britain, she compiled folios on 'British Artists' for the National Council of Women in London with reproductions of art by women and biographies. Her 'war diaries'[29] (1941–45) chart the action of engagement and the action regarding the continuing struggle for women's rights. Active in these accounts as in her early career[30] her life spanned a period in the history of women in art and design which experienced dramatic forward momentum and change. Writing in 1903 she said: 'When the *Glasgow School of Painters* was written there were not any very outstanding women artists in Glasgow, but now things have changed.'[31] Dewar was on the cusp of those changes. She began her career in art at a time when women in Scotland had no suffrage and struggled, with her contemporaries, for the right to equal educational opportunities; for the right to vote as equals with men; for the right to nude models in life drawing classes; for the right to entry into such fields as metalworking, architecture and a host of other areas of art and design which had once been all-male preserves. From her student days when she 'had the temerity to send a silverpoint to the Institute, long before . . . [she] . . . ceased to be a student at the S. of A.'[32] until the end of her life, De Courcy Lewthwaite Dewar stretched the boundaries of the 'possible', often challenging the status quo.

One criticism that has been levelled at her work is that it did not develop sufficiently nor did it focus solely on art and design but was dispersed in the many 'causes' for which she was known in Glasgow. Perhaps one must criticise Dewar's work within the context of the social history of its time accepting that in her lifetime, as with many women in the literary arts from this era, women in the visual arts were consistently faced with barriers to which they were by force of circumstance compelled to respond or acquiesce. Perhaps, too, it must be acknowledged that not all advances in art and design at the turn of the century were necessarily made in the form of objects produced or pictures hung on gallery walls but often in the crossing of boundaries which had been established for women in the arts. Her work was unquestionably diluted and perhaps weakened as a result of these struggles which drained time and energy from the 'art', yet Dewar's contribution as a member of the vanguard of women in the arts in Glasgow as teacher, historian, activist, Glasgow Style metalworker and designer of fine enamels cannot be denied.

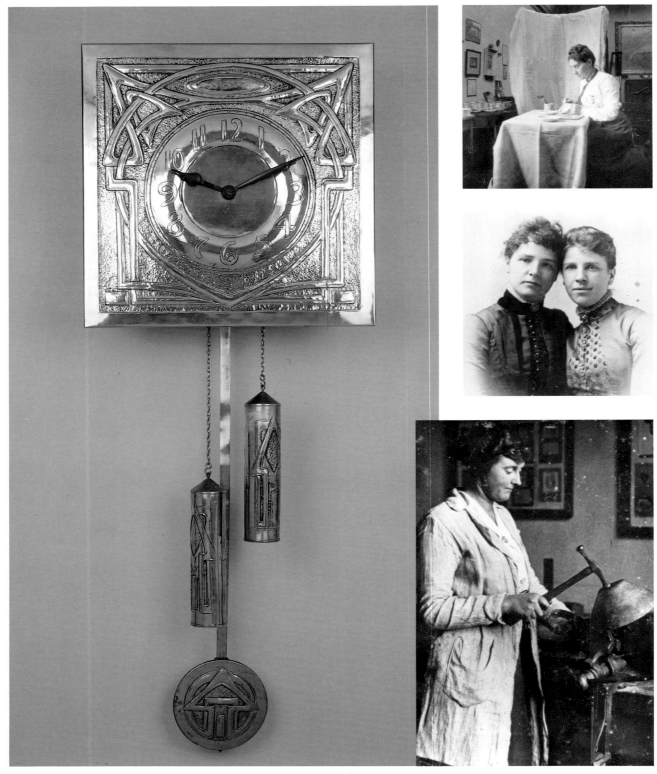

fig. 213
Wall Clock, Margaret Gilmour, tin with design of Celtic interlacing and central plaque of blue enamel, 45.7 square. (Coll: S.I. Jackson. Photo: Glasgow Museums and Art Galleries)

fig. 214 *(top right)*
Helen Walton in her studio, *c.*1900s. (Glasgow Society of Women Artists)

fig. 215 *(centre right)*
Margaret and Mary Gilmour, *c.*1900. (Private Collection. Photo: Glasgow Museums and Art Galleries)

figs. 216 *(lower right)*
Woman metalworker, Glasgow School of Art, *c.*1920s. (Glasgow Museums and Art Galleries)

THE SISTERS' STUDIOS
'THEIR SOLE HANDIWORK'
by Jude Burkhauser

New training opportunities at the Art School for enterprising women, and the increasing number of unmarried women who sought a means of earning their own livelihood, contributed to a phenomenon in Glasgow which might be termed the 'sisters' studios' whereby a number of sister teams set up production studios in various parts of the city. Workshops, places of instruction, exhibition spaces, and retail outlets, the 'sisters' studios' became important points of contact for artists and served as social centres where camaraderie and exchange of ideas took place.[1] *Nouveau riche* Glaswegians who desired to display their new status by embellishing their homes commissioned a range of handcrafted items from these local studios. This increased demand for custom designed interior fittings, windows, and furniture for the upwardly mobile Glasgow home plus Glasgow's buoyant economy supported attempts at self-sufficiency by 'ladies' now striking out on their own, some by necessity and some by choice. The independent studios excelled in repoussé metalwork in a variety of applications, including door and lock plates, fire surrounds, mirror frames, candle sconces, wall panels and furniture insets which contributed to the wide-spread, local influence of the Glasgow Style.

On several occasions *The Studio* magazine sent representatives to Glasgow to visit the studios and to select new works for illustration. Editor Gleeson White's visit to Margaret and Frances Macdonald's studio is well known. After leaving the School of Art in 1894, the Macdonalds shared a studio in Hope Street from 1896 to 1899, where they produced poster designs, embroidered panels, leaded glass designs, and repoussé metalwork (fig. 139). Part of the energetic movement in the decorative arts emanating from Glasgow, their studio hosted many of the major artists and designers of the Glasgow Style movement including Jessie M. King, E.A. Taylor, and Talwin Morris.[2] After his visit, White praised the metalwork of the Macdonalds, expressing surprise that such large items as repoussé mirror surrounds and panels for tearooms were made 'by their sole handiwork'.[3] The Macdonald sisters were not alone.

There were a number of other sister teams and women partners who worked in tandem producing metalwork, ceramics, textiles and jewellery including among others: Margaret and Mary Gilmour, Hannah and Helen Walton, Dorothy and Olive Smyth, and the Begg sisters. All former students at the School of Art, the women had worked in the Decorative Arts Studio, a room 'specially fitted up . . . to give instruction in . . . glass staining, pottery, repoussé and metalwork, wood carving and book-binding, besides artistic needlework

taught by a lady.' At one point in the studio's history the students interacting included: Charles Rennie Mackintosh, Herbert MacNair, the Macdonald sisters, Marion Wilson, Kate Cameron, Jessie M. King, Emily Hutcheson, Agnes Raeburn, and W.G. Morton. The roster, it has been said, read like a Who's Who of the Glasgow Style.[4]

Although her parents subsidised her earliest studio, by 1906 De Courcy Dewar was beginning to find it possible to support herself, earning enough from her salary as a teacher at the School of Art and from commissions for enamel pendants, metal caskets and plaques to consider covering her studio costs herself. Writing in response to her parents' suggestion that she become self-sufficient Dewar replied:

> I think it is a rather good idea of yours making me pay for my Studio rent & taxes, it is really just what I wanted to make me work harder. . . . I think I can quite well do it as I make about £30 a year at the School of Art besides what I make by commission. The latter is not very much or very big yet & varies. Since December this winter I have sold about £18.10, that is exceptional for so short a time & of course is not clear profit as silver and other material has to be bought out of it. . . . This year the studio rent is up £1 & the fire insurance has risen from 6/– to 11/–.[5]

Among the more prominent Glasgow 'sisters' studio' teams were **Margaret Gilmour** (1860–1942) and her sister **Mary Gilmour** (1872–1938) (fig. 215) who by 1893 established a studio at 179 West George Street which they maintained for about fifty years. The Gilmour Studio, well known in downtown Glasgow, attracted a wide variety of craft students, beginners and experienced alike, from the surrounding neighbourhoods, who wished to make useful and beautiful objects for their homes. The Studio taught a range of crafts including metalwork in brass and pewter, embroidery, leatherwork, ceramic decoration, wood carving, wood staining and painting. Although successful and well known in the city, the Gilmours never promoted themselves beyond Glasgow. No doubt they were kept busy enough fulfilling local commissions for an extensive range of household items in the Glasgow Style including mirror surrounds, candle sconces, clock faces, desk sets, jardinières, and fire surrounds, many perhaps intended as bridal gifts for it was unusual for a couple in Glasgow *not* to receive artistic brassware as a wedding gift at that time.[6] The Gilmours' metalwork bears a characteristic style often inset with jewel-like beads of enamel as seen in a white metal wall clock executed in repoussé with Celtic interlacing enhanced by a

central bead of blue enamel (fig. 213). The quality of their craftsmanship and competence in finely wrought finishing is seen in their brass desk set also with a Celtic motif. Daughters of John Gilmour, a muslin merchant, and Jean Anderson, from Paisley, the Gilmour sisters were from a family of eleven children. Prolific and accomplished craftswomen, Margaret Gilmour had her own display of beaten brass and copperwork at the '1901 Glasgow International Exhibition' and was principal designer for the studio while her younger sister, Mary Ann Bell Gilmour, did more production work and the third sister, Agnes, kept the accounts.

fig. 217
Brass Alms dish with enamel insets, Mary Gilmour, exhibited at 'Glasgow International Exhibition', 1901, signed: MG, circular diameter 58.0, height 3.3. (Glasgow Museums and Art Galleries)

The **Begg Sisters**, another set of Glasgow's multi-talented craftswomen, were also part of a large family of five sisters and two brothers and all of the women—Grace, Mary S., Isabella, Jean and Annie—were accomplished artists working in the Glasgow Style. We know little about their lives and although only one sister, Mary S. Begg, received formal art training at the Glasgow School of Art, each of the sisters worked artistically in embroidery (fig. 218), and several of them practised wood carving, woodburning, and painting. Mary Strachan Begg (always known as Mary S. Begg) attended Saturday morning classes at the Glasgow School of Art. She was a pupil/teacher from the age of sixteen specialising in embroidery, painting and carving.[7]

Constance, Hannah and **Helen Walton** (fig. 214) a three sister team, were daughters of painter Jackson Walton, and produced Glasgow Style art and design objects. While Constance painted fine watercolour and

fig. 218
Fuchsia Tea Cosy, Mary Begg, embroidered silk, twentieth-century. (Glasgow Museums and Art Galleries)

oil pictures, Hannah and Helen Walton decorated ceramics and glassware. Their youngest brother George Walton was a successful designer commissioned by Miss Cranston to decorate her Argyle and Buchanan Street tea-rooms. George Walton established a reputation as an ecclesiastical and house decorator who later fulfilled commissions for private and commercial patrons, including stained glass windows for Glasgow shipping magnate William Burrell and a series of shop interiors for Kodak. Hannah Walton (1863–1940), a skilful miniaturist exhibited with Helen Walton (1850–1921) at the 'Glasgow International Exhibition' in 1888. They taught throughout the 1890s in a studio in their residence in Glasgow. Helen taught ceramic design and decoration at the Art School between 1893 and 1904.[8] The Walton sisters' finely detailed glassware with hand painted insects, figures and flowers and painted ceramic ware with various florid motifs are easily distinguished (fig. 219).

Another extremely versatile sister team was Rose, Dorothy and Olive Carleton Smyth, the latter who, between them, worked in a variety of applied art media

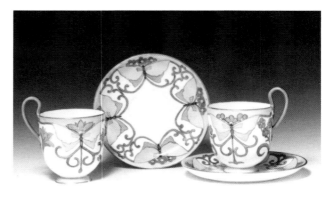

fig. 219
Tea set, Helen Walton, 1905–10, porcelain, overglaze decoration. (Glasgow Museums and Art Galleries)

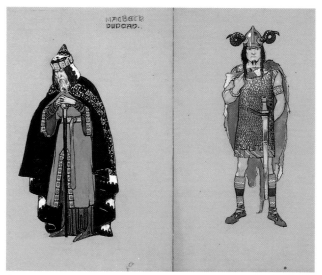

fig. 220
left: Duncan, costume drawing for *Macbeth*, Dorothy Carleton Smyth, *c*.1900s, chalk and watercolour on paper.
right: Horned figure, costume drawing for *Macbeth*, *c*.1900s, chalk and watercolour on paper. (Glasgow School of Art)

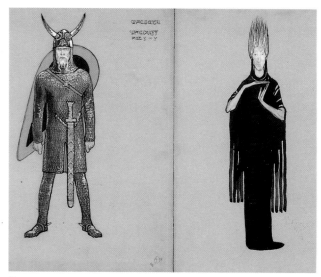

fig. 221
left: MacDuff, costume design for *Macbeth*, Dorothy Carleton Smyth, *c*.1900s, watercolour and chalk.
right: Witch number 2, costume design for *Macbeth*, *c*.1900s, watercolour and chalk. (Glasgow School of Art)

including gesso, fresco painting, sgraffito, illumination on vellum, black and white work, and textiles. As representative examples of this period of women in design it is interesting to examine the Smyth sisters' careers more closely. **Dorothy Carleton Smyth** (1880–1933) (fig. 304), multi-talented and versatile, excelled in costume design and worked into the 1920s for theatrical productions in London, Sweden and Paris. Smyth was selected to serve as the chief of decoration and stage costume for the world tour of the Quinlan Opera Company (*c*.1916) and designed for a number of Shakespearean Festivals in Stratford-upon-Avon, the first in March 1906 for the F.R. Benson Company. Her London stage career included costume design for productions of *Richard III*, *Othello*, *Carnival* and for a controversial new staging of *A Midsummer Night's Dream*. Early in her career however she was a portraitist specialising in sketches of well-known theatre personalities, known in Glasgow art circles for her fine drawings and paintings.

Born in Glasgow of Irish and French heritage with family origins in Fife the Smyths were daughters of jute manufacturer, William Hugh Smyth and Elizabeth Ramage. Dorothy's sisters Olive, an artist, and Rose, a composer, were her lifelong companions. Described as a 'dark, vivid type', original in all she touched, 'not the least so in the artistic clothes she designs for herself'; Dorothy Smyth's principal interest as a student at Glasgow School of Art was theatre and costume design, although she worked in stained glass, sculpture, drawing and painting. Her fascination with exotic clothes combined with a love of the theatre, drew her into involvement with costume design for the 'sagas' or masques that were so prominent a part of art school life.

In 1906 Smyth produced a 'miracle play' to benefit a local mission 'across the river' for which she designed and made the costumes. Fra Newbery and Charles Rennie Mackintosh attended the performance in the 'very bare hall . . . with rough brick walls' which Mackintosh then offered to 'drench' with Newbery paying the expenses.[9]

Dorothy Smyth first studied art in Manchester but attended the Glasgow School of Art from 1898 until 1905. A product of Newbery's decorative arts studio, she exhibited her stained glass window, *Tristan and Iseult* (*c*.1901) (fig. 76), at the 'Glasgow 1901 International Exhibition' and showed a painting of a 'card-playing group' in the Glasgow School of Art Club exhibition that year which received favourable reviews for its technique and was commended as being 'especially . . . effective and original'.[10]

Smyth had several patrons early in her career; a Dr Oswald from Glasgow, who had begun to follow her career with interest by 1902, commissioned two portraits and in 1903 an anonymous lady with a 'desire to further [Smyth's] painting' decided to sponsor her study abroad. Not only had the woman patron paid for the young artist's membership to the Glasgow Society of Lady Artists' Club, and to an artists' club in Paris, but she also funded her trip to Paris, Italy and Switzerland. Smyth thought she would go only to Paris, but was advised by the sometimes domineering Newbery to stay in Florence instead as he said it would do her more good. Perhaps this was because of Newbery's contact there, Signor Fernando Agnoletti who had worked in Glasgow and assisted Newbery in Italy with the Turin 1902 Exhibition. Agnoletti tutored De Courcy Dewar and 'Nell' Paxton

Brown and was translator for Delville whom Newbery hired although he spoke no English. Smyth, redirected by Newbery, went to Florence staying with Signor and Signora Agnoletti. Paris must have interested her, despite Newbery's admonition, as she spent two weeks there on her way home and, although she had done no work, upon her return she remarked that she had 'just absorbed'.

By September 1903, Smyth's portraiture caught the eye of Glasgow dealer Craibe Angus who had 'taken quite a fancy to her work' and offered her a 'one man show'. One of Smyth's closest friends was Dewar whose studio was a frequent meeting place and a useful 'loaner':

> . . . Dorothy and I went into Craibe Anguses. Dorothy had come up to ask me for the lone [sic] of my studio some day as she has got a commission, through [him], to paint a gentleman's portrait, so we went into the dealer's to say it could be managed.[11]

Smyth's commission, perhaps, was to depict Martin Harvey as Dewar later mentioned she had 'done a clever sketch of . . . Harvey as Sidney Carton' adding 'she is very keen on anything theatrical & is beginning to look rather theatrical herself . . . she has been starring it in the boxes lately.'[12]

In December Smyth exhibited two watercolour sketches of Ellen Terry (as Portia and as Nance Oldfield), and one of Louis Waller as Monsieur Beaucaire plus a sketch of Fred Terry in Angus' gallery. Smyth was introduced to Ellen Terry by Angus when Terry visited the gallery to view work by her son, Gordon Craig, which Angus was exhibiting. Louis Waller was appearing in the play Monsieur Beaucaire and Smyth arranged sittings in the artists' dressing rooms when they were rehearsing at the Theatre Royal and Royalty in Glasgow that year. The sketches, done on brown paper, were said to have been 'treated in a strikingly original manner'.[13] Smyth took advantage of the fact that in autumn some of the best known actors and actresses from the South visited Glasgow and in her series of portraits included Jennie Taggart, the singer, and actor George Alexander.[14]

By March 1906, Smyth had been principal costume designer for several School masques. At a tea party at the Lady Artists' Club she was introduced to F.R. Benson a Shakespearean producer who asked her to show him her costume designs (figs. 220–221). Smyth's costumes were her 'forte'. She was ingenious at making dresses out of cheap material that according to Dewar, 'looked gorgeous'.[15] Smyth showed Benson the designs at the theatre on Saturday and received a letter from him Monday morning with a formal offer of appointment for his Shakespearean tour ending up with the festival at Stratford-upon-Avon. She was to be paid £2.10 weekly plus travelling expenses and Newbery, Craibe Angus and Athenaeum theatrical director,

Mr Graham Price, all helped her 'arrange matters'. It was not much money, but Smyth saw it as an opening into the London theatre world through a ring of costume designers which was 'difficult to break through'. Benson liked her work enough to ask that she plan to stay with him the following year, but Dewar cautioned her friend to 'see how she liked this short trial first.'[16]

Benson's was a touring company and Smyth, young and inexperienced, found him 'considerate of his people' and protective when arriving in a new town.[17] The experience was a positive one and although she promised Benson she would return the following year he encouraged her to return sooner. Smyth's mother, however, was 'not very keen on it' as she feared it would 'mean the breaking up of their home if Dorothy went away'.[18] Although Smyth did not return that year eventually she returned to theatre work and spent a number of years in Paris and Stockholm as designer and producer. But she did not find the way of life enjoyable. When asked once why she did not continue in this line, she replied that '£2000 a year would not tempt [her] to have anything to do again with the bickerings of operatic life.'[19]

In 1910 she worked for Matheson Lang's London company designing costumes in collaboration with 'Ferris', located at 29 Pelham Place, London, for Lang's production of Othello at the New Theatre. In that same year she worked for Martin Harvey's production of Shakespeare's Richard III appearing at the Lyceum Theatre for which she designed and executed the costumes. Her designs were competent and well received but her most noteworthy costumes were produced for Mr Granville Barker's production of A Midsummer Night's Dream (figs. 222–223), in February 1914 at the Savoy. In fact, the costumes for the production received more notice than the performance 'arousing much interest' for their unconventionality. They were influenced by the exotic designs of Leon Bakst and his costumes for Diaghilev's Ballet Russes with their daring colours and oriental motifs. The costumes, accused of 'Orientalising Shakespeare's fairies', were compared to Bakst: 'Anyhow they look like Cambodian idols and posture like Nijinsky in Le Dieu Bleu.'[20] Startled by the fact they were all gold (fig. 224) with the exception of 'one blob of scarlet—Puck', critics saw the production as original and unusual bearing the 'hall mark of the new theatre . . . impregnated by the note of Futurism.'[21]

Later in 1914 Smyth became Principal of Commercial Art at the School of Art teaching miniature painting and the history of costume and armour. From this time her career centred on teaching rather than professional theatre. From 1902 Smyth exhibited regularly with the Glasgow Society of Lady Artists in addition to showing with her dealer, Craibe Angus; a gesso panel by her was shown at the 'Scottish National Exhibition'; and she was represented in Turin, Cork,

Toronto and Budapest with the School of Art exhibits. A successful book illustrator, she contributed to de luxe editions of Stevenson, Kipling and Shakespeare. In addition she designed stone carvings and bronzes for the Greenock War Memorial, and developed a wide reputation through her writings and lectures. As 'Paint Box Pixie', she broadcast art talks for children on the BBC. She was appointed the first woman director of the Glasgow School of Art in 1933 but died suddenly of a cerebral haemorrhage before she could assume the post. An obituary notice said of her, 'The sudden death of Miss Dorothy Carleton Smyth has taken away one of Scotland's most original and brilliant artists.'[22]

fig. 224
Costume design produced by Dorothy Carleton Smyth for *Midsummer Night's Dream*, 1914, the Savoy Theatre. (By Courtesy of the Trustees of the Theatre Museum, Victoria & Albert Museum, London)

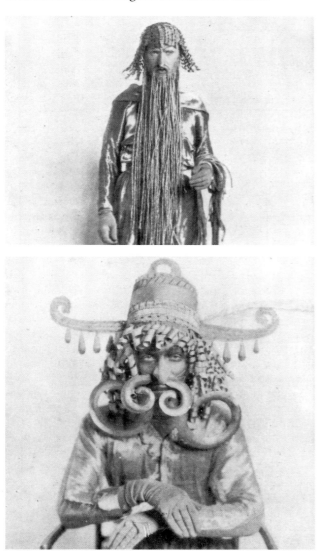

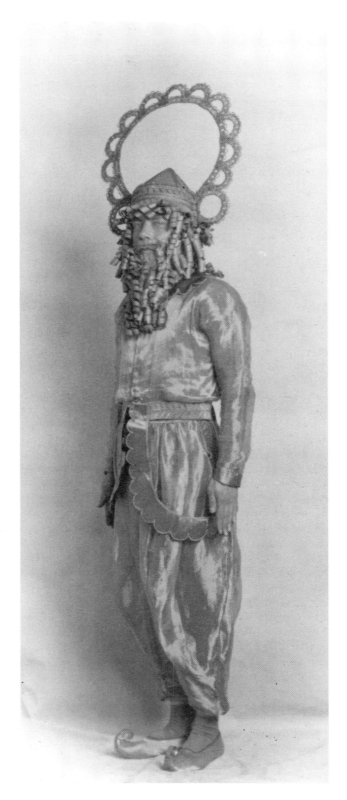

figs. 222–223
Costume designs produced by Dorothy Carleton Smyth for *Midsummer Night's Dream*, Dorothy Carleton Smyth, 1914. The Savoy Theatre programme credits read: 'The management owes many thanks to Victor Maclure for painting the Scenery; to Miss Dorothy Carleton Smyth, Mrs Owen and Mr Savage for making the Dresses . . . ' Critics considered them 'futuristic'. (By Courtesy of the Trustees of the Theatre Museum, Victoria & Albert Museum, London)

Another talented sister in this remarkable team was **Olive Carleton Smyth** (1882-1949) and although a few excellent examples of her work remain, not much has been recorded of her life. Also born in Glasgow, she attended the School of Art from 1900 until 1909 and worked as illuminator, decorator, gesso and fresco artist. Smyth was recruited as a tutor while still a student by Newbery for his studio classes where she taught sgraffito, illumination and gesso from 1902 to 1914. As a young art student, Smyth was a frequent visitor to De Courcy Dewar's studio and an active member of the coterie of women from the art school recorded in Dewar's private letters. She worked with her sister Dorothy and Dewar on the masques and was sketched by Dewar in one of her masque costumes. Olive Smyth shared her sister's enthusiasm for theatrical life and at one point was 'seriously thinking of taking it up.'[23] In 1906 while Dorothy Smyth joined the Benson company to design costumes for their Shakespearean tour, Olive assisted American actress, Mrs Ross Whytell, in the organisation of a benefit matinée performance in Glasgow for the victims of the San Francisco earthquake. On the day of the performance, 'a lot of School of Art girls' including the daughters of Fra and Jessie Newbery and the American consul, were at the theatre selling programmes (designed by Jessie M. King), tea and flowers.[24]

Gesso was just one medium in which Olive Smyth worked. She may have been influenced by Margaret Macdonald, a member of the preceding generation of art school women, whose large scale public commissions must have provided an important model. Smyth and her friends frequented the Willow Tea Room Salon de Luxe, designed by Mackintosh in collaboration with Macdonald, and the gesso at the Willow may have inspired the young artist who shared Macdonald's enthusiasm for the medium. Smyth surely knew of Macdonald's work and we know there was personal contact between Olive Smyth and Margaret Macdonald, for Smyth's portrait of Macdonald is one of the few works by her to have survived and one of the only known portraits of the artist. The work portrays Macdonald in profile with a characteristic arrangement of twisted branches similar to those shown in the *Rose Boudoir* in Turin in 1902. Both artists exhibited in Turin and both were to spend considerable time in France. Their work also shares an affinity with that of the Vienna Secessionist Gustav Klimt in the employment of jewel-like highlights, and in shared design motifs particularly the Japanese-inspired use of patterned clothing as a design element, exemplified in one of Smyth's later paintings entitled *Pythias Buys Amber* (1927) (fig. 228). An exquisite work from around the same time *The Guardiani* (c.1925) (fig. 229) also shows her consistent use of Celtic design. Both of these splendidly detailed paintings are on vellum in body colour with metallic highlights and are among the best of Olive Smyth's known works. Her amazing

fig. 225
The Seventh Day, Olive Carleton Smyth, c.1920s, body colour on vellum, 43.3 × 66.1. (Coll: Robert Lawrence, Gallery '25, London. Photo: Sotheby's)

precision and ability to render minute detail in a manner similar to Jessie M. King is remarkable.

In addition to showing her work in Turin in 1902, Smyth contributed to School of Art exhibitions in Cork and Toronto. In 1905 she became a member of the Glasgow Society of Lady Artists' Club frequently exhibiting with her sister and their friends Dewar, King and Paxton Brown. Smyth found ample exhibition opportunities and acceptance for her work abroad, particularly in France, but although she exhibited in group shows, it was not until 1937 that she had her first solo exhibition in Glasgow.[25] Her work was shown in the Paris Salon of 1913, the year before she gave up her job as tutor in gesso and illumination at the School of Art. This work entitled *Peer Gynt* (c.1912) was purchased on the opening day for a private collection of 'standing'. It is possibly a variation on the *Pen Gynt* [sic] now thought to be *Peer Gynt*, which was purchased from a 1912 exhibition in Toronto, Canada, which shows four mounted knights in armour with a fifth standing figure now in the collection of the National Gallery of Canada, Ottowa.[26] Another drawing on vellum, a technique she said 'gave the effect of figures drawn on ivory',[27] was exhibited at the Royal Academy and sold on the first day of the exhibition. In 1913 Smyth showed a similar work in the School of Art Club exhibition at the Institute described by the critic as 'tinted on vellum' and 'about as splendid as Beardsley could have done, but making Omar's little girl look as wicked as Salome, which is too bad'.[28] We do not know the title of the finely detailed work illustrated (fig. 227) but it may well be similar to, if not, the vellum drawing mentioned which is now in a private collection. Several of Smyth's drawings were illustrated in *The Studio*, and her international reputation was enhanced by exhibitions in Paris and Munich, and the purchase of works by galleries in Canada and Tokyo. In 1917 Smyth was selected to contribute to the Fine Arts Section of the Foire de Lyon, France. Her exhibit was a

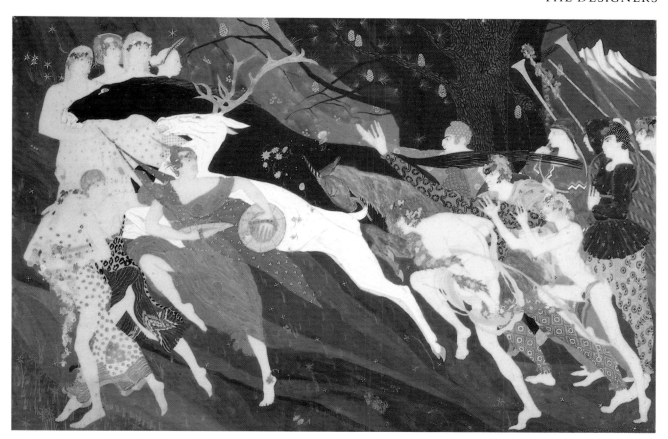

Celtic subject, *The Two Hunters of Terg Thoun* (*c.*1917) and was the only work by a British exhibitor in the section of this 'invited' show.[29] Listed in the 1927 and 1934 editions of *Who's Who in Art*, one of her works, *Bacchanale* (*c.*1929) (fig. 226) was presented to the Paisley Art Gallery in 1929.

Olive Smyth was described by a Glasgow art critic in the late 1930s as 'small, fast talking and tweed-suited'.[30] She was an effective teacher, both at Westbourne School for Girls and at the Art School, and early in her career one of her pupils, Miss Jean Arthur, then fifteen years of age, had one of her pictures entitled *Orchids* (*c.*1914) accepted by the Royal Scottish Academy. It was said that she was the youngest exhibitor.[31] Smyth was appointed head of the Design Department at the School of Art after the death of her sister Dorothy in 1933. Her 1937 one-woman retrospective exhibition showed art deco influence in bold design and bright colour and the variety of media and treatment were commended for their skill and accomplishment and included portraiture and figure subjects in oils, frescoes, mosaics, illuminations, drawings in black and white, and woodcuts.

One of Smyth's watercolours was sold in auction in Edinburgh in 1986 and several others have been located in private collections in the USA and Britain. Dorothy

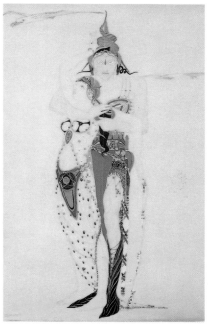

fig. 226 *(top)*
Bacchanale, Olive Carleton Smyth, 1929, gouache and gold paint on vellum, 47.0 × 63.0, gift to museum in 1929. (Coll: Paisley Museum and Art Gallery. Photo: Glasgow Museums and Art Galleries)

fig. 227
Two figures with Seagull, Olive Carleton Smyth, *c.*1913, drawing, ink and tempera on vellum, unframed, 28.7 × 18.0. (Coll: Mrs Lena Fleming. Photo: Glasgow Museums and Art Galleries)

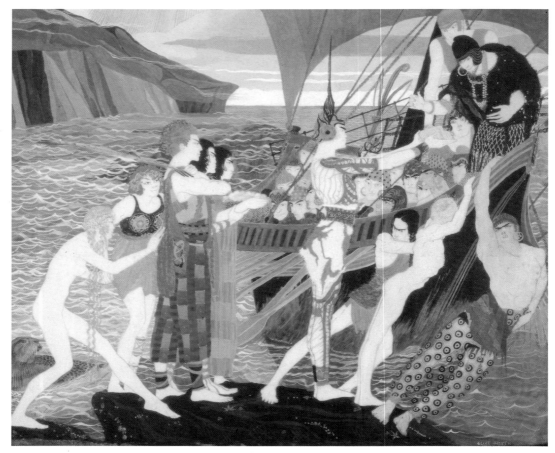

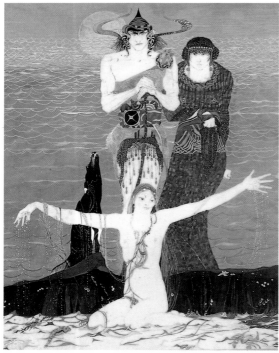

Smyth, seldom separated from her sister in life was, fittingly, also represented in the sale with her water-colour of a pierrot done in the style of Bakst. The Smyths are, perhaps, the best representatives of the versatile and multi-talented 'sisters' from the late Glasgow Style era whose work carried on into the 1920s and 1930s. They practised a wide range of design arts, often simultaneously, with remarkable skill. Having retired her post in the School of Art to her successor Tom Purvis in 1937, Olive Carleton Smyth died in 1949 at Cambuslang, in the family home she had long shared with her sisters.

In addition to natal sisters involved in the movement there were a number of 'other sisters' who, although unrelated by birth, worked in shared studios in production of Glasgow Style objects. The collective spirit that early enlivened the designs of 'the Four' was a pervasive influence and many other designer teams formed deep and lasting partnerships. They encouraged each other in their art, collaborated on projects and were frequently lifelong companions. Just one example of such a shared studio is that of Jessie M. King and Helen Paxton Brown.

fig. 228 *(top)*
Pytheas Buys Amber, Olive Carleton Smyth, 1927, body colour on vellum, 33.6 × 39.4. (Coll: Robert Lawrence, Gallery '25, London. Photo: Sotheby's)

fig. 229 *(left)*
The Guardiani, Olive Carleton Smyth, 1925, body colour on vellum, 31.1 × 25.5. (Coll: Robert Lawrence, Gallery '25, London. Photo: Sotheby's)

Helen Paxton Brown (1876–1956), or 'Nell', a Glasgow native who excelled in embroidery, was the lifelong colleague of Jessie M. King. From their student days until King married artist/designer E.A. Taylor, the women shared a studio flat at the top of an insurance building at 101 St Vincent Street (c.1898 to 1907). The women's friendship was strong and long-lasting. Even a disturbance such as King's inadvertently locking Paxton Brown out of their studio one weekend could not endanger it—mutual artist-friend, De Courcy Dewar, wrote in 1903: 'Nell came up to my studio afterwards for a little as Jessie was off to the Highlands & has taken their studio key with her.'[32] The pair were inseparable companions during school and on weekend cycling trips.

At the time Paxton Brown and King shared their studio in Glasgow, King's career evolved rapidly and she exhibited internationally in the 'Venice Biennale' (1899), and the 'Turin International Exhibition of Decorative Arts' (1902). By 1903, King was preparing for a one-woman exhibition in Berlin, providing illustrations for major publishers such as Dent and bindings for Chivers in Bath and MacLehose in Glasgow, while her studio mate, Paxton Brown, was painting and just beginning to secure commercial art commissions. Dewar, their teaching colleague at the School of Art, often mentions Paxton Brown in her letters as visitor to her studio, comrade for sketching excursions, gallery visits, exhibition tours, theatre performances and afternoon 'tea at Miss Cranston's', as well as a confidante and adviser. One of Dewar's letters reveals the women also served as models for each other's drawing:

> . . . called in for a minute or two at Nell and Jessie's studio. They were both in and Nell was quite busy. I am glad she is working now as she is clever and I think only needed a good start. She was designing a cover for the *Girl's Realm* and had some other book on. She goes down to London at the end of this week to interview some editors. Both she and Jessie have had very good introductions to Dent and several other well known publishers. Jessie has illustrated several books for Dent. You will see two of Nell's sketches in this month's No. of *The Studio*. 'The Rose' a sketch of Jessie in her grand-mother's dress. . . .[33]

The article in *The Studio* preceding the drawings was a feature on Glasgow's new tea-room décor by Mackintosh and Margaret Macdonald. Their new works, gesso panels which had been exhibited in the 'Vienna 1900 Secession Exhibition', *The May Queen* (c.1900) and *The Wassail* (c.1900), were now adorning Miss Cranston's Ingram Street Tea Rooms. Along with illustrations of interior views of and praise for the Mackintoshes' work was the notice of Paxton Brown and her two drawings seen as the work of 'a clever and rising young artist'.[34]

Paxton Brown's trip to London to secure commercial work was successful as she sold the *Girl's Realm* (c.1904) cover and returned with a second assignment, a 'head piece' and 'two stories to illustrate'.[35] Later that year, she travelled to Paris as she would frequently throughout her life. Paxton Brown was earnestly interested in painting and both she and Jessie M. King were elected to membership of the breakaway group, 'The Glasgow Society of Artists', started by physician and artist Alexander Frew, the husband of painter Bessie MacNicol. Although not long-lived, the organisation provided an alternative to the Glasgow art establishment for those painters dissatisfied with the all male Glasgow Art Club. Dewar informs us:

> . . . in the afternoon I went to the Private View of the 'Glasgow Society of Artists'. You will remember this club was started about a year ago by some of the younger men who thought they did not get justice in the Art Club. Only painters belong to it, Jessie [M. King] and Nell [Paxton Brown] are in it. . . .[36]

Although Paxton Brown's artwork had received early notice,[37] from 1900 until the early 1920s there are few reviews of her work recorded. King went on to achieve international recognition and notice in those years, yet the divergent paths of their respective careers did not affect their longstanding friendship.

A talented needlewoman, Paxton Brown was appointed instructress to the 91D classes (Article 55 Classes) in 'art embroidery' for the teachers' diploma programme at the School of Art in 1904 and continued to teach in the Saturday classes until 1907. Under the tutelage of Jessie Newbery and Ann Macbeth, embroidery had emerged from being a minor subject to the most important craft then taught at the School achieving international recognition. From 1907, a separate section of the Annual Report was devoted to the Embroidery Department. From 1911 to 1913 Paxton Brown returned to the School as a teacher of bookbinding.

Paxton Brown was actively involved with the Lady Artists' Club from 1908 until the late 1940s, often co-exhibiting with King. From the 1920s she regularly exhibited figurative drawings, landscapes, oil portraits, and what she called 'snapshots'—watercolour sketches of children done in sittings of twenty-five minutes. In the 1920s her work, like that of King, became concerned with the use of bright colour and bold form which she employed in embroideries and paintings. In 1925 she was commissioned to paint twelve Nursery Rhyme panels for Mount Blow in Dalmuir, the institution under the Glasgow Corporation Child Welfare Scheme. Each panel was large and depicted a different nursery rhyme. Public institutional murals were enjoying some focus in the region and both Jessie M. King and E.A. Taylor designed murals for public buildings, including schools, about this time.

Demonstrating their unconventional and controversial new use of colour Paxton Brown and King devised a joint exhibition at the 'Club', 'Spring In Three Rooms', (April 1931) (fig. 230), which would show their critics how full colour could be employed in home decoration. The pair transformed three rooms, using brilliantly coloured carpets, batik and embroidered curtains, hand painted crockery, and two suites of bedroom furniture made to the artists' designs which were painted in plain bright colours—daffodil yellow and cream and green. The addition of a wall frieze in linen, illustrations and watercolours completed the scheme.[38] This modern use of colour in interior decoration and concern for the totally conceived design environment was too progressive for contemporary Glasgow's dark stained furnishings and the artists found little sympathy for their interior design concepts. In 1932 they again mounted a two-woman show of their work called 'Ten Days In May' at the 'Club' Gallery exhibiting hand painted pottery, pictures, dressing table sets, decorative ware and embroidery. Their May 1935 exhibition, entitled 'Youth's The Stuff', included embroideries by Paxton Brown and King's newest ideas for a line of wooden artist-designed toys.[39] Paxton Brown exhibited almost annually at the 'Club' from this point focusing on embroidered textiles that were seen by one critic as 'brilliant essays in colour'.[40] Despite her seemingly prolific output in embroidery and painting, in the 1980 retrospective exhibition, 'Glasgow School of Art Embroidery', no examples of her work could be found. Most fittingly, perhaps, one pastel drawing which does remain is an excellent portrait of Jessie M. King (fig. 231).

JANE YOUNGER

by Anne Ellis

Jane Younger (1863–1955) also recognised the benefits of shared working space. From 1906 until the war in 1914, she shared a West George Street studio with designer Annie French. Bookplates by both artists demonstrate not only how closely the two women worked together, but also their stylistic affinity with the rest of the group. A former Park School girl, and contemporary of Mackintosh and the Macdonald sisters at Glasgow School of Art, Younger stands near Fra Newbery and Frances Macdonald in a class photograph taken about 1894. Like many of her 'sisters', she studied watercolour techniques and attended Jessie Newbery's embroidery classes.

Remembered by her family as an adventurous young woman, 'quite a rebel', Younger was devoted to painting. Perhaps her devotion to art developed as an antidote to a progressive deafness which was to become profound in later years, when communication was only possible through a note-pad which she kept by her at all times. Yet her disability did not prevent her entering art school, nor going alone to Paris in the nineties, nor making various lone sketching trips abroad, brave

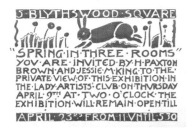

fig. 230 *(top)*
Spring in Three Rooms, a card for the Glasgow Society of Lady Artists' exhibition, Jessie M. King and Helen 'Nell' Paxton Brown, April 1931, 10.9 × 14.6. (Coll: Barclay Lennie Fine Art Ltd. Photo: Glasgow Museums and Art Galleries)

ventures for an unaccompanied young lady at the turn of the century.

Younger's interest in bookplates is not surprising, considering her family connection to the Blackie publishing firm. Younger's sister, Anna married the publisher Walter W. Blackie in 1889, so Jane had every opportunity and encouragement to follow her interest in this art form. Blackie's firm specialised in 'Prize Books' and specially-designed bookplates were important in the educational and children's book section of the business. As a fellow student, she was also in a position to recommend Mackintosh's work to her brother-in-law, who was looking for an architect to design a house in Helensburgh. Normally, and quite rightly, the credit for their actual introduction goes to Talwin Morris, a close friend of the Macdonald sisters, and Blackie's Chief of Graphics, but Younger would have been well acquainted with Mackintosh's designs. She certainly admired them to the extent that she sent him some of her own work, seeking his opinion on it. His reply to her letter, which is mildly encouraging but very formal, hangs at the Hill House.

Younger accompanied Anna and Walter Blackie on their tour of Northern Italy and Switzerland in 1902, the year Mackintosh began work on the Hill House. It was also the year of the Turin Exhibition; Jane Younger exhibited there, so too did Blackie's firm, entering several books illustrated by Talwin Morris. It is quite probable that the Blackies and Miss Younger attended the exhibition, though it is not specifically mentioned in the diary of their journey. The portières exhibited by Younger at Turin are very similar in style to the original curtains designed by Margaret Macdonald Mackintosh for the drawing room at Hill House. Younger designed several pieces for the house, including bedspreads, one of which is now in the guest room. The cover for the window seat (now badly faded) also looks like Younger's work, but its origin is uncertain and more than likely done by Macdonald Mackintosh.[41] A watercolour of the garden by Jane Younger also hangs in the house and shows how her painting developed along completely different lines from the stylised manner of her purely decorative pieces. Presumably, Younger felt that there was a difference between 'pure art' and decoration. Landscape paintings done slightly later allow further comparison between the tightly organised and stylised manner she used in her decorative pieces and her looser, more impressionistic painting style. A bookplate by her studio-mate Annie French, was designed for Younger and placed in a copy of *The History of the Glasgow Society of Lady Artists' Club* of which she was a member.

fig. 231 *(centre opposite)*
Jessie M. King, Helen Paxton Brown, 1902, ink, chalk, watercolour, 21.5 × 16.0. (Coll: Jean Wannop. Photo: Glasgow Museums and Art Galleries)

fig. 232 *(lower opposite)*
The Garden Gate, Jane Younger, watercolour, c.1900, 69.9 × 54.1. (Coll: Ruth Currie. Photo: Glasgow Museums and Art Galleries)

The Younger family, involved in the cotton trade, were respected and prosperous residents of the Woodland area of the city. In the Glasgow Necropolis, a gravestone designed by Jane Younger marks the site of the family tomb.

fig. 233
Jessie M. King at the Gate of the Green Gate Close, 1949.

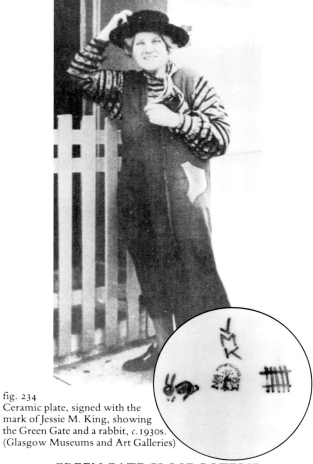

fig. 234
Ceramic plate, signed with the mark of Jessie M. King, showing the Green Gate and a rabbit, c.1930s. (Glasgow Museums and Art Galleries)

GREEN GATE CLOSE COTERIE

by Jude Burkhauser and Bille Wickre

This 'sister studio' phenomenon was not restricted to Glasgow for women shared studios or worked in informally organised groups throughout the United Kingdom. As in the case of the Glasgow Boys, 'Glasgow Girls' were not geographically limited to Glasgow, but settled in other parts of the country taking their particular style of work with them. One example of this migration was a group of women artists working in what contemporary writers called the 'Green Gate Close Coterie' in Kirkcudbright (fig. 236). Either permanent residents of the village, or long term visitors, the women were attracted by the artistic environment and unspoiled beauty of the place. The 'coterie' included: Jessie M. King, Helen Paxton Brown, Mary Thew, Marion Harvey, Anna Hotchkis, Agnes Harvey, and other Glasgow trained artists.

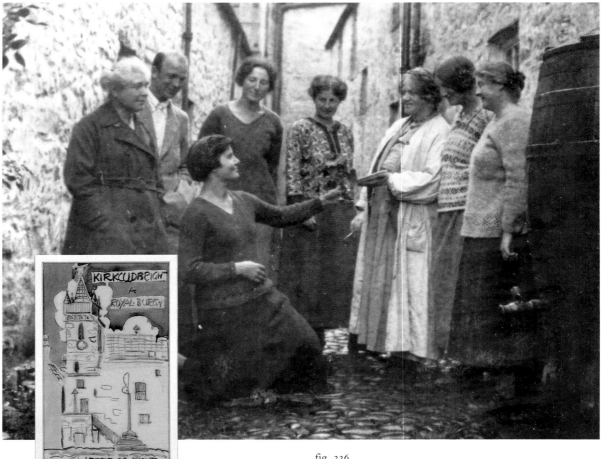

fig. 235 *(inset)*
Kirkcudbright: A Royal Burgh, designed by Jesssie M. King, published by Gowans and Gray, Ltd., 1934. (Coll: Barclay Lennie Fine Art Ltd. Photo: Glasgow Museums and Art Galleries)

fig. 236
Members of The Green Gate Close Coterie, *c*.1925, left to right: unknown, Miles Johnson, Dorothy Johnson (née Nesbit, kneeling), Anna Hotchkis, Isabel Hotchkis, Jessie M. King, Dorothy Sutherland (née Johnstone) at Kirkcudbright. (Glasgow Museums and Art Galleries)

Although physically absent from Glasgow, they maintained close ties with the city, participating in art organisations, and exhibiting in major exhibitions and small galleries. Some of them lived part of the year in Glasgow and part in Kirkcudbright.

When Jessie M. King and E.A. Taylor settled in Kirkcudbright, the small town in southwest Scotland known as an artistic centre throughout Britain, there were at least fifty practising artists in residence.[42] The town was sometimes compared to Italy in terms of the quality of its light and atmosphere. An *Evening News* article on women artists of southern Scotland, stated: 'The light here is a wonderful thing. Even when it rains, it remains luminous—I remember the same effect when I stepped out into the porch at Milan cathedral and looked over the Square swimming in light. . . . '[43] King had purchased the Green Gate (fig. 233), an eighteenth-century house, servants' cottages and outbuildings, in 1908. In 1913, King and Taylor converted the large barn to a studio, and restored the cottages to be rented out to artists.[44] Soon the artistic

coterie at Green Gate Close was formed. King felt rejuvenated and inspired in Kirkcudbright, 'The Little Town of Never-Weary', and the stimulation of contact with other artists, among them E.A. Hornel, was useful to her work. She wrote: 'I think it was a happy wind which blew me to Kirkcudbright . . . and a happier chance which elected to show us a dwelling where one might nest . . . my gratitude is to it and its fair welcome so human—of whom not the least are the inmates of Broughton House, E.A. Hornel and his sister.'[45] King and Taylor became important members of the community, attracting a circle of international artists into their orb. Robert Burns, Head of Painting at the Edinburgh College of Art, said that no students' training was complete without a stint at Green Gate.[46]

Although King kept a studio in another part of the village, she painted pottery in an attic studio at Green Gate and played an important role inspiring and encouraging the other women.[47] Paxton Brown, King's long term collaborator, made important contributions to the resident women artists' group but was just one of King's colleagues who had migrated south

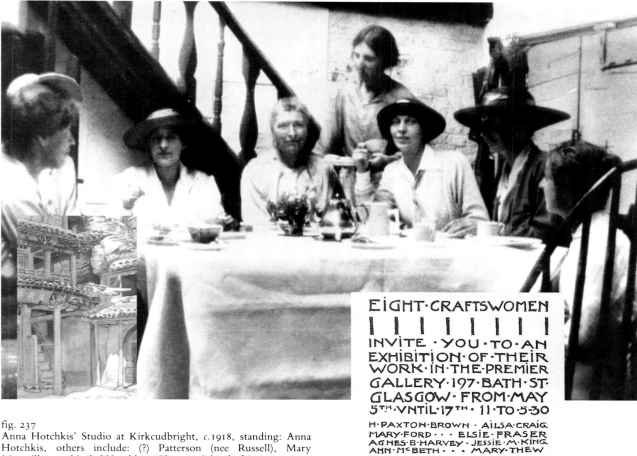

fig. 237
Anna Hotchkis' Studio at Kirkcudbright, c.1918, standing: Anna Hotchkis, others include: (?) Patterson (nee Russell), Mary Macmillan, and Isobel Hotchkis. (Glasgow School of Art)

fig. 238 (inset)
The Facade of O-Mi-To Fo Cave, Anna Hotchkis, tempera, 56.2 × 37.1, illustrated in Buddhist Sculpture at the Yun Kang Caves, Peiping, 1935, P. 116. (Private Collection)

fig. 239
8 Craftswomen, Jessie M. King, card for Glasgow Society of Lady Artists' exhibition, c.1930s, black and white woodcut, 9.5 × 12.0. (Coll: Barclay Lennie Fine Art Ltd. Photo: Glasgow Museums and Art Galleries)

with them joining artists Marion Harvey, Anna Hotchkis, and others in what became a shared studio enclave. **Marion Harvey** (1886–1971), although she did not live in Green Gate Close, was a member of the 'close coterie'. She painted landscapes and animal subjects in both oil and watercolour and was especially renowned for her representations of canines. **Anna Hotchkis** (1885–1984), (fig. 237) an oil and watercolour painter specialising in figures and landscapes, came to study landscape painting with Taylor in the 1920s and returned periodically to the 'Close' until the 1940s when she settled there permanently. With the help of a sympathetic mother who painted watercolours, Hotchkis convinced her father to allow her to attend the Glasgow School of Art despite her delicate health. Her father insisted that she attend only half days, but Fra Newbery was scornful of the arrangement and soon had her enrolled for two full days a week for courses in drawing and anatomy. After a year at the School, Anna and her two sisters became part of a circle of female art students studying in Munich with Hans Lasker. When the family moved to Edinburgh, Hotchkis transferred

to Edinburgh College of Art for the remainder of her training and upon completion of her formal education opened a studio in the city.[48] Hotchkis travelled extensively in China, Europe and North America, always gathering material and painting in watercolour and oil. She was especially influenced by Chinese art when she visited China for the first time in 1922. She taught in China at Yenching University, Peking from 1922 to 1924.[49] Travels in China with her American friend, painter Mary Mulliken, resulted in two jointly written and illustrated books, one the story of their perilous journey to the Nine Sacred Mountains and another Buddhist Sculptures at the Yun Kang Caves (1935). As a member of the Glasgow Society of Lady Artists' Club she exhibited frequently in Glasgow, London, Edinburgh, Kirkcudbright, Los Angeles and Hong Kong.[50]

Mary Thew (1876–1953) and Agnes Bankier Harvey (1869–1947) were members of the 'coterie' who were part of a larger metalwork movement that involved numerous 'other sisters' working throughout Britain.

BY WOMEN'S HANDS:
THE METALWORKERS

by Jude Burkhauser

A wide range of studio work was practised by Scottish women designers and while embroidery is most frequently associated with the Glasgow Style movement, we know that metalworking—primarily in enamel and repoussé—was also an extremely prevalent craft discipline in the 'sisters' studios' into the 1900s. Elsewhere in Britain, women were similarly engaged in the production of metalwork. In addition to Glasgow, cities where jewellery making was practised, particularly by women, were Birmingham, Edinburgh, and London with smaller movements in Liverpool, Sheffield, and Aberdeen.[51] Although women were excluded by division of labour within the Arts and Crafts Movement from some areas of production and it is debated by scholars such as Anthea Callen and Lynn Walker whether the overall political location of women in art and design was forwarded by their participation in crafts where this division seems to have been maintained,[52] it is clear that female jewellers in Britain at the turn of the century flourished as both designers and makers. Toni Lesser Wolf, in her article 'Women Jewellers of the British Arts and Crafts Movement', points to the paradox of Arts and Crafts practice:

> In this dual atmosphere of forward looking revisionism and retrograde double-standardization . . . some of the most unique designs from this fertile period in the history of jewellery came from women's imagination, and much exquisite workmanship, especially in the field of enamels, was done by women's hands.[53]

In the field of jewellery making as with other areas of art and craft production, Glasgow was in the avantgarde with its innovative 'Scotto-Continental' approach. Mackintosh and 'the Four' all designed distinctive jewellery and it is generally agreed that the Macdonald sisters executed both their own and the men's designs. An often cited silver necklace designed by Mackintosh and made by Margaret Macdonald has the familiar motif of birds in flight with wirework clouds and seed pearl droplets. Margaret's sophisticated silver pendant with two facing female heads (fig. 242) was made for the Newberys and in some early accounts mis-attributed to Mackintosh. Both Frances Macdonald and Herbert MacNair designed and made jewellery, although little survives, and while working in Liverpool the pair sent a case full of jewellery to the 'Turin International Exhibition'. In the few designs by Frances Macdonald which remain we see the emblems of the Glasgow Style—the head, the heart, the rose and the leaf—in elegant linear arrangements (fig. 241). As mentioned earlier Frances Macdonald taught design for jewellery in the enamelling department at the School of

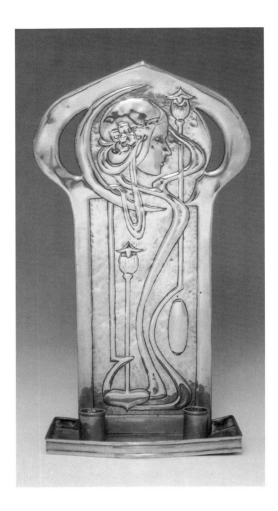

fig. 240
Crescent Moon, sconce, anonymous, possibly Agnes Bankier Harvey, early twentieth-century, repoussé brass. (Private Collection. Photo: Glasgow Museums and Art Galleries)

Art after the MacNairs' return from Liverpool to Glasgow. Certainly it was in design for enamelling where De Courcy Dewar excelled as did Jessie M. King. King, who designed pendants, buttons, mirrors, button hooks, brushes and belt buckles for Liberty and Co. for its 'Cymric' line, is said to have been second only to Archibald Knox as a Liberty jewellery designer (fig. 246 and 248).[54]

In addition to these relatively well-known Glasgow Style designers, there were a number of 'other sisters' from Glasgow involved in production of art jewellery and metalwork. The first, **Rhoda Wager** (*c.*1875–1953) (fig. 243), trained at Bristol Art School before moving to Glasgow where she eventually became art mistress at the Girls Public School, Kilmacolm *c.*1900 later teaching at Mount Florida School *c.*1903. She pursued her final qualification as a teacher in drawing and painting during this time at Glasgow School of Art and was elected an affiliate member of the Lady Artists' Club. Her repoussé tray (fig. 244), now in the collection of the Glasgow Art Galleries, and the other items

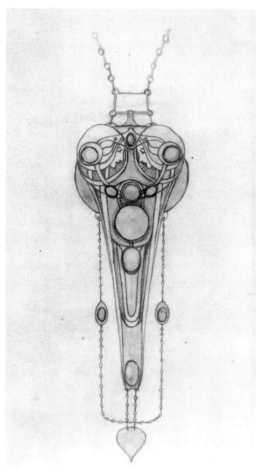

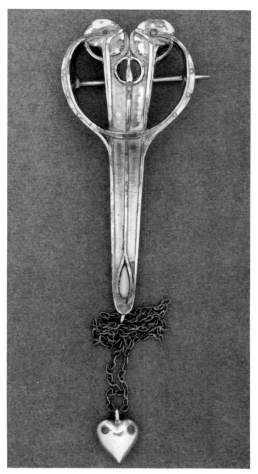

fig. 241
Design for pendant, with flanking female heads, Frances Macdonald MacNair or Herbert MacNair, c.1902–11, pencil and watercolour on cardboard, 170 × 137 mm. (Private Collection. Photo: Roger Billcliffe, Fine Art Society)

fig. 242
Pendant, Margaret Macdonald, cast and chased silver, set with turquoise and amethyst, c.1890s, 22.7 × 3.4. (Private Collection. Photo: Glasgow Museums and Art Galleries)

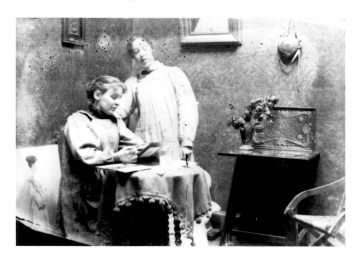

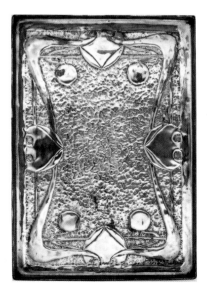

fig. 243
Rhoda Wager, c.1897, working with watercolours in her studio with a 'sister' unknown to us. Wager made the copper tray on the table, now in Glasgow Art Gallery and Museum. (Photo: Dorothy Judge)

fig. 244
Jewellery tray, Rhoda Wager, c.1900, copper repoussé, 49.6 × 31.2. (Glasgow Museums and Art Galleries)

which appear in an early studio photograph exemplify the types of objects being made by the 'sisters' studios'. Wager exhibited jewellery and metalwork with the School of Art Club in 1901 and at Cork in 1902. She worked in Glasgow at the height of the Glasgow Style eventually returning to Bristol where she taught at St Mary Redcliffe School and took vacation classes with noted silversmith and jeweller, Bernard Cuzner.

Cuzner, who became the head of metalwork at Birmingham School of Art in 1910, had studied with Arthur Gaskin, another designer for Arthur Lasenby Liberty's 'Cymric' range of jewellery which was in the Arts and Crafts style and employed the application of Celtic designs on mass-produced silver objects. Gaskin had been a visitor to Dewar's enamelling class in Glasgow when Wager studied there.[55] Arthur Gaskin and his wife Georgina Evelyn France Gaskin, metalsmiths who met at the Birmingham School of Art and married in 1894, were contemporaries of Fra and Jessie Newbery and shared similar ideals. As exhibiting members of the Birmingham group of artists, the Gaskins were proponents of Arts and Crafts ideology in Birmingham, then the centre of industrial jewellery manufacture in Britain. The group set out to rectify the lack of original design inspiration in mass-produced contemporary jewellery in much the same way that Jessie Newbery worked for originality in embroidered designs in Glasgow.

Rhoda Wager, student of the Newberys, sometimes employed enamel insets in her later jewellery work; probably studied enamelling with Dewar and may have worked part-time with her in the School of Art studios about 1900–06 where she also perhaps came in contact with Gaskin. After her move to Bristol, Wager may have had further contact with Gaskin through Gaskin's pupil, Cuzner, which may have influenced her decision to specialise in jewellery. She eventually emigrated to Fiji with her brother, settling in Sydney, Australia where she established a working production studio and sold hand-wrought jewellery. In twenty-five years as a jewellery designer she completed at least 12,000 pieces which were all meticulously recorded in her sketchbooks. She sent work back to Glasgow for exhibition at the Lady Artists' Club in 1919. Strong-willed, determined and a clear-headed and industrious businesswoman, Rhoda Wager died in 1953 in Australia.[56]

Another metalworker and enameller who was linked with both Dewar and Liberty designer Jessie M. King was **Agnes Bankier Harvey** (1874–1947). Harvey attended Glasgow School of Art from 1894 until 1899 and then studied at the London School of Silversmithing. From 1904 until 1908, Harvey served as tutor of silversmithing at Glasgow School of Art. A member of the Lady Artists' Club, she contributed enamelled jewellery regularly to their annual exhibitions. Harvey studied in London with a Japanese master to learn the fine art of cloisonné and much of her enamel work was done in 'the Japanese fashion' using

distinctive wire outlining. One noted piece was an altar cross in brass and cloisonné (fig. 245) with symbolic emblems of Matthew, Mark, Luke and John.[57] In addition to fine enamelwork, technically sound and constructionally solid, she made objects in brass and beaten repoussé and completed commissions for various badges as well as gun tompions for HMS *Ajax*. Harvey won a silver medal in the national competitions while a Glasgow student and a silver medal for metalwork at the 'Women's Exhibition' in London in 1910. She exhibited internationally, including Turin, Cork, Budapest and Berlin. In her later life she resided in Green Gate Close in Kirkcudbright and as a life-long friend of Jessie M. King was a key member of the 'Close Coterie' that evolved there. Harvey's house on the cobbled lane had a purple door, the walls were adorned with examples of her brasswork, and she worked on a specially installed stove producing cloisonné enamels.

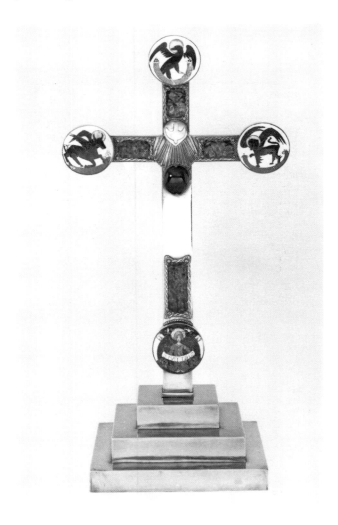

fig. 245
Altar cross, Agnes Bankier Harvey, in brass and cloisonné enamels with mother of pearl and pebblestone inserts, 1924, 55.1 × 28.3. (Private Collection. Photo: Glasgow Museums and Art Galleries)

Jessie M. King provided an important link with a number of Glasgow's female jewellery designers including another of her long-time friends, **Mary Thew** (1876–1953), who is also a metalworker of interest. Thew had studied at the Glasgow School of Art from 1894 until 1896 but then married and had a family and it was not until later in life that she turned to jewellery making in order to earn her living. It is said she had several lessons from Rhoda Wager[58] and then set up her own working studio in Glasgow. Later she moved to the Green Gate Close in Kirkcudbright and became a working member of the women artists group. A member of the Glasgow Society of Lady Artists' Club she contributed finely wrought jewellery which was mainly Arts and Crafts in approach, employing stylised motifs of Celtic inspiration (fig. 247). In 1925, a 'particularly fine case of jewellery—brooches in metal and precious stones, rings, necklaces and other articles',[59] was shown at the Glasgow Society of Lady Artists' Club and won their Lauder award. Thew's metalwork bears a trademark wirework surround and is usually set with semi-precious stone insets.

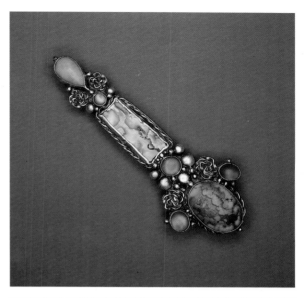

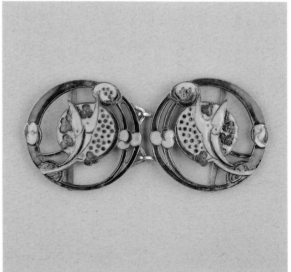

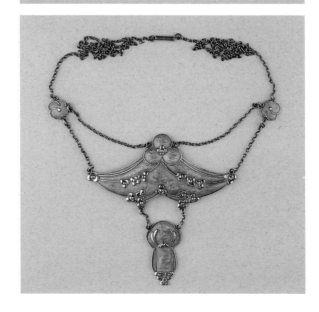

fig. 246
Silver and enamel button with floral motif. Jessie M. King. Designed for Liberty & Co. (Coll: Victor Arwas, London. Photo: Sotheby's)

fig. 247 *(top right)*
Brooch, Mary Thew, early twentieth-century, silver set with green and yellow stones. (Private Collection. Photo: Glasgow Museums and Art Galleries)

fig. 248 *(centre right)*
Waist buckle, Jessie M. King, c.1907, silver and enamel. (Glasgow Museums and Art Galleries)

fig. 249 *(right)*
Pendant, Jessie M. King, c.1910, silver and enamel, stylised floral motif. (Glasgow Museums and Art Galleries)

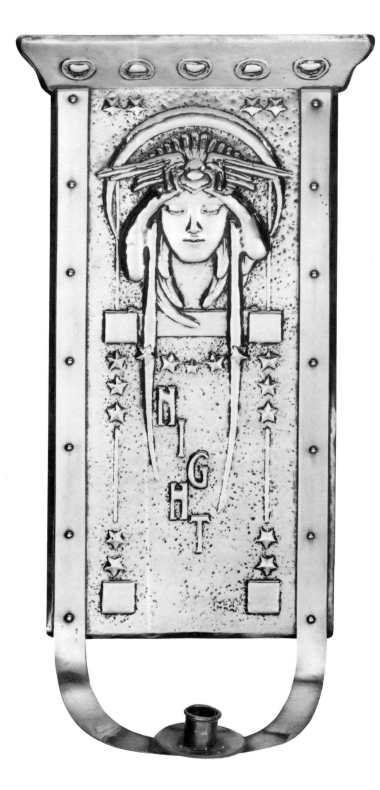

Marion Henderson Wilson (1869–1956) excelled in the production of well crafted metalwork after training at the School of Art from 1884 to 1896. Her repoussé work, like that of the Gilmour sisters, was mainly in brass, copper, and tin. Wilson's Celtic design inspiration is seen on a variety of objects, many employing the cabbage roses and hearts so much a trademark of the Glasgow Style. Wilson's flowing linear designs are distinctive and she often used faces as a design motif (fig. 250). Another Glasgow 'sister' linked by her metalwork at the School of Art was **Helen Muir Wood** (1864–1930) who trained with the Mackintosh group from about 1882 until *c.*1900 and was later teacher of enamels at the School. Muir Wood worked in metal and stained glass and painted ceramics. Several pieces by her in metal are illustrated in an early *The Studio* article on Glasgow Designers.[60] As a member of the Glasgow Society of Lady Artists' Club she exhibited in their annual exhibitions, at the '1901 Glasgow International Exhibition' and with the 'School of Art Exhibition' in Cork in 1902.

Although by early 1900 most large scale Glasgow Style interior commissions had declined, the style was applied in a range of smaller scale applications in the work of many women and carried on into the 1920s. Metalwork and embroidery were the areas where the influence extended the longest and both De Courcy Dewar in Enamels and Ann Macbeth in Embroidery continued to teach at the School of Art until 1928. The work of their former colleagues, the successful designers from the Glasgow movement including the Macdonald sisters, Jessie M. King and Annie French, were held up as examples to be emulated by the young students, but what had been an avant-garde movement to the preceding generation was passé to their successors and was a style to be cast aside in the pursuit of the new. Anne Knox Arthur succeeded Ann Macbeth for a short time in the Embroidery Department but a new direction emerged at the end of the 1920s and into the early part of the 1930s which found its main focus in the field of ceramics. This will be discussed by Jonathan Kinghorn later in this chapter. Kathleen Mann Crawford was the successor to Jessie Newbery and Ann Macbeth in the Embroidery Department into the 1930s and her work demonstrates the new direction which emerged after the decline of the Glasgow Style.

fig. 250
Night, Marion Henderson Wilson, wall sconce, repoussé brass, female head with stars and hearts and single candle holder, early twentieth-century, 56.0 × 27.7. (Private Collection. Photo: Glasgow Museums and Art Galleries)

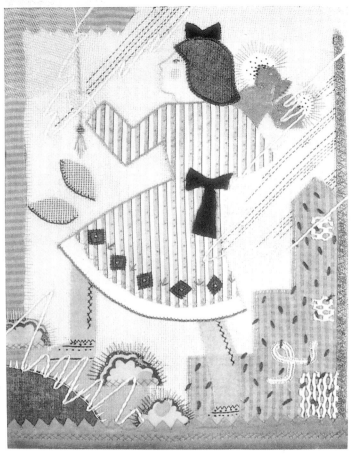

THE LITTLE VISITOR *by Kathleen Mann*

fig. 251
The Little Visitor, Kathleen Mann, *c.*1930s, striped, check, and plain appliqué fabrics and net on an open weave canvas, hand and machine stitched, 40.5 × 30.5. (Glasgow Museums and Art Galleries)

KATHLEEN MANN CRAWFORD

by Liz Arthur

Kathleen Mann was born in Kent and trained at the Croydon School of Art from 1924 until 1928, where she studied dress and design under Rebecca Crompton. She gained a scholarship to the Royal College of Art where she developed an interest in peasant dress. At the instigation of Professor Randolph Schwabe, she published a book, *Peasant Costume in Europe*, in 1931. Following a year teaching design at Cheltenham College of Art she was appointed Head of the Embroidery Department at Glasgow School of Art where she succeeded Anne Knox Arthur. At that time the department still rigorously adhered to the teaching laid down at the beginning of the century and the Governors saw the need to introduce someone with fresh ideas. Kathleen Mann proceeded to breathe new life into the department and it is ironic that while she was encouraging her students to create life-sized figure panels the Mural Department was producing very small things. She introduced machine embroidery which she used with flair and assurance (fig. 251).[61]

It is symptomatic of the changes which had taken place that in 1934 when she married her colleague Hugh Crawford RSA she had to resign. The principal Mr W. O. Hutchison tried to persuade the Governors to allow her to stay as he 'didn't want to lose the best Mann on his staff', but it had become policy that women were not allowed to continue in certain professions after marriage. Afterwards she held private classes in her flat which were attended by some former students including teachers from the Saturday classes.

Mann exhibited widely and her work featured in *The Studio* magazine's special volume, 'Modern Embroidery' in 1933. Four years later she published *Appliqué Design and Method* and *Embroidery Design and Stitches*. She also published *Designs from Peasant Art* in 1939.

In 1949 she moved to Aberdeen where she taught a wide variety of subjects but by 1955 she had abandoned embroidery to concentrate on painting and illustration. She became a member of the Scottish Society of Artists and continues to paint.

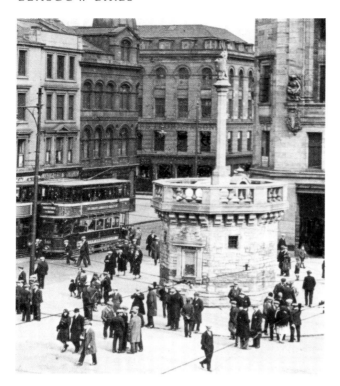

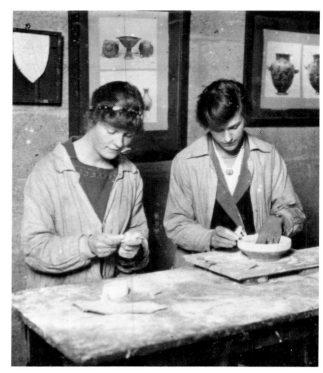

THE DESIGNERS:
INTO THE 1930s

by Jonathan Kinghorn

The years that followed the end of the Great War were not kind to Glasgow. The mighty 'second city of the Empire', within whose boundaries almost all classes of manufacture were produced, was in truth essentially reliant upon basic heavy industries and fickle foreign markets. It has consequently suffered recession periodically but never this ferociously. As business dwindled the city went into general decline and this exacerbated some of the worst living conditions, overcrowding and unemployment in Europe.

Times and tastes were changing and, with economy the order of the day, major building projects and decorative commissions were few and far between. Glasgow's general taste, never really adventurous, followed the national trend towards conservatism. Furthermore, by 1930 the great individuals who had created the Glasgow movement were no longer forces to be reckoned with. The Newberys had retired to Dorset, Margaret Macdonald Mackintosh and Herbert MacNair had stopped working, Frances Macdonald MacNair and Mackintosh himself were dead.

There was still however money and patronage in the city and there were some opportunities for talented or resourceful artists and craftworkers. The explosive burst of artistic activity that the city had witnessed at the turn of the century had not quite spent its force. The talent that Fra Newbery recognised and nurtured was

still there. The Glasgow School of Art continued to flourish despite the war and even the Scottish Guild of Handicraft Ltd, whose very survival had been in question in 1913, managed to maintain a presence in the city into the late 1920s.

Glasgow continued to support an active and enthusiastic artistic community. The studios on and around Garnet Hill were as busy as ever. Opportunities for showing and selling abounded at the exhibitions, bazaars and sales of work centred on the more comfortable West End area. One of the newer and more philanthropic venues was 'The Arthur Studios' at No. 15 Rose Street. This had been set up in 1931 by Anne Knox Arthur, who left her post as head of Embroidery at the School of Art to 'enable a permanent show in Glasgow of decorative work by local students'.[62]

The most important forces for women artists and craftworkers in the city remained the School of Art and, a stone's throw away in Blythswood Square, the Glasgow Society of Lady Artists' Club. As a social club the society had gone from strength to strength and now

fig. 252 *(left)*
Mercat Cross, Glasgow, *c.*1930s, designed by architect Edith Burnet Hughes, with sculpture designed by Margaret C.P. Findlay, and lettering by Helen A. Lamb.

fig. 253 *(right)*
Women in ceramic studios, Glasgow School of Art, *c.*1920–30. (Glasgow Museums and Art Galleries)

had a considerable waiting list for lay membership. Artist members were admitted by a ballot of members —who were not slow to reject anyone whose work was considered inadequate. The Society celebrated its golden jubilee in style in 1932 with a dinner so oversubscribed that a second evening had to be arranged. Such annual dinners continued to be held until the outbreak of war in 1939.

As well as a season of three annual exhibitions specialising in oils, watercolours and craftwork (timed to catch the Christmas market) the Society held occasional special subject exhibitions. Several of these were staged in the 1930s including one of the most successful, 'The Art of the Book' of 1934. To this Jessie M. King sent much of her best work. The annual exhibition was transferred to the McLellan Galleries for the first time in 1926 and again in 1930 so the general public could be admitted. In the following year men were admitted to the gallery at No. 5 Blythswood Square itself—albeit in the company of members! The quality and variety of work shown remained high and the Lauder award was given to lettering, pottery, sculpture, silversmithing and enamels, weaving and needlework—more crafts than in any other decade. Some of the members were attempting ever more ambitious work. The stoneware crackle glaze jar that won Dorothy C. Dorman the Lauder award in 1934 for example was a far greater accomplishment technically than the 'painted china' shown in the 1890s.

It was through the various exhibitions and craft shows more than anything else that women artists established and maintained their reputations. Though 'the Four' were no longer active many of the most gifted and successful pre-war artists were still working. Some of their number had moved far away and others had abandoned their work for one reason or another, but surprisingly many continued doggedly to exhibit.

From her retirement in Patterdale, Ann Macbeth sent work regularly to Glasgow and Jessie Keppie not only exhibited but also served as president of the Glasgow Society of Lady Artists' Club from 1928–31. Jessie M. King, Agnes Raeburn, Helen Paxton Brown and others who settled in Kirkcudbright and elsewhere were able to remain familiar figures in Glasgow. The Gilmour sisters, Ailsa Craig, Mary Russell Thew and many other perhaps less well known artists and craftworkers soldiered on, often in much the same style as before.

After the First World War new names began to attract attention as a younger generation benefiting from the full range of facilities of the Mackintosh building graduated from the School of Art and entered the field.

For some women their work was little more than a hobby. Much of the craftwork sold at the innumerable bazaars was of a very mediocre quality. 'China painting' for example was particularly popular in the 1930s. Vast quantities of Staffordshire bone china or porcelain from Rosenthal or Limoges were decorated with patterns (usually floral) learned in evening classes or copied. Most of this work was given as Christmas or wedding presents and never intended for sale.

For other women, particularly those who lost husbands or fiancés in the war, their work had a

fig. 254 *(below left)*
Porcelain saucer with wave design by Elizabeth Mary Watt, *c.*1930s, diameter 13.9. (Coll: Brian and Liz McKelvie. Photo: Glasgow Museums and Art Galleries)

fig. 255 *(below right)*
Pan, E.M. Watt, Delft Caledonian 'Crown', *c.*1930, porcelain vase with design of 'Pan', 10.4 × 11.6. (Private Collection. Photo: Glasgow Museums and Art Galleries)

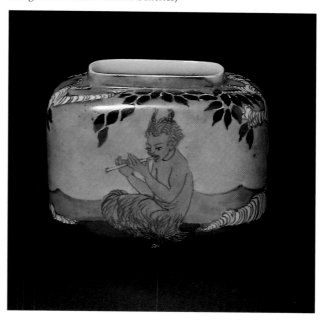

greater significance and became a way of life. It was difficult to earn any real income from art or craftwork. The lucky women had private incomes to sustain them but most relied either upon the support of their husbands or upon a salary, often from teaching an art or craft subject.

Elizabeth Mary Watt (1886–1954) was typical of these genuinely gifted women. She received her diploma from the School of Art in 1917 and apparently dreamed of painting the portraits of royalty. Throughout her long career she did indeed paint portraits—but of commoners. She painted landscapes and fairy pictures, too, but she also produced craftwork, chiefly painted wooden boxes and decorated ceramics (fig. 254). It sold well and she confided to a newspaper in 1931 that the ceramics in particular had become 'a useful source of income'.[63] By 1939 she was lamenting to Nan Muirhead Moffat that: 'now, alas, I paint butter dishes for the proletariat!'[64] Her work was attractive, original and often of the highest quality (fig. 255). She remained a prolific ceramic decorator until her death in 1954; she never married. Even Jessie M. King, who was capable of much better work, painted large quantities of ceramics for sale to the tourists in Kirkcudbright.

Some of the most gifted and dedicated women were able to make a successful career out of their art, at least by teaching. Many of these were associated at some stage with the School of Art. The School stood in the very heart of the artistic community on Garnet Hill and

was the focus of much activity and development into the new decade. Social as well as artistic life revolved around it. The staff was, at any one time, quite small and close knit. Throughout the 1930s for example De Courcy Lewthwaite Dewar, Evelyn Beale, Georgina Goldie Killin, Alexander Proudfoot and his assistant Ivy Hunter Gardner (all teachers at the School) lived just down the road at 15 Woodside Terrace.

Of these serious artists the most determined were able to secure senior professional positions within their field. Grace Melvin taught lettering and illumination at the School from 1920. She left in 1927 to become Head of Design at the Vancouver School of Art, a post she held until 1952. One of the most remarkable of the 'Glasgow Girls' however was surely Dorothy Carleton Smyth. As well as excelling in a bewildering variety of media she was an extremely effective teacher. In 1933 it was she who was appointed as Director of the Glasgow School of Art (fig. 256). Although she died suddenly before she could take up the post, it was nevertheless a very significant and momentous choice. Fra Newbery encouraged talent wherever he found it—he praised Mary Thew because 'she drew like a man'.[65] With the election of Dorothy Carleton Smyth as Director this policy reached its logical end, and surely Fra Newbery must have approved.

fig. 256
Glasgow School of Art staff, c.1933, with the newly appointed 'Director', Dorothy Carleton Smyth, who died before she could assume her post. (Glasgow School of Art)

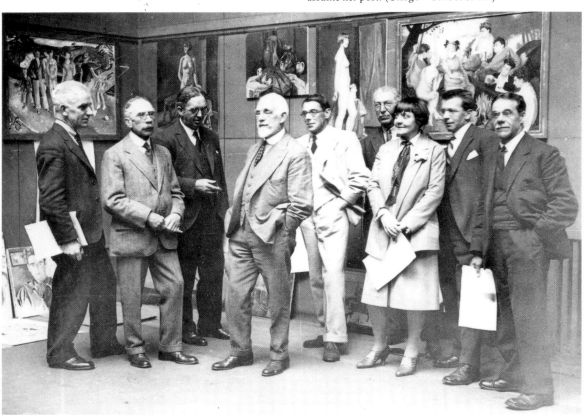

THE PAINTERS

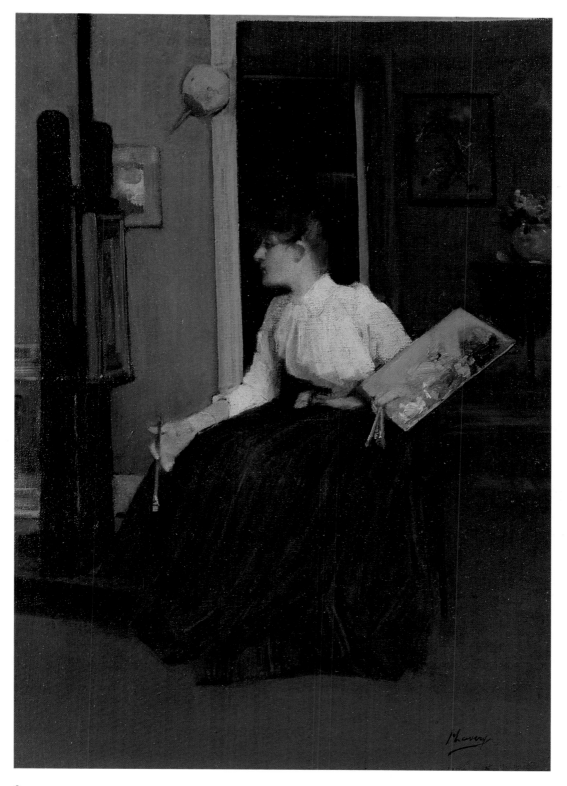

fig. 257
In the Studio, John Lavery, *c*.1890, oil on canvas, 54.0 × 38.4. (Coll: The McLean Museum & Art Gallery, Greenock.
Photo: Glasgow Museums and Art Galleries)

187

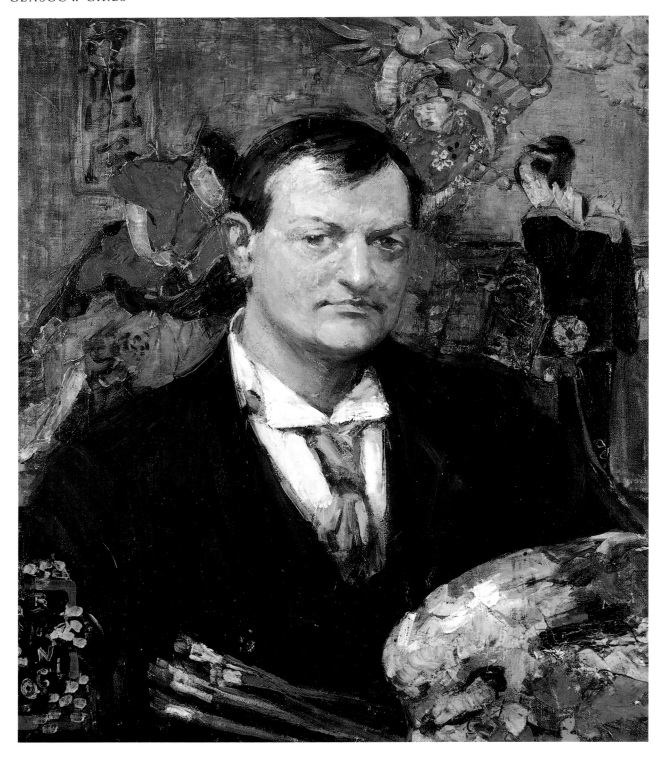

fig. 258
E. A. Hornel, Bessie MacNicol, 1896, oil on canvas, 76.0 × 61.0. Painted in Hornel's studio at Kirkcudbright. In the background is a Japanese kakemono. (E. A. Hornel's Trust, Kirkcudbright)

INTRODUCTION: THE GLASGOW BOYS
by Ray McKenzie

Reference has already been made to the reasons why 'Glasgow Girls' has been adopted as a generic title for the artists and designers under consideration in this book (see Preface), and it was suggested that the force of the expression derived from its implied analogy with the more familiar group of artists popularly known as the Glasgow Boys (fig. 259). The equivalence, however, is not a very exact one. Unlike their female counterparts, who were active in the entire range of fine art, handicraft and design disciplines, the Boys belong more or less exclusively within the fine art tradition. With one or two minor exceptions they were devoted to the conventional easel picture in watercolour or oil. But there were among the 'Girls' a significant number who were also primarily painters (fig. 260). In many cases they worked in a style that is so reminiscent of the Boys themselves (figs. 262 and 263) that their creative ambitions cannot really be understood except in relation to the developments initiated by their slightly senior male colleagues.[1]

Who were the Glasgow Boys? The question is not as innocent as may seem, for although we tend to think of them as a group, their collective identity has no very clear boundaries. The precise catalogue of who did and who did not belong has been a matter of dispute among historians for as long as they have been written about—which is perhaps not surprising when we consider how acrimoniously they fought amongst themselves whenever the question of formal membership arose. Closer examination reveals that they tended to relate to each other more as a cluster of smaller cohorts, with key figures such as James Guthrie (1859–1930), John Lavery (1856–1941) and W.Y. Macgregor (1855–1923) acting as artistic magnets within a wider pattern of shifting personal allegiances. It is worth noting also that in geographical terms their name is slightly misleading. Not only was comparatively little of their work concerned with urban subject matter, but many of them had far stronger loyalties to places both distant from Glasgow, and very different from it in character: Brig o'Turk and Cockburnspath for Guthrie (fig. 259); Stirling for William Kennedy (1859–1918); Kirkcudbright for Hornel (1864–1933) (fig. 258). On almost every level of meaning the label Glasgow Boys involves a sweeping oversimplification. It is, in fact, little more than an art historical convenience.

In general terms, the Glasgow Boys claim our admiration today for their introduction, in the 1880s, of an approach to painting that was as revolutionary in Scotland as Impressionism had been in France a decade earlier. With very little precedent in the established Scottish tradition to take a lead from, they virtually invented a manner of handling pigment which combines a bold and virile tactility with a sensitivity to the subtlest modulations in form and texture. They showed a predilection for mundane subject matter drawn from rural life—including the kitchen gardens which have led to their quite unjust disparagement as mere 'kailyard' painters—so that many of their pictures can be described as 'earthy' in more than just a metaphorical sense. Guthrie's *A Hind's Daughter* (1883) and Macgregor's *The Vegetable Stall* (1883–4) are two works in which all these characteristics appear in their most accomplished form, while George Henry's (1858 or 1860–1943) *A Galloway Landscape* (1889) represents a later and more refined development, as well as a shift towards a more consciously Post-Impressionist idiom.

Fundamental to their artistic creed was the belief that the objects they interpreted on canvas should be shown simply for what they were and not as vehicles for symbolic or any other meaning, so it is not surprising that they were vehement opponents of every form of academic painting. They despised the pompous narrative works that annually graced the walls of Edinburgh's Royal Scottish Academy. More than anything they reserved their most concentrated contempt for those painters who adhered to the creed that every picture tells a story, and whose painted anecdotes typified the work promoted by the Glasgow Art Club. They called them the 'Gluepots'.

Nor was their hostility to the academic tradition just a matter of aesthetics; art politics came into it as well. Their struggle to establish a contemporary style was paralleled by an ongoing battle with the major institutions that largely controlled the destiny of all serious Scottish painters at this time, such as the Royal Scottish Academy itself, and more locally the Royal Glasgow Institute. In this, they were not unlike the angry young painters involved in Secessionist groups in many other parts of Europe. But their opposition to establishment orthodoxy is of special interest here

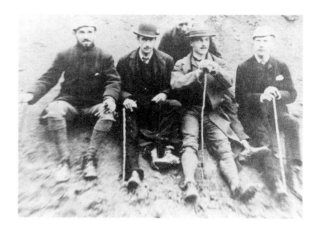

fig. 259
Glasgow Boys at Cockburnspath in 1883: E.A. Walton, Joseph Crawhall, George Walton, James Guthrie and J. Whitelaw Hamilton. (Glasgow School of Art)

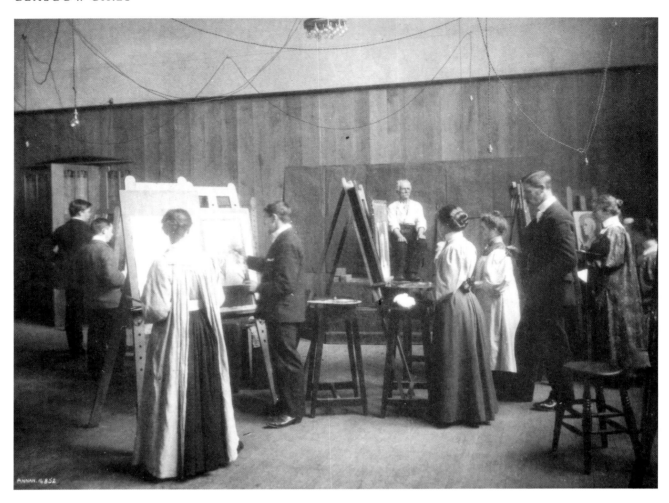

fig. 260
Photograph of Glasgow School of Art studio with easels and students painting. (Glasgow School of Art)

because it offers a precedent of sorts for the women painters who were to emerge slightly later, and who were to encounter similar difficulties in gaining access to the venues, platforms and patrons they needed to sustain their careers. The parallel is only valid up to a point, however. The later history of the Boys is characterised by a steady process of capitulation to the values and institutions they formerly opposed. Lavery's flatulent *State Visit of Queen Victoria* (1890) the elevation of Guthrie to the Presidency of the Royal Scottish Academy in 1902, the Knighthoods conferred later on both painters—these are just some of the events that mark the general drift of the Boys towards establishment respectability. Alexander Roche's (1861–1921) venomous denunciation of the work of the Macdonald sisters offers an even more depressing illustration of how the youthful rebellion of one generation can harden into rigid intolerance of the innovations of the next.

For most of the women painters discussed in this chapter, a retreat into lucrative orthodoxy does not

LADY WHO PAINTS *A LA* GLASGOW SCHOOL.

fig. 261
Ladies who paint à la Glasgow Boys, Tom Browne, 1903, illustration from *Frivolous Glasgow* by Mark Allerton.

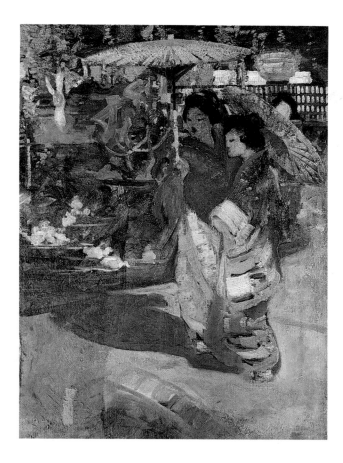

fig. 262
In a Japanese Garden, George Henry, c.1893, oil on canvas, 76.2 × 63.5. (Glasgow Museums and Art Galleries)

fig. 263
The Japanese Parasol, Margaret Wright, c.1900, oil on canvas, 40.6 × 35.5. Margaret Wright was influenced by the 'Glasgow Boys'. Born in Ayr in 1884, the daughter of Thomas Wright, stationer and printer, she studied at the Glasgow School of Art from 1902 to 1908, and may have continued her studies in France. She exhibited regularly at the Glasgow Institute and also at the Royal Scottish Academy and at the Paisley Institute. Wright liked to paint children at play, as well as landscapes of the Clyde coast and Loch Tay. She contributed illustrations to *Recording Scotland* published by The Pilgrim Trust in 1952. (Coll: I. D. Lloyd-Jones. Photo: Glasgow Museums and Art Galleries)

seem to have been such a readily available option. To the various other institutional obstacles they encountered we have to add the more subtle, but also more pervasive influence of prejudice, and the predisposition of a male-dominated art world to regard all work by 'lady artists' as by definition lightweight in every sense of the word. For some of them these difficulties were further compounded by the various other social, marital or parental responsibilities they had to assume in tandem with their careers as artists. Dying in childbirth at the age of thirty-four, Bessie MacNicol (fig. 264) had pitifully little time to fulfil the enormous promise of her early work. Stansmore Dean lived considerably longer, but it would appear that her marriage to Macaulay Stevenson (1854–1952)—himself a former Glasgow Boy—created perpetual frustrations in the fulfilment of her aspirations as a painter.

Above all what distinguishes the general historical situation of these women painters from that of the Boys was the lack of a sympathetic and stable power base through which to consolidate their artistic achievements. With the exception of the Glasgow Society of Lady Artists, which of course they had to create for themselves, and the support they were able to offer each other during their time as students or teachers at the Art School, these women were to a large extent on their own. It would be a gross exaggeration to suggest that they did not enjoy many of the fruits of artistic success, or that in their efforts to enter the profession they were confronted by nothing but closed doors. The position of women in Scottish society was changing far too rapidly for that. All the same, when we compare the biographies assembled here with what we know of the experience of the Boys, it is hard to avoid the conclusion that they had to knock just that little bit harder to make those doors open.

fig. 264
Self-portrait, Bessie MacNicol, *c.*1894, oil on canvas, 40.7 × 30.5. (Glasgow Museums and Art Galleries)

BESSIE MACNICOL (1869–1904)

by Ailsa Tanner

Bessie MacNicol (fig. 264), the most important woman painter in Glasgow at the turn of the century, was respected by her contemporaries, fellow artists as well as patrons. Writing in 1908 after her death, James Caw, one of the most prominent art figures of the day who was then the newly appointed Director of the National Galleries of Scotland, admitted that she was 'probably the most accomplished lady-artist that Scotland had yet produced'.[1] Percy Bate lamented 'how great was the bereavement that the art of Scotland has sustained by her untimely end',[2] and yet, fifty years later she was all but forgotten.

MacNicol was born in Glasgow on 15th July, 1869, the elder of twin girls. Her father was a schoolmaster and her paternal grandfather was a clothier at Bonhill in the Vale of Leven where there were extensive printfields, and at least one MacNicol is recorded as a pattern designer. It is tempting to think there may have been a background of craft talent leading to art, given opportunity. MacNicol was equally talented in music, according to her friend and critic Percy Bate.[3] In 1887, at the age of eighteen, she entered Glasgow School of Art and until 1892 studied under the charismatic Fra Newbery, who encouraged her to join his informal summer school at Lundin Links in Fife, and to continue her studies in Paris.[4] According to Bate's posthumous article for *Scottish Art and Letters*, 'In Memoriam: Bessie MacNicol Painter', although she attended classes at the Académie Colarossi she found the teaching too repressive. She seems, however, to have gained from the experience in other ways:

> . . . her individuality was not given a chance; she was restrained and repressed rather than encouraged, and her study there resolved itself more into a mental training than a manual one. She haunted the galleries, moved by the masterpieces of Vandyke, Velasquez and Botticelli; she evolved and learnt to express to herself, something of her theories and aims. . . .[5]

MacNicol exhibited for the first and only time at the Royal Academy in 1893. Her small-scale yet important work, *A French Girl* (1894) (fig. 265), was the first painting she exhibited at the Glasgow Institute of the Fine Arts in 1895 after her return from Paris. The picture, a study of a girl's head in profile, shows a remarkable maturity of achievement. The composition, for a portrait, is unconventional, the colour harmonious and the brushwork fluid and assured. Percy Bate noted: 'at the hands of a sympathetic hanger

fig. 265
A French Girl, Bessie MacNicol, 1895, oil on canvas, 38.1 × 48.3. In a letter to Hugh Hopkins *c*.1894 written from Crail, of which two pages remain, Bessie McNicol writes: ' . . . I have done a head of a French Tottie however, which is rather jolly—pretty I mean! Heliotrope sleeves—needless to say!'. (Private Collection. Photo: Sotheby's)

it was placed as it deserved . . . [and] created a distinct sensation. . . . Art lovers at once saw that in Bessie MacNicol a new artistic force had arisen in Glasgow'.[6]

In 1896, MacNicol acquired her own studio at the top of 175 St Vincent Street in Glasgow. It was also in the same year that she spent some time in Kirkcudbright the small town in the southwest of Scotland that was a 'Mecca' for the Glasgow School artists. While there, she associated with Hornel, his brother-in-law William Mouncey, William McGeorge, and other artists—all migrants from Glasgow like herself—who became known as what W. E. Henley called the 'Kirkcudbright School'. At that time, she was impressed with the richness of colour and paint quality in Hornel's work, and the colour of her own paintings lightened and brightened. Although influence by Hornel was limited to this brief period, MacNicol painted a portrait of the artist in his studio and the work demonstrates that his influence on her painting at the time was significant.

Despite the fact that little documentary material on the artist has survived, Hornel, who never threw anything away, kept her letters to him during 1897, and these are now at his former residence, Broughton House, in Kirkcudbright. They tell us about her painting friends, mainly younger Glasgow Boys whom she had met at Kirkcudbright; about Hornel himself, George Henry, John Keppie, David Gauld, Harry Spence (known for some reason as 'the josser'), and the photographer Robert McConchie; and her Glasgow friends, especially Alexander Frew whom she was to marry in 1899. Bessie MacNicol does not often mention her own work but in the first letter to Hornel she writes of the portrait:

I do not know how my work is to get along. I am fighting away with them in my own desultory way. I think I will send your portrait to the Institute. I will rub it down & then work a little. Any men who have seen it like it immensely & advise me to send it.[7]

In her third letter she adds:

I had David Gauld up seeing your portrait. He said he wished I had painted it in greys and purples. Also, wanted me to take out the palette & to paint the coat a grey black. Of course that is quite another story—at least Gauld's way of telling the story.[8]

The portrait was duly exhibited in the 1897 Glasgow Institute, and did not receive very favourable reviews. The critic of the *Glasgow Herald* reviewed it in isolation from the other portraits at the very end of his notice on figure subjects and genre subjects. He ended his review:

Mr Hornel has grown impatient at sitting, for the expression on his face, Napoleonic in its strength, the forelock carried down the ample brow is not of a meek and saintly colourist. Probably Mr Hornel would make reply that he does not want to pose in

such a role. What one can feel is that the lady artist has not sufficiently interpreted the bright intelligence with which he is not less assuredly endowed.[9]

This is an example of the pointless and biased criticism to which MacNicol was subjected during her life. At the other extreme her only one woman exhibition at Stephen Gooden's Art Rooms in 1899 was barely noted. It was as if contemporary critics did not know how to categorise her work. On the one hand she was praised for having a masculine style and denied her femininity, while on the other her work as a woman was given more than full due of praise by James Caw in his book, *Scottish Painting Past and Present*. He said that MacNicol was nearer in spirit to Berthe Morisot than any 'Englishwoman' he could think of.

Other letters tell us something of her own personality: fun-loving, full of life and high spirits, but with a deep commitment to painting. Her second letter to Hornel, mainly about the frame for her portrait of him, also has notes on paint:

I wanted to tell you also something about paint— Frew told me, and whatever he may not know I think he does know something of the chemistry of colours. He says chromes can stand any length of time without being affected by the air, as there is so much sulphur in both, but used in conjunction with lead (Flake White) it turns black in a few days. Also that chromes used with cadmium turn black almost at once—emerald green also—even used pure. . . . I am using Zinc White now myself—and Cadmium in flesh painting.[10]

In the same letter she shows annoyance at Dott, the Edinburgh art dealer who had said of her painting *Rose* (c. 1896), 'It is easily to be seen Hornel had most of the painting of that to do!' MacNicol's characteristic reply: 'I could of "ker-slewed" him when I heard.'

A happy family background is hinted at in Glasgow, at 4 Oakfield Terrace, with her father, then a Headmaster, her English mother and her two younger sisters. With them she was a 'New Woman' of the time. She led a busy social life with visits to the theatre and enjoyed many other sprees. In her sixth letter she wrote:

John Keppie came up to see me the day after I returned from Kirkcudbright, & was inviting me to go for a cycle run with him. I have got a new kind of cycling skirt, which is divided, so far up, but is just like a walking skirt when I am standing. I put the Mater into fits when I was in the shop buying it, by dancing a hornpipe behind the woman's back. They are like wide Jack Tar 'bags'. I am getting on splendidly & am quite a scorcher. I have not gone more than 10 miles yet but can pass

machines & people without running them down for certain.[11]

We learn too from her letters that she was a martyr to hay fever. This explains the liquid eyes and open mouth of her splendid early self-portrait (fig. 264). Summer was, for her, a time of misery. Towards the end of 1897, she was taken ill. Liver trouble was diagnosed and mercury prescribed. She responded to this, but mercury has a depressive effect on the system and the disillusionment in her last letter to Hornel at Christmas was apparent. She wrote: 'How are you getting on with your work, Ned? About mine I say nothing because you did not like it from the start. You should have told me that and not have said you liked it very much—you sweep!'

A few months before that, an exchange of paintings had taken place. She received a painting from Hornel, which she called *The Kite Flyer Picture* (c.1894) one of his Japanese paintings, and she arranged for his portrait to be forwarded to Kirkcudbright where it still hangs above the fireplace in the dining room of Broughton House. Her actual association with Kirkcudbright probably ceased after 1897, while her painting continued to develop and gain in both confidence and maturity.

At that time, her favourite subjects were young girls painted *en plein air* under trees in dappled sunlight. This effect had been explored earlier by James Guthrie in his *Midsummer* of 1892, and in early portraits by David Gauld which were mistakenly called 'Impressionist', but Bessie MacNicol added her own interpretation and feeling. Very often the figures hold posies of flowers, and it must be admitted that they hid the necessity to paint hands which were never her strong point.

These paintings were not necessarily portraits although she did paint many portraits of men, as well as women, and one unforgettable study of a baby, which one critic considered to be her masterpiece. Her portraits were usually of friends and relatives, painted straightforwardly, and are excellent likenesses. In paintings such as *Under the Apple Tree* (1899) (fig. 303) and *Autumn* (c.1898) the likeness, even if it exists, is not the main object of the picture. The purpose here was to create a unity of design, form and colour. The paintings are poetical evocations of youth and beauty set against landscape backgrounds suggesting a particular season and are painted with vigour and confidence. Often Bessie MacNicol used herself as model, and these paintings were called at that time 'fancy portraits'.

Bessie MacNicol sometimes altered her works, in order to develop an earlier painting, or if she was dissatisfied she might alter drastically. *Under the Apple Tree* has two dates, 1896 and 1899. Another example of this was the portrait of her sister, Jessie, which she sent to the 'Munich Secession Exhibition' in 1896. It was titled, *Ein Schottisches Mädchen* (1896) and was illustrated in the catalogue. *The Green Hat* (c.1900) now in the Edinburgh City Collection, appears to be this painting, cut down from a three-quarter view to just head and shoulders, and the hat, which may have gone out of fashion, has been changed and made smaller.

MacNicol's interest in costume may be seen in many other paintings. On returning from Paris, she brought a feather boa and several extravagant hats. It was the age of Fancy Dress Balls, when it was fashionable to dress up in the costume of another period. MacNicol's friend Alexander Frew had a collection of costumes, a number of which he lent for the *tableaux vivants* at the 'Fancy Fair' held in 1895 at the Fine Art Institute to raise funds to build a gallery for the Lady Artists' Club. We have MacNicol's description of a Fancy Dress Ball at the Glasgow Art Club in December 1896, to which she went with Frew. She does not describe her own costume except to say, 'my raving locks were hanging down my back kept in place by an arrangement which was neither more nor less than an abridged halo.' This may possibly be seen in a photograph taken by Alexander Frew, and the brocaded top and full white sleeves are those in the painting, *Autumn* (fig. 307) which almost in contradiction, shows a young girl against the leaves of a chestnut tree.

In *A Girl of the 'Sixties'* (c.1899) (fig. 266) one of the artist's 'fancy portraits', the figure is portrayed in crinoline, with a pill-box hat, her hair in a chignon and with a black band round her neck. Bessie MacNicol was not so prejudiced about outmoded fashions as the Glasgow critic of Pinero's play, *Trelawny of the 'Wells'* which came to the Royalty Theatre in September, 1898. He condemned crinolines as being grotesque, vulgar and ridiculous. Bessie delighted in them and painted watercolours of women in these dresses from the past, with fans and muffs, frills and furbelows. It is interesting that Miss Kate Cranston, the noted tearoom proprietor, who had commissioned Charles Rennie Mackintosh to design her interiors, shared MacNicol's interest and wore a crinoline even in Edwardian Glasgow. The young woman in *A Girl of the 'Sixties'* is shown out of doors under the branches of an oak tree. This is probably the most successful of her paintings in this genre and is finely painted and subtle in colour.

It was probably painted around 1899, when Bessie MacNicol married Alexander Frew, a physician trained in gynaecology who had given up medicine to become a full-time painter. A man of many talents and interests, Frew was a keen yachtsman and many of his paintings were of marine subjects. When he married Bessie MacNicol, he resumed his practice at their house in Hillhead, Glasgow. The previous owner had been D.Y. Cameron, brother of Katharine Cameron, who had built a large studio at the back of the house. While she worked there MacNicol's paintings increased in scale.

Vanity (fig. 309), one of her most important canvases, is an example of this large scale work and

shows the back view of a half draped woman admiring herself in a hand mirror. It was probably painted in 1900, as it was exhibited at Munich in 1901. The painting is now dated 1902, so MacNicol must have worked on it again when it came back to this country. *Vanity* was a *tour de force* and, as a London *Times* critic noted, ' . . . evidently inspired by the *Venus with the Mirror* of Velasquez . . .'[12] This is the painting, more familiarly known as the *Rokeby Venus* (*c.*1650), which is in the National Gallery in London. Like many other artists MacNicol looked at other paintings for ideas but managed to turn variations of familiar themes into her

own original interpretations. Another large painting, *Motherhood* (*c.*1902) (fig. 268) of her sister Minnie and young son, was exhibited at the Munich Glaspalast in 1903. The young mother is sitting on a sofa gazing at her baby, a subject which recalls Orchardson's *Master Baby* (1886), at the National Gallery of Scotland in Edinburgh. Also clearly observed and lovingly painted was the tender study, *Baby Crawford* (*c.*1902) (fig. 267), exhibited at the Glasgow Institute in 1902.

fig. 266
A Girl of the 'Sixties', Bessie MacNicol, 1899, oil on canvas, 81.3 × 61.0. (Glasgow Museums and Art Galleries)

At the same time as the Institute exhibition of 1902, and further along Sauchiehall Street at Warneuke's Gallery, was the first exhibition of the Glasgow Society of Artists, a breakaway group under the leadership of MacNicol's husband, Alexander Frew. An expression of dissatisfaction with the way the Institute was run at that time, the society was small and most of the Glasgow Art Club did not join. In this first exhibition, Alexander Frew, his wife Bessie MacNicol, and W.A. Gibson produced most of the works exhibited. E.A. Walton, the Glasgow Boy who had gone to London, sent a work from there and Jessie M. King and several other women artists exhibited.

The fourth exhibition of the society was held in 1905, not in Glasgow, but at the Doré Gallery in London. The catalogue entries for MacNicol's works read, 'The Late Bessie MacNicol,' for on 4th June, 1904, Bessie MacNicol died while expecting her first child. Her husband, a specialist in gynaecology, seems to have been in attendance; he certainly signed the death certificate. She was not, as we have seen, very robust. The year before she had lost both her parents, she was probably overworking, and there may have been problems with the pregnancy. Alexander Frew had to live with this until he ended his own life, in January 1908. Seven months earlier he had married a young singer, Olive Ginevra Jarvis. Perhaps the marriage did not work out, for after selling the house and all her husband's and Bessie MacNicol's paintings, she remarried in November of the same year. It may be because of this that so little documentary material is left.

Of course, questions are asked—how much has been lost by Bessie MacNicol's early death at the age of thirty-four, and how would she have developed if she had survived? Her last paintings, which might point the way, are as a group extremely enigmatic. With *Motherhood* and *Baby Crawford*, her style had developed understandably into maturity, with the rich use of paint and colour. In later works, *The Ermine Muff* (*c.*1903), *Phyllis in Town* (1904) and '*Mary*' (*c.*1903) she painted with great virtuosity, but more thinly against very dark backgrounds once more. It is, however, the dead quality of the large eyes one notices. One misses the vitality, the spontaneous *joie de vivre* which was present in earlier works. The portrait of '*Mary*'—the title in inverted commas—is a mystery. Is it a 'fancy portrait' of her sister who had died long before, at the age of six, as if she were still alive, and Bessie's age? We shall never know.

MacNicol trained at Glasgow School of Art where the direct painterly approach, with emphasis on tonal values, so admired in the work of the Glasgow Boys, was promoted. MacNicol shared so much with the Glasgow Boys, she should be considered a fringe member of the group. As *bon camarade* she was certainly known by the younger members; she was influenced by their work, and like them was interested in the work of Bastien-Lepage—as we see in her painting, *The Goose Girl* (1898) (fig. 270)—and also in Whistler and in 'things Japanese'. Women were not eligible for election to the Glasgow Art Club at the time, but at her funeral at Sighthill Cemetery, many of her brother artists went to pay their tribute to the memory of the deceased. The grave was covered with wreaths, including a large one inscribed: 'From the Glasgow Art Club with sincere regret for the loss of a true artist.'[13]

MacNicol, although only thirty-four years of age, in less than twelve years had exhibited in Scotland, London and on the Continent at Ghent, Munich, Vienna, Dresden, and St Petersburg, and in the United States in both Pittsburg and St Louis. There is so much we shall never know about Bessie MacNicol for, apart from the few letters and photographs, only the paintings remain. There are no sketchbooks, no diaries and no one alive now with memories. There is a great achievement in her best paintings. As her friend Percy Bate wrote: 'She had the gift of paint.'[14]

fig. 267
Baby Crawford, Bessie MacNicol, 1902, oil on canvas, 61.7 × 50.8. (City of Edinburgh Art Centre. Photo: Antonia Reeve)

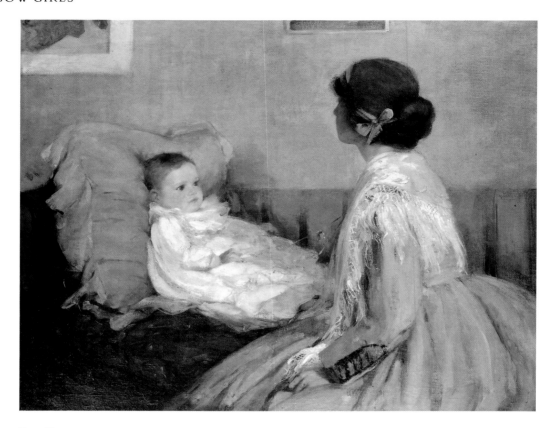

fig. 268
Motherhood, Bessie MacNicol, 1902, oil on canvas, approx. 101.8 × 127.0. The Corporation of Glasgow wished to purchase *Motherhood* from the Glasgow Institute in 1905 but their offer of £150 was not accepted by the late artist's sister. (Private Collection. Photo: Sotheby's)

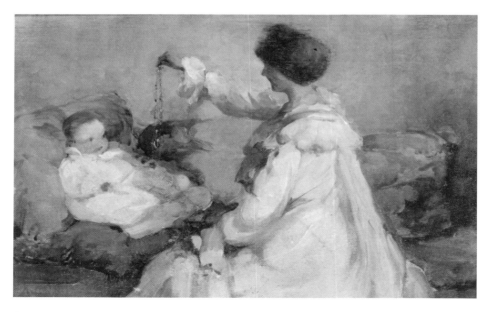

fig. 269
Study for Motherhood, Bessie MacNicol, 1902, oil on board, 21.5 × 34.0. This version has a resemblance to *Hydrangeas* by Philip Wilson Steer, now in the Fitzwilliam Museum, Cambridge, which was illustrated in *The Artist* in February 1902. (Coll: Mrs Joan Valerie Dunn. Photo: Sotheby's)

fig. 270

The Goose Girl, Bessie MacNicol, 1898, oil on canvas, 135.0 × 81.3. The first studies of the girl were made *c.*1891 at Lundin Links in Fife at an informal summer school organised by Fra Newbery. The composition, however, shows the influence of *Pauvre Fauvette* by Jules Bastien-Lepage. Dated 1898 the painting was exhibited at the 'Women's International Exhibition', Earls Court, London, in 1900 where it was noted and illustrated in Vol. XX of *The Studio*. (Coll: Miss J. S. Brown. Photo: A G Ingram Ltd.)

fig. 271
Self-portrait, Norah Neilson Gray, *c*.1918, oil on canvas, 71.0 × 61.0. (Coll: Her great-nephew, Dr Edward Armour. Photo: Sotheby's)

NORAH NEILSON GRAY (1882–1931)

by Catriona Reynolds and Jude Burkhauser

Norah Neilson Gray's (fig. 271) stylised works, from oil portraits to landscape watercolours, were as carefully designed as a piece of Glasgow Style jewellery. For this reason she fits well into turn of the century Glasgow's development when qualities of design were pre-eminent. Writing of Gray in 1930, one year before her untimely death, at age forty-nine while she was at the height of her powers, a critic commented in the *Glasgow News*:

It is sometimes remarked that women painters do not attain the same strength and sureness of power which characterises men. It may be suggested also that, after centuries of men painters and men critics of painting, it is not surprising that the man's point of view is dominant. . . . Whatever may have been the prejudice against women painters, Miss Neilson Gray has been able to overcome it, for her works are in galleries of Paris, Brussels, Nice and Toronto, as well as in those of Great Britain and Ireland, and she is well 'hung' in the Royal Academy, the International Society of Sculptors, Painters and Engravers, the National Portrait Society, the Salon des Artistes Français, and the Beaux Arts.[1]

Gray was born in 1882 in Helensburgh, a town closely associated with Scottish painters including several of the Glasgow Boys. Daughter of George Gray, a Glasgow ship owner, and Norah Neilson from a Falkirk auctioneering family, she was second youngest of seven children and her sisters Muriel and Tina remained her closest friends throughout her life. Each pursued a formidable career in their own fields. Muriel was to become a lecturer in English at Glasgow University, only the second woman to be appointed to the staff of the University at that time. Tina, after working as a Voluntary Aid Detachment nurse during the First World War, became a surgeon, no small decision for a woman of thirty-six in 1920.

Gray started her artistic career in 'The Studio' at Craigendoran just outside Helensburgh run by the Misses Park and Ross. 'The Studio' was one of a number of private drawing studios available to young 'ladies' before they were granted entry into the schools of art. Its teachers, Miss Park and Miss Ross, were pupils of Bouguereau and Fleury and advertised in their prospectus were Alexander Roche and John Lavery, two of the painters associated with the Glasgow Boys group, as visiting artists.

From 1901, Gray commuted to Glasgow to study in the life class at the School of Art but soon after the family moved to the city. Tutor of the class, Belgian Symbolist Jean Delville, spoke little English and required an interpreter. Delville was one of few instructors from the Continent to be employed in Britain at that time and had been hired by Newbery, in what must have been considered a daring move. Delville and the other 'Symbolist' artists were seen to be a part of what was then regarded as the 'decadent' and 'baneful' new art movement. Norah remained a student at the Art School until 1906. During this time she had her first picture accepted for the Royal Academy (a portrait of her eldest sister, Gerty) and was soon exhibiting regularly at the Academy, the Glasgow Institute and the Salon in Paris. She taught fashion design and drawing at the School of Art (1906) and at St Columba's School, Kilmacolm, where she was nicknamed 'Purple Patch' for her habit of asking students to look for colour in shadows. By 1910, she had her own studio at 141 Bath Street and held her first one-woman exhibition at Warneuke's Gallery, Glasgow. Her sense of style and independent spirit were demonstrated when she covered the magenta walls of the gallery with a natural scrim and used toned-down frames in place of the usual gold.

If her individualistic taste was noted and questioned by the critics, her talent for so-called 'female' portraiture and children's portraits was evident. Gray's distinctive colour schemes, unconventional placement of images upon the canvas, and 'purple patch' shadow patterns were all trademarks. She excelled as a portraitist, and her reputation for capturing the essence of her sitter was commented on: 'The illustrations denoted her vivid insight into the heart of the child. . . . We are constantly assured by public speakers that it is a very difficult thing to secure the child's attention . . . as Miss Gray has done here. . . .'[2] Her affinity with her subjects, particularly children, was remarkable because she was a rather shy woman and consequently judged 'aloof'. It is thought her seemingly cool nature created a barrier which discouraged close friendships with anyone other than her family. She did take part in art school events, however, and an early design for a School of Art 'At Home' Card indicates that she was active in this out-of-school activity. Probably through an involvement in the masques for which Gray designed some costumes, she knew fellow tutor Dorothy Carleton Smyth and painted Smyth's portrait c.1910 for her first one-woman exhibition.

In 1914 the First World War began that would, as a result of women's entry into a host of what had been up to then considered masculine occupations, ultimately help change women's role in British society. In that same year Gray was elected a member of the Royal Scottish Society of Painters in Watercolour and had her watercolour illustrations to Wordsworth's *Ode on Intimations of Immortality from Recollections of Early*

Childhood published by Dent. This series of fanciful watercolours must have shown the public another side of Norah Neilson Gray's art. Elfinlike children inhabiting fairytale landscapes, find comparisons in the early illustrations of Katharine Cameron, Annie French and Jessie M. King, linking her with her contemporaries, yet Gray's style and technique were highly individual. These fantasy watercolours have a rich textural detail that was built up by a pointillist technique and gives an effect similar to that used by the French Impressionist Seurat. A development of this style may also be seen in the mystical and more dramatic painting, *One of our Trawlers is Missing* (*c.*1915) (or *The Missing Trawler*), which was purchased by the Glasgow Corporation and is now in the collection of Glasgow Art Gallery and Museums. In an unfinished sketch, found among the artist's papers at the bottom of a trunk containing reviews provided by her clipping service, we can see that she worked these paintings first in pencil laying out the overall design placement on the page, assigning each section a letter and making corresponding notes on the borders of the page with colour indications. A stippling was next made with a fine brush and/or pencil to give texture to the desired area and then the flat areas overpainted with a coloured wash. Norah Neilson Gray was in contact with Jessie M. King and her husband E. A. Taylor in Paris around the time she was producing these works. Taylor, who had contacts with *The Studio* editors, corresponded with a number of artists from Glasgow including Gray who taught with King at the Art School. Gray had been invited through Taylor to send artwork to *The Studio* from among her recently completed illustrations for Dent's publication of Wordsworth. In a letter of 7th October, 1912 Gray wrote:

> I have posted to you (also care of the Editor of *The Studio*) another drawing *Mist in an Autumn Garden* . . . which I think better than *Shadow Farm*. You asked me if I preferred oil or watercolour. I prefer oil—it's a much wider field & I'm desperately interested in people's faces. Doing a few of these watercolour drawings is a pleasure but if I do too many they become feeble and unspontaneous.[3]

In the next few years, Norah Neilson Gray was to produce some of her most powerful work—direct in its subject matter, and very different in mood from her watercolours. The war inspired what are probably her most important paintings. A powerful image, *The Country's Charge* (*c.*1915), depicting a woman and child huddled in a striped shawl, was exhibited at the Royal Academy and sold on behalf of the Red Cross. The painting was bought by Joseph Bibby and reproduced in *Bibby's Annual* of 1915, which was widely distributed and used as an appeal for the Royal Free Hospital to which it was subsequently presented. A bleak yet hauntingly powerful image is created in one of her strongest portraits, *The Belgian In Exile*

(*c.*1915) known as *The Belgian Refugee* (fig. 272), which was exhibited at the Glasgow Institute in 1916, the Royal Academy in 1917, and Paris in 1921, where it was awarded a bronze medal. Gray went to France to work as a Voluntary Aid Detachment nurse for the Scottish Women's Hospital in the French Red Cross Hospital at the Abbaye de Royaumont in the Spring of 1918, just at the time of the last great onrush of the German Army when the hospital was frequently being bombed. Gray painted in the day-time when she was relieved after night duty, sketching soldiers and staff and the setting of her group portraits, the cloisters of the Abbaye, then a ward for the injured. The medieval cloisters provided a striking backdrop for her compositions, casting the familiar strong shadow which one finds in most of her paintings, across the uniformed figures of the nurses, doctors and soldiers who served their country during the Great War. In 1920 she was commissioned by the Imperial War Museum Women's Work Committee to record the staff at the Hospital for the permanent collection of their new Museum in London. Priscilla Lady Norman, wife of Sir Hugh Norman, who had run a hospital in France in the first months of the war, was the leader of the Committee. Lady Norman had seen another eyewitness contemporary painting of the Scottish Women's Hospitals painted by Gray, probably the *Hôpital Auxiliaire d'Armée 30, Abbaye de Royaumont* (1918) (fig. 273), which depicted many of the doctors, soldiers and nurses and eventually became Gray's more well-known wartime image. In July 1919, Gray had corresponded with the Museum concerning her painting of French soldiers completed in the war-zone the previous May stating she did not wish her work to be considered for the small representative 'Women's Work Section—or anything women's suffrage, just now.'[4] Her description of the painting, which she hoped the Museum would purchase for its collection, was a 'view of soldier-patients . . . (seen by a woman, if you like)'. She felt they should accept it because it was 'painted from within, at the time and absolutely true to fact . . .' and because the scene would be 'unfamiliar to anyone who has not worked in a first-line hospital in France'. Also because it was unlike the pictures of 'rows of tidy beds which usually are the subject of hospital pictures', and she believed the War Museum should have a record of what was done 'by the British for the French Army in the way of Hospitals.' She was adamant that the picture 'should not be in the Women's Work Section'.[5] Despite the artist's wish that the Museum buy her work without considering the fact that she was a woman, apparently her insistence that it not be segregated in a 'Women's Work Section' of the collection, prevented the first painting's recommendation for purchase as the Museum's main budget for acquisitions had been expended.[6] In the following year, however, Gray was commissioned by the 'Women's Work Section' for a similar painting, *The*

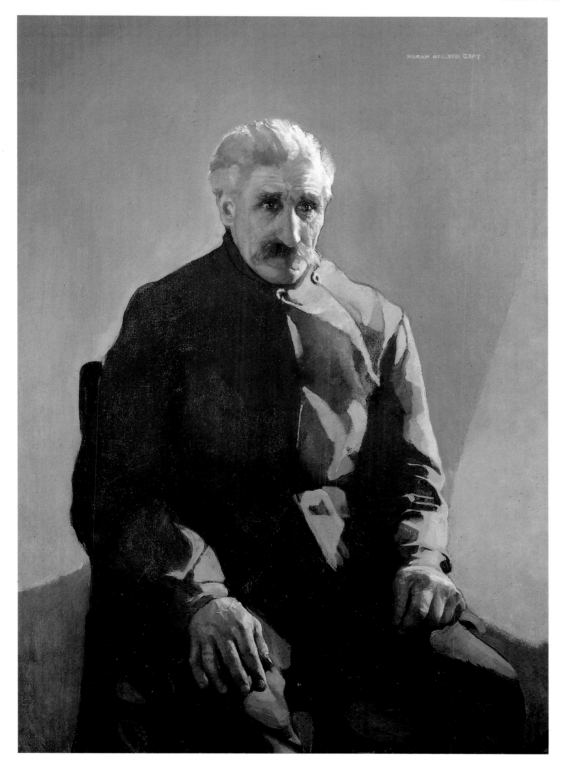

fig. 272
The Belgian Refugee, Norah Neilson Gray, 1916, oil on canvas, 125.7 × 87.6. This strong but sensitive portrait of a Belgian from Liège who came to live in Glasgow when his country was invaded by the Germans gained the Bronze Medal in Paris in 1921. (Glasgow Museums and Art Galleries)

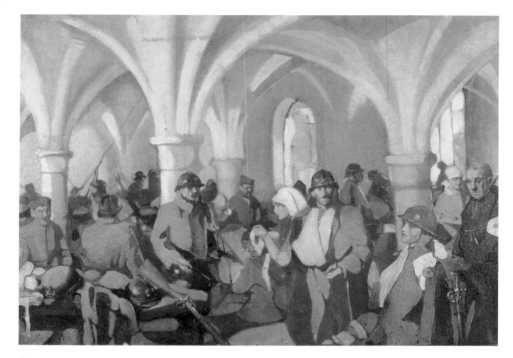

fig. 273
Hôpital Auxiliaire d'Armée 30—Abbaye de Royaumont, Norah Neilson Gray, 1918, oil on canvas, 70.0 × 98.0.
(Coll: Dumbarton District Libraries and Museums. Photo: Glasgow Museums and Art Galleries)

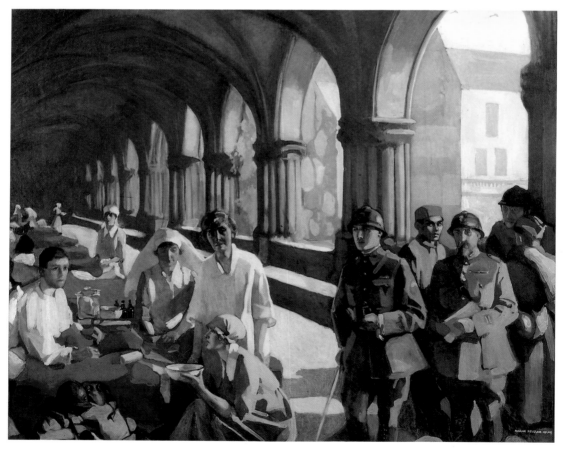

fig. 274
The Scottish Women's Hospital, Norah Neilson Gray, 1920, oil on canvas, 114.0 × 139.0. (The Imperial War Museum)

Scottish Women's Hospital (c.1920) (fig. 274), which was a more formal arrangement of the staff than the first picture. Lady Norman and her Committee wanted to include a portrait of Dr Frances Ivens for which Norah Neilson Gray had sittings. Very different but no less interesting representations of the war time can be seen in a set of crayon drawings of soldiers from various regiments. Their solemn thoughtful faces, shoulders hunched against the cold, are handled with exceeding sensitivity. Gray shows, in these drawings, a talent for portraiture on a more intimate scale than her official commissions. At every scale the war provided a catalyst for Norah Neilson Gray to produce some of her most important work.

Having secured a Bronze medal in 1921 in Paris, in 1923 she won the *Médaille d'Argent* there for her painting *La Jeune Fille* (1923). A contemporary news account related:

> Probably no artist in the land has climbed the rungs of the art ladder earlier or more decisively than Miss Gray. We think we are right in saying that no other woman has won these two Parisian honours. . . . France, too, continues to honour Miss Gray, for her *Little Brother*, exhibited in the Salon, was one of the few of the whole exhibition

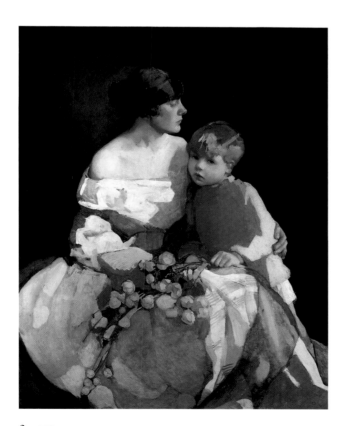

fig. 275
Little Brother, Norah Neilson Gray, 1920–22, oil on canvas, 127.0 × 101.6. (Glasgow Museums and Art Galleries)

chosen to be reproduced in colour in *L'Illustration*. [7]

After the First World War, she returned to Glasgow and to commissioned portraiture. Depictions of young women and children were to become her forte and she was kept busy with a large number of private commissions, many of well-known Glaswegians. Critics, however, found fault with the form and prominence given to flowers, textiles or other decorative elements that were somewhat in the spirit of Gustav Klimt, the Austrian Secessionist whose portraits of women and children had employed similar yet far more abstract conventions.

Local recognition of her achievements came in 1921 when she was appointed to the hanging committee of the Royal Glasgow Institute of the Fine Arts—the first woman to be so appointed. Her fellow painter on the committee was Glasgow Boy, J. Whitelaw Hamilton. A two-page feature on her work from that year in *Scottish Country Life* stated:

> In art as in literature . . . the individual may be assisted; but not any combination of men, or of societies, can retard his or her development, or his or her slow or rapid achievement. Miss Gray is to be honoured because she has fought her own art battles, and achieved by virtue of her own compelling ability. [8]

Another measure of her success in Scotland and the recognition she had achieved were her public commissions, such as the *Portrait of Professor Cathcart* (1927) at the University of Glasgow. Norah Neilson Gray was at last, in the early 1920s, becoming successful in Scottish art circles. From this period comes her large painting *Little Brother* (c.1920–22) (fig. 275), exhibited at the Royal Academy in 1922 and bought by the Glasgow Corporation for the permanent collection at Kelvingrove at the Memorial Exhibition of her work in 1932.

In 1922 she was asked to contribute a drawing to Sir Edwin Luytens' Queen's Dolls' House, then in preparation. The idea of the Dolls' House was that it be a miniature palace containing works representative of the best art of the period. 'Glasgow Girls' Jessie M. King and Margaret Macdonald Mackintosh also had been invited to contribute works. King's *Mermaid* accompanied miniatures by Macdonald and Gray to London. A thank you note to Gray, from Princess Marie Louise, acknowledged the contribution.

In the 1920s the three sisters Gray, all then professional and unmarried women, bought a car, which enabled them to spend much more time at the family home on Loch Long, some thirty-five miles west of Glasgow, which they had recently inherited. A large number of Gray's landscape watercolours were painted in this area. These later paintings border on Modernism: in *Wine Dark Waters* (1928) (fig. 277) which depicts the view across the water from the garden of their

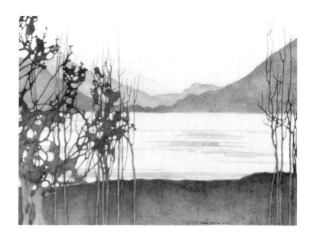

lochside home, Gray incorporated both the characteristically strong shapes, harmonious colours and the stippling effect she had earlier adopted, and at the same time moved toward the more abstract expressionistic *July Night, Loch Lomond* (1923) (fig. 278). In one of the most recent reviews of Gray's work, on the occasion of the 'Centenary Exhibition of the Glasgow Society of Lady Artists' the critic stated that there were some of the women artists whose work did not reflect what anyone else was doing at that time:

> . . . like Norah Neilson Gray, whose own strong individuality coloured everything. . . . (Gray) was a portrait painter who, at her best, as in *The Belgian Refugee* could hold her own with any of the men, and whose watercolours . . . had a potent simplicity that presages certain landscape abstracts, like Bet Low's of sixty years later.[9]

Gray exhibited regularly not only in Scotland but at both Salons in Paris, and in 1926 had a one-woman exhibition at Gieves Art Gallery in London. Despite a serious operation she continued to paint and exhibit her work. At the time of her early death, of cancer in 1931, it was noted that she had been more honoured in Paris than at home and that, 'she was in the forefront of

fig. 276
Norah Neilson Gray, *c.*1920s. (Photo: Catriona Reynolds)

Scottish women painters; indeed she was the foremost Scottish woman painter'[10] of that time. Commenting in 1976 on the Helensburgh and District Art Club's twenty-fifth anniversary exhibition 'West of Scotland Women Artists', critic Martin Baillie said:

> Norah Neilson Gray . . . was probably the major talent . . . she is one might say, the social realist member of the group. . . . As against the dark . . . academic oils we have the art-nouveau qualities of . . . *July Night, Loch Lomond*. A fusion of these two (that of course is a lot to ask) would have made Norah Neilson Gray a formidable figure indeed. As it is she is often forgotten. . . .[11]

Although the Glasgow Art Galleries purchased a number of her works, the paintings were, like many of the works of women in the arts worldwide, consigned to the museum's stores. The contemporary reviews we are able to read of Norah Neilson Gray's work give some indication of the international status and recognition the artist had achieved in her lifetime.

figs. 277 and 278
Wine Dark Waters, Norah Neilson Gray, *c.*1928, watercolour, 35.5 × 45.5. (Coll: Catriona Reynolds. Photo: Glasgow Museums and Art Galleries)
July Night Loch Lomond, Norah Neilson Gray, *c.*1922, watercolour on board, 20.2 × 25.3. (Private Collection. Photo: Glasgow Museums and Art Galleries)

STANSMORE DEAN (1866-1944)

by Ailsa Tanner

with research assistance from Jennifer Shewan May

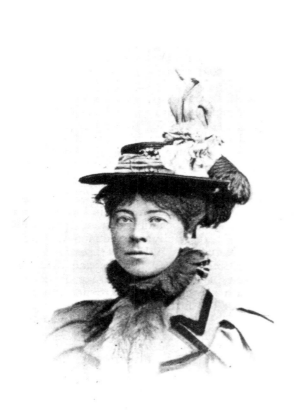

An artist may die unrecognised, and be forgotten for many years until, perhaps, a small collection of works is seen together once more. Reappraisal is made, quality is given its due and a reputation is restored. This is the case with the work of Stansmore Dean Stevenson (fig. 279).

Quite possibly Stansmore Dean found her unusual first name, which was a family one, to be an advantage, for her work when first exhibited was taken to be by a man. Stansmore Richmond Leslie Dean was born in Glasgow on 3rd June, 1866. Her father was Alexander Davidson Dean (1814–1910), a master engraver and artist from Aberdeen, and, in 1846, co-founder and active partner in the printing firm of Gilmour and Dean. She was the youngest daughter of six surviving children, and from an early age was known as Stanny. The family (fig. 283) moved to Balgray House, a large house in Kelvinside designed by William Leiper, a well-known Glasgow architect.

fig. 279
Stansmore Dean, *c.*1900. (National Library of Scotland)

Stansmore like her father was talented, and from 1883 studied at the Glasgow School of Art. Her particular friend, also a student, was Margaret Rowat, sister of the future Mrs Jessie Newbery. Charles Rennie Mackintosh, David Gauld and Bessie MacNicol were also fellow students. In 1890 she was the first woman to be awarded the Haldane Travelling Scholarship and studied in Paris at Colarossi's *atelier* with August Courtois.

She first exhibited at the Glasgow Institute in 1894 and regularly until 1910, then after a gap from 1928 until 1932. She also exhibited at Paisley, Liverpool, once at the Royal Scottish Academy and twice at the International Society in London, a great honour especially for a woman. The President of the Society was James McNeill Whistler and we may see his influence in some of her work (fig. 281). As far as we know she was never a student of his, but she could have seen his work at the Glasgow Institute and in London.

From 1896 Stansmore Dean had a large studio at 180 West Regent Street, and by 1900 she was making a name for herself locally. She had spent almost every summer abroad with fellow artists in the South of France. She also visited Brittany (fig. 282) and Holland judging from titles of her exhibited work. In 1902 her life changed dramatically when she married Robert Macaulay Stevenson as his second wife. His first wife had died not long before, in childbirth, and Stansmore not only became the wife of a demanding personality, but was to share the responsibility of bringing up his child. That Jean Macaulay Stevenson remembered her with great affection is proof that she succeeded well. Though of forceful character herself, in marriage she used tact and good sense to manage her husband without seeming to do so.

It would also be her responsibility to run Robinsfield, his large house by the side of Bardowie Loch. There they each had their own studio, and she continued to paint and exhibit. In late 1905 and the spring of 1906, she showed two paintings in the United States at Buffalo, and in Canada at Toronto. One was the portrait of *Neil Munro* (*c.*1905), now in the Scottish National Portrait Gallery and said to be the first time a painting was bought from a living artist, and the other *Meditation* (1899) (fig. 280).[1] The latter may have been the same as a painting exhibited at the Paris Salon, 'Société Nationale des Beaux-Arts', in 1899, titled *Pensive*, and illustrated in the catalogue.

As an artist member of the Society of Lady Artists' Club in Glasgow she was elected convenor of a decoration committee formed in 1908 to supervise alterations to the Clubhouse at 5 Blythswood Square.

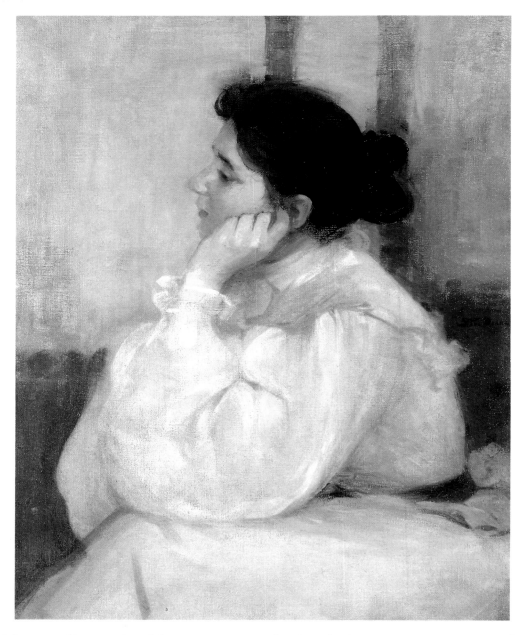

This forceful personality convinced her own committee that the only man in Glasgow for the job was Charles Rennie Mackintosh. Unfortunately Mrs Higgenbotham, the Lay President, and her Council did not agree, and though Mackintosh's distinctive new black porch and some wallpapering were completed surreptitiously during the summer, the Council took over the work of the decoration committee and no further work was commissioned from Mackintosh. Stansmore Dean resigned in protest and her resignation was accepted with alacrity by the Council, though later the Artist Members raised a petition to have her reinstated. Eventually matters were smoothed over, but by then the Stevensons were preparing for their first exile from Robinsfield, for there were financial difficulties and on Stansmore's advice they let the house and went to live in France.

The move was made in 1910 to Montreuil-sur-Mer, on the Pas de Calais, an interesting old town surrounded by ramparts, where they were to stay, even through the First World War, until 1926. At first Stansmore helped in the YMCA outside the town and Macaulay looked after the needs of soldiers on the trains passing through the station to the front, but later in 1916 when GHQ with Sir Douglas Haig in command

fig. 280
Meditation, Stansmore Dean, oil on canvas, c.1899, 77.7 × 61.0. (Private collection, Photo: Glasgow Museums and Art Galleries)

fig. 281 *(above opposite)*
Girl in a Straw Hat, Stansmore Dean, c.1910, oil on canvas, 68.5 × 55.8. The influence of Whistler is seen in this portrait. (Coll: Peter J.B. Shakeshaft. Photo: Sotheby's)

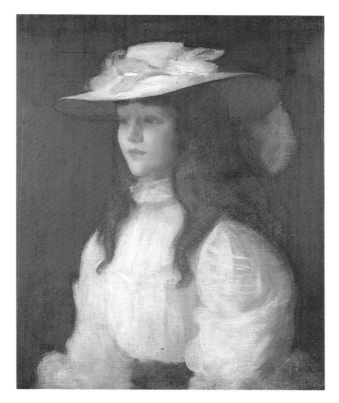

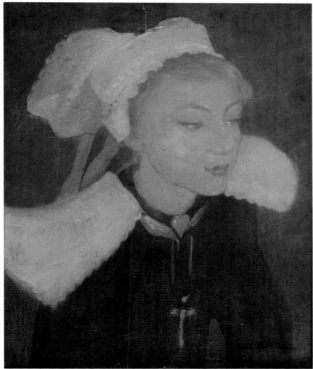

moved to Montreuil from St Omer, they both provided refreshments for staff who could not leave the town. This was in a hut on the ramparts, the first Scottish Churches' Hut. It also served as a place where soldiers could write letters, and on Sundays became a church where Haig himself worshipped.

In his autobiography, *In the Meantime* (1942), the novelist Howard Spring recalled with gratitude the civilised and unstuffy hospitality he enjoyed with the Stevensons while posted at Montreuil. He also remarked on the enduring beauty of Mrs Stevenson, which had survived the worries of war and hard work. Though the Germans did not reach Montreuil in the 1918 advance, they came within nineteen miles of the town.[2]

There cannot have been any time for painting in this busy period, and Stansmore did not exhibit again until 1927 when they were settled once more at Robinsfield. The house provided the setting for social occasions which are remembered to this day, but once again financial difficulties arose. After a visit to the States to see a brother of Macaulay they went in 1932 to live in south west Scotland at Kirkcudbright, at the Mayfield Hotel, and later at Borgue. They were able to use one of Jessie M. King's studios in Green Gate Close, but it is doubtful whether Stansmore painted there at all. Her eyesight was failing, and from 1939 there was yet another war with other priorities.

On 15th December, 1944, Stansmore Dean Stevenson died in the Cottage Hospital at Castle Douglas. At that time she and her husband were staying at Borgue Hotel, near Kirkcudbright. The event passed without note for the Allied advance in France filled the minds of people as the Second World War drew to its close in Europe. One cannot but feel that here was a real talent which was undervalued and underdeveloped.

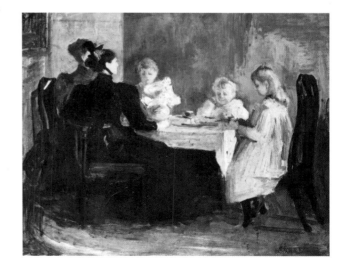

fig. 282
Breton Girl, Stansmore Dean, c.1898, oil on canvas, 54.6 × 45.7. (Private Collection. Photo: Glasgow Museums and Art Galleries)

fig. 283
Family At Table, Stansmore Dean, c.1895, oil on canvas, 37.5 × 46.3. The artist's family. (Private Collection. Photo: Sean Hudson)

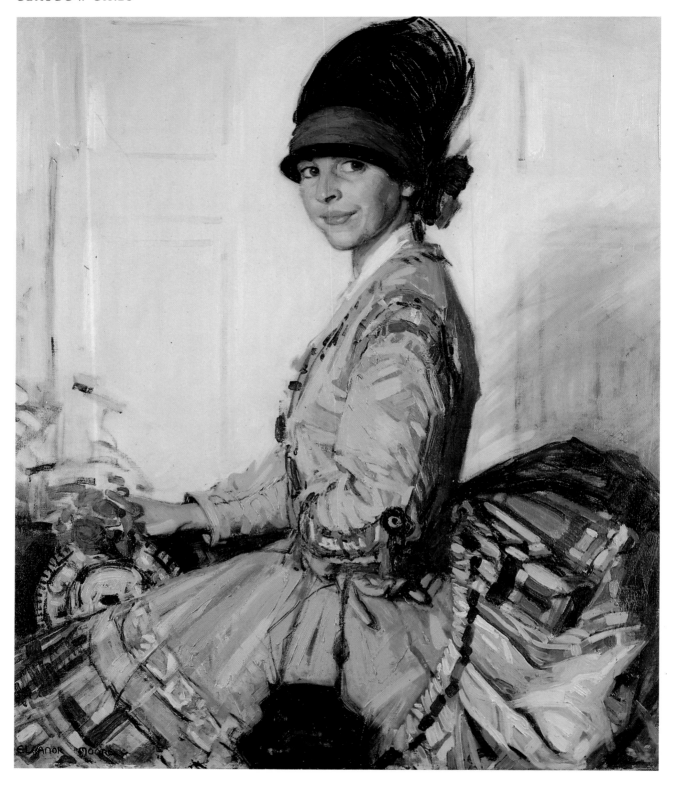

fig. 284
The Silk Dress, Eleanor Allen Moore, *c.*1918, oil on canvas, 97.5 × 86.2. (Private Collection. Photo: Glasgow Museums and Art Galleries)

ELEANOR ALLEN MOORE (1885-1955)

by Ailsa Tanner

Eleanor Allen Moore (fig. 286) was a near contemporary of Norah Neilson Gray. Like Jessie M. King, she was a daughter of the manse, but unlike Jessie her parents did not discourage her from using her talents for painting and for playing the piano. Her father, the Revd Hamilton Moore, was Irish, and Eleanor was born at Glenwhirry, County Antrim, on 26th July, 1885. Her mother was Scottish, from St Cyrus near Montrose, and the family came over to Scotland in 1888, first to Edinburgh, and then in 1891 to Newmilns in Ayrshire, where her father was minister of Loudoun Old Parish Church.

She was the eldest of a family of six, and life was never dull at Loudoun Manse, a charming old house with later additions, which Robert Burns had visited when he was at Mossgiel. In 1902 at the age of seventeen she went to the Glasgow School of Art, travelling from Newmilns every day. She studied under Delville and Artot, and Fra Newbery thought highly of her work. She first exhibited at the Glasgow Institute in 1909 and was just beginning to be noticed in reviews when war broke out in 1914. There was little time for painting during the war as a Voluntary Aid Detachment nurse at Craigleith Hospital in Edinburgh.

The Silk Dress (c.1919) (fig. 284) was exhibited at the 1919 Institute Exhibition and was illustrated in the catalogue. The artist did not have a studio at the manse, nor could she afford to pay for models to sit for her, so many of her early works are self-portraits, with the background of manse interiors. Like Bessie MacNicol, and influenced by Henry and Lavery, she borrowed a Victorian crinoline and a bustle and painted herself. There was trouble later, when paint was found on the dresses.

She married Dr Robert Cecil Robertson of Kilmarnock in 1922. Their daughter was born in the following year, and early in 1925 they sailed to the Far East for her husband to take up an appointment in Public Health in Shanghai.

To begin with it was a difficult and dangerous time in Shanghai (fig. 285) as there were serious anti-foreigner riots, but when things settled down it was possible to explore the flat Yangtse delta country by houseboat (fig. 289), and visit the then unspoilt ancient walled cities of Soochow and Wusih. E.A. Moore realised what a fascinating country she had the opportunity to paint, and she painted landscapes and townscapes, but

above all she loved to paint the Chinese people; men (fig. 288), women, and children. This was made easier after 1928 when the Shanghai Art Club was formed ' . . . to balance the present purely commercial atmosphere of Shanghai'.[1] Premises were acquired and interesting models (fig. 287) were found by the resident caretaker.

Life in Shanghai was a privileged one for foreigners, and a loyal and reliable staff gave a woman artist freedom from household chores and child-minding. This precious time was spent, not in playing bridge or mahjong, but in using her trained eye to observe this strange world round her, and record it swiftly and vividly. Unlike Hornel and Henry, though she loved Chinese art, she was not influenced by it. She painted oriental subjects with Western eyes, using her Glasgow training.

In August 1937 this way of life ended abruptly when British women and children were evacuated from Shanghai to Hong Kong, and she never went back. On return to this country she felt bypassed by new styles, and with the advent of another war and the death of her husband in Hong Kong in 1942 she did not in fact paint much more. She died in Edinburgh on 17th September, 1955.

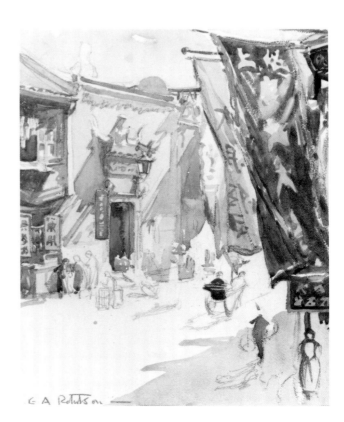

fig. 285
Street Scene, Shanghai, Eleanor Allen Moore, c.1927, watercolour, 51.0 × 40.0. Painted between 1925 and 1930. (Private Collection. Photo: Glasgow Museums and Art Galleries)

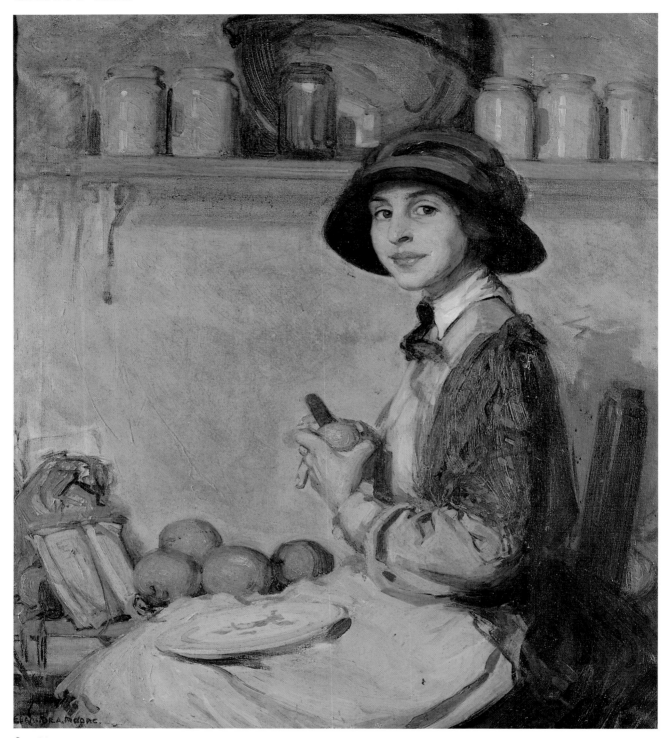

fig. 286
Marmalade, Eleanor Allen Moore, *c.*1913, oil on canvas, self-portrait, 97.5 × 86.0. A self-portrait painted in the kitchen of Loudoun Manse, Newmilns, Ayrshire. (Private Collection. Photo: Glasgow Museums and Art Galleries)

fig. 287 *(left opposite)*
The Opium Smokers, Eleanor Allen Moore, *c.*1936, oil on board, 35.0 × 43.1. (Private Collection. Photo: Glasgow Museums and Art Galleries)

fig. 288 *(above opposite)*
The Letter Writer, Eleanor Allen Moore, *c.*1936, oil on canvas, 52.0 × 55.0. (Coll: Lady Anderson. Photo: Glasgow Museums and Art Galleries)

fig. 289 *(right opposite)*
Houseboat At Henli, Eleanor Allen Moore, 1936, oil on board, 41.8 × 35.0. The railway between Shanghai and Hangchow crosses the Grand Canal at Henli where in the 1930s the Shanghai Rowing Club held its Annual Regatta. (Private Collection. Photo: Glasgow Museums and Art Galleries)

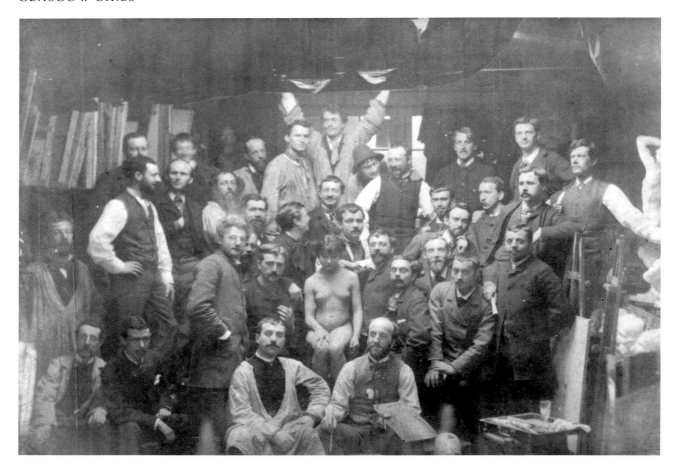

'BLINKERS ON OUR IMAGINATION'
by Jude Burkhauser

To emasculate art by suppressing the study and representation of the nude—absolutely the highest form of pictorial art—is simple prudery . . . with the only result of setting narrow limits to our art and putting blinkers on our imagination. . . . [1]

The issue of granting women art students access to nude models was controversial when Fra Newbery assumed his post in 1885 and press clippings in Newbery's scrapbooks chronicle the debate. In the Slade School in London 'where these pernicious modes of study first took their origin', men and women worked side by side in the life class while in Germany at the time 'it was impossible to witness such a sight'.[2] Early life classes at Glasgow School of Art were separate and unequal. Women did not have live models but drew from the cast and later from the draped figure as in many other schools. Although we find a nude study (fig. 291) in one of De Courcy Dewar's student sketchbooks (c.1895), there is no firm documentation

fig. 290
An all-male life drawing class with their nude female model at Glasgow School of Art, c.1870. (Photo: Private Collection)

to confirm access at that time to the nude model at Glasgow.[3] Considered morally degrading by the most conservative, and an absolute necessity by the then liberal, access to live nude models for both men and women (although in separate classes and with chaperones)[4] appears to have been firmly established at the School by at least c.1903.[5] Certainly it was no longer an issue by 1913 when in a School of Art Club exhibition a Miss Amour won a prize for 'her figure composition, a study in the nude' which was described as 'a bold effort in colour and remarkable in its draughtsmanship'.[6] By 1919 study from the nude was commonplace and student, May Reid (1897-1987) (fig. 292), photographically documented the nude model from her studio to use in completing her graduation piece, Night and Day (c.1920) (fig. 293). A competent large-scale oil study of two winged 'presences' which echoes Pre-Raphaelitism, the painting was completed under the tutelage of Maurice Greiffenhagen. Reid studied from 1915–21 and a collection of life sketches (1919–20) which relate to Night and Day from her student portfolio remain along with a colour sketch for the work.

According to artist J.C. Horsley, RA (whose views gained him the nickname 'clothes Horsley'),[7] who had been associated with South Kensington and spoke in Portsmouth at the Church Congress in 1885 where the issue of live models for both men and women was hotly debated, the opposition to women's access to the nude figure was on two levels—moralist and sexist. Speaking of representation of the nude by students in the national competitions Horsley not only saw it as a danger to a woman's reputation (for he said: '. . . There were only three studies of naked women, but all done by female students, thus trained at the public expense to assist in the degradation of their sex . . .'[8]) but also demonstrated that in his view it was inappropriate for women to enter this area of art practice:

> The result of all this miserable work is useless . . . for even if they [females] gained any increase of skill from such study it is quite inapplicable to the forms of art work within the compass of their powers to execute successfully.[9]

The denial of access to the nude model helped keep women from competing with men in the 'forms of artwork' considered 'true' or 'fine' art and confined to what were referred to as the 'womanly arts'—the decorative or applied arts—particularly textiles. So linked with embroidery was the 'feminine', that the term used by John Ruskin in his influential book *Sesame and Lilies* to refer to needlework was 'Ladies' work'.[10] There was no question who it was that would exclusively engage in embroidery. These 'gendered spheres' and Victorian moralism were responsible for the initial lack of training opportunities for women in nude figure drawing which helped ensure male artists' exclusive domain in the fields of painting and sculpture where ability to draw, paint and sculpt the figure was imperative to the successful rendering of historical themes. It is only recently that art historians are taking these facts into consideration in re-evaluation of art history:

> Women painters like women writers, have been more harshly judged and more quickly consigned to the storage rooms of history than their male counterparts. . . . Denied special education, unable to avail themselves of such necessary conventions as nude models, women were isolated from the mainstream of artistic production and then criticised for the 'triviality' of the work they produced in effective exile.[11]

Royal Academicians responded to the 'Models and Morals' debate which had by 1885 grown perilously close to also endangering men's access to the nude. In their response to a proposed ban of nude models for men, we have strong testament to the perceived effect this lack of access would have on one's development as an artist:

> Do away with the study of the nude? cried Mr Woolner . . . it is ridiculous to think about it. Why it would be throwing away one of the artist's greatest advantages.[12]

> It is, of course, impossible to acquire the highest excellence in art, or the highest excellence of which the painter may eventually be capable, without an earnest and thorough study of the nude.[13]

Although women did have access to children and family as models, they did not have equal availability to nude models in art classes where tutors could correct and instruct their drawing. As a result, many turned from figurative work toward the painting of still life and flowers:

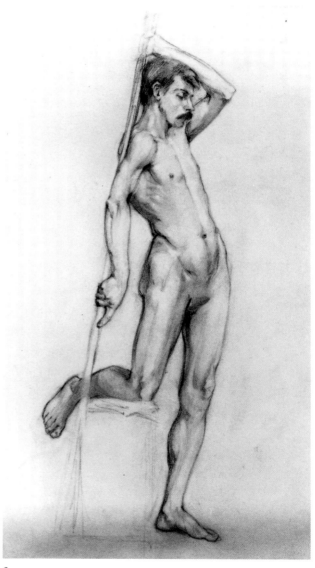

fig. 291
Glasgow School of Art sketchbook, De Courcy Lewthwaite Dewar, 1895. This drawing in De Courcy Lewthwaite Dewar's early school sketchbook indicates early access to the nude by female students. (Coll: H.L. Hamilton. Photo: Glasgow Museums and Art Galleries)

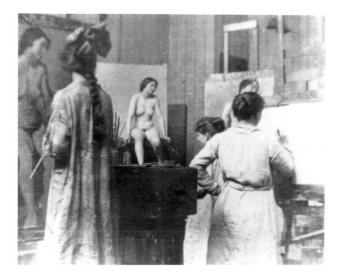

fig. 292
Student May Reid (left with bow) drawing in her life class. By 1914–20 women's access to live nude models was commonly accepted. After leaving the School of Art, Reid travelled, lived and worked for a time in Monte Carlo then married and settled in London where she seems to have done no further painting. (Coll: Dr Mabel Tannahill. Photo: Glasgow Museums and Art Galleries)

fig. 293
Night and Day, May Reid, 1920, oil, 150 × 90. Reid's *Night and Day*, with Pre-Raphaelite echoes, was done as her diploma piece under the tutelage of Maurice Greiffenhagen. (Coll: Dr. Mabel Tannahill. Photo: Sotheby's)

By the late eighteenth century flower painting had become a common genre for women artists. The characterisation of flower painting as petty, painstaking, pretty, requiring only dedication and dexterity is related to the sex of a large proportion of its practitioners . . . for the social definition of femininity affects the evaluation of what women do to the extent that the artists and their subjects become virtually synonymous.[14]

In their book *Old Mistresses*, British art theorists Griselda Pollock and Rozsika Parker, acknowledging the ranking of art disciplines into 'high art' (i.e. painting and sculpture) and 'lesser arts' (i.e. decorative or applied arts) identified an important connection between what they termed sexual categorisation, meaning male-female gender divisions, and the new hierarchy of the arts. By examining the history of flower painting, the authors demonstrated a link between sex and status in fine art which ranked the painting of flowers as a 'lesser' genre. Flower painting was only one area, however, where the emergence of women in large numbers into a particular art form resulted in a corresponding change in its status. The origins of flower painting are found in sixteenth and seventeenth-century Europe as a branch of still life painting. As a major art form in Holland, its popularity continued into the twentieth century, and although there were a few women involved, at first the painting of flowers and still life was primarily a male province. It was not until large numbers of women adopted the genre in the late eighteenth century that the perception of flower painting as a 'lesser' form of artistic representation evolved. Pollock and Parker stated that, 'despite . . . complicated iconographic programmes of many flower paintings, one twentieth-century commentator wrote: "Flower painting demands no genius of a mental or spiritual kind, but only the genius of taking pains and supreme craftsmanship."'[15] *Old Mistresses* demonstrated the 'trivialisation' of flower painting showing that although flowers had long been used as signifiers of mortality or morality and carried a host of other symbolic associations, as we have seen with the Glasgow Rose, painters of flowers came to be seen as 'painters of trifles'.

The tendency to identify woman with nature at a time when the 'feminine' itself was devalued led to ghettoisation of flower painting within the rank of the 'lesser' crafts. While presenting the concept of this ranking of the genre via sexual categorisation, Parker and Pollock do not seem to carry further their analysis to address the issue of the devaluation of nature as a

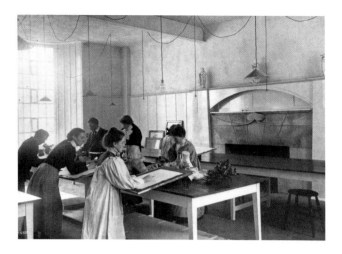

whole. For not only did the entry of women into flower painting contribute to its marginalisation but denigration of 'Nature' as a whole contributed to the genre's demise. No longer revered as sacred by post-agrarian society, nature was to be conquered and controlled as Riane Eisler demonstrates in her important work *The Chalice and the Blade* (1987).[16] Eisler chronicles bias in cultural evolutionary accounts and demonstrates where preconceptions of cultural historians and scholars have resulted in blinkered conclusions. Looking specifically at Neolithic art and the culture that produced it, she shows that in analysing art production in society:

> One of the most striking things . . . is what it does not depict. For what a people do not depict in their art can tell us as much about them as what they do. In sharp contrast to later art, a theme notable for its absence from Neolithic art, is imagery idealising armed might, cruelty, and violence-based power. . . . What we do find everywhere—in shrines and houses, on wall paintings, in the decorative motifs on vases, in sculptures in the round, clay figurines, and bas reliefs—is a rich array of symbols from nature. . . .[17]

Standing at our current evolutionary crossroads, Eisler posits her 'gender holistic theory of cultural evolution' where the lethal power of the 'blade' or 'dominator' model of society, historically associated with a social system based on sexual ranking, and the nurturing and life-generating powers of the 'chalice' or 'partnership' model, based on linking rather than ranking must be perceived. Eisler states: 'the underlying problem is not . . . sex. The root of the problem lies in a social system in which the power of the "Blade" is idealised. . . . '[18] Writing along similar theoretical lines, in *Return of the Goddess* (1982), Edward C. Whitmont commented on the 'Feminine and its repression' saying that, 'the androlatric value system of the patriarchy . . . caused both sexes to devalue, not so much woman, *per se*, but the feminine, and the entire magico-mythological dimension.'[19]

The Scot's Celtic regard for nature, a Newbery-inspired 'partnership' ideal, and a regard for the 'magico-mythological dimension', no doubt played a significant role in the employment of natural imagery, particularly flowers, in the work of Glasgow artists

fig. 294 *(above)*
Drawing from nature in the Art School, *c.*1900. Women worked from live examples and models as a result of the Scottish Education Department's decision to abandon drawing from plaster casts in favour of life. Both Jessie and Fra Newbery advocated that their students work from live specimens, plant and animal, and there was an animal room in the school's basement to accommodate the live models. (Glasgow School of Art)

fig. 295
Sketch from nature by Jessie Keppie, *The Magazine*, 1895, pencil. (Glasgow School of Art)

(fig. 296). Jessie M. King, one woman whose work displayed this basis, wrote in her early notebooks of encounters with fairies, employed organically growing forms, and was recorded as having had a 'magico-mystical' experience as a young woman which influenced her life and work.[20] Charles Rennie Mackintosh's studies of flowers, (disputedly co-produced and co-signed by Margaret Macdonald Mackintosh, who most argue did not contribute to their production) continued throughout his life. This regard for nature and flowers was nurtured while King and her colleagues were attending the Glasgow School of Art. From the Art School's earliest days, courses emphasised the study of drawing from what was primarily floral ornament. In a speech by the Lord Reay to public school teachers upon presentation of certificates for proficiency in drawing, he stressed the importance of instruction in 'drawing for design as it applied to the manufactures in the district, especially with regard to the study of flowers'. Lord Reay stated that since science and art education in Scotland had been taken over by the 'Scotch [sic] Education Department . . . from South Kensington authorities, they, in Glasgow, had wisely insisted that all drawing should be done from common objects and nature, instead of from cards of ornament or models . . . formerly encouraged by . . . South Kensington'.[21] In a review of Jessie M. King in *The Studio* the issue of the artist and nature and South Kensington's antipathy to an interpretive approach to drawing from nature was given prominence:

Miss King would persist in seeing things and representing them entirely with her own vision, and absolutely in her own way. Hence her failure as a South Kensington student, and her success as an artist. Miss King's deep and artistic love of Nature brooks no interference. Like a person living in this world, but not of it, Nature has for her a symbolism and a meaning which comes only to those who unreservedly yield themselves to Nature's influence . . . and this intense love of Nature is translated into the language of line by an imaginative conception. . . .[22]

This 'revolution' over South Kensington in favour of drawing from nature had, perhaps, been fuelled in part by the work of the Glasgow Boys many of whom passed through Glasgow School of Art as students or tutors. Inspired by the work of the Impressionist painters in France, the 'Boys from Glasgow' had revolted against the dreary historicism of the Academy and what they dubbed the 'Gluepot' School of painting, and had taken easel and paints to the countryside where they worked from life. Their *en plein air* paintings were filled with light and nature and the reputation of the school spread abroad through important exhibitions, as did their influence at home. 'Glasgow Girls', although peripherally involved with the Boys as a group, were also drawing and painting from nature. As we have seen, Bessie MacNicol and Norah Neilson Gray figure in the group of women artists who found inspiration and source material for their work in nature, particularly in the use of flowers as iconographic symbols. Gray's portraiture often employed flowers, leaves or branches as a design element. Bessie MacNicol often posed her figures *en plein air* as in *Under the Apple Tree* (1899) (fig. 303). Several other 'Glasgow Girls', however, worked predominantly in the genre of flower painting or were influenced by nature in their work. Jessie Newbery's textile designs employ conventionalised floral motifs and some of her earliest work has an affinity with designs of Christopher Dresser, showing the influence of the 'cult of the plant and the line'.[23] In addition to Newbery's preference for drawing from nature as a source of design inspiration, popularisations of flower imagery, such as that seen in Art Nouveau postcards, for example, the series reproducing Walter Crane's illustrations from the book *Flora's Feast* (1888), were in the common vocabulary. International exhibitions had familiarised Glasgow artists with the Japanese methods of representation for plants and animals which had been developed and recorded in their painters' manuals. Numerous species of flora and fauna were depicted with great detail yet simultaneously reduced to the minimum necessary characteristic elements. This regard for nature can be seen especially in the work of one woman, Katharine Cameron.

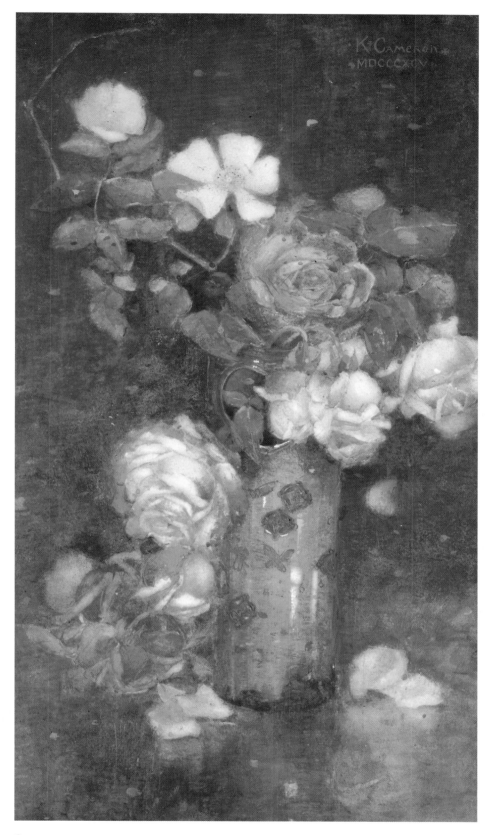

fig. 296
Roses, Katharine Cameron, 1895, watercolour, 53.75 × 31.25, verso: Painted at Connel Ferry Argyll.
(Coll: Mrs Rachel Moss. Photo: Sotheby's)

PAINTERS OF FLOWERS

by Ailsa Tanner

Katharine Cameron (1874-1965) RSW RE FRSA (fig. 297) was an extremely versatile artist. As well as her illustration work, she delighted in drawing and painting flowers (fig. 296), and she can be considered one of the finest flower painters of her generation. She particularly excelled in the difficult task of painting roses of every kind. There are two books with illustrations of her flowers, an anthology of poems edited by Edward Thomas, *The Flowers I Love*, published first in 1915, and *Where the Bee Sucks* by Iolo A. Williams, published in 1929. These are not true illustrations, but colour reproductions of watercolour paintings, several of which show her interest in oriental art. She also enjoyed painting landscapes, particularly in the Scottish Highlands. These were painted in a somewhat similar style to the watercolours and wash drawings of her brother, D.Y. Cameron. Like him, she was also a good etcher. The fine lines possible in that medium suited her meticulous draughtsmanship in describing the delicate structure of flowers (fig. 298). 'It is chiefly through the amazing range of flower subjects that Katharine Cameron has endeared herself to a large public at home and abroad. And, as recorded in *The American Magazine of Art*, at the opening of an exhibition in the Corcoran Gallery in Washington, 'her skill [is as] effective in the medium of etching as it is in watercolour.'[24]

Cameron was born in Glasgow the fourth daughter in a family of seven surviving children of the Revd Robert Cameron and his wife Margaret, a talented watercolour painter. On being questioned when she first began to be interested in painting, Cameron replied:

> I began life as an artist. It never entered my head not to be an artist. From infancy it was my work and play and at all times I was encouraged by the sympathy and loving interest of my family. Among the recollections is that of being constantly absorbed in drawing and in cutting out little figures to paint them in colour—back and front.[25]

Every encouragement was given to Catherine, as she then spelled her name, and to her older brother David Young Cameron who was to become a well-known painter and etcher. As with many women artists whose opportunities were linked with father or brother artists, the relationship must have been both a help and a disadvantage. Her brother would have introduced her to his artist friends, many of whom were Glasgow Boys, and she would have been recognised as D.Y. Cameron's sister, but was somewhat eclipsed by his fame.

Cameron was a student at the Glasgow School of Art under Newbery from 1890-1893, going on later to Paris, to the Académie Colarossi. On her return she

fig. 297
Portrait of Katharine Cameron in a headband. 'Scottish Women of Note – Miss Katharine Cameron, RSW, SSA', article from *The Scots Pictorial*, 18th October, 1919, p. 469. (Mitchell Library, Glasgow)

prepared for her first exhibition in 1900 at James Connell's in Glasgow. In this early stage of her career, Cameron produced some of her most interesting works in a romantic vein. These paintings were recognised by H.C. Marillier in the *Art Journal* of 1900 who wrote that Cameron 'paints romantic subjects in a romantic way, because she loves them, and because they are a vital part of her existence. She has the true race feeling of the Celt for love and legend . . . old ballads and fairy mysteries furnish most of her themes'.[26] There were also in this exhibition delicate studies of bees (fig. 298), for which she had a special affinity. A critic of the exhibition noted that their 'delicate suggestion of hairiness, blended colour and heavy flight, and the minute accuracy of almost microscopical detail, are such as we are only accustomed to find in the work of Japanese artists'.[27] In this first exhibition she had shown watercolours of scenes from Scottish ballads, such as *Binnorie* and *Proud Maisie*, so that the illustration of legends and poems seemed a natural step for her to take, and even though illustration was not an art form chosen particularly by Cameron, it was one she was commissioned by others to do over the whole of her career.

After Cameron's important first exhibition, she

moved from Glasgow to Stirling, where she illustrated her first books, *Water Babies* by Charles Kingsley in 1905 and *The Enchanted Land*, by Louey Chisholm in 1906. She was also the illustrator of several small books in the series *Told to the Children* edited by Chisholm, and published by T.C. and E.C. Jack. She travelled to Italy in 1908 to prepare for her most important illustration work for Amy Steedman's *Legends and Stories of Italy*, (1909) also published by T.C. and E.C. Jack. In *Stella Maris* (1908), and in *Madonna* (1908), she equals Jessie M. King in imagination, execution and decorative style. *Madonna* is a splendid example of the Glasgow Style in illustration. She also illustrated several small books for T.N. Foulis, including *Aucassin and Nicolette* around 1912. As a whole, her illustrations of Arthurian legends and Celtic tales from this period lack the very high quality of book illustration at this time.

In 1928, Katharine Cameron married the connoisseur and writer, Arthur Kay. They lived in Edinburgh where Cameron continued to paint and illustrate books. In 1929 she was commissioned by John Lane to illustrate *Haunting Edinburgh* by Flora Grierson; in it her love of Edinburgh is expressed in drawings and watercolours. Cameron was elected a member of the Royal Scottish Society of Painters in Watercolours in 1897, and a full member of the Royal Society of Painter-Etchers and Engravers in 1964. Her etchings and watercolours are held in the Victoria & Albert Museum, the British Museum, and thirty etchings in the Library of Congress in Washington DC. Regular exhibitions of her work were shown at the Scottish Gallery in Edinburgh, and in 1959 she was selected by T & R Annan in Glasgow as the last artist to exhibit in their original gallery which had been a 'Sauchiehall Street landmark' for more than half a century.[28] Katharine Cameron gained many awards and a great deal of recognition in her lifetime, as an acknowledged fine painter of flowers in watercolour, as an etcher and as a book illustrator.

fig. 298
April, Katharine Cameron, n.d., 24.0 × 8.8, etching. (Glasgow Museums and Art Galleries)

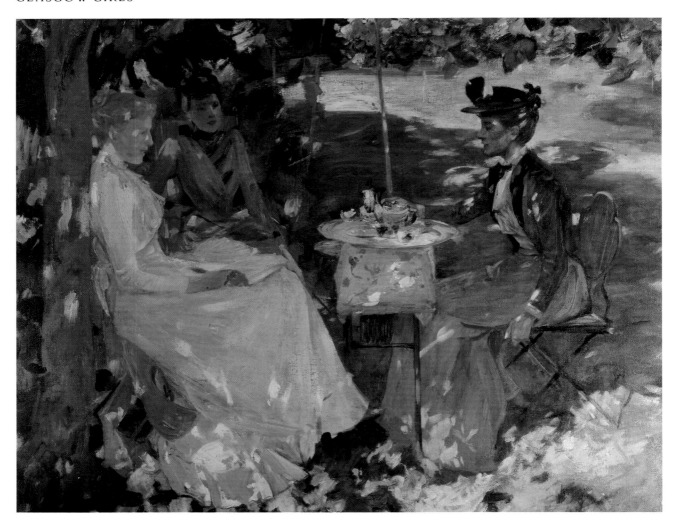

Maggie Hamilton (1867–1952) was born in Glasgow, but when she was young her parents, like many others, moved to the attractive small town of Helensburgh which was full of gardens and flowers. Unlike Katharine Cameron, she preferred oils to watercolours in painting flowers. She does not appear to have had any formal training in art, but her brother, James Whitelaw Hamilton, was associated with the Glasgow Boys and when they were painting at Cockburnspath in 1883 she was asked by James Guthrie's mother to help keep house there. She was painted by Guthrie several times, and was one of the sitters for his Diploma painting, *Midsummer* (1892) (fig. 299), which shows her having tea with two friends in her Helens-

burgh garden. In 1897 she married A.N. Paterson, the architect and younger brother of Glasgow Boy James Paterson, and they had two children, one of whom, Viola, became an exciting artist in her own right. Maggie Hamilton helped to decorate, with embroideries, the house Paterson designed for them in Helensburgh, 'The Long Croft'. These embroideries with floral and figure designs in the Arts and Crafts tradition were inserted in the wood panelling of the public rooms. Hamilton loved flowers (fig. 300) and her early paintings of them, possibly influenced by Guthrie, are memorable. Her later work, mainly still lifes in the Dutch tradition, have dark backgrounds and are painstakingly realistic.

fig. 299
Midsummer, Sir James Guthrie, 1892, oil on canvas, 99.0 × 124.7. Maggie Hamilton is on the left, possibly her sister in the middle and a Miss Walton on the right. They are having tea in the garden of Thornton Lodge, Helensburgh, the family house of the Hamilton family. (Coll: The Royal Scottish Academy Diploma Collection. Photo: Helensburgh and District Art Club)

Living not far away from Maggie Hamilton by the side of the Gareloch at Rhu was **Lily Blatherwick** RSW (1854-1934) (fig. 301), another woman who painted flowers, in oils and watercolours, and later made very individual lithographs of them. Blatherwick was, with her father, Dr Charles Blatherwick, a founder member of the Scottish Society of Painters in Watercolour in 1878, but was not elected full member until 1890. It was then that the Society received the Royal title and became what we know as the RSW. Before then, in catalogues, she was acknowledged as a Lady Member, or as an Associate Member. She painted

flowers (fig. 302) most sensitively, mainly in water-colour, and as far as we know without other training than from her father, a talented amateur artist. After his death in 1895, and her marriage in 1896 to Archibald Standish Hartrick, son of her father's widow by her first marriage, Blatherwick left her home in Rhu on the Gareloch for London, and from there went to villages in Gloucestershire, Acton Turville and Tresham. In 1906 they returned to London where Hartrick taught at the Camberwell School of Art and at the Central School. In London she was introduced to the art of lithography as Hartrick was a founder member of the

fig. 300
Nasturtiums, Maggie Hamilton, 1894, oil on canvas, 40.6 × 50.8. Painted before 1897 when the artist married A.N. Paterson. (Private Collection. Photo: Sotheby's)

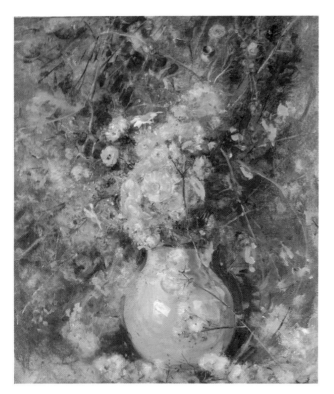

Senefelder Club, named after the inventor of lithography. Hartrick relates that at the first meeting about a dozen artists, including several women, handed in their names, but does not say if Lily Blatherwick's was among them.[29] She exhibited her exquisite flower prints with them in 1923.

While still living in the country they shared an exhibition in London at the Continental Gallery in 1901. Blatherwick showed a series of flower paintings, perhaps her most important works, illustrating *A Year in the Garden* (*c*.1901), which were purchased by Mrs E.J. Horniman in 1901. They were then incorporated into the decoration of Mrs Horniman's drawing room at 'Garden Corner' on Chelsea Embankment, designed by C.F.A. Voysey.[30] Unfortunately, they appear to have been lost. Lily Blatherwick continued to send work to Scotland for exhibitions as well as showing in London at the New English Art Club and the International Society. Older than her husband, she died before him at Fulham in 1934. He was always supportive and appreciative of her work, and as they had no children, Blatherwick was able to devote a great deal of time to her art. In his autobiography, A.S. Hartrick wrote: 'She painted the feeling and spirit of flowers in a way that was unique.'[31]

The last painter in this group of artists who specialised in the painting of flowers is **Constance Walton** (1865-1960), RSW (fig. 38). She was a younger member of the large and talented Walton family which included Glasgow Boy Edward Arthur, artist/designer George, architect Richard, and her sisters, Helen and Hannah More, who shared a craft studio in Glasgow. She was trained in Paris but lived mainly in Glasgow, and in Milngavie after her marriage to William Henry Ellis in 1896. There were two daughters from the marriage. Before then she had been elected as a member of the RSW in 1887, and had exhibited an ambitious altarpiece at the Institute in 1892. She continued to paint and exhibit her paintings, mainly of flowers, in watercolour. While her work before her marriage was often figurative, it may have been the necessity to stay at home with a young family, limiting her access to models, that led her to concentrate on flower painting.

fig. 301 *(top)*
Lily Blatherwick painting at Haddington, A. S. Hartrick, 1885, ink in sketchbook, 26.0 × 20.0 approx. A drawing of Lily Blatherwick working at her portable easel. Women painting *en plein* air in Scotland where there was a Celtic regard for nature, were part of the new method that rebelled against the dreary historicism of the Gluepot School. (Vea Black)

fig. 302
Flowers and Berries, Lily Blatherwick, *c*.1890, oil on canvas, 76.8 × 64.0. (Coll: Vea Black. Photo: Glasgow Museums and Art Galleries)

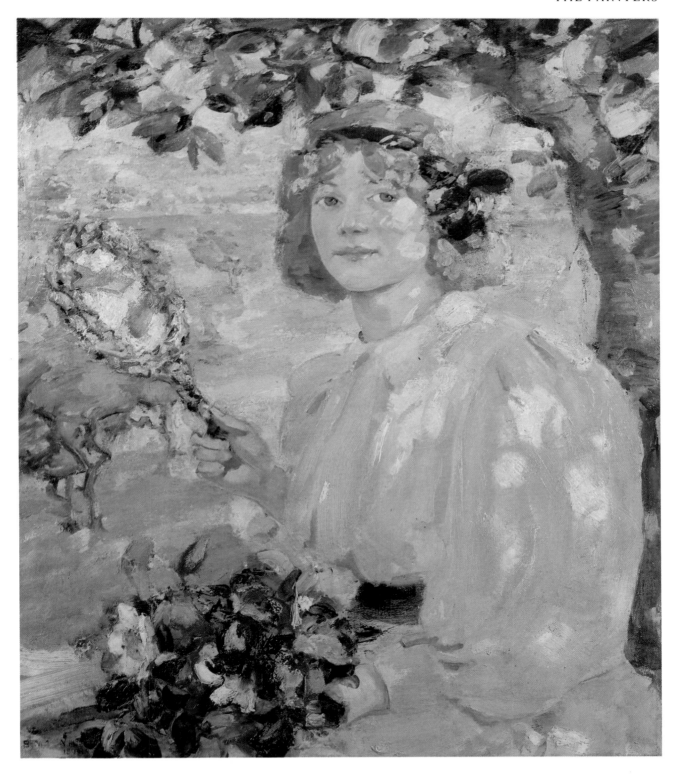

fig. 303
Under the Apple Tree, Bessie MacNicol, 1899, oil on canvas, 75.2 × 64.1. (Glasgow Museums and Art Galleries)

fig. 304
Self-portrait, Dorothy Carleton Smyth, 1921, oil on canvas, 76.8 × 68.6. Although Smyth shows herself actively engaged with her work, she negotiates the conflict with a smile—a tradition exemplified by Judith Leyster. (Glasgow Museums and Art Galleries)

ON VISUAL ICONOGRAPHY AND THE 'GLASGOW GIRLS'
by Adele Patrick and Hilary Robinson

It is perhaps enough of an indictment of the gender-specific nature of even the more recent history of British Fine Art that, long after resuscitation of interest in the Glasgow Boys, we find the 'Glasgow Girls' should only have begun to be comprehensively exhumed, relocated and named as individuals in 1990—almost a century after their work first gained popularity. That the work has been lost, forgotten, misattributed and largely unseen up to this point must lead us to examine attitudes concerning women and art practice of the late ninteenth and early twentieth centuries. During the period 1880-1920, the 'Lady Artist' continued to be viewed as an anomaly.[1]

The proprietorial and cultural mores that allowed men, unchallenged, to assume the generic designation 'artists' indicates the problematic position of women and their work during this period. In 1908, three members of the Glasgow Society of Lady Artists' Club 'fought strenuously' for the retention of the word 'lady'—holding the designation was 'an honourable one' against the claim that, by this date 'lady' would be viewed as 'too Victorian'. Mrs Maxwell Hannay made an impassioned speech and quoted from Ruskin's *Sesame and Lilies* in support of her views. The name remained.[2] This was an act of deference by the more forward-looking group of women in the club towards older, founder 'lady' members. Perceptions of women artists and their work (as in the use of 'lady') are inextricably linked to other ideas concerning gender difference. In extant paintings and debate, masculinity and femininity are often foregrounded both iconographically and in criticism.

It is clear that the iconography and subject matter of the 'Glasgow Girls' has its precedent in the history of masculine practice. Idealised, generic and exotic images of women proliferated in the nineteenth century. Much is revealed about the complex and contradictory gender-determined position of women as painters through contemporary debates and criticisms surrounding the work. The woman artist appears to have had to tread a precarious path. While apparently in a position of power with regard to creating images of women, she had also to comply with the conspiracy of silence on issues of equality, confirming and preserving demarcations of femininity and masculinity in her iconography and her view of herself. Her best work

fig. 305 *(opposite left)*
Self-portrait, Angelica Kaufmann. Women produced paintings of themselves as practising artists. (National Portrait Gallery, London)

fig. 306 *(opposite right)*
Self-portrait, Gwen John. The turn of the century saw a shift in emphasis towards women artists producing self-portraits that do not show them in the act of painting. (National Portrait Gallery, London)

and her portraits of men would be credited with having suggested a 'masculinity' or 'mastery' that was a characteristic of all great art. A memorial article on Bessie MacNicol clearly defines the gender-specific qualities that had ensured her success saying 'While her strong mind was in sympathy with the subjects of such pictures as the vigorous *John Rennie*, the searching *Alexander Frew* and the well-modelled *William Lamont*, her feminine sensitiveness could express itself in women's portraits of great charm and beauty'.[3] Contemporary criticism often defined, enjoyed, or vilified the woman artist and her work through her sexuality. Work of the 'Glasgow Girls' and the criticism which has sought to interpret it betrays the impossible terms and conditions that the artists have had to adopt. Iconography, technique, their propriety or otherwise as 'lady artists' are all inscribed within judiciously fixed gendered boundaries.

It could be argued that public recognition and appreciation of the works of the Glasgow Boys came before mythologising of the 'Glasgow Girls' and that the women's work derives from a masculinised vision of what might be termed 'good art'. If so, we might view it as acceptable to have work by women described as 'masculine'. However, we can now reject many of the premises on which 'good (masculine) art' was produced and judged. It is apparent that the critic is correct when he identifies that in MacNicol's painting the artist interpreted charm and daintiness, and that these essentially feminine characteristics have been interpreted in a masterly way,[4] but 'masterly' too is a gendered term having the signification of essentially masculine expertise, and is used in opposition to the fact of MacNicol's being a woman.[5]

The uses of metaphors of sexuality tended to reiterate differences between women painters and their 'authentic' male counterparts. After her death (at thirty-four, in childbirth), Bessie MacNicol received an ironic accolade: 'The most marked characteristic of all Bessie MacNicol's work is its virility. . . . This masculinity and vigour was apparent throughout all her career.'[6] Women who were congratulated for their 'masculinity' were those whose iconography conformed to masculine ideas concerning 'good art'. MacNicol was commended for 'dextrous and altogether delicious renderings of femininity'[7] in work which confirmed the position of woman as object. Work which achieved a seductive signification entered relatively freely into the dominant art historical canon, but the gender of the artists jeopardised any reading of the image as fully formed or authoritative. *The Ermine Muff* (*c.*1903) and *Phyllis in Town* (*c.*1904), whilst satisfying preconditions for sensual objectification of women, were

referred to as 'little masterpieces' and criticism of *A French Girl* (*c.*1894) (fig. 265) also includes the diminutive: 'the unconventional charm of this little work'.[8] The use of the diminutive corresponds to the idea of women as childlike and intuitive. The 'lady artist' was assumed unlikely to be engaged in the rigours of real artistic enterprise. Her works were seen to spring from innocence and, by extension, ignorance of the real experience of art-making in the male domain. Set against the achievements evident in the body of women's work, this overview of homogenised 'dainty workmanship'[9] exposes the paternalistic and prejudicial concept of the woman artist in criticism. Norah Neilson Gray's undeniable skills are attributed to a specifically unknowing form of genius by one critic who said: 'As a child she was almost inordinately attached to the pencil, drawing things continuously "out of her head" long before she understood or could possibly understand the significance of her juvenile preposition.'[10] Bessie MacNicol's talents were also pictured as almost accidentally hers. She had 'the happy faculty of child portraiture' and the capacity to 'evolve on the canvas the idea which momentarily possessed her'.[11]

Pamela Gerrish Nunn has written: 'If women would be artists—and by 1880 it was undeniably evident that they would—the oppostion would all the more doggedly approve a certain model and discourage or ridicule or ignore any other.'[12] Certainly, discouragement and ridicule hindered Scottish women artists from breaking free from conservatism and conformity. The attacks on women artists had been consistent and often fierce before the 1880s—Sir William Fettes Douglas at the Royal Institution in 1884 had revealed the reactionary nature of the opposition to them when he said: 'She goes about dressed to look as like a man as possible—and a miserable puny little man she makes—and her works are like her.'[13]

Some criticism and much work suggests that although women artists achieved a technical expertise that matched male artists, their iconography and relationship with patrons was to exist only within a narrow feminised discourse, for example: 'Miss Gray is at her best in the rendering of types of her own sex.'[14] The controversy surrounding Bessie MacNicol's portrait of E.A. Hornel (fig. 258) was due to the presumptuous rendering of the artist in a scale which failed to emphasise the magnitude of his genius. In the otherwise glowing *In Memoriam*, the critic summarily dismisses the 'tentative portraiture of her experimental period—such as the much-criticised E.A. Hornel'.[15]

Women artists through European art history have been critically placed in relation to their own image as well as to their images of other women. Well versed in how the different sexes were ideally depicted in high art, women artists must have been aware of the contradictions of their positions. It is interesting, then, that not only did many women produce self-portraits, but that so many should have produced self-portraits that showed them in the act of painting—or holding the attributes of their profession. Rosalba Carriera, Elisabeth Vigée-Lebrun, Judith Leyster, Artemisia Gentileschi, Marie Bashkirtseff, Elizabetta Siriani, Adelaide Labille-Guyard, Angelica Kaufmann are just a few who produced paintings of themselves as practising artists. In some cases it would be hard to determine how much such a self-portrait would be a statement of self-purpose. In addition, some of the self-portraits, influenced by the current iconographies of femininity, now need to be carefully distinguished from paintings of muses or the personifications of the art of painting. This is a tradition that has always been problematic in that it foregrounds the concept of the mythic woman, or the timeless female 'Art', over the creative woman artist. Marina Warner has written:

> The relation between the artistic convention and social reality produces meaning; the representation of the virtue in the female form interacts with ideas about femaleness, and affects the way women act as well as appear. As Aristotle argued, mimesis—imitation—brings about methexis—participation—and a constant exchange takes place between images and reality.[16]

The production by women of self-portraits that show them as artists is a phenomenon common enough to be significant. Men did produce occasional images of themselves with palette and brush, but by and large, male artists do not seem to have had the same impulse behind their self-portraits. One reason for the significantly larger proportion of self-portraits by women as artists can be found in the 'novelty value' of the woman-as-artist to the client. But over and above this, for the women, the interest in self-portraiture as a genre may be found in a need to negotiate the conflicting roles of (in the widest meaning of the words) 'femininity' and 'artist'. What is of particular interest when looking at the work of the 'Glasgow Girls' is that the turn of the century saw a shift of emphasis towards women artists producing self-portraits that do not show them in the act of painting—Gwen John, Suzanne Valadon and Paula Modersohn-Becker are probably the best known examples from outside Glasgow. The majority of their self-portraits do not make direct reference to the profession. The context in which women were making art was shifting on a number of levels, and the choices that women made in how they represented themselves and other women reflects and adds to the complexity of those changes. Women had gained access to major art academies towards the end of the nineteenth century; the feminist movement was strengthening its suffragist wing. A woman who was active and creative beyond the domestic sphere (no matter what terminology the critics used about her and her work), knew that a number of other women were functioning as professional artists. The Tate Gallery bought its first oil by a woman in 1890; the Royal Academy in its 1900 annual exhibition showed

works by 300 women—far fewer than the number of men, but still a sizable number of professional women artists.[17] Changes in the representation of women in art were in part a response to this. The symbolist movement of the nineteenth century shows a deep fear on the part of male artists of women and the 'feminine'. Images of Salome, the Sphinx and other beautiful, unknowable and deadly women abounded. By 1900, Freud had published some of his most important texts, including *The Interpretation of Dreams* (1905), and *Three Essays on the Theory of Sexuality*. In 1914, he published *On Narcissism*, propounding radically differing accounts of women's and men's relation to their self image. The same period saw the Fauves and other avant-garde groups using the female nude to make their major and formative artistic statements. The mythic, often predatory 'types' of the nineteenth century had gone; instead, artists such as Kirchner and Matisse painted complaisant available 'types' suggesting a sexual relationship between the male artist and the female model.[18] Women imaging women at this time were precariously balanced in their choice; how to retain their womanhood, be successful artists by their own criteria and how to represent femaleness. The conflicts are apparent in the Glasgow Girls' differing approaches to imaging women.

Dorothy Carleton Smyth's self-portrait (fig. 304) is one of few by any of the group to show the artist *herself* at work. Various aspects remove it from the immediate suggestion that it is a self-portrait. We do not see the painting on which she is working; we see the side of the canvas and the artist's laden brush. She looks out at us with a smile and slightly raised eyebrows, as if acknowledging us entering her studio rather than scrutinising her own image. In this it relates to a tradition exemplified by Judith Leyster's self-portrait, where the artist turns, laughing, to the viewer, from a painting of a male fiddler. Although Smyth shows herself engaged with her work, and refuses to idealise her own self image, thus disrupting the role of the 'feminine' in the studio, she negotiates the conflict and its potential anxiety with the smile—a typically 'feminine' form of address, conspicuous by its absence in the self-portraits of men.

The smile reappears in the self-portrait by Eleanor Allen Moore, *The Silk Dress* (1918) (fig. 284) a wonderfully self-assured image of a woman confident in her physical appearance and emotional presence, qualities conveyed through the pose, her expression, the colours and handling of the paint and the dramatic composition. The title is curiously self-effacing—why not *Self-portrait Wearing a Silk Dress* rather than the bland reference to the dress, ignoring the woman who was wearing it and who also wielded the brush? But in this it follows the convention of the time, that portraits of men would tend to be named, while portraits of women would tend to be 'typed' or titled according to an attribute or prop.[19] *The Silk Dress* illustrates clearly the conflicts between the term 'woman' and the term 'artist'—one cannot imagine Dürer calling one of his

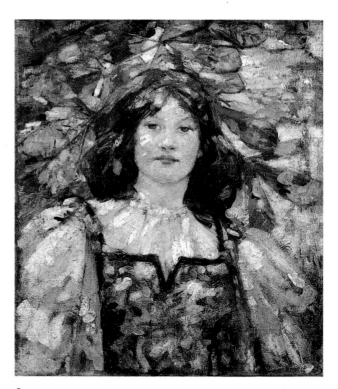

fig. 307
Autumn, Bessie MacNicol, 1898, oil on canvas, 61.3 × 51.3. The image of woman is collapsed completely back into Nature. (Aberdeen Art Gallery and Museums)

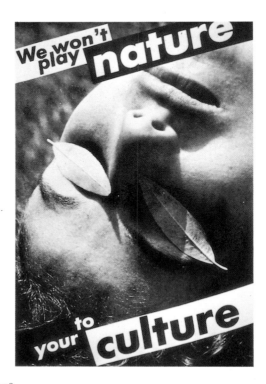

fig. 308
We Won't Play Nature to Your Culture, Barbara Kruger, 1984, mixed media.

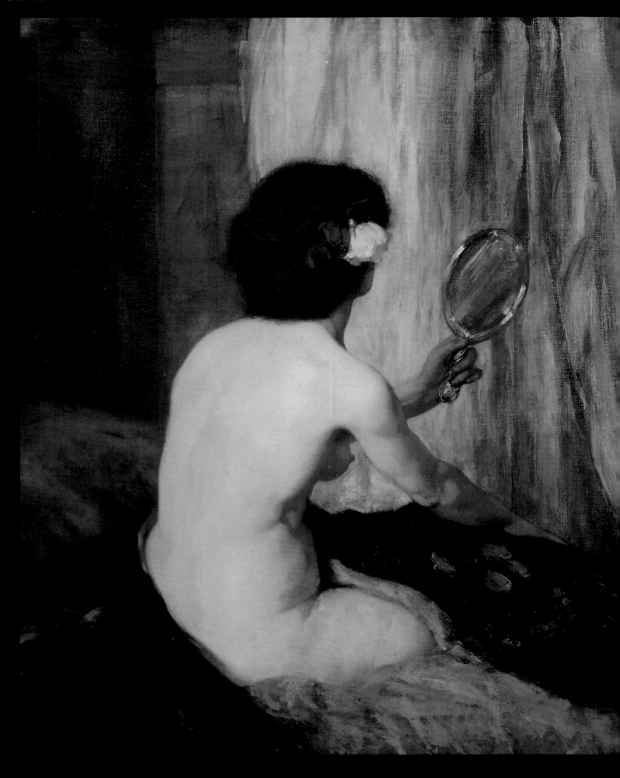

fig. 309
Vanity, Bessie MacNicol, 1902, oil on canvas, 114.3 × 126.9. Women were depicted as objects in painting and woman's body was regarded as an appropriate vehicle with which to express virtues, ideals and the anthropomorphism of nature—see *Vanity* (1902), *Meditation* (1899). Indeed, almost half of the works viewed for this publication are images of unnamed women. Women artists were encouraged to reflect such ideas. (Private Collection. Photo: Sotheby's)

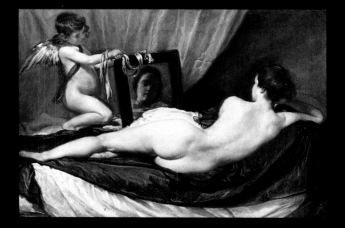

fig. 310
The Toilet of Venus or the *Rokeby Venus*, Diego Velasquez, 1650, oil
on canvas, 122.5 × 177.0. Problematic issues are raised by the
conjunction of woman with a mirror. (National Gallery, London)

equally exquisitely dressed self-portraits *The Blue Kid Gloves*. The area of exchange was summed up succinctly by John Berger in his comment: 'Men look at women. Women watch themselves being looked at. This determines not only most relations between men and women but also the relation of women to themselves.'[20] The choices made by Eleanor Allen Moore were also made by Elisabeth Vigée-LeBrun in her self-portraits a century earlier. She too presents herself according to the contemporary 'feminine' fashion—again dressed in silks and smiling, but with more wide-eyed innocence than *The Silk Dress*. The artists evoke interestingly similar emotions; confidence and lightness.

Self-portraits by Norah Neilson Gray (fig. 271) and Bessie MacNicol (fig. 264) are both named as such. It is instructive to compare Bessie MacNicol's self-portrait with her other images of women. A clear demarcation can be seen between how she represented herself and her approach to the feminine in her other paintings of women. In the self-portrait she shows herself close to the picture-plane, with no extraneous background elements intruding. Both this and the colours evoke late Rembrandt self-portraits. Her head is held with the chin up, in an assertive and confident fashion. Her opened mouth and slightly closed eyes we can read as intensity or engagement—here we read them as intellectual and artistic engagement, though the same elements in another context could be read as sexual engagement. Her neck too can be read in two ways; either as confident positioning of the head, or (in psychoanalytic terms) as the phallic substitute needed to make the image of the woman deeply reassuring. Woman's neck is used iconographically in a way man's never is, at its most obvious in the Oriental and mythic work of Ingres, and when exploited by Hollywood, particularly with Greta Garbo (fig. 311).[21]

The generic term is used in titling many of

MacNicol's paintings of women—*Lamplight* (1901), *Vanity* (1902), *The Ermine Muff* (c.1903), *The Japanese Embroidery* (c.1900) and so forth. *Autumn* (c.1898) (fig. 307) is an example of a powerful genre, the representation of women as essentially more closely linked to nature than men. It is an issue that has attracted much debate in the women's movement with exploration of the social construction of naturalness, irrationality and emotionality as feminine qualities, and the linking of masculinity with culture, rationality and intellect. Artist Barbara Kruger synthesised these issues in her untitled work consisting of a woman's face overlaid with the words, *We Won't Play Nature to Your Culture* (1984) (fig. 308). A century earlier than Kruger, women artists, engaged with the iconographic norms of their time, found themselves in the awkward (and ultimately untenable) position of supporting an ideology of representation that placed their gender beyond the role of being producers of culture, but rather being reproducers of and in nature.[22] In *Autumn*, the image of woman is collapsed into Nature. Named after a season she is on the same plane compositionally with the tree, merged decoratively in use of light and colour. Equating women with nature, reaches its apotheosis in representation of women with (or as) flowers and landscape, and is typified socially by roles assigned to women as mothers and nurturers.

MacNicol's *Study for Motherhood* (c.1902) (fig. 269) and *Motherhood* (c.1902) (fig. 268) begin to present as problematic women's relationship to children. The sketch shows the woman engaged with her child, as does *Master Baby* (1886) by W.Q. Orchardson; the viewer's attention is directed to the infant away from the woman. The title *Motherhood* prompts us to consider the relationship between the two, rather than the child alone. In the finished painting, a considerable change has taken place in the suggested relationship. The light draws our gaze to the baby, whose own gaze returns us to the mother. She is now shadowed, still and physically self-contained, attached only to the baby by their mutual look and by the 'umbilical cord' of her necklace which the child is clutching. The potential withdrawal of the mother is hinted at, as are separation, individuation and the inevitable loss of what is for the baby a blissful didactic relationship.

Problematic issues are raised in another of MacNicol's paintings, *Vanity* (1902) (fig. 309). Women's bodies have been depicted in conjunction with mirrors throughout European art history. The paintings can be intended to symbolise time passing, fading beauty, or the vice of vanity. Above all else though, the conjunction of a woman with a mirror reinforces her 'to-be-looked-at-ness', her objecthood, the fact that she is a sight. A common theme within painting for well over a century was that of *Susanna and the Elders*, where the moral of the story, truth and purity will win the day, was seldom painted; the woman-as-sight reinforced by the gaze of the Elders was the preferred aspect.

fig. 311
Ninotchka, Greta Garbo, 1939, MGM film directed by Ernst Lubitsch, photo published in *The Great Films*, Bosley Crowther, (New York, 1967). The woman's neck is used iconographically in a way that man's never is.

fig. 312
A French Girl, Bessie MacNicol, 1894, oil on canvas, 38.1 × 48.3. (Private Collection. Photo: Sotheby's)

Tintoretto further reinforced the theme by giving one of his Susannas a mirror, with which she also gazes at herself. MacNicol's *Vanity* is within this tradition. The woman is unnamed, she gazes into her mirror; she is nude and faceless. The problems inherent for women in this form of representation were fore-grounded ten years after MacNicol painted it, when Velasquez' *Rokeby Venus* (1650) (fig. 310), (National Gallery, London) was slashed by suffragette Mary Richardson as a way of protesting at the veneration of women in this form while actual women were being tortured by force-feeding in prisons. The *Rokeby Venus* shares all the iconographic elements of MacNicol's *Vanity*.

The ethnic or exotic subject was often used symbolically as an emblem of the Other, the seductive, the strange by artists of both sexes. *Exotic* (c.1923) by Norah Neilson Gray, was a 'masterpiece', on show in the artist's studio to demonstrate her skill to potential patrons. How much this corresponds to contemporary conservative, imperialist taste and how far *Exotic* is remote from another reality, from women's proscribed view of themselves can be estimated in comparison to the artist's self-portrait (figs. 315 and 271). Here she is neatly but firmly buttoned into a splendid, loose-fitting jacket and holding a small bunch of violets; she is in a studio, or drawing room. *Exotic* represents an exoticism that was remote from yet a symbol for the commonly feared excesses of their own profession.[23]

Considering the boundaries of the 'feminine' it is surprising to find within the *oeuvre* of the 'Glasgow Girls', such a large proportion of works which depict an idea of the exotic, the oriental and the ethnic. However, in these paintings of 'the ethnic' the pose of the subject is made to conform to all the conditions for stereotypical characterisation (e.g., *Breton Girl* (c.1898) (fig. 282) and *The Opium Smokers* (c.1936) (fig. 287).) Although such paintings are large in number, few subjects are named. The woman artist can be seen retrospectively to have confirmed her position as an artist by controlling the subject in this way. She appealed to an audience whose values she understood, and presented an unthreatening generic documentation

of the ethnic. In looking at women's images of the exotic, it is valuable to draw on the correspondence between women as objects and the objectification of the Orient which 'Because it is made into a general object, . . . can be made to serve as an illustration of a particular form of eccentricity'.[24] The paintings which most clearly represent nineteenth century occidental thought allow for a reading of the female/Orient as exotic, sexual and sensual, childlike, decorative. Life in the Orient was a 'life of colour', but the paintings are as much symbols of conservatism and dominance as are the unnamed images of young Scottish women painted to be viewed in a European context. Edward Said wrote that: 'The Orient was routinely described as feminine, its riches as fertile, its main symbol the sensual woman. . . . Moreover, Orientals, like Victorian housewives, were confined to silence and to unlimited enriching production.'[25] To the extent that subject-matter in art-production relates to the interests at any particular time of patronage, women and the ethnic subject were portrayed by male and female artists in ways that reflected and carried the dominant nineteenth-century eurocentric view. Paintings that drew woman and the exotic together (*Exotic*, *The Old Junk Woman* (c.1936) (figs. 314 and 263), *The Japanese Parasol* (c.1900), etc.) fulfilled a specific function within an Occidental art market and ultimately within the bourgeois home and institutions.

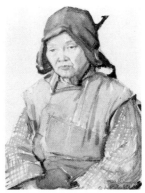

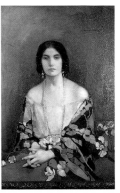

fig. 313 *(top)*
Old Hulks, Margaret Nairn (née White), c.1930s, watercolour. Margaret Nairn (1903–1990), a student of the Glasgow School of Art in the 1920s with Mary Armour, Nairn married Bryce Nairn, CBE, a Glasgow vet, in 1928 who later joined the Foreign Service. She sketched and painted with Sir Winston Churchill in France, Madeira, Morocco and studied with Oscar Kokoschka in the United States. (Private Collection)

fig. 314
The Old Junk Woman, Eleanor Allen Moore, c.1936, watercolour, 71.0 × 54.6. (Mrs E. W. Bingham. Photo: Glasgow Museums and Art Galleries)

fig. 315 *(right)*
Exotic, Norah Neilson Gray, c.1923, oil on canvas, 108.0 × 83.8. Exotic represents an exoticism that was both remote from and yet a symbol for the commonly feared excesses of their own profession. (Private Collection)

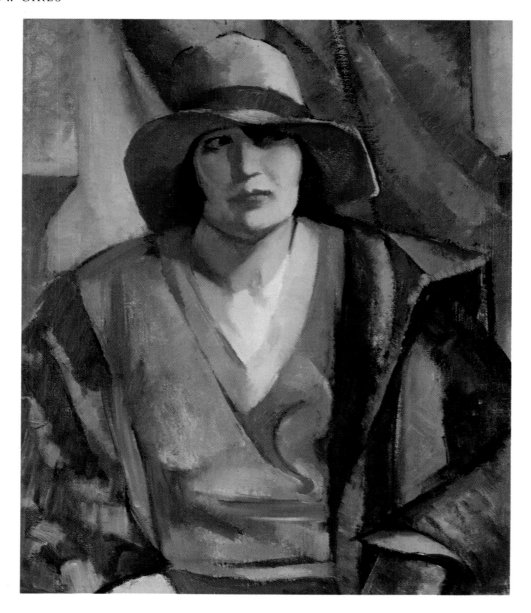

fig. 316
Girl in Pink Hat, Mary Viola Paterson, *c*.1930s, oil on canvas, 63.5 ×
53.2. (Coll: Mary-Anne Paterson. Photo: Sotheby's)

THE PAINTERS:
BETWEEN THE WARS
by Ailsa Tanner and Jude Burkhauser

This last group of painters includes younger women
who trained at the Glasgow School of Art from shortly
before the First World War to several years after. They
had experienced the sorrow and hardships of war and
difficult unsettling years following. It was a period of
great change. Women obtained the parliamentary vote,
and attitudes to them and to their ability to work were
changing, if slowly. Because so many young men had
died, many single women were left to earn their own
living. For painters, both men and women, it was a
most difficult time. Glasgow was entering industrial
recession, the bottom fell out of the art market and
prices became ridiculously low. The fashion of bare
uncovered walls in interior design did not help, and the
art world itself was in a state of flux with 'ism'
following 'ism'. Despite this gloom a liberation of
colour in painting is probably the most noticeable
feature in this period. Alexander Reid, who had
encouraged the Glasgow Boys, now showed the work
of the Scottish Colourists in Glasgow, and in 1919, an
important exhibition of French paintings, mainly by
the Impressionists, was shown in the Glasgow Art
Gallery, also arranged by Reid.

It might seem strange to select **Agnes Miller Parker** (1895–1980) as a representative of this period when her best work is in wood engraving and in black and white. Unfortunately, her paintings are difficult to locate, though she did gain her diploma at the Glasgow School of Art in drawing and painting in 1916. However, her wood engravings speak to us of her time, and her draughtsmanship is so fine that she merits inclusion. Agnes Miller Parker is not as well-known in Scotland as her work deserves, for though she was born in Irvine in Ayrshire, studied at the Glasgow School of Art from 1911 to 1917, and then worked as an instructress in the School, she spent the greater part of her working life in England, and only came back to Glasgow in 1955.

In 1918 she married William McCance, another brilliant graduate of the Glasgow School of Art, and from 1920 until 1928 was art mistress at Maltmans Green School at Gerrard's Cross, and then at Clapham High School and Training College. In her painting at this time she shared her husband's Vorticist approach, but it will be for her outstanding work in wood engraving that she will be best remembered.

Her first important work was as illustrator of *The Fables of Aesop*, (1931) printed by The Gregynog Press. This was followed by outstanding illustrations for *Down the River* (1937) and *Through the Woods* (1936) by H.E. Bates. They show her skill in drawing and her unerring sense of balance (figs. 317–318) in the design of black and white, and the brilliance of her technique in the demanding art of wood engraving, where her ability to use both her hands equally well was an advantage. Much of her later work was for the Limited Editions Club of New York from 1938, when Thomas Gray's *Elegy written in a Country Churchyard* was printed. She also illustrated plays and poetry by Shakespeare and the novels of Thomas Hardy. Her marriage was dissolved in 1963, and she re-assumed her maiden name. Agnes Miller Parker's last home was at Lamlash, on the Isle of Arran, but she died in Ravenscraig Hospital, Greenock in 1980.

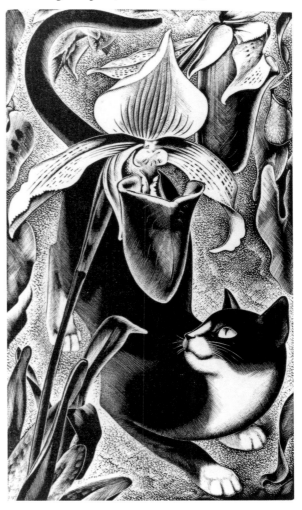

fig. 317
Sauve qui peut, Agnes Miller Parker, *c.*1935, wood engraving, 17.5 × 10.0. (Coll: Mrs Ann D. Quickenden. Photo: National Library of Scotland)

fig. 318
Coquitte, Agnes Miller Parker, *c.*1935, wood engraving, 17.5 × 10.0. (Coll: Mrs Ann D. Quickenden. Photo: National Library of Scotland)

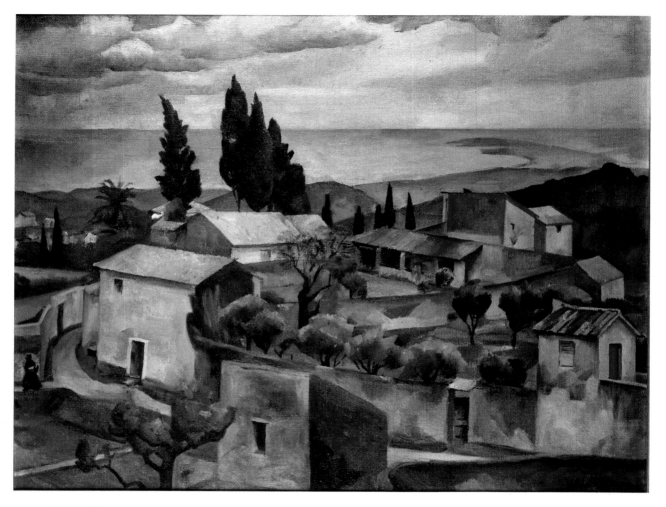

fig. 319
Mediterranean Farm by the Sea, Mary Viola Paterson, oil on canvas, *c*.1930, 50.9 × 61.2. (Private Collection)

Agnes Miller Parker gained her wider outlook on art while working in England and Wales, but **Mary Viola Paterson** (1899–1981) went further, to France and the Mediterranean. Alone of this group of painters, she never used her diploma at any time to teach. Paterson was a member of one of Scotland's artist families, and richly endowed with talent. This talent was encouraged at the Glasgow School of Art by Maurice Greiffenhagen, who had been head of the School of Drawing and Painting since 1906. She had also studied for a short time under Professor Henry Tonks at the Slade, and when she gained her diploma at Glasgow in 1924, went to Paris to study with Simon and Besnard at L'Académie de la Grande Chaumière and under André L'Hôte.

French influences are strong in her work, and her admiration for Cézanne (fig. 319) and Toulouse-Lautrec is

fig. 320
French Window, Mary Viola Paterson, *c*.1930s, oil on canvas, 59.3 × 38.0. (Coll: Mary-Anne Paterson. Photo: Sotheby's)

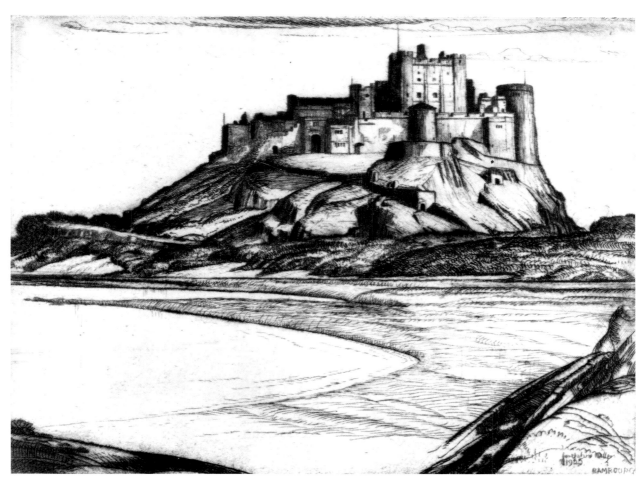

evident in the structure of her paintings. The technique owes more to her training in Glasgow. Paterson loved France and was able to spend much of her working life there. She rejoiced in the landscape of the South and in the brilliance of colour revealed by the Mediterranean sun, and was able to share this, and her own great love of life in her paintings of France and Italy, and especially of Malta and the Maltese.

Paterson was versatile, for as well as painting in oil and watercolour she designed three stained glass windows for St Bride's Church in Helensburgh which were executed by Guthrie and Wells of Glasgow from 1924 to 1931, and she enjoyed scene painting with Muriel Sterling and other friends at Malvern Festivals of plays directed by Sir Barry Jackson. She was also interested in printmaking, in lithography, etching and wood engraving, and also in a unique form of colour printing which she called 'Wood Types'. A line drawing was engraved on the wood block which separated the different areas of watercolour brushed in before printing. This technique allowed a greater realisation of form than was usually possible in printmaking.

The work of Paterson speaks for her own times, the years between the wars. It is stylish, witty and lively, and reflects the good life possible then for the privileged. When the Second World War started Paterson was in France, and only managed to leave with the last boat home through the Mediterranean. During the war she worked with the Admiralty at Oxford, and only later did she come back to her old home in Helensburgh where the large garden and the culinary arts took up most of her energies. Her last years were dogged by illness and she died in 1981.

Josephine Haswell Miller (*née* Cameron, 1890–1975), studied at the Glasgow School of Art from 1905 to 1914. While still a student she executed a mural on canvas entitled *Science* (*c.*1913) which is still at Possilpark Library in North Glasgow. She also studied in Paris, and in London with Sickert. In 1916 she married a fellow student, A.E. Haswell Miller. She taught etching (fig. 321) at the School of Art from 1924 to 1932. When her husband was appointed Keeper of the Scottish National Portrait Gallery they moved to Edinburgh. In 1938 Josephine became the first woman to be elected Associate of the Royal Scottish Academy. Her style is unmistakably of her time, clean-cut and commanding.

fig. 321
Bamborough Castle, Josephine Haswell Miller, 1925, etching, 13.7 × 18.1. (Glasgow Museums and Art Galleries)

A Glasgow woman painter who made a lifetime career in teaching was **Jessie Alexandra Dick** (1896–1976), better known by her signature J. Alix Dick. She taught drawing and later painting at the Glasgow School of Art from 1921 until 1959. She also painted and exhibited mainly portraits and still lifes and in 1960 was elected Associate of the Royal Scottish Academy. She is still remembered with gratitude by her students as a fine teacher, so it is all the more distressing to learn that after her death several fine watercolours, including *The Glasgow School of Art* (fig. 65) were found by a neighbour about to be thrown away.

Also included in this group of painters from Glasgow who were all working between the war years is the only living painter represented in this book, **Mary Armour** (1902–) (fig. 322). Although known in Britain for her still life studies, including her trademark jugs with flowers, Mary Armour does not consider herself a 'flower painter'. She was a young student at the end of the Glasgow Style era at the School and thus creates for us a bridge between the past and present day. We can see in looking at Mary Armour's life and work some of the identical struggles ongoing for women in the arts, but also observe greater opportunities for recognition. A brief look at Mary Armour's life and accomplishments will exemplify the direction of the painting of the 'Glasgow Girls' into the 1920s and 1930s.

Mary Armour (Mary Nicol Steel), the daughter of a steelworker from Blantyre, Lanarkshire, was born in 1902 and relates that her father had a special love and appreciation of flowers that she too has shared in her lifetime.[1] Armour won a scholarship at the age of eleven to attend Hamilton Academy where she had the good fortune to have as art mistress, Penelope Beaton, who provided a strong role model to the young woman. Beaton, who was later to join the staff of the Edinburgh College of Art, recognised Armour's talent and encouraged her student to take up a career in art. Beaton was able to convince Armour's father to send her to the Glasgow School of Art.

A student at the Glasgow Art School from 1920, with a post diploma year in 1925, her training in painting was with (Professor) Maurice Greiffenhagen, RA and David Forrester Wilson, RSA. Armour entered the School at the time when many of the influential figures of the Glasgow Style movement, such as Fra and Jessie Newbery, Ann Macbeth, and others including Dorothy Carleton Smyth and De Courcy Lewthwaite Dewar, were still on the scene, many as lecturers. Although the works of the older generation of Glasgow Style illustrators, such as Jessie M. King and Annie French, were then held up in the School as models to be emulated, Armour forged her own path, developing her own style, and maintaining her own creative integrity. This independent 'spirit' was like that which Newbery had earlier cultivated in Jessie M. King and the students of the Mackintosh group. It is not surprising to find that Mary Armour defied the

preferences of her painting instructor Greiffenhagen, who expected a religious subject for her large figurative diploma painting, to paint instead the realist work she titled *A Pit Head Scene* (*c.*1925). The painting's defiant subject matter and treatment may have accounted for her failure to win the First Prize that year for painting.[2]

After her post diploma year she taught art in ordinary schools in Cambuslang and Glasgow. Although Mary Armour was to win the Guthrie Award for the best

fig. 322
Portrait of Mary, William Armour, *c.*1920s, oil on canvas, 48.0 × 38.0. (Private Collection. Photo: Glasgow Museums and Art Galleries)

fig. 323
Still Life with Lemons, Mary Armour, 1945, oil on canvas, 61.0 × 50.7. (Private Collection. Photo: The Fine Art Society, Glasgow)

work on view at the RSA by a young Scottish artist in 1937, marriage to fellow artist William Armour in 1927 made her departure from the teaching profession inevitable as she was forced to resign her full-time post until the law which prohibited married women full-time employment was changed. Marriage (fig. 324), however, to another painter and teacher brought her true partnership. She was elected an Associate Member of the Royal Scottish Academy in 1941. Eventually, Armour taught again during the Second World War at St Bride's School, Helensburgh, when the marriage bar was temporarily suspended and there was a need for women to fill posts vacated by men. After the Education (Scotland) Act was passed in 1945 removing the bar entirely, Armour returned to full-time teaching and in 1951 she was appointed lecturer in still life at the Glasgow School of Art, a post she held until her retirement in 1962. The contact she had as a lecturer in painting with young students at the Glasgow School of Art proved an important influence for her as well as for her students. From this period in her career, her paintings, already characterised by rich use of paint textures, became more adventurous in their colour. This tendency persisted and in a retrospective exhibition held in honour of her eighty-fifth birthday by the Fine Art Society in 1986 some of the most vital and colourful works were her most recent.

As Roger Billcliffe noted in his introduction to the catalogue for this one woman retrospective exhibition, retirement from teaching was by no means an end to her activity in the arts for she exchanged the stimulus of teaching for the time and freedom to concentrate on her painting. A decade of intense activity, with extensive mixed and solo exhibitions, followed and further established her reputation 'as one of the leading painters of her generation'.[3] Armour's election as Royal Scottish Academician in 1958 confirmed her status in art circles in the West of Scotland. She was only the second woman painter to be elected to the Royal Scottish Academy by that date; a sculptor, Phyllis Bone had been the first in 1944, then Anne Redpath in 1952. Armour's painting is known throughout Scotland and Great Britain and she has exhibited widely throughout her long and successful career. The only painter in this book to have received due recognition of her work in her lifetime, her paintings are in public, corporate, and private collections of standing throughout Great Britain and abroad. As well as full membership of the RSA, she has been awarded the Honorary Degree of LL.D by the University of Glasgow and the Honorary Presidencies of the Royal Glasgow Institute of the Fine Arts and the Glasgow School of Art. These have been richly deserved in a life devoted to art.

Armour worked in her vigorous and characteristic style up to 1988 when failing eyesight prevented her from continuing to paint. Always willing to spend time with fellow artists or researchers who call upon her for advice and information, Mary Armour is, at age eighty-eight, straight talking and outspoken as ever. She is rightly considered one of Glasgow's (and Scotland's) 'living treasures'.

When one considers the legacy given by older generations of painters to those working between the wars, and up to the present day, one is forced to admit there is no direct link. Each painter was an individual whose work, although perhaps acclaimed in the lifetime of the artist, was nevertheless overlooked or totally forgotten later. The connecting link, if any, must be in the common denominator of their similar training at the Glasgow School of Art, still a 'hothouse for experimentation' in all of the arts, even though the artists may have attended at different periods. There is always influence in the interaction among students and participation in the same art scene of the city, its exhibitions and societies. Reaction is the normal response to work by a previous generation and only a gap of time allows interest to reawaken. The tradition of painting in a broad style based on the works of the Glasgow Boys, with feeling for the medium of oil paint, has been a continuing feature of the teaching at the Glasgow School of Art.

fig. 324
Willie Armour Painting, Mary Armour, 1928, oil on board, gilt frame, glazed, 57.4 × 43.0. (Private Collection. Photo: Glasgow Museums and Art Galleries)

AFTERWORD

GHOULS, GAS PIPES, AND GUERILLA GIRLS:
A WIDER LEGACY
by Jude Burkhauser

This book opens a door. The key to unlock it was fashioned by many people and many books, and it will take many more to fully explore the vast vistas that lie behind it. But even opening this door a crack reveals fascinating new knowledge about our past—and a new view of our potential future.[1]

In studying acquisition policies of major museums in America one discovers that although almost half of working artists in the United States are women, over 95 per cent of works hanging in American museums are by men.[2] Considering the impressive body of art and design work by the Glasgow women we have just seen and the issues with regard to gender in art and design that these 'Glasgow Girls' negotiated, it may be surprising for some to learn that the percentages of women represented in major British art collections are not significantly higher than those in the United States. In the National Gallery in London, for example, eight of 2,002 paintings are by women, while the Tate has 14,790 works of which 942 (6 per cent) are by women.[3] It is not just in lopsided acquisition policies or limited permanent collection display that art by women's hand is internationally marginalised. From 1980 to 1986, the Guggenheim Museum in New York City mounted fifty-two one-artist shows—only two by female artists. While in Britain we see similar statistics at the Tate Gallery where from 1900 to 1986 there were 206 individual shows by men and only eight by women. It is not because there are few women who 'will be artists', however, for of all working artists in America 40 per cent are women; yet the National Endowment for the Arts reported that in 1987 women artists were only represented in mainstream institutions 10 per cent of the time.[4]

Whenever such telling statistics are cited, the question is raised: What *do* women in the Arts want? As the new generation 'Guerilla Girls' have stated, it is *not* reverse discrimination through imposed quotas for representation in exhibitions, galleries or institutions. The 'Guerilla Girls', an international organisation of professional artists, arts administrators and art historians, are committed to effecting change from within the system. They envisage initiation of permanent change through 'cultivating an awareness' of key issues, providing access to information, and through the provision of balanced education 'which in itself might yield a different future' for succeeding generations of women in the arts. We have seen recently the

types of change 'Guerilla Girls' endorse. For example, standard art history survey texts, such as W.H. Janson's authoritative new edition of *The History of Art*,[5] now include women artists for the first time. Now evolving world-wide is 'feminist-informed' art history whose final aim is 'not merely a new art history aiming to make improvements, bring up to date, season the old with current intellectual fashions or theory soup' but instead aims for a paradigm shift in cultural history as a

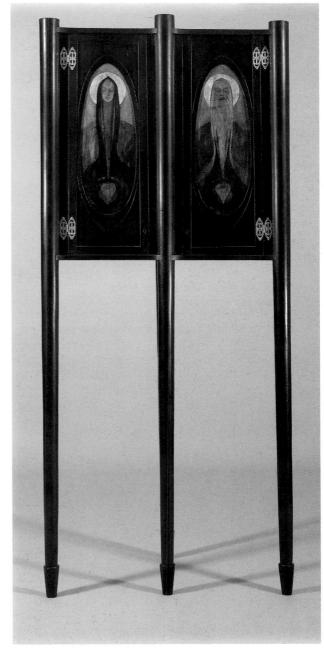

fig. 325 *(opposite and right)*
Matriarch and Patriarch Corner Cabinet, attributed to Margaret Macdonald and Charles Rennie Mackintosh, *c.*1900, probably a Bible cabinet. (Fischer Fine Art, London)

whole which will 'challenge the present by means of how we re-represent the past'.[6]

As a part of this emergent process we have seen on an international scale, the 'excavation' and reclamation of women in art and design such as the sculptor Camille Claudel in France, the women of the Pre-Raphaelite movement in England such as Elizabeth Siddal, the international designers, Sonia Delaunay, Eileen Gray, and Sophie Taeuber-Arp, the Russian avant-garde designers Alexandra Exter, Lubiov Popova and Varvara Stepanova, the British designers Ethel Mairet and Vanessa Bell, and now the reclamation of women from Scotland's avant-garde art and design movement —the 'Glasgow Girls'.

Women have, by and large, not written art history and women artists have left few written commentaries:

> . . . women did not become practised in the craft of self-definition. They did not take the podium as prophets to define schools or movements. They did not know it would be helpful to put their ideas about what they were doing into packageable metaphors and slogans, partly for the media and historians to pick up and so use to identify them in the future, and partly so that by bringing their own themes into consciousness they could sharpen their sense of direction for future work.[7]

As a result, these lost voices—who would write from their own experience—have not been heard. The lives, work and ideas of women such as the 'Glasgow Girls' were ranked as secondary stories and have not informed our collective analysis in art. What we know as cultural history has often eliminated half of the account; a large scale omission evidenced by the significant amount of material which has formed the body of this book. Such omissions in any other discipline would be considered a fatal methodological flaw.

Attitudes have been changing and re-representation of women in our collective cultural history is under-way, yet the fact that there were women who 'mattered' in art history and that 'feminine' values may be a force central, not only to our past, but also to our prospects for a better future[8] are still anathema to some. When historian Julius Meier-Graefe commented in his *Encyclopedia of Modern Art*, that: 'In Glasgow, English art was no longer hermaphrodite' but 'passed entirely into the hands of women'[9] there can be little doubt that his pronouncement implied diminution. Madsen's subsequent use of the quotation which relegates the importance of the women of the Glasgow Style to a footnote confirms this fact.[10] Feminist theory has alerted us to the devaluing of woman within the dominant discourse under which Meier-Graefe, Madsen and other *fin-de-siècle* art historians laboured. We have seen how this bias encompassed not just woman *per se* but the 'feminine' principle as a whole. Whitmont's work, *The Return of the Goddess*, while 'not

excusing or explaining away' devaluation of the feminine, argues for a gender holistic viewpoint which would move beyond the patriarchy/matriarchy dichotomy that 'makes us see discrimination against women, primarily, where we must deal with a repression of femininity in women and men.'[11] He argues for the evolution of a holistic human culture where those traits ascribed to one sex or the other and devalued as part of the 'fixing of the feminine' are re-evaluated and re-integrated in a move toward psychic wholeness. Another cultural theorist who has moved beyond sexual polarities to embrace this gender holistic perspective in cultural analysis, Riane Eisler, offers a new theory of cultural evolution. She contends that there are two paradigms of society: the dominator model (the Blade) in which one sex is ranked over the other, and the partnership model (the Chalice) in which linking replaces ranking.[12] Glasgow's *fin-de-siècle* art, perceived as an art that was entirely in the 'hands of women' (i.e. the 'feminine') by 1905, and the work of women in art and design from that period must be re-perceived within this cultural evolutionary context. For the spirit of mutual co-operation and support which infused the lives and histories of the artists and designers of the Glasgow Style epitomises the collective, life-generating and nurturing powers of the 'partnership' model and is stamped indelibly in the artistic productions of the era. As the Modern movement emerged in Britain into the 1920s the 'feminine' iconography and 'Chalice' rationale of Glasgow's 'Scotto-Continental' Art Nouveau gave way to the

fig. 326
Design for *Vanity* handkerchief, Margaret Macdonald, 1915–23, pencil and watercolour on brown tracing paper laid on cream paper, 22.5 × 22.0. (Hunterian Art Gallery)

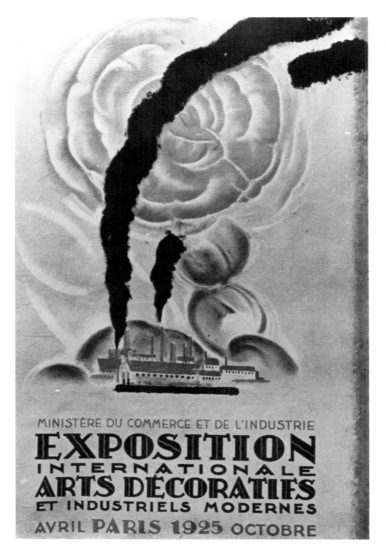

MINISTÈRE DU COMMERCE ET DE L'INDUSTRIE

EXPOSITION
INTERNATIONALE
ARTS DÉCORATIFS
ET INDUSTRIELS MODERNES
AVRIL **PARIS 1925** OCTOBRE

machine-inspired designs of Art Deco and Art Moderne that would carry on to the 1930s and 1940s. By the 'Paris 1925 Exhibition of Decorative Art', which embraced the Modern Movement with its machine-made, mass-produced ethos, Glasgow artists and designers who had once been so prominent in the international arena, were no longer an influential part of the scene. The handcrafted and collaborative 'feminine' ethos of the Glasgow Style, symbolised by the *Rose Boudoir* (fig. 87) of Charles Rennie Mackintosh and Margaret Macdonald in the 'Turin International Exhibition' in 1902, was eclipsed by the ethos of the new 'metropolis', and the poster of the 'Paris 1925 Exhibition', showing a factory with smoke stacks billowing superimposed over a full blown rose (fig. 327) is a telling example of this transition in the concerns of international art and design.[13]

Recent feminist-informed enquiry has created an opening in art historical discourse which has allowed new forms to emerge, many determined by women themselves. In the wake of these changes, surveys such as *'Glasgow Girls'* have aimed to move beyond traditional evaluations of design techniques, painterly approach and 'women's issues' and 'to embrace the totally new consideration of the production and evaluation of art and the role of the artist' which this new discipline demands.[14] It has not been popular stuff, this excavation of the 'Glasgow Girls', although in the end museum directors who would have none of it in their galleries capitulated and art school directors who were indifferent to it were eventually convinced to lend their support. Both the amount of money required and the lack of money available for the project could have derailed it from its course. Once located, however, money made it possible to override bureaucratic objections and admonitions that it could not possibly be done. Dogged persistence finally convinced remaining sceptics that a non-Scot could indeed be 'bothered' with Scottish

fig. 327
Exposition Internationale Arts Décoratifs et Industriels Modernes - Paris 1925, Charles Loupot, poster. (Bibliotheque des Arts Décoratifs, Paris)

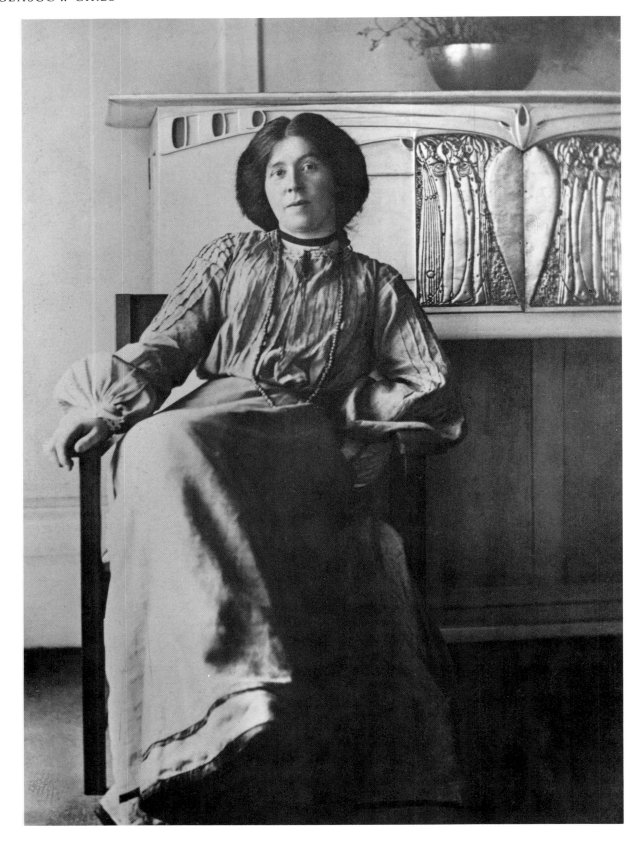

fig. 328
Margaret Macdonald Mackintosh, seated before her writing desk. (T & R Annan and Sons, Ltd., Glasgow)

art and convinced them of the fact that 'women-in-art' was a nation in itself to whom one might owe allegiance. Lack of encouragement from the 'world at large' for such endeavours is nothing new. Virginia Woolf wrote of it in 1929 in *A Room of One's Own*:

> The indifference of the world which Keats and Flaubert and other men of genius have found so hard to bear was in her case not indifference but hostility . . . surely it is time that the effect of discouragement upon the mind of the artist should be measured, as I have seen a dairy company measure the effect of ordinary milk and Grade A milk upon the body of the rat. . . . Now, what food do we feed women artists upon? I asked. . . .[15]

Young women in the arts have been starved for stories of other women, tales of those maverick 'sisters' whom they might learn from, look up to, find compatriots in and emulate as role models. Had it been known that the art students of Secessionist Vienna had strewn flowers at the feet of a woman, of an artist, such as Margaret Macdonald Mackintosh, to demonstrate their high regard for her work, it might well have altered one's destiny. But it would take twenty years from the time I, as a young art student, was presented with a partial art history at a prominent Art and Design College in America in the 1960s before I would discover Margaret Macdonald, in an enigmatic photograph (fig. 328) in the Textile Museum in Washington, DC, that would draw me to her despite an ocean and half a century. Arriving in Glasgow, I discovered myself just one of a number of women, pilgrims of a sort, who had come from Canada, from America, from the Continent, all seeking traces of our collective past in the person of Margaret Macdonald and her compatriots from the Glasgow School of Art.

> For the women whose stories are told here . . . have been pioneers. Before them, because of a number of factors, few women artists surfaced, though many worked. . . . But the women represented here, in varying degrees depending on age and family circumstance, struggled alone to become what they did. Many others failed to keep moving toward goals to which instinct and intellect had pointed them. Some paid dearly for survival.[16]

We were hungry for their stories—even if it took travelling across continents. We followed in one another's footsteps knocking on the same doors, asking the same questions, re-discovering fire, the wheel, electricity because there was no record of our past.

> . . . whatever effect discouragement and criticism had (on women artists)—and I believe that they had a great effect—was unimportant compared with the other difficulty which faced them . . . that was that they had no tradition behind them, or one so short and partial that it was of little help.

For we think back through our mothers if we are women. . . .[17]

'Glasgow Girls': Women in Art and Design 1880–1920 is the locus where these paths converged, where our concerns overlapped and where our collective search for a fully informed art history of Glasgow at the turn of the century impelled us. Although many different voices are contained here, with varied points of view, the contributors to this book have shared a common purpose and that is a nurturing of the 'woman of the future', a feeding if you will of women artists, on morsels of mythic re-perception gathered in from such lost histories as those of the 'Glasgow Girls'. It is in these 'footsteps' which one might follow, role models one might choose to emulate and in their challenge of the status quo that one may find the most important legacy of women in art and design in Glasgow from 1880 to 1920. A legacy which this book documents and offers as an 'opening' to a fuller investigation of individual 'Glasgow Girls'.

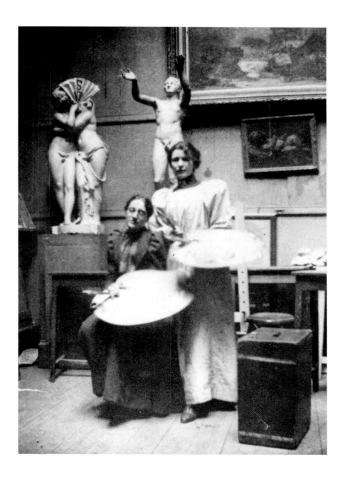

fig. 329
Ann Macbeth and an unknown woman in the painting studios, Glasgow School of Art. (Glasgow School of Art)

NOTES

Preface

1 Jude Burkhauser, (ed.) *'Glasgow Girls': Women in the Art School 1880–1920*, (Glasgow, 1988).

2 Cordelia Oliver, 'The Glasgow Girls', *The List*, 18th August, 1988, p. 63. The definite article in the title here is, of course, a misquotation.

3 Glasgow Museums and Art Galleries, Kelvingrove. *Exhibition of Scottish Painting*. (Glasgow, 1961), p. 5.

4 Scottish Arts Council, *The Glasgow Boys*. Part II, (Glasgow, 1968) p. 77.

5 Kaye Lynch, Sheena MacGregor and Jacki Parry, 'Women Artists in Glasgow', *The Visual Arts in Glasgow*. (Glasgow, 1985), p. 8.

Introduction

1 Kaye Lynch, Sheena MacGregor and Jacki Parry, 'Women Artists in Glasgow', *The Visual Arts in Glasgow*, (Glasgow, 1985), p. 8.

2 Lynch, MacGregor and Parry, p. 8.

3 Ailsa Tanner, 'Some Scottish Women Artists of the Past', *Chapman*, Vol. VI, No. 3-4, 1980, quoted in Jude Burkhauser, *'Glasgow Girls': Women in the Art School*, catalogue, (Glasgow, 1988), inside front cover.

4 Joy Hendry, 'Editorial', *Chapman*, Vol. VI, No. 3–4, 1980, quoted in Jude Burkhauser, *'Glasgow Girls': Women in the Art School*, inside front cover.

5 John Loughery, 'Mrs Holladay and The Guerilla Girls', *Arts Magazine*, (October, 1987), p. 63.

6 Anthea Callen, *Angel in The Studio: Women in the Arts and Crafts Movement 1870–1914*, (London, 1979), p. 124.

7 'Women-in-Art' seminar, Glasgow School of Art, Department of Historical and Critical Studies, 1988, unpublished statistics.

8 'Women-in-Art' seminar, Glasgow School of Art, Department of Historical and Critical Studies, 1988, unpublished statistics.

9 Eleanor Tufts, 'Beyond Gardner, Gombrich and Janson: Towards a Total History of Art', *Arts Magazine*, LV (April, 1981), pp. 150-54. For a reclamation of women artists.

10 Gloria Orenstein, 'Review Essay: Art History', *Signs*, I, (Winter, 1975), p. 525. Quoted in Thalia Gouma-Peterson and Patricia Mathews, 'The Feminist Critique of Art History', *The Art Bulletin*, (September, 1987), Vol. LXIX, No. 3, p. 351.

11 Carol Duncan, 'When Greatness is a Box of Wheaties', *Artforum*, (October, 1975), p. 64. Quoted in Gouma-Peterson and Mathews, p. 351.

12 Rozsika Parker and Griselda Pollock, *Old Mistresses: Women, Art and Ideology*, (New York, 1981). Quoted in Gouma-Peterson and Patricia Mathews, p. 328. See also Pollock, 'Women, Art and Ideology. Questions for Feminist Art Historians', *Woman's Art Journal*, IV, (Spring/Summer, 1983), p. 42.

13 Liz Bird, 'Threading The Beads: Women In Art In Glasgow, 1870-1920', in *Uncharted Lives*, (Glasgow 1983), p. 99.

14 Parker and Pollock continued: '. . . men and women had followed historically different and finally contradictory paths so that by the nineteenth century what was understood by the term woman (a passive dependant through domestic and maternal roles) and what the artists represented (an anti-social, independent creator) were set in an antagonistic relationship. . . .' Griselda Pollock and Rozsika Parker, *Old Mistresses: Women, Art and Ideology*. (New York, 1981) quoted in Gouma-Peterson and Mathews, p. 328.

15 Linda Nochlin, 'Why Are There No Great Women Artists?', in Vivian Gornick and Barbara Moran (eds.), *Woman In Sexist Society, Studies in Power and Powerlessness*, (New York, 1971), p. 483.

16 Cynthia Ozick, 'Women and Creativity: The Demise of the Dancing Dog', in Gornick and Moran, *Women in Sexist Society: Studies in Power and Powerlessness*, p. 446.

17 Nochlin, p. 447.

18 Wendy Martin, 'Seduced And Abandoned In The New World: The Image of Woman in American Fiction', in Gornick and Moran, (eds.) *Women in Sexist Society: Studies in Power and Powerlessness*, p. 345.

19 A. Oakley, 'Great Britain', *Creative Woman In Changing Societies*, (United Nations, 1985), p. 133.

20 Glasgow School of Art Annual Reports, 1880-1920.

21 Liz Bird, 'Ghouls and Gas Pipes: Public Reaction to Early Work of the Four', *Scottish Art Review*, Vol. XIX, No. 4, 1975 and Thomas Howarth, *Charles Rennie Mackintosh and the Modern Movement*, (London, 1977), for an account of the early work of 'The Four'.

22 Ailsa Tanner, *West of Scotland Women Artists*, (Helensburgh, 1976), p. 19.

23 Glasgow Museums and Art Galleries, *The Glasgow Style*, (Glasgow, 1984), for an account of the Glasgow Style.

24 Liz Bird, 'Threading the Beads', p. 115.

25 Stephen Tschudi Madsen, *Sources of Art Nouveau*, (New York, 1976), p. 292.

26 Rozsika Parker, *The Subversive Stitch: Embroidery and the Making of the Feminine*, (London, 1984), p. 186.

27 John Loughery, 'Mrs Holladay and The Guerilla Girls', *Arts Magazine*, (October, 1987), p. 63.

28 'Ideology is not a conscious process, its effects are manifest but it works unconsciously, reproducing the values and systems of belief of the dominant group it serves. . . . The current ideology of male dominance has a history. It was adumbrated in the Renaissance, expanded in the eighteenth century, fully articulated in the nineteenth century and finally totally naturalised with the result that in twentieth-century art history it is so taken for granted as part of the natural order it need not be mentioned. This ideology is reproduced not only in the way art is discussed, the discipline of art history, but in works of art themselves. It operates through images and styles in art, the ways of seeing the world and representing our position in the world that art presents. It is inscribed into the very language of art.' Parker and Pollock, p. 80.

29 'Louise Nevelson', review article, in *Cue Magazine*, 4th October, 1941, quoted from 'The Female Experience and Artistic Creativity', in *Women and Creativity*, (California, 1978), p. 2.

30 P. Morton Shand in a letter to William Davidson, dated 31st March, 1933, Hunterian Art Gallery Archives, University of Glasgow.

31 P. Morton Shand in a letter to William Davidson, dated 7th April, 1933, Hunterian Art Gallery Archives.

32 P. Morton Shand, 'Scenario For A Human Drama', *The Architectural Review*, (January, 1935), p. 25.

33 Catalogue citation number 541 and 542, for Margaret Macdonald and Charles Rennie Mackintosh. 'International Exhibition of Modern Jewellery', 1960.

34 Ray McKenzie in response to Shand's article, quoted in Jude Burkhauser, *'Glasgow Girls': Women in the Art School 1880-1920*, catalogue, (Glasgow, 1988), p. 5.

35 Isabelle Anscombe, *A Woman's Touch: Women in Design From 1860 to the Present Day*, (London, 1984), p. 15.

36 Nochlin, pp. 508–509.

Chapter One

1 By 1889 approximately 75 per cent of students from Glasgow School of Art went on to work in design fields.

2 We are indebted to Ailsa Tanner for this information.

3 *Art Journal Special Number*, 1888, p. 7.

4 See Provost Alexander Ross, *Scottish Home Industries*, (Dingwall 1895, republished in 1980 by the Molendinar Press, Edinburgh, with historical note by Alexander Fenton); also R. Munro Ferguson, 'Scottish Home Industries Association' in *Transactions of the Edinburgh Art Congress*, (Edinburgh, 1890).

5 Eileen Boris brings out this point forcibly in her study of the American Arts and Crafts Movement, *Art and Labor*, (Philadelphia, 1986).

6 Neil Munro, *Para Handy and Other Tales*, (Edinburgh and London, 1931), p. 653. These shrewd and humorous sketches first appeared *c.* 1901 in the columns of the *Glasgow Evening News*.

7 For example, Mrs Elder's significant gift of fine art to the Glasgow Museums and Art Galleries. However, Mrs Douglas of Orbiston's bequest of Italian paintings, sculpture and decorative arts to the Art Gallery in 1863 would appear to be an important exception.

8 Munro, pp. 507–508.

9 Whitney Walton elaborates this point in 'To Triumph before Feminine Taste—Bourgeois Women's Consumption and Hand Methods of Production in Mid-Nineteenth-Century Paris', *Business History Review*, Vol. 60, No. 4, pp. 541–563.

10 Lecture by Charles Rennie Mackintosh, 'Seemliness', January, 1902, Hunterian Art Gallery, University of Glasgow.

11 For this information on the tea-rooms, I am indebted to Perilla Kinchin's forthcoming publication, *Tea and Taste—Glasgow Tea-Rooms, 1875–1975*, (White Cockade Publishing), which gives a full illustrated account of the subject.

12 J.H. Muir, *Glasgow in 1901*, (Glasgow, 1901), p. 166, giving a delightful account of the tea-rooms among other features of Glasgow life.

13 *Evening News*, 13th April, 1895, p. 2.

14 For a detailed catalogue of Mackintosh's work for Miss Cranston see Roger Billcliffe, *Charles Rennie Mackintosh: The Complete Furniture, Furniture Drawings and Interior Designs*, (London, 1980). See also Pamela Robertson, 'Catherine Cranston', *Journal of Decorative Art Society*, Vol. 10, 1986, pp. 10–17.

15 J.J. Waddell, 'Some Recent Glasgow Tea-Rooms', *Builder's Journal and Architectural Record*, Vol. 17, (1903), pp. 126–31.

16 This information on the tea-rooms is based mainly on interviews with several of Miss Cranston's former waitresses, notably Miss Mary McKechnie (1946).

17 Neil Munro, *Erchie*, (Edinburgh and London, 1931, originally published under the name Hugh Foulis in 1901), p. 525.

18 Throughout this section I am indebted to Eleanor Gordon, *Women and the Labour Movement in Scotland 1850–1914*, unpublished PhD thesis, Faculty of Social Sciences, University of Glasgow, 1985, and to Siân Reynolds, *Britannica's Typesetters*, (Edinburgh, 1989).

19 Changing number of women in selected occupations in Glasgow: (Census data)

	1851	1891	1911
Textiles	27,500	20,883	15,741
Clothing	16,261	19,749	20,938
Printers	—	428	1,036
Domestic servants	14,484	19,264	16,219

20 See Ann Phillips and Barbara Taylor, 'Sex and Skill: Notes towards a Feminist Economics', *Feminist Review*, No. 6, 1980.

21 Margaret Irwin, 'Women's Industries in Scotland', *Proceedings of the Philosophical Society of Glasgow*, 1895–6, p. 1.

22 The following letter was sent to the *Daily News* from the General Secretary of the Bookbinders Union regarding a strike by men in the Collins factory: 'The substitution of female labour for men's work in factories and workshops is no advantage to women generally, though it may suit the women who displace the men, this is no advantage to the wives, daughters, sisters and mothers of the displaced workmen. If there is one industry in which Christian principles should prevail and from which "sweating" should be entirely absent it is surely that which has to do with the manufacture and production of bibles.' A further letter blamed the employers for violating Christian principles and the teachings of the Bible by stripping men of their role as breadwinners and making them dependent on the earnings of women (even though two-thirds of the men were unmarried!). *The Bookbinders and Machine Rulers' Consolidated Union Trade Circulars and Reports*, 1896–1900, December, 1897, p. 249 and March, 1898, p. 310.

23 *The Engineer*, 13th December, 1867. I am grateful to Mark O'Neill for drawing my attention to this reference.

24 *The Drapers' Record* advised against the employment of females in such shops either as assistants or buyers: 'Many retail firms, especially in the provinces are represented in their dress departments by female hands. I cannot but help thinking this is a mistake . . . it is a well-known thing that young ladies have neither the flexibility of wrist nor the muscular development of arm that are required to tighten a piece of dress goods, therefore they are little calculated to keep their stock in good condition, notwithstanding their laudable efforts in that direction.' *Drapers' Record*, 27th August, 1887, p. 57. The same journal was highly critical of American stores for allowing women to enter the field against the stronger sex as buyers: '. . . one of the chief disadvantages under which employers of female labour have to suffer is the venality of the latter. . . . In business as in the more tender pursuit of *l'amour*, the wiles of wicked man prove too much for the average woman.' *Drapers' Record*, 24th December, 1887, p. 470.

Chapter Two

1 *The Young Woman*, (London, 1893) and *The Woman At Home, Annie S. Swan's Magazine*, (London, 1894) and *New Woman Magazine* (London, 1890).

2 Hulda Friedrichs, 'The Old Woman and the New', *The Young Woman*, (London, 1893), p. 275.

3 Friedrichs, p. 275.

4 Friedrichs, p. 273.

5 Friedrichs, p. 275.

6 See also *The Woman At Home, Annie S. Swan's Magazine*, Vol. 1, 1894.

7 Hall Caine, quoted in 'Our Contributors Club II: Are Women Inferior to Men?' *The Young Woman*, October, 1893, p. 67.

8 *An Account of the Opening Ceremonies*, The Scottish Arts Club 1894; Jessie M. King Collection, Special Collections, University of Glasgow.

9 *Glasgow Evening News*, 13th November, 1894.

10 Elspeth King, *The Scottish Women's Suffrage Movement*, (Glasgow, 1978), p. 17.

11 Margaret Bain, 'Scottish Women in Politics', *Chapman*, Vol. 4, No. 3-4, 1980, p. 6.

12 The Glasgow Society of Lady Artists was founded in 1882, and in 1893 had taken the name Glasgow Society of Lady Artists' Club. This club has been referred to by writers, historians and the members themselves by various names, in part because it has undergone some changes over the years. Throughout this text the Glasgow Society of Lady Artists' Club is referred to by that name, as well as: 'Society of Lady Artists', 'Lady Artists' Society', 'Lady Artists' Club', 'the Society', and, sometimes just 'the Club'.

13 Jane Steven, 'Account of the Early Days of the Club', in De Courcy Lewthwaite Dewar, *A History of the Glasgow Society of Lady Artists' Club*, (Glasgow, 1950).

14 *Book of Rules*, Glasgow Society of Lady Artists' Club, 1882.

15 Jean Kelvin, 'Clubs and Clubwomen', *The Glasgow Herald*, 28th March, 1936.

16 This and subsequent quotations from De Courcy Lewthwaite Dewar's letters are from correspondence with her parents in Ceylon *c.*1903–06, in the collection of H.L. Hamilton. Letter of 18th February, 1906.

17 *The Lady's Review of Reviews*, April, 1901 quoted in Elspeth King, *The Scottish Women's Suffrage Movement*, (Glasgow, 1978), p. 14.

18 *The Lady's Review of Reviews*, April 1901, quoted in King, p. 14.

19 Thomas Howarth, *Charles Rennie Mackintosh and the Modern Movement*, (London, 1977), p. 58.

20 Lack of information was due in part to a prevailing Victorian sense of privacy on the part of those alive who were interviewed, and in part to a concentrated focus on the major figure of the movement, Mackintosh, who had himself been ignored until Howarth's important work, *Charles Rennie Mackintosh and the Modern Movement*, documented the architect and helped to bring him recognition.

21 Paul Seton, 'Confessions of a Royal Academician', *The Woman at Home, Annie S. Swan's Magazine*, 1894.

22 Lucy Raeburn, *The Magazine*, November, 1894, collection of the Glasgow School of Art.

23 Margaret Swain, 'Mrs Newbery's Dress', *Costume*, 1978, p. 69.

24 Adolf Loos, quoted in Giovanni Fanelli and Ezio Godoli, *Art Nouveau Postcards*, (New York, n.d.) p. 33. Perhaps a bit prematurely Adolf Loos, the architectural critic, wrote in 1898: 'Women's fashion is an appalling chapter in the history of civilisation . . . but now even this period is over. . . .' Loos was critical of the over-aesthetic approach to interior design which conceived of an interior as a self-contained work of art.

25 J. Taylor, 'Modern Decorative Art at Glasgow', *The Studio*, Vol. XXXIX, 1906, p. 31.

26 Mary Newbery Sturrock, quoted in Margaret Swain, 'Mrs Newbery's Dress', p. 64.

27 Frau Anna Muthesius, *Das Eigenkleid der Frau*, (Krefeld, 1903).

28 This information was kindly provided to me by John Blackie, in an interview, 31st March, 1990.

29 Hermann Muthesius, *Das Englische Haus*, quoted in William Buchanan, ed., *Mackintosh's Masterwork: The Glasgow School of Art*, (Glasgow, 1989), p. 9.

30 Yvonne Brunhammer, *Art Deco Style*, (London, 1983), p. 8.

31 Brunhammer, p. 8.

Chapter Three

INTRODUCTION

1 The *Haus eines Kunstfreundes* was built in Glasgow in 1990 through the generosity of Mr Graham Roxburgh.

2 Meeting with Agnes Raeburn in September, 1946.

3 Jude Burkhauser, ed., *'Glasgow Girls': Women in the Art School, 1880–1920.* (Glasgow, 1988), p. 8.

4 My last contact with one of the 'Glasgow Girls', Grace Melvin, came in the 1970s. Grace lived in a romantic, flower-covered, timber house in Vancouver, British Columbia. She had been a student of Ann Macbeth's and remembered Jessie Newbery well. She worked in embroidery and watercolour, mainly flower studies. I met her first when she came to a lecture of mine on 'Mackintosh and the Glasgow Style' in Victoria, B.C. She brought samples of her work including a large, embroidered, halter-like collar. I visited her subsequently at her home in Vancouver and encouraged a graduate student to compile a record of her life.

5 Liz Bird, 'Threading the Beads: Women in Art in Glasgow 1870–1920', in *Uncharted Lives*, (Glasgow, 1983), p. 99.

6 W.G. Morton told me that he painted a lunette for one of the Art School shows; Mackintosh was impressed and asked Newbery to introduce them. Morton was invited to join the Mackintosh group but he 'did not like the way "the Four" were living' and refused; he would not enlarge on this statement.

FRA NEWBERY, JESSIE NEWBERY AND THE GLASGOW SCHOOL OF ART

Liz Bird's essay, 'Women in Art Education', is an amended and abridged version of 'Threading the Beads: Women in Art in Glasgow, 1870–1920', in *Uncharted Lives*, (Glasgow, 1983).

1 Glasgow Museums and Art Galleries, *The Glasgow Style 1880–1920*, (Glasgow, 1984), p. 8.

2 Liz Bird, 'Threading the Beads: Women in Art in Glasgow, 1870–1920', *Uncharted Lives*, (Glasgow, 1983), pp. 98–117.

3 Bird, p. 98.

4 The scroll states that 'a history of the School would be incomplete without mention of . . .', and goes on to list numerous male graduates, but no women.

5 John Groundwater, *The Glasgow School of Art Through a Century, 1840–1940*, (Glasgow, 1940), p. 3.

6 Sheriff Alison speaking at the Glasgow School of Art, 1850, quoted in Groundwater, p. 4.

7 *Minute Books of the Mechanics Institute*, 1841, p. 2. Strathclyde University Archives.

8 Bird, 'Threading the Beads', p. 101.

9 Report of the Glasgow School of Art Annual Meeting, 1885, Glasgow School of Art Archives.

10 This information was generously provided by Juliet Kinchin.

11 The *Art Journal* article prefaced their comments with a report of the competition results: 'In the National Competition . . . sixteen gold medals were awarded, three of which went to Birmingham, and three to Glasgow. To the latter school, indeed, belong the chief honours of the competition, for the Glasgow students carried off in addition to their three gold medals, eight of silver, and twenty-three of bronze.' Unidentified press clipping, *Art Journal*, October, 1897, in Glasgow School of Art Press Cutting Book, Vol. I, p. 16.

12 Francis Newbery, 'The Place of Art Schools in the Economy of Applied Art', address to the *National Association for the Advancement of Art and Its Application to Industry*, (London, 1890), pp. 447–450.

13 'First International Studio Exhibition I', *The Studio*, Vol. XXIV, 1901, p. 178.

14 Bird, 'Threading the Beads', pp. 107–108.

15 De Courcy Lewthwaite Dewar, 'War Diary', 1943, Strathclyde Regional Archives.

16 Correspondence Bessie MacNicol to E.A. Hornel, 1897, in the Broughton House Collection, E.A. Hornel Trust, Kirkcudbright.

17 Francis Newbery, 'An Appreciation of the Work of Ann Macbeth', *The Studio*, Vol. XXIX, 1903, p. 40.

18 Lynn Walker, 'Women in Design' conference, University of Edinburgh, 1989.

19 Unidentified, undated press clipping, Glasgow School of Art Press Cutting Book, 1913, p. 156.

20 Upon the occasion of the official opening of the new Mackintosh-designed building for the School, a masque Newbery had written, *The Birth and Growth of Art*, was presented on the first day of the five day celebration. Newbery had been instrumental in the development of the new building and had managed to secure the architectural design commission for his rising young protégé Mackintosh. The opening coincided with the celebration of Newbery's twenty-fifth year as Director. Unidentified, undated press clipping, Glasgow School of Art Press Cutting Book, 1909, p. 76.

21 Dewar letters, 19th November, 1903.

22 De Courcy Lewthwaite Dewar, unpublished letters to her parents in Ceylon, November, 1903, H.L. Hamilton Collection.

23 Dewar letters, 24th December, 1903.

24 Anthea Callen, *Angel in the Studio: Women in the Arts and Crafts Movement*, (London and New York, 1979), p. 123.

25 Rozsika Parker, *The Subversive Stitch: Embroidery and the Making of the Feminine*, (London, 1984), p. 8.

26 Gleeson White, 'Some Glasgow Designers and Their Work: Jessie Newbery', *The Studio*, Vol. XII, 1897, p. 48.

27 Nikolaus Pevsner, *Academies of Art Past and Present*, (Cambridge, 1940).

28 Quentin Bell, *The Schools of Design*, (London, 1963).

29 Pamela Gerrish Nunn, *Victorian Women Artists*, (London, 1987).

30 In fact, Scotland had been in advance, for the Trustees Academy was established in Edinburgh in 1760 with money from the Board of Manufactures in order to promote good textile design. The history of the Trustees Academy and of the various provincial schools of design shows an ongoing debate over the distinction between fine and applied arts. Should the schools train artists or designers, should they recruit artisans or gentlemen? S. Macdonald, *The History and Philosophy of Art Education*, (London, 1970).

31 Anthea Callen, *Angel in the Studio: Women in the Arts and Crafts Movement 1870–1914*, (London, 1979), p. 27.

32 Callen, pp. 27–40.

33 Nunn gives a complete discussion of this phenomenon.

34 Enrolment records, Glasgow School of Art.

35 James Fleming quoted by Liz Bird, 'The Designers', in Burkhauser, p. 25.

36 Undated press clipping cited in Bird, 'The Designers', in Burkhauser, p. 25.

37 *Glasgow Evening News*, 22nd May, 1895.

38 The Central School was to be involved in 1898 in the case of Miss L.M. Wilkinson, who was refused admission to the bookbinding class run at the school on the grounds that it was a trade class and restricted to men. The school colluded with the trade union regulations and refused to admit Miss Wilkinson, arguing that she was 'an amateur'. Callen, pp. 188–191.

39 Callen, p. 9.

40 'Art Work for Women I', *Art Journal*, 1872, cited in Callen, p. 35.

41 Callen, p. 123.

42 Gleeson White, 'Some Glasgow Designers and Their Work I', *The Studio*, Vol. XI, 1897, p. 48.

43 'Review Notice', *The Studio*, Vol. XXVI, 1902, p. 101. Quoted in F.C. Macfarlane and E.F. Arthur, *Glasgow School of Art Embroidery 1894–1920*, Glasgow Museums and Art Galleries, (Glasgow, 1980).

44 Ann Oakley, *Creative Women in Changing Societies*, (New York, 1985), p. 133.

45 As Linda Nochlin points out: '. . . the choice for women seems always to be marriage or a career; if such were the alternatives presented to men, one wonders how many great artists, or even mediocre ones, would have opted for commitment to their art—especially if they had been reminded from their earliest moments that their only true fulfilment as men could come from marriage and raising a family'. From Linda Nochlin, 'Why Are There No Great Women Artists?', in Vivian Gornick and Barbara K. Moran, *Women in Sexist Society: Studies in Power and Powerlessness*, (New York, 1971), p. 496.

46 Unidentified newspaper clipping in the De Courcy Lewthwaite Dewar diaries, 10th May, 1944, Strathclyde Regional Archives, Glasgow.

47 A.J. Belford, *Centenary Handbook of the Educational Institute of Scotland*, (Edinburgh, 1946), p. 413.

48 Glasgow School of Art Staff Lists, Registrar's Office:
Full-time: 75 male 9 female (1988)
Full-time: 64 male 9 female (1990)

49 Letter from Katharine Cameron Kay to Douglas Percy Bliss dated 15th March, 1949, Glasgow School of Art Collection.

50 By the end of the century these books had become elaborate, such as Sir Michael Balfour's *Album amicorum 1596–1610* (now held in the National Library of Scotland), which included autographs and a series of paintings depicting scenes and characters in Padua and Venice.

51 Presented to the Hunterian Art Gallery, Glasgow University, in 1959.

52 Fawkes (1570–1606), an English conspirator associated with the 'gunpowder plot', the object of which was to kill the King and members of Parliament on its opening of 5th November, 1605. Fawkes was caught and executed. Today, 5th November is celebrated with the burning of Fawkes in effigy.
Benjamin E. Smith, *The Century Encyclopedia of Names*, (London, 1903).

THE GLASGOW STYLE

1 J. Taylor, 'Modern Decorative Art at Glasgow', *The Studio*, Vol. XXXIX, 1906, p. 31.

2 Gleeson White, 'Some Glasgow Designers and Their Work—Part I', *The Studio*, Vol. XI, 1897, p. 86.

3 Glasgow Museums and Art Galleries, *The Glasgow Style*, (Glasgow, 1988), p. 8.

4 Charles Rennie Mackintosh to Margaret Macdonald Mackintosh, personal correspondence, 15th May, 1927, Hunterian Art Gallery Archives.

5 Jessie R. Newbery, 'Foreword', in *Charles Rennie Mackintosh/Margaret Macdonald Mackintosh Memorial Exhibition*, (Glasgow, 1933), pp. 1–2.

6 Glasgow Museums and Art Galleries, *The Glasgow Style*, (Glasgow, 1984), p. 8.

7 G. White, 'Some Glasgow Designers—Part I', p. 86.

8 G. White, 'Some Glasgow Designers—Part I', p. 87.

9 G. White, 'Some Glasgow Designers—Part I', p. 100.

10 G. White, 'Some Glasgow Designers—Part I', p. 89.

11 Liz Bird, 'Ghouls and Gas Pipes: Public Reaction to Early Work of the Four', *Scottish Art Review*, Vol. XIV, No. 4, 1975, p. 13.

12 *Glasgow Evening News*, 13th November, 1894, p. 4.

13 Thomas Howarth, *Charles Rennie Mackintosh and the Modern Movement*, (London, 2nd edition, 1977), p. 26.

14 *Quiz*, 15th November, 1894.

15 Letter to the Editor, *Glasgow Evening News*, 16th November, 1894, p. 3.

16 Jude Burkhauser, text panels, 'New Woman' and 'Spook School' for *'Glasgow Girls': Women in the Art School*, Glasgow School of Art, 1988.

17 Isabelle Anscombe, *A Woman's Touch*, (London, 1984), p. 51.

18 Letter to the Editor, *Glasgow Evening News*, 16th November, 1894, cited in Bird, 'Ghouls and Gas Pipes', p. 15.

19 White, 'Some Glasgow Designers—Part I', p. 92.

20 Jan Marsh, *Pre-Raphaelite Women*, (London, 1988).

21 Bird, 'Ghouls and Gas Pipes', pp. 16, 28.

22 Anonymous critic (probably Gleeson White), 'The Arts and Crafts Exhibition', *The Studio*, Vol. IX, 1896, p. 204.

23 G. White, 'Some Glasgow Designers—Part I', p. 89.

24 A.S. Levetus, 'Glasgow Artists in Vienna'. Unidentified press clipping, 1900, in the Glasgow School of Art Press Cutting Book, 1909, p. 57.

25 'Alexandra Exter, Liubov Popova and Varvara Stepanova', quoted in Ann Sutherland Harris and Linda Nochlin, *Women Artists, 1550–1950*, (New York, 1976), p. 61.

26 Harris and Nochlin, p. 213.

27 Desmond Chapman-Huston, 'Charles Rennie Mackintosh', *Artwork*, 1930, Vol. 6, No. 21, p. 29.

28 Mario Amaya, *Art Nouveau*, (London, 1966), pp. 151–154.

29 Levetus, 'Glasgow Artists in Vienna', p. 57.

30 Hugh Cheape and Jane Kidd, 'Vienna and the Scottish Connection', *Antique Collector*, Vol. 54, No. 8, 1983, pp. 38–39.

31 *Decorative Kunst*, October, 1897, Vol. I, No. 1.

32 Anonymous, 'The International Exhibition of Modern Decorative Art at Turin—The Scottish Section', *The Studio*, Vol. XXVI, No. 112, 1902, p. 96.

33 Thomas Howarth, *Charles Rennie Mackintosh 1868–1928. A Memorial Tribute* (Toronto 1978), p. 10.

34 Anonymous, 'International Exhibition . . . Turin', p. 96.

35 Enrico Thovez, 'The First International Exhibition of Modern Decorative Art at Turin', *The Studio*, Vol. XXVI, No. 112, 1902, p. 46.

36 Levetus, 'Austrian Section at the Turin Exhibition of Modern Decorative Art', *The Studio*, Vol. XXVI, No. 112, 1902, p. 46.

37 Celia and Gerald Larner, *The Glasgow Style*, (Edinburgh, 1979), p. 2.

38 William Buchanan, 'Japanese Influences on the Glasgow Boys and Charles Rennie Mackintosh', *Japonism in Art*, (Tokyo, 1980), p. 291.

39 Van Gogh was, himself, especially interested in Japanese art and objects and frequently incorporated Japanese articles, motifs and stylistic devices into his paintings. Wichmann provides a very thorough discussion of Japonism. *Le Père Tanguy* is in the collection of Stavros Niarchos. T. Wichmann, *Japonism*, (London, n.d.), p. 43.

40 Desmond Chapman-Huston, *The Lamp of Memory*, (London, 1949), p. 125.

41 Hermann Muthesius, *Das Englische Haus, 1904–1905*, quoted in Jocelyn Grigg, *Charles Rennie Mackintosh*, (Glasgow, 1987), p. 22.

42 Thomas De Quincey, *Confessions of an Opium Eater*, (London, First Edition, 1822).

43 Germaine Greer, *The Obstacle Race*, (London, 1979), p. 324.

44 Margaret Swain, 'Mrs Newbery's Dress', *Costume*, 1978, p. 66.

45 Andrew McLaren Young, *Charles Rennie Mackintosh (1868–1928): Architecture, Design and Painting*, (Edinburgh, 1968), p. 20.

46 Barbara G. Walker, *The Woman's Encyclopedia of Myths and Secrets*, (New York, 1983), p. 866.

47 Pierre Col, quoted by Walker, p. 868.

48 Julius Meier-Graefe, *Encyclopedia of Modern Art, 1904–1905*, quoted by S. T. Madsen in *Sources of Art Nouveau*. (New York, 1976), p. 292.

Chapter Four

MARGARET MACDONALD

1 In January, 1933, Newbery's wife Jessie wrote of the forty year friendship with the Mackintoshes: 'with never a rift between us . . . our lives were closely and affectionately interwoven.' Letter from Jessie Newbery to Mrs Randolph Schwabe, 12th January, 1933. Quoted by kind permission of Lady Alice Barnes.

2 Lucy Raeburn, 'Round the Studios', *The Magazine*, October/November 1893, Glasgow School of Art, pp. 22–5.

3 'The Arts and Crafts Exhibition', *The Magazine of Art*, XX, 1896–7, pp. 32–3.

4 Gleeson White, 'The Arts and Crafts', *The Studio*, IX, pp. 189–204.

5 Gleeson White, 'Some Glasgow Designers and Their Work', *The Studio*, Vol. XI, 1897, pp. 86–100.

6 *Quiz*, 15th November, 1894.

7 Gleeson White, 'Some Glasgow Designers and Their Work', *The Studio*, Vol. XI, 1897, pp. 86–100.

8 Ibid.

9 'Ein Mackintosh Tee Haus in Glasgow', *Dekorative Kunst*, VIII, 1905, p. 266.

10 P. Morton Shand to William Davidson, correspondence, 31st March, 1933. Hunterian Art Gallery, University of Glasgow, Mackintosh Collection.

11 Charles Rennie Mackintosh to Hermann Muthesius, correspondence, 27th March, 1903. Private Collection.

12 Sir Harry Barnes, 'The Newberys', *C.R. Mackintosh Society Newsletter*, 30, 1981.

13 Charles Rennie Mackintosh to Margaret Macdonald Mackintosh, personal correspondence, 16th May, 1927. Hunterian Art Gallery, University of Glasgow, Mackintosh Collection.

14 Barnes, 'The Newberys'.

15 Hermann Muthesius, Preface to the folio of the Mackintoshes' *House for an Art Lover* designs, Darmstadt, 1902, p. 3.
Timothy Neat's essay is a selective introduction to 'Meaning and Symbolism' in the work of the Macdonald sisters extracted from an extended analysis of meaning and symbolism in the work of Charles Rennie Mackintosh and the 'Glasgow Four': a book to be published under the title *Part Seen: Part Imagined* by Timothy Neat.

16 Charles Rennie Mackintosh to Margaret Macdonald Mackintosh, personal correspondence, May/June, 1927. Hunterian Art Gallery, University of Glasgow, Mackintosh Collection.

17 Thomas Howarth, *Charles Rennie Mackintosh and the Modern Movement*, (London, ed. 1977), p. 19.

18 Charles Rennie Mackintosh, lecture, 'Seemliness', 1904. Hunterian Art Gallery, University of Glasgow.

19 Mackintosh, 'Seemliness'.

20 *The Studio*, Vol. I, April, 1893.

21 Mackintosh, 'Seemliness'.

22 The thistle was widely seen and used by John Ruskin and others in the Victorian period to symbolise impoverishment and infertility; such symbolism was based on Natural facts and Biblical precedent.

23 Richard Muther comments on the Vienna Secessionist Exhibition, 1900. Wolfgang Pfeiffer Archives, Berlin.

FRANCES MACDONALD

1 Glasgow School of Art Annual Report, 1894, Glasgow School of Art.

2 Gleeson White, 'Some Glasgow Designers and Their Work', *The Studio*, Vol. XI, 1897, pp. 86–100.

3 Jude Burkhauser (ed.), *'Glasgow Girls': Women in the Art School, 1880–1920* (Glasgow 1988).

4 Charles Rennie Mackintosh's alleged comment was cited by Pamela Reekie (Robertson) in *Margaret Macdonald Mackintosh*, (Glasgow, 1983), n.p.

5 Liz Bird, 'Ghouls and Gas Pipes: Public Reaction to Early Work of the Four', *Scottish Art Review*, Vol. 14, No. 4, 1975, p. 13.

6 Thomas Howarth, *Charles Rennie Mackintosh and the Modern Movement*, (London, 1977) p. 24.

7 Howarth, p. 24.

8 Illustrated by Mario Amaya in his book *Art Nouveau*, (London, 1968).

9 Amaya states, 'Mackintosh, who led the Glasgow Four (his wife, Margaret Macdonald, and Herbert and Frances MacNair), seemed to the Vienna Secessionists such as Josef Hoffmann, Joseph Olbrich, Koloman Moser and Gustav Klimt to be the natural solution to the Art Nouveau quandary into which floreated abstractions had worked themselves by this time'. Amaya, p. 50.

10 Jude Burkhauser (ed.), *'Glasgow Girls': Women in the Art School, 1880–1920* (Glasgow, 1988), p. 19.

11 I am indebted to James Macaulay, Mackintosh School of Architecture, for theoretical discussion of this point, Glasgow, School of Art, January, 1990.

12 Catalogue for *The London Salon of the Allied Artists' Association Ltd.* July 1908, Royal Albert Hall.

13 Art training in Britain was co-ordinated by the Central Training School of Art which had been located in South Kensington, London since 1863.

14 *Glasgow Evening News*, 17th November, 1894.

15 *The Bailie*, 14th November, 1894, p. 11.

16 'New' of course refers to the New Woman. *Glasgow Evening News*, 13th November, 1894.

17 A viewer's description of one of the drawings in the autumn exhibition of 1894 reads like a commentary on *The Fountain*: 'The background of one of these masterpieces consisted of various parts of anatomy subjects floating about in an objectless manner in a sea of green mud. . . . Painting figures with no clothes on has always excited opposition from a large portion of the public, but these ambitious enthusiasts in their search after truth paint their figures without even their flesh on.' *Glasgow Evening News*, 13th November, 1894. Liz Bird discusses public reaction to the students' work in 'Ghouls and Gas Pipes: Public Reaction to Early Work of "The Four",' *Scottish Art Review*, Vol. 19, No. 4, 1975, pp. 13–16, 28.

18 *Glasgow Evening News*, 22nd May, 1895.

19 *Glasgow Evening News*, 25th January, 1895. They met with less favourable response in London when a poster done by the Macdonald sisters and MacNair was exhibited in 'A Collection of Posters', at the Royal Aquarium, 1896. In his introduction to the *Illustrated Catalogue of the Second Exhibition*, Edward Bella wrote: 'Certainly, there is a tendency in some of these later posters to incoherency and a sacrifice of everything to freedom of line, particularly in the case of certain extreme examples coming from America and from Glasgow. . . .'

20 This was a more conservative exhibition than Macdonald generally favoured. She exhibited with them in 1896, 1897, (cat. 1309, *The Star of Bethlehem*, a relief) and 1898 (cat. 82, Spring).

21 *The Liverpool Courier*, 29th August, 1896.

22 She exhibited once, in 1898, with the Royal Scottish Society of Painters in Watercolours and only once as a student at the 1893 Glasgow Institute of Fine Arts. This is in marked contrast to her sister, Margaret, who exhibited regularly with the RSW, and who was a member of the Society. Margaret also exhibited on occasion with the GIFA.

23 Outside of *The Studio*, a new journal devoted to the arts and crafts that appeared in 1893 with Gleeson White as its editor, only *The Artist* concerned itself with the relationship between art, design, industry and craft. Mackintosh was criticised by *The Artist* but not vitriolically: 'Mr Mackintosh exhibits a hall settle which would have been very nice if it were not for its decorations . . . [he] also exhibits a brass panel, entitled *Vanity*. The title is appropriate enough, as it is impossible to discern what the design is supposed to represent. . . .' Mabel Cox, 'The Arts and Crafts Exhibition', in *The Artist*, October 1896, p. 39.

24 See for example, *The Daily Telegraph* (London), 3rd October, 1896 which considered 'the most interesting feature in the present display the paintings of Ford Madox Brown'. This same article roundly criticised Burne-Jones' drawings for the Kelmscott Press' *Chaucer* as 'sickly attenuated' and 'as far as anything could possibly be from the freshness and unforced naïveté of the first great English poet'. The adverse criticism received by 'the Four' has been highly over-rated. In context, they fared quite well particularly considering their competition. The articles in *The Studio* far offset any vague remarks in the press.

25 'The Art Movement—the Arts and Crafts Exhibition I', in *The Magazine of Art* (London), November, 1896–April, 1897, p. 35.

26 Mabel Cox, 'The Arts and Crafts Exhibition', in *The Artist*, October, 1896, p. 38. Unfortunately, Cox did not name the artists, but the description fits perfectly Macdonald's *Clock in Beaten Silver, With Beaten Brass Weights and Aluminium Pendulum*, (cat. 285). She said: 'There is a very good wall-clock with a square face of beaten silver, with brass weights and chains, and a large flat pendulum with cherubs' faces beaten upon it. This is a very good form of clock, both for practical and artistic reasons. The work on this one is good, and the result is very satisfactory.'

27 Report of the First Council Meeting, 23rd December, 1897, in the Archives of the Tate Gallery.

28 *The Times*, London, 16th May, 1898, p. 12.

29 *The Times*, London, 16th May, 1898, p. 12.

30 Minutes of the Council Meeting, 16th February, 1899 and March, 1899, Archives of the Tate Gallery.

31 She exhibited two watercolour drawings, *Spring* (item 211) and *Lover's Land* (item 213). Her sister, Margaret, also exhibited two watercolours. See the catalogue for the 'Second Exhibition of the International Society of Painters, Sculptors and Gravers', Knightsbridge, May–July, 1899.

32 *Glasgow Evening News*, 22nd May, 1899. Another critic commenting on the exhibition wrote: '. . . and the Scots dialect, spoken with the accent of Glasgow, seems most in favour.' *The Westminster Gazette*, 10th May, 1899.

33 In 1899 Macdonald married her colleague, Herbert MacNair, and moved to Liverpool. Even after their return to Glasgow in 1908, she retained her Liverpool ties. The London Salon had strong Liverpool connections; for example, Gerard Chowne, MacNair's colleague at Sandon, was a founding member of the Association. See the catalogue for the first exhibition, *The London Salon*, 1908.

34 The Sandon Studios had been in existence for seven years when this was written and it was still considered 'progressive'. *The Liverpool Courier*, 10th April, 1912.

35 She exhibited *Waves Kissing the Faces of the Rocks* (item 14), *A Panel* (item 34), *A Blue Rose* (item 25) and *Sleep* (item 38). See catalogue for the first 'Exhibition of Modern Art', 2nd–30th May, 1908.

36 *The Liverpool Daily Post and Mercury*, 1st May, 1908. The critic obviously considered her work superior to that done by her husband, MacNair, whom he noted in passing as doing works 'in a similar vein of fancy, with some success'.

37 *The Liverpool Courier*, 2nd May, 1908.

38 *The London Salon of the Allied Artists' Association*, Catalogue for the Second Exhibition, 1909.

39 See the Catalogue for the London Salon, July, 1908. I suspect that *The Birth of the Rose* exhibited in London in 1908 is the painting which appears in *The Last Romantics: the Romantic Tradition in British Art* (cat. 410) (London, 1989) and in Roger Billcliffe's *Mackintosh Watercolours* (Glasgow, 1979) (cat. xiv) as *The Sleeping Princess*, c.1909–15.

40 For example, Roger Billcliffe, *Mackintosh Watercolours*, (Glasgow, 1979) pp. 46–47.

41 Bram Dijkstra, *Idols of Perversity* (Oxford, 1986), p. 61–62.

42 The exhibition catalogue for *The Last Romantics: the Romantic Tradition in British Art* tells us that Macdonald's 'work is characterised by an interest in symbolism, mythology and fairy subjects', p. 179.

43 See, for example, Hélène Cixous, 'The Laugh of the Medusa' in *Signs* (Summer, 1976).

44 See, for example, Hélène Cixous, 'Castration or Decapitation?', translated by Annette Kuhn for *Signs: Journal of Women in Culture and Society*, Vol. 7, no. 1, 1981, p. 44–45.

45 Male figures appear infrequently in Macdonald's work and when they do, they are very androgynous. Macdonald's depiction of feminine men conforms remarkably with Cixous' discussion of bisexuality in 'The Laugh of the Medusa', p. 884–885.

46 I am using Toril Moi's phrasing here. See Toril Moi, *Sexual/Textual Politics: Feminist Literary Theory* (London, 1985), p. 105.

47 Roger Billcliffe, *Mackintosh Watercolours*, (Glasgow, 1979) pp. 46–47.

48 *Difference*, as both difference with regard to meaning and deferral of meaning, becomes the significant centre of Macdonald's pictures. I am using Jacques Derrida's concept of difference (*différence*) and his insistence upon the plurality of the text as well as the constant deferral of meaning.

JESSIE M. KING

1 Nan Muirhead Moffat, *Round the Studios 1939*, '*Portraits of Twelve Lady Artists at Work*', (Milngavie, 1982).

2 Jessie M. King, 'Lecture on Design', unpublished manuscript, Jessie M. King Collection, Special Collections, University of Glasgow Library, p. 3.

3 Jessie M. King, 'Lecture on Design', King Collection.

4 Letter from De Courcy Lewthwaite Dewar to her parents in Ceylon, 23rd September, 1903.

5 Dewar letters, 9th December, 1903.

6 Colin White, *The Enchanted World of Jessie M. King*, (Edinburgh, 1989), p. 34.

7 Charles S. Mayer, *Bakst*, The Fine Art Society Ltd, (London, 1976), p. 6.

8 'Most Artistic Town', unidentified, undated press clipping, King Collection.

9 'Beatrice', 'A Close Coterie: Women Artists in the South,' *Glasgow Evening News*, 16th April, 1925.

10 'Versatility in Art: Woman's Works on View at Glasgow' unidentified, undated press clipping, Jessie M. King Collection.

11 Unidentified, undated press clipping, Jessie M. King Collection.

12 Unidentified, undated press clipping, Jessie M. King Collection.

13 Jessie M. King, 'Lecture on Design', Jessie M. King Collection.

14 Jessie M. King notebook, unpublished ms., documented in 1987 and paraphrased in White, *Enchanted World of Jessie M. King*, p. 18.

15 Unidentified, undated journal article, Jessie M. King Collection.

16 Undated, unidentified press clipping, Jessie M. King Collection.

17 Jessie M. King, 'Lecture on Design', Jessie M. King Collection.

18 'Glasgow Lady Artists', unidentified, undated press clipping, Jessie M. King Collection.

ANNIE FRENCH

1 Annie French, letter to Vere Gordon, 5th May, 1954.

2 Weekend, *The Scotsman*, 1985.

3 Simon Houfe, *Dictionary of British Book Illustrators and Caricaturists 1800–1914*, (London, n.d.), p. 229.

4 'Studio Talk', *The Studio*, Vol. XXXVIII, 14th July, 1906, p. 164.

5 Annie French, letter to Vere Gordon, 5th May, 1954, private collection.

6 Annie French, postcard to relative, 1954.

JESSIE NEWBERY

1 School of Art Prospectus, 1894.

2 Linda Parry. *Textiles of the Arts and Crafts Movement*. (London, 1988) n.p. She explains that William Morris had taught himself to embroider through a study of old pieces, by unpicking them in order to be better able to design for the medium.

3 Francis Newbery, 'The Place of Art Schools in the Economy of Applied Art', *Transactions of the National Association for the Advancement of Art and its Application to Industry*, Edinburgh Meeting, 1889. London, 1890, pp. 447–450.

4 White, 'Some Glasgow Designers—Jessie Newbery', *The Studio*, Vol. XII, 1897, p. 48.

5 She had been inspired by the mosaics she saw in Rome and Ravenna when taken on a visit to Italy by her uncle Robert Wylie Hill in 1882.

6 These items were probably commissioned by St Bride's Episcopal Church, Hyndland, Glasgow. Kellock Brown executed the metalwork.

7 White, 'Some Glasgow Designers', p. 47.

8 Ibid.

9 *Glasgow Evening News*, 10th December, 1900. Press Cuttings Book, Glasgow School of Art.

10 'Review Notice, Arts and Crafts Exhibition', *The Studio*, Vol. XXXVII, p. 241.

11 'Review Notice, Glasgow International Exhibition', *The Studio*, Vol. XXIII, 1901, p. 237.

12 In 1915 this prize was awarded to her younger daughter Mary.

13 De Courcy Lewthwaite Dewar, *History of the Glasgow Society of Lady Artists' Club*, (Glasgow, 1950).

14 Unidentified press clipping, *Glasgow Evening News*, 24th February, 1913, Glasgow School of Art Press Cutting Book.

ANN MACBETH

1 Francis Newbery, 'An Appreciation of the Work of Ann Macbeth', *The Studio*, Vol. XXVII, 1902, p. 40.

2 *Glasgow Evening Times*, 15th December, 1902.

3 Peter Wylie Davidson, *Applied Design in the Precious Metals*, (London, 1929) and *Educational Metalcraft*, (London, 1913).

4 Margaret Swanson was an assistant in the department from 1910–12 and then returned to teaching in Ayrshire. She later published *Needlecraft in the School*, 1916, *Needlecraft for Older Girls*, 1920, and *Needlecraft and Psychology*, 1926.

5 Glasgow School of Art, Annual Report, 1914–15.

6 Glasgow School of Art, Annual Report , 1913–14.

7 'Glasgow Studio Talk', *The Studio*, Vol. LVII, 1916, p. 264.

8 This information comes from Jane Parkes, a student at the school, in an interview with Elspeth King, and correspondence of the 'Glasgow and West of Scotland Society for Women's Suffrage' in the Mitchell Library.

9 The collar is illustrated in *The Studio*, Vol. XLIV, 1908, p. 291.

10 Newbery, p. 42.

11 Margaret Swanson, *Educational Needlecraft*, (London, 1911) p. 2.

DE COURCY LEWTHWAITE DEWAR

1 This and subsequent Dewar letters are from a collection of De Courcy Lewthwaite Dewar's letters to her parents in Ceylon, 1903-1906, in the collection of H.L. Hamilton. Letter of November, 1903.

2 This information was provided by Miss Kathleen Howe.

3 *The Studio*, Vol. XLVII, 1909, pp. 156–158.

4 'Women's Work: Exhibition in Glasgow', *Glasgow Herald*, 3rd November, 1910.

5 'Glasgow School of Art Exhibition', *The Studio*, Vol. XV, 1899, p. 280.

6 'Some work by the students of the Glasgow School of Art', *The Studio*, Vol. XIX, 1900, pp. 232–240.

7 'Studio Talk', *The Studio*, Vol. XXIV, 1902, p. 283.

8 Dewar letters, 15th September, 1903.

9 Dewar letters, 12th February, 1903. They collaborated on at least one piece in which she did the enamelling and he did the metalwork, a commission for the 'Alison' Trophy Challenge for the Annual Competition in Boys' Choirs of the Glasgow Music Festival.

10 Dewar letters, 12th February, 1903.

11 Dewar letters, 12th February, 1903.

12 Dewar letters, 15th February, 1903.

13 Dewar letters, 15th September, 1903.

14 Dewar letters, 9th September, 1903.

15 Dewar letters, 9th September, 1903.

16 Dewar letters, 15th November, 1903.

17 Peter Wylie Davidson, *Applied Design in the Precious Metals*, Longman's Technical Series, (London, 1929), pp. 25–26.

18 Unidentified press clipping, 15th June, 1915, Press Cutting Book, Glasgow School of Art.

19 Dewar letters, 13th May, 1906.

20 Dewar letters, 9th December, 1903.

21 At the 'Glasgow International Exhibition 1901', Dewar entered seven repoussé and enamel items including picture frames, a casket, a finger plate and a mirror. In another showing in 1902 at the 'Cork International Exhibition', her work was represented by four enamelled panels and a tea caddy. When the Glasgow School of Art was invited to send a selection of work to the United States for the 'St Louis Exhibition' in 1904, Dewar sent three exhibits: *Fair Rosamond* (*c.*1903), a casket which had been exhibited at the Royal Academy, Edinburgh; a small metal box possibly the one illustrated in *The Studio* 1909 (Vol. XLVIII, 1909, pp. 156–158), 'Studio Talk', and a large glass mirror frame which had been exhibited in the 'Glasgow Exhibition at the People's Palace' in 1898. Dewar Letters, 7th January, 1904.

22 Unidentified, undated press clipping, Glasgow School of Art Press Cutting Book, 1902.

23 Dewar letters, 5th April, 1903.

24 'Studio Talk', *The Studio*, Vol. XXXVI, 1905, pp. 75, 78.

25 'Studio Talk', *The Studio*, Vol. XXXVI, 1905, pp. 75, 78.

26 'The Scottish Guild of Handicraft is being made into a United Company & the provisional committee has sent me an invitation to join. It is the only Art Workers Guild in Scotland for applied Arts so I think I will as it will be a great help. You can always have some piece of your work exhibited in their rooms in Sauchiehall Street and besides getting a little profit from the sales you are likely also to get commissions from the Guild.'

27 'A Glasgow Artist's Work', undated press clipping, Glasgow School of Art Press Cutting Book, 1924.

28 De Courcy Lewthwaite Dewar, *History of the Glasgow Society of Lady Artists' Club*, (Glasgow, 1950).

29 De Courcy Lewthwaite Dewar, 'War diary', 1943, unpublished manuscript, Strathclyde Regional Archives. Each of the three portfolio covers was designed by Dewar and is done in the technique of crayon batik on paper which is then applied to card. In June/July, 1944 she records in her 'war diary' that she has just hung an exhibition at the 'Lady Artists' Club' which features the artists' biographies for the National Council of Women. Dewar served as an artist member of the Central Committee for the Training and Employment of Women, Scottish Branch, and was on the executive board of the NCW, Glasgow Branch.

30 She lectured on her enamelling and organisational assistance for such clubs as the Soroptimists, Lady Artists, Scottish Czechoslovakia Club, and the NCW, in all of which she was actively involved as a member.

31 Dewar letters, 22nd April, 1903. At the 'Glasgow International Exhibition 1901', Dewar entered seven repoussé and enamel items including picture frames, a casket, a finger plate and a mirror.

32 Dewar letters, 12th September, 1906.

THE SISTERS' STUDIOS

1 De Courcy Lewthwaite Dewar, letters to her parents in Ceylon, 1903–1906, contained in H.L. Hamilton Collection, Glasgow.

2 Philippe Garner, 'British Design', *The Phaidon Encyclopedia of Decorative Arts, 1890–1940*, (Oxford, 1978) p. 277.

3 Gleeson White, 'Some Glasgow Designers and Their Work, Part I', *The Studio*, Vol. XI, 1897, p. 93.

4 Michael Donnelly, *Glasgow Stained Glass*, Glasgow Museums and Art Galleries, (Glasgow, 1986), p. 31.

5 Dewar letter, 11th February, 1906.

6 'Modern Metal Work', 4th April, 1924, unidentified press clipping in Glasgow School of Art Press Cutting Book.

7 Information about the Begg sisters was kindly provided by Dr Gillian Rodgers.

8 Glasgow Museums and Art Galleries, *The Glasgow Style*, (Glasgow, 1984), pp. 51–2.

9 Dewar letters, 1st March, 1906.

10 'School of Art Club', *Record*, 11th November, 1901, Glasgow School of Art Press Cutting Book.

11 Dewar letter, 8th November, 1903.

12 Dewar letter, 8th November, 1903.

13 Unidentified press clipping, 12th October, 1903, Glasgow School of Art Press Cutting Book.

14 Dewar letter, 11th October, 1903.

15 Dewar letter, 20th March, 1906.

16 Dewar letter, 20th March, 1906.

17 Dewar letter, 13th May, 1906.

18 Dewar letter, 13th May, 1906.

19 'Obituary Dorothy Carleton Smyth', *Bulletin*, 16th February, 1933, Glasgow School of Art Press Cutting Book, 1933, p. 26.

20 *Midsummer Night's Dream* Review article, *The Sketch*, 11th February, 1914, p. 168.

21 *Midsummer Night's Dream* Review article, *Tatler*, 18th February, 1914, p. 197.

22 'Obituary', *Bulletin*, 16th February, 1933, p. 26.

23 Dewar letter, 3rd May, 1906.

24 Dewar letter, 3rd May, 1906.

25 Unidentified press clipping, *Glasgow Herald*, 1937, Glasgow School of Art Press Cutting Book, p. 191.

26 Purchased from the 'Fifth Loan Exhibition' at the Art Museum of Toronto, 1912. This exhibition included work from the Glasgow School of Art. This work is now in the collection of the National Gallery of Canada, Ottowa.

27 Press clipping, 'As Dainty as a Baby's Sneeze', *Glasgow Herald*, 1937, Glasgow School of Art Press Cutting Book.

28 Unidentified press clipping, 24th February, 1913, Glasgow School of Art Press Cutting Book, 1913, p. 160.

29 Unidentified press clipping, *Herald*, 8th April, 1917, Glasgow School of Art Press Cutting Book, 1914.

30 Press clipping, 'As Dainty as a Baby's Sneeze', *Glasgow Herald*, 1937, Glasgow School of Art Press Cutting Book.

31 Unidentified press clipping, May 1914, Glasgow School of Art Press Cutting Book, 1914, p. 97.

32 Dewar letter, 2nd June, 1903.

33 Dewar letter, 19th May, 1903.

34 'Studio Talk', *The Studio*, Vol. XXVIII, 1903, p. 287.

35 Dewar letter, 2nd June, 1903.

36 Dewar letter, 19th March, 1903.

37 'Glasgow School of Art: Exhibit of the Glasgow School of Art Club', *Glasgow Herald*, 11th August, 1902, Glasgow School of Art Press Cutting Book.

38 'Colourful Display'. Unidentified clipping, 10th April, 1931, Glasgow School of Art Press Cutting Book, 1931.

39 'Glasgow Lady Artists'. Unidentified clipping, May, 1935. Jessie M. King Collection, Special Collections, University of Glasgow.

40 Unidentified press clipping, *Bulletin*, 21st October, 1941, Glasgow School of Art Press Cutting Book.

41 Recollections of Mrs Hedderwick, Jane Younger's niece. The bedspread is still displayed in the Hill House, Helensburgh, guest bedroom.

42 'Most Artistic Town'. Unidentified, undated press clipping, Jessie M. King Collection.

43 'Beatrice', 'A Close Coterie: Women Artists of the South', *The Evening News*, 10th April, 1925. Press clipping Jessie M. King Collection.

44 Colin White, *The Enchanted World of Jessie M. King*, (Edinburgh, 1989), pp. 73, 95.

45 Jessie M. King, *The Green Gate*, (London, 1917), dedication page. Cited in Sharon Brady, *Book Illustrations of Jessie M. King*, unpublished dissertation, Glasgow School of Art, 1986.

46 White, p. 95.

47 'Beatrice, 'A Close Coterie', Jessie M. King Collection.

48 Alison Downie, 'Portrait of a Lady Artist', *Glasgow Herald: The Woman's Herald*, 9th September, 1982, p. 8.

49 We are indebted to Ailsa Tanner for this information and for her generous assistance on other parts of this text. Contemporary critics praised the effects of Anna Hotchkis' travels on her art; one stating that: 'Her work, with its soft outlines, its delicate atmosphere, and its refinement of colouring, finds a natural expression in watercolours which admirably express the soft vague mountain evenings, the lonely trees of the Rockies, the glowing warmth of scenes in Pekin [sic].' 'Beatrice', 'A Close Coterie', Jessie M. King Collection.

50 Downie, p. 8.

51 Toni Lesser Wolf, 'Women Jewellers of the British Arts and Crafts Movement', *Journal of Decorative and Propaganda Arts*, Autumn, 1989, p. 38.

52 Differing points of view are expressed by Anthea Callen and Lynn Walker in Judy Attfield and Pat Kirkham, (eds.) *A View From the Interior*, (London, 1989), pp. 151–164 and pp. 165–173, respectively.

53 Wolf, p. 32.

54 Wolf, p. 43.

55 Dewar letter, 11th February, 1906. Gaskin, it appears, became more closely involved in the production of metalwork while his wife, Georgina, seems to have been more the designer.

56 *The Ladies Field*, 14th January, 1899, cited in Anne Schofield, 'The Art of Rhoda Wager', *Australian Antique Collector's Annual*, p. 24.

57 'Beatrice', 'A Close Coterie', Jessie M. King Collection.

58 Glasgow Museums and Art Galleries, *The Glasgow Style*, (Glasgow, 1984), p. 198.

59 *The Glasgow Style*, p. 198.

60 'Some Work by the Students of the Glasgow School of Art', *The Studio*, Vol. XIX, 1900, p. 232.

61 The Articles 39 and 55 classes continued under her direction and she became involved with the Needlework Development Scheme which was instituted by J. & P. Coats in 1934 in conjunction with the four Scottish art schools.

62 *The Bulletin*, 23rd September, 1931.

63 *The News*, 29th June, 1931.

64 Nan Muirhead Moffat, *Round the Studios 1939*, (Milngavie, 1982). This book is a selection of interviews originally published in the *Glasgow Herald*, in 1939.

65 Moffat.

Chapter Five

INTRODUCTION:
THE 'GLASGOW BOYS'

1 A standard text on the Glasgow Boys is Roger Billcliffe's, *The Glasgow Boys*, (London, 1987).

BESSIE MACNICOL

1 James Caw, *Scottish Painting Past and Present*, (London, 1908), p. 436.

2 Percy Bate, 'In Memoriam: Bessie MacNicol', *Scottish Art and Letters*, 1904, Vol. III, No. 3, p. 198.

3 Percy Bate, p. 198.

4 I am indebted to Miss Jean Stewart Brown for this information.

5 Percy Bate, p. 198.

6 Percy Bate, pp. 198–199.

7 Bessie MacNicol letter to E.A. Hornel (number 1), in the Broughton House Collection, Kirkcudbright.

8 MacNicol letter to Hornel (number 3).

9 *Glasgow Herald*, 11th March, 1897, p. 4.

10 MacNicol letter to Hornel (number 2).

11 MacNicol letter to Hornel, (number 6).

12 *The Times*, 24th February, 1910, p. 10.

13 *Glasgow Evening News*, 8th June, 1904, p. 4.

14 Percy Bate, p. 198.

NORAH NEILSON GRAY

1 'Miss Norah Neilson Gray, RSW', *Glasgow News*, January, 1930. Undated press cutting, Glasgow School of Art Press Cutting Book.

2 James Shaw Simpson 'Miss Norah Neilson Gray, RSW', *Scottish Country Life*, March 1921, p. 100.

3 Personal correspondence, Norah Neilson Gray to E.A. Taylor, Merle Taylor Estate, Special Collections, University of Glasgow.

4 Correspondence, Norah Neilson Gray to Mr Yockney, dated 30th July, 1919. Archives of the Imperial War Museum, London.

5 Correspondence, Gray to Yockney, 30th July, 1919. Archives of the Imperial War Museum.

6 Correspondence, Yockney to Gray, 2nd August, 1919, Archives of the Imperial War Museum.

7 Undated press clipping, c.1924, Private Collection.

8 J.S. Simpson, *Scottish Country Life*, March, 1921, p. 101.

9 Cordelia Oliver, statement on the occasion of the 'Centenary Exhibition of the Glasgow Society of Lady Artists' at the Collins Gallery, University of Strathclyde, Glasgow.

10 'Scots Woman Artist, Passing of Norah Neilson Gray', *Glasgow Daily Record and Mail*, 29th May, 1931.

11 Martin Baillie commentary on the 1976 'Helensburgh and District Art Club's Twenty-fifth Anniversary Loan Exhibition', 'West of Scotland Women Artists'.

STANSMORE DEAN

1 *Neil Munro*, bought by the Scottish National Portrait Gallery in 1931.

2 Howard Spring, *In the Meantime*, (London, 1942), pp. 112–114.

ELEANOR ALLEN MOORE

1 1928 Exhibition Catalogue, Shanghai Art Club.

'BLINKERS ON OUR IMAGINATION'
PAINTERS OF FLOWERS

1 Mr G.F. Watts, RA, quoted in 'Models and Morals', *The Pall Mall Budget*, 15th October, 1885, Newbery Press Cutting Book, The Mitchell Library, Glasgow.

2 J.C. Horsley address to 1885 Church Congress, reported in unidentified, undated clipping in Francis Newbery Press Cutting Book, Mitchell Library, Glasgow.

3 Glasgow School of Art sketchbook, De Courcy Lewthwaite Dewar, private collection, Glasgow. De Courcy Lewthwaite Dewar's sketchbook dating from 1901 contains a drawing from a nude model. The sketchbook is in a private collection.

4 'If we take drawing from life to mean the nude, it is possible that students from the GSA drew the nude model by 1881. The school's 'Table of Classes' shows seven female students attending an evening life class'. Janice Helland, unpublished PhD dissertation, 'Frances and Margaret Macdonald: "The New Woman" in Fin-de-Siècle Art', University of Victoria, Canada, pp. 55–56.

5 I am indebted to Ailsa Tanner for this information.

6 'GSA Club Exhibition'. Unidentified press clipping, 15th February, 1913, Glasgow Press Cutting Book.

7 I am indebted to George Rawson, Glasgow School of Art Librarian, for this information.

8 Horsley, address to Church Congress.

9 Horsley, address to Church Congress.

10 John Ruskin, *Sesame and Lilies, The Ethics of Dust, the Crown of Wild Olives, With Letters on Public Affairs, 1859–1865*, (London, 1905), p. 249.

11 Vivian Gornick and Barbara K. Moran, *Women in Sexist Society: Studies in Power and Powerlessness*, (New York, 1971), pp. 27–28.

12 Mr T. Woolner, RA, *Pall Mall Budget*, 15th October, 1885, Newbery Press Cutting Book, The Mitchell Library, Glasgow.

13 Mr Frank Dicksee, ARA, quoted in *Pall Mall Budget*, 15th October, 1885, Newbery Press Cuttings Book, The Mitchell Library, Glasgow.

14 Griselda Pollock and Rozsika Parker, *Old Mistresses: Women, Art and Ideology*, (London, 1981), p. 51.

15 Pollock and Parker, p. 51.

16 Riane Eisler, *The Chalice and the Blade*, (San Francisco, 1987), p. 17.

17 Eisler, p. 17.

18 Eisler, p. 18.

19 Edward C. Whitmont, *Return of the Goddess*, (London, 1987), p. 123.

20 Jessie M. King, school notebook, documented 1988 by the author and paraphrased by Colin White in *The Enchanted World of Jessie M. King*, (Edinburgh, 1989), p. 18.

21 Lord Reay, Address at Awards Ceremony, Glasgow School of Art, undated clipping, c.1900, from Glasgow School of Art Press Cutting Book.

22 'First International Studio Exhibition I', *The Studio*, Vol. XXIV, 1901, p. 178.

23 Christopher Dresser, 'The Cult of the Plant and the Line', quoted in Stephen Madsen, *Sources of Art Nouveau*, (London, 1974 edition), p. 27.

24 T.J. Honeyman, 'Katharine Cameron', *Scottish Field*, October, 1959, p. 27.

25 Honeyman, p. 26.

26 H.C. Marillier, 'The Romantic Watercolours of Katharine Cameron', *The Art Journal*, 1900, p. 149.

27 *The Artist*, III, 1901, p. 86.

28 Honeyman, p. 26. This was the first 'one-man' show devoted exclusively to watercolours and drawings of various places, principally in the Highlands, which had captured her imagination during memorable holidays.

29 A.S. Hartrick, *A Painter's Pilgrimage Through Fifty Years*, (Cambridge, 1939), p. 217.

30 'Mr C.F.A. Voysey's Architecture', *The Studio*, XLII, 1908, p. 25, ill. p. 20.

31 Hartrick, p. 179.

VISUAL ICONOGRAPHY

1 In *Academy Pictures*, the publication that featured work from the Royal Scottish Academy, the highest number of women artists shown was seventeen in 1895 out of a total number of artists shown that year of 252. Esme Gordon, *Royal Scottish Academy 1826–1976*. London, 1976.

2 De Courcy Lewthwaite Dewar, *A History of the Glasgow Society of Lady Artists' Club*, (Glasgow, 1950), pp. 21–22.

3 Percy Bate, 'In Memoriam: Bessie MacNicol', *Scottish Art and Letters*, Vol. III, No. 3, 1904, p. 204.

4 Percy Bate, p. 204.

5 'Portraits that Charm', unidentified clipping from Norah Neilson Gray's own Press Cutting Book. In a situation similar to MacNicol's an unnamed critic states that Norah Neilson Gray's painting could be 'assertive without losing its femininity', but all such 'positive' criticism was based at best on the masculine/ rational feminine/intuitive paradigm. Unidentified clipping, Gray Press Cutting Book, Private Collection.

6 Percy Bate, p. 208.

7 Percy Bate, p. 203.

8 Percy Bate, p. 198.

9 Percy Bate, p. 203.

10 J.S. Simpson, 'Miss Norah Neilson Gray RSW', *Scottish Country Life*, March, 1921, p. 100.

11 Percy Bate, p. 205.

12 Pamela Gerrish Nunn, *Victorian Women Artists*, (London, 1987), n.p.

13 Gordon, p. 154.

14 'A Clever Lady Portraitist' and 'Portraits That Charm', undated, unidentified newspaper articles from Gray's Press Cutting Book. In 'Portraits That Charm' the author states, 'Happy are the women who possess portraits by Norah Neilson Gray painted when they had their babies at their knees or when the flush of girlhood was their possession.'

15 Percy Bate, p. 207.

16 Marina Warner, *Monuments and Maidens: An Allegory of the Female Form*, (London, 1985) p. 37.

17 Nunn, pp. 215–217.

18 Duncan says, 'In the eyes of both generations of artists, woman's mode of existence—her relationship to nature and to culture—is categorically different from man's. More dominated by the processes of human reproduction than men, and, by situation, more involved in nurturing tasks, she appears to be more of nature than man, less in opposition to it both physically and mentally.' Carol Duncan, 'Virility and Domination in Early Twentieth Century Vanguard Painting', in Norma Broude and Mary Garrard (eds.), *Feminism and Art History*, (New York, 1982), pp. 302–303.

19 Personal interview with Ailsa Tanner. She also said, 'My mother gave it the title "The Silk Dress". She could not afford to paint anyone but herself, which she did often. The dress was borrowed.'

20 John Berger, *Ways of Seeing*, (Harmondsworth, 1972), p. 21. First, these complexities are opened up by E. Ann Kaplan in an article about film discussing the 'inherently voyeuristic' and usually 'male' look of the camera, the gaze of men within the film, and the look of the male spectator. She states that 'men do not simply look, their gaze carries with it the power of action and of possession that is lacking in the female gaze. Women receive and return a gaze but cannot act on it.' Second, the sexualisation and objectification of women is not simply for the purposes of eroticism; from a psychoanalytic point of view, it is designed to annihilate the threat that woman (as castrated, and possessing a sinister genital organ) poses. E. Ann Kaplan, 'Is the Gaze Male?', in Snitow, Stansell, Thompson (ed.), *Desire: The Politics of Sexuality*, (London, 1983), pp. 322–323.

21 MacNicol's painting, *A French Girl*, comes closest among her other works (in terms of the elements used) to the self-portrait. Again, the woman's head and shoulders fill the space; mouth and eyes are half-opened; the posing of the neck is compositionally important. The crucial differences though are that here the generic title is used—the woman remains unnamed, as an anthropological type; and she is placed not only in profile, but also with her eyes cast down, rather than looking in front of her.

22 R. Betterton, 'How Do Women Look? The Female Nude in the Work of Suzanne Valadon', in Hilary Robinson, (ed.) *Visibly Female, Feminism and Art Today*, (London, 1987), p. 258. She states, 'Men too can look critically, but within forms of culture made for and by men they are less likely to be forced constantly to negotiate a viewpoint. Nor do I want to suggest that women automatically look in a detached and critical way. Looking (or producing) as a woman is dependent on a certain consciousness that such looking is, or could be, different from a masculine viewpoint. Such consciousness in turn depends on a recognition that women's social and cultural experience is itself differently arrived at. It also requires a consciousness that women's experience could be positive and productive, capable of giving voice and vision.'

23 Rosalind Coward, *Female Desire: Women's Sexuality Today*, (London, 1984), p. 77.

24 Edward Said, *Orientalism*, (New York, 1978).

25 Edward Said, 'Orientalism Reconsidered', in Francis Taylor, (ed.) *Europe and its Others*, Vol. 1, 1985, pp. 14–20. 'Images of women and the bizarre jouissances of Orientals' could 'serve to highlight the sobriety and rationality of Occidental [cf. masculine] habits.'

THE PAINTERS: BETWEEN THE WARS

1 Interview, Mary Armour, 23rd February, 1990.

2 Interview, Mary Armour, 23rd February, 1990.

3 Roger Billcliffe, *Mary Armour: A Retrospective Exhibition*, The Fine Art Society, (Glasgow, 1986).

Afterword

1 Riane Eisler, *The Chalice and the Blade*, (San Francisco, 1987), p. 28.

2 'Some Facts About Women Artists', National Museum of Women in the Arts, Washington, DC, 1988.

3 Christina Burnett and Janine Marmont, (producers), *Ordinary People: Why Women Become Feminists*, Channel 4 Television.

4 National Museum for Women in the Arts.

5 W. H. Janson, *History of Art*, (New York, 1987), cited in 'Some Facts About Women Artists', National Musem of Women in the Arts.

6 T. Gouma-Peterson and P. Matthews, 'The Feminist Critique of Art History', *The Art Bulletin*, September, 1987, Vol. LXIX, No. 3.

7 Eleanor Munroe, *Originals: American Women Artists*, (New York, 1979), p. 27.

8 Edward C. Whitmont, *Return of the Goddess*, (London, 1987), pp. 147–148.

9 Julius Meier-Graefe, *Encyclopedia of Modern Art, 1904–1905*, quoted by S. T. Madsen in *Sources of Art Nouveau*, (New York, 1976), p. 292.

10 S. T. Madsen, *Sources of Art Nouveau*, (New York, 1976), p. 292.

11 Whitmont, p. 127.

12 Eisler, p. 28.

13 Illustrated in Yvonne Brunhammer, *The Art Deco Style*, (London, 1983), p. 6.

14 Griselda Pollock, *Vision and Difference: Femininity, Feminism and the Histories of Art*, (London, 1988), p. 17.

15 Virginia Woolf, *A Room of One's Own*, (London, 1942), pp. 78–80.

16 Munroe, p. 25.

17 Woolf, p. 114.

BIBLIOGRAPHY

BOOKS

Allied Artists' Association. *The London Salon of the Allied Artists' Association, Ltd.* Catalogue for the first exhibition. July, 1908.

Allied Artists' Association. *The London Salon of the Allied Artists' Association, Ltd.* Catalogue for the second exhibition, 1909.

Amaya, M. *Art Nouveau.* London, 1966.

Anscombe, I. *A Woman's Touch.* London, 1984.

Arthur, A. Knox. *An Embroidery Book.* London, 1920.

Arthur, L. and F.C. Macfarlane. *Glasgow School of Art Embroidery 1894–1920.* Glasgow, 1980.

Attfield, J. and P. Kirkham. *A View from the Interior: Feminism, Women and Design.* London, 1989.

Barilli, R. *Art Nouveau.* Middlesex, 1969.

Belford, A.J. *Centenary Handbook of the Educational Institute of Scotland.* Educational Institute of Scotland. Edinburgh, 1946.

Bell, Q. *The Schools of Design.* London, 1963.

Berger, J. *Ways of Seeing.* Harmondsworth, 1972.

Billcliffe, R. *Charles Rennie Mackintosh: The Complete Furniture, Furniture Drawings, and Interior Designs.* London, 1980.

The Glasgow Boys. London, 1987.

The Hill House. Edinburgh, 1985.

Mackintosh Textile Designs. London, 1982.

Mackintosh Watercolours. London, 1979.

Boris, E. *Art and Labor.* Philadelphia, 1986.

Broude, N. and M. Garrard, eds. *Feminism and Art History.* New York, 1982.

Brunhammer, Y. *Art Deco Style.* London, 1983.

Buchanan, W. ed. *Mackintosh's Masterwork: The Glasgow School of Art.* Glasgow, 1989.

Burkhauser, J. ed. *'Glasgow Girls': Women in the Art School, 1880–1920.* Glasgow, 1988.

Callen, A. *Angel in the Studio: Women in the Arts and Crafts Movement 1870–1914.* London and New York, 1979.

Caw, J.L. *Scottish Painting Past and Present.* London, 1908.

Chapman-Huston, D. *The Lamp of Memory.* London, 1949.

Coward, R. *Female Desire: Women's Sexuality Today.* London, 1984.

Davidson, P.W. *Educational Metalcraft.* London, 1913.

Davidson, P.W. *Applied Design in the Precious Metals.* London, 1929.

Deems, R. ed. *Schooling For Women's Work.* London, 1979.

De Quincey, T. *Confessions of an Opium Eater.* London, 1822.

Dewar, D.L. *A History of the Glasgow Society of Lady Artists' Club.* Glasgow, 1950.

Dijkstra, B. *Idols of Perversity.* Oxford, 1986.

Donnelly, M. *Glasgow Stained Glass.* Second Edition. Glasgow, 1985.

Eisler, R. *The Chalice and the Blade.* San Francisco, 1987.

Fanelli, G. and E. Godoli. *Art Nouveau Postcards.* New York, n.d.

Glasgow Museums and Art Galleries. *Exhibition of Scottish Painting.* Glasgow, 1961.

The Glasgow Style, 1880–1920. Glasgow, 1984.

Glasgow School of Art. *Exhibition of Ancient and Modern Embroideries.* Glasgow, 1916.

Glasgow Society of Lady Artists' Club. *Book of Rules,* Glasgow, 1882.

Glasgow Society of Women Artists. *A Centenary Exhibition to celebrate the founding of the Glasgow Society of Lady Artists in 1882.* Catalogue by Ailsa Tanner, Glasgow, 1982.

Gordon, E. *Royal Scottish Academy of Painting, Sculpture and Architecture, 1826–1976.* London, 1976.

Gornick, V. and B. K. Moran. *Woman In Sexist Society: Studies In Power and Powerlessness.* New York, 1971.

Greer, G. *The Obstacle Race.* London, 1979.

Grigg, J. *Charles Rennie Mackintosh.* Glasgow, 1987.

Groundwater, J. *The Glasgow School of Art Through a Century, 1840–1940.* Glasgow, 1940.

Harris, A.S. and L. Nochlin. *Women Artists, 1550–1950.* New York, 1976.

Hartrick, A.S. *A Painter's Pilgrimage Through Fifty Years.* Cambridge, 1939.

Houfe, S. *Dictionary of British Book Illustrators and Caricaturists, 1800–1914.* London, n.d.

Howard, C. *Twentieth Century Embroidery in Great Britain to 1939.* London, 1981.

Howarth, T. *Charles Rennie Mackintosh and the Modern Movement.* 2nd Edition, London, 1977.

Irwin, D. and F. *Scottish Painters at Home and Abroad 1700–1900.* London, 1975.

Ives, M. *The Life of Ann Macbeth of Patterdale.* Published privately.

Kinchin, P. *Tea and Taste—Glasgow Tea-rooms, 1875–1975.* White Cockade Publishing, Oxford, forthcoming.

Kinchin, P. and J. *Glasgow's Great Exhibitions, 1888, 1901, 1911, 1938.* Oxford, 1988.

King, E. *The Scottish Women's Suffrage Movement.* Glasgow, 1978.

King, J.M. *The Green Gate.* London, 1917.

Koch, A. *Moderne Stickereien.* Darmstadt, Vol. I, 1903, Vol. II, 1909.

Larner, G. and C. *The Glasgow Style.* London, 1976.

Little, E. *Chronicles of Patterdale.* Penrith, 1961.

Macbeth, A. *Embroidered Lace and Leatherwork.* London, 1924.

The Countrywoman's Rug Book. Leicester, 1929.

Needleweaving. Kendal, 1926.

The Playwork Book. London, 1918.

Macbeth, A. and M. Spence. *School and Fireside Crafts.* London, 1920.

Macbeth A. and M. Swanson. *Educational Needlecraft.* London, 1911.

Macdonald, S. *The History and Philosophy of Art Education.* London, 1970.

McLellan Art Galleries. *Charles Rennie Mackintosh and Margaret Macdonald Mackintosh Memorial Exhibition.* Foreword by Jessie R. Newbery. Glasgow, 1933.

Madsen, S.T. *Sources of Art Nouveau.* (reprint edition) New York, 1976.

Marsh, J. *Pre-Raphaelite Women.* London, 1988.

Martin, D. *The Glasgow School of Painting* with introduction by Francis Newbery, London, 1897.

Mayer, C.S. *Bakst.* London, 1976.

Moffat, N.M. *Round the Studios 1939: Portraits of Twelve Lady Artists at Work.* Milngavie, 1982.

Moi, T. *Sexual/Textual Politics: Feminist Literary Theory.* London, 1985.

Muir, J.H. *Glasgow in 1901.* Glasgow, 1901.

Munro, E. *Originals, American Women Artists.* New York, 1979.

Munro, N. *Brave Days in Glasgow.* Edinburgh, 1904.

Para Handy and Other Tales. Edinburgh and London, 1931.

Erchie. Edinburgh and London, 1931.

Muthesius, A. *Das Eigenkleid der Frau*. Krefeld, 1903.

Muthesius, H. Preface to the folio of the Mackintoshes' *House for an Art Lover*. Darmstadt, 1902.

House and Garden. London, 1906.

Naylor, G. *The Arts and Crafts Movement*. London, 1971.

Newbery, F. *The (R)Evolution of Woman*. Glasgow, n.d.

Nunn, P.G. *Victorian Women Artists*. London, 1987.

Parker, R. *The Subversive Stitch: Embroidery and the Making of the Feminine*. London, 1984.

Parker, R. and G. Pollock. *Old Mistresses: Women, Art and Ideology*. London, 1981.

Parry, L. *Textiles of the Arts and Crafts Movement*. London, 1988.

Pevsner, N. *Academies of Art Past and Present*. Cambridge, 1940.

Pevsner, N. *Pioneers of Modern Design: from William Morris to Walter Gropius*. Harmondsworth, 1960.

Pollock, G. *Vision and Difference: Femininity, Feminism and the Histories of Art*. London, 1988.

Reekie, P. *Margaret Macdonald Mackintosh*. Glasgow, 1983.

Reynolds, S. *Britannica's Typesetters*. Edinburgh, 1989.

Rheims, M. *The Flowering of Art Nouveau*. London, 1966.

Robinson, H. ed. *Visibly Female: Feminism and Art Today: An Anthology*. London, 1987.

Ross, Provost A. *Scottish Home Industries*. Dingwall, 1895. Republished 1980 by the Molendinar Press, Edinburgh, with historical note by Alexander Fenton.

Ruskin, J. *Sesame and Lilies. The Ethics of Dust, The Crown of Wild Olives with letters on public affairs, 1859–1866*. London, 1905.

Said, E. *Orientalism*. London and New York, 1978.

Scottish Arts Council. *The Glasgow Boys, Part II*. Glasgow, 1968.

Shearer, D.R. *Why Paisley?* Paisley, 1985.

Snitow, Stansell, Thompson, eds. *Desire: The Politics of Sexuality*. London, 1983.

Sotheby, Parke Bernet and Co. *Jessie M. King and E.A. Taylor Illustrator and Designer*. London, 1977.

Sotheby, Parke Bernet and Co. *Sotheby's At Scone Palace*. London, 1981.

Spencer, I. *Walter Crane*. Studio Vista, London, 1987.

Spring, H. *In the Meantime*. London, 1942.

Stokland, T. ed. *Creative Women In Changing Societies: A Quest For Alternatives*. New York, 1985.

Stone, M. *When God was a Woman*. San Francisco, 1976.

Swanson, M. *Needlecraft in the School*. London, 1916.

Needlecraft for Older Girls. London, 1920.

Needlecraft and Psychology. London, 1926.

Tanner, A. *West of Scotland Women Artists*. Helensburgh, 1976.

Tonge, J. *The Arts of Scotland*. London, 1938.

Walker, B.G. *The Woman's Encyclopedia of Myths and Secrets*. New York, 1983.

Warner, M. *Monuments and Maidens: The Allegory of the Female Form*. London, 1985.

White, C. *The Enchanted World of Jessie M. King*. Edinburgh, 1989.

Wichman, T. *Japonism*. London, n.d.

Wilson, S. *Beardsley*. Oxford, 1976.

Wood, C. *The Pre-Raphaelites*. London, 1981.

Woolf, V. *A Room of One's Own*. London, 1942.

Young, A.M. *Charles Rennie Mackintosh (1868–1928): Architecture, Design and Painting*. Edinburgh, 1968.

ESSAYS AND JOURNAL ARTICLES

Anonymous. 'The Arts and Crafts Exhibition'. *The Magazine of Art*, Vol. XX, 1896–1897.

Anonymous. 'Die Glasgow Kunstbewegung Charles Rennie Mackintosh und Margaret Macdonald Mackintosh'. *Dekorative Kunst*, Vol. V, No. 6, 1902.

Anonymous. 'Ein Mackintosh-Teehaus in Glasgow'. *Dekorative Kunst*, April, 1905.

Anonymous, 'Glasgow Designers'. *Dekorative Kunst*, Vol. II, No. 2, 1898.

Anonymous. 'Our Contributors Club II: Are Women Inferior to Men?' *The Young Woman*, 1894.

Anonymous. 'Models and Morals'. *The Pall Mall Budget*, 15th October, 1885.

Anonymous, 'Women Locomotive Tracers'. *Engineering*, 13th December, 1867.

Arthur, L. 'Glasgow School of Art Embroideries. 1894–1920'. *Journal of the Decorative Art Society*. 1980.

Bain, M. 'Scottish Women in Politics'. *Chapman*. Vol. 4, No. 3–4, 1980.

Barnes, Sir H. 'The Newberys'. *C. R. Mackintosh Society Newsletter*. No. 30, 1981.

Bate, P. 'In Memoriam: Bessie MacNicol'. *Scottish Art and Letters*, Vol. III, No. 3, 1904.

Beckett, J. and D. Cherry. 'Art, Class and Gender 1900–1910'. *Feminist Art News*, Vol. 2, No. 5, 1987.

Begg, M. 'Jessie M. King'. *Scottish Book Collector*, August, 1987.

Billcliffe, R. 'J.H. MacNair in Glasgow and Liverpool'. *Annual Report and Bulletin of Walker Art Gallery*. Liverpool. 1970–1971.

Bird, L. 'Ghouls and Gas Pipes: Public Reaction to Early Work of the Four'. *Scottish Art Review*, Vol. IV, 1975.

'Threading The Beads: Women In the Arts In Glasgow 1870–1920'. In Glasgow University. *Uncharted Lives*. Glasgow, 1983.

Buchanan, W. 'Japanese Influences on the Glasgow Boys and Charles Rennie Mackintosh'. *Japonism in Art*. Tokyo, 1980.

Callen, A. 'Sexual Division of Labor In the Arts and Crafts Movement'. In J. Attfield and P. Kirkham, *A View From the Interior: Feminism, Women and Design*.

Cixous, H. 'The Laugh of the Medusa'. K. and P. Cohen, trans. *Signs: Journal of Women in Culture and Society*, Vol. 1, No. 4, 1976.

'Castration or Decapitation?'. A. Kuhn, trans. *Signs: Journal of Women in Culture and Society*, Vol. 7, No. 1, 1981.

Chapman-Huston, D. 'Charles Rennie Mackintosh'. *Artwork*. Vol. 6, No. 21, 1930.

Cheape, H. and J. Kidd. 'Vienna and the Scottish Connection'. *Antique Collector*, Vol. 54, No. 8, 1983.

Cliff, M. 'Object into Subject: Some Thoughts on the Work of Black Women Artists'. In Hilary Robinson, ed. *Visibly Female, Feminism and Art Today: An Anthology*. London, 1987.

Cox, M. 'The Arts and Crafts Exhibition'. *The Artist*, October, 1896.

Duncan, C. 'When Greatness is a Box of Wheaties'. *Artforum*. October, 1975.

Friedrichs, H. 'The Old Woman and the New'. *The Young Woman*. London, 1890.

Garner, P. 'British Decorative Arts'. In *The Phaidon Encyclopedia of Decorative Arts*, 1890–1940. Oxford, 1978.

Gear, J. 'Trapped Women: Two Sister Designers, Margaret and Frances Macdonald'. *Heresies* 1, Winter, 1978.

Gouma-Peterson, T. and P. Mathews. 'The Feminist Critique of Art History'. *The Art Bulletin*, September, 1987. Vol. LXIX, No. 3.

Griffin, S. 'Women and Nature'. In *Made from this Earth*. London, 1982.

Harland, H. and A. Beardsley. *The Yellow Book*. Vol. X, July, 1896.

Hendry, J. 'Editorial'. *Chapman*. Vol. VI, No. 3–4, 1980.

Honeyman, T. J. 'Katharine Cameron'. *Scottish Field*. October, 1959.

Jeune, Lady. 'Ideal Husband'. *The Young Woman*. London, 1892.

Larson, P. 'Glasgow and Chicago: Stencilled and Other Prints'. *Print Collector's Newsletter* 10, March–April, 1979.

Levetus, A.S. 'Glasgow Artists in Vienna'. Unidentified press clipping, 1900, Glasgow School of Art Press Cutting Book, 1909.

Lynch, K., S. Macgregor and J. Parry. 'Women Artists in Glasgow'. *The Visual Arts In Glasgow*, Glasgow, 1985.

Loughery, J. 'Mrs Holladay and The Guerilla Girls'. *Arts Magazine*. October, 1987.

Marillier, H.C. 'The Romantic Watercolours of Katharine Cameron'. *The Art Journal*, 1900.

Martin, W. 'Seduced and Abandoned In the New World: The Image of Women in American Fiction'. In V. Gornick and B. K. Moran. *Woman in Sexist Society*. New York, 1971.

Nochlin, L. 'Why Are There No Great Women Artists?' In V. Gornick and B.K. Moran. *Woman In Sexist Society*, New York, 1971.

Oakley, A. 'Great Britain'. In T. Stokland, ed. *Creative Women in Changing Societies*. New York, 1985.

Oliver. C. 'The "Glasgow Girls" Review Article'. *The List*, 18th August, 1988.

Orenstein, G. 'Review Essay: Art History'. *Signs*, Vol. I, Winter, 1975.

Ozick, C. 'Women and Creativity: The Demise of the Dancing Dog'. *Motive 29*. March–April 1969.

Phillips, A. and B. Taylor. 'Sex and Skill: Notes towards a Feminist Economics'. *Feminist Review*, No. 6, 1980.

Raeburn, L. *The Magazine*, Vols. 1–4, 1893–1894.

Reekie, P. 'The Mackintosh Circle (Part II)'. *Charles Rennie Mackintosh Society Newsletter*, No. 31, Winter–Spring 1981–1982.

Robertson, P. 'Catherine Cranston'. *Journal of Decorative Art Society*, Vol. X, 1986.

Said, E. 'Orientalism Reconsidered'. In Francis Taylor, ed. *Europe and its Others*. Vol. 1, 1985.

Schofield, A. 'The Art of Rhoda Wager'. *Australian Antique Collectors' Journal*.

Schubert, G. 'Women and Symbolism: Imagery and Theory'. *The Oxford Art Journal*, Vol. 3, No. 1, April, 1980.

Seton, P. 'Confessions of a Royal Academician'. *The Woman at Home. Annie S. Swan's Magazine*. 1894.

Simpson, J.S. 'Miss Norah Neilson Gray RSW'. *Scottish Country Life*, March, 1921.

Spencer, I. 'Francis Newbery and the Glasgow Style'. *Apollo*, No. 98, 1973.

Sturrock, M.N. 'Remembering Charles Rennie Mackintosh'. *The Connoisseur*, August, 1973.

Swan, A. *The Woman at Home. Annie S. Swan's Magazine*, Vol. I, 1894.

Swain, M. 'Mrs. J.R. Newbery 1864–1948'. *Embroidery*, Vol. XXIV, No. 4, 1973.

Swain, M. 'Ann Macbeth'. *Embroidery*, Vol. XXV, No. 1, 1974.

'Mrs Newbery's Dress'. *Costume*, No. 24, October, 1978.

Tanner, A. 'Some Scottish Women Artists of the Past'. *Chapman*, Vol. VI, No. 3–4, 1980.

Tufts, E. 'Beyond Gardner, Gombrich and Janson: Towards a Total History of Art'. *Arts Magazine*, Vol. LV, April, 1981.

Waddell, J.J. 'Some Recent Glasgow Tea Rooms'. *Builders' Journal and Architectural Record*, Vol. 17, 1903.

Walton, W. 'To Triumph before Feminine Taste—Bourgeois Women's Consumption and Hand Methods of Production in Mid-Nineteenth Century Paris'. *Business History Review*, Vol. LX, No. 4.

Wolf, T.L. 'Women Jewellers of the British Arts and Crafts Movement'. *Journal of Decorative and Propaganda Arts*. Autumn, 1989.

THE STUDIO

1896 Gleeson White, 'The Arts and Crafts'. Vol. IX, pp. 189–205.

1897 Gleeson White, 'Some Glasgow Designers I'. Vol. XI, pp. 86–100.

1897 Gleeson White, 'Some Glasgow Designers II/III'. Vol.XII, No. 55, pp. 47–51.

1899 'Review Notice: Glasgow School of Art Club'. Vol. XV, pp. 277–280.

1900 'Glasgow School of Art'. Vol. XIX, pp. 53–55.

1900 'Some Work by the Students of the Glasgow School of Art'. Vol.XIX, pp. 234–240.

1901 'Glasgow International Exhibition III'. Vol.XXIII, No. 102, pp. 237–244.

1901 'First International Studio Exhibition Part I'. Vol.XXIV, No. 105, pp. 172–187.

1902 'Some Work by the Students of Glasgow School of Art'. Vol. XXIII, No. 86, p. 239.

1902 'Review of Annual Exhibition Glasgow School of Art'. Vol. XXIV, No. 106, pp. 288–289.

1902 'Exhibition of the Royal Glasgow Institute of the Fine Arts'. Vol. XXV, pp. 204–209.

1902 E. Thovez, 'The First International Exhibition of Modern Decorative Art at Turin', Vol XXVI, p. 46–48.

1902 'International Exhibition of Modern Decorative Art (Turin)' Vol.XXVI, No. 112, pp. 91–103.

1902 Francis Newbery, 'An Appreciation of the Work of Ann Macbeth'. Vol. XXVII, No. 115, pp. 40–49.

1903 'Some Experiments in Embroidery'. Vol. XXVIII, No. 122, pp. 279–284.

1903 'Francis Newbery on Ann Macbeth'. Vol. XXIX, pp. 40, 213–214.

1903 'Glasgow Studio Talk'. Vol. XXIX, pp. 213–214.

1905 'Review Christmas Exhibition at the John Baillie Galleries, London'. Vol. XXXIV, No. 144, pp. 168–170.

1905 'Review John Baillie Galleries Exhibition'. Vol. XXXVI, No. 152, pp. 161–162.

1906 'On the work of Annie French'. Vol. XXXVIII, No. 160.

1906 Ludwig Hevesi. *Special Number: The Art Revival in Austria*.

1906 'Review Arts and Crafts Exhibition'. Vol. XXXVII, No. 156, pp. 129–144.

1906 J. Taylor, 'Modern Decorative Art In Glasgow'. Vol. XXXIX, pp. 31–36.

1907 'Annie French'. Vol. XLII (No. 176).

1908 'Mr C. R. A. Voysey's Architecture'. Vol. XLII, p. 25.

1908 'Crafts Exhibition, Liverpool'. Vol. XLIV, p. 291.

1909 Vol. XLVII, pp. 156–158.

1910 J. Taylor, 'The Glasgow School of Embroidery'. Vol. L, No. 208, pp. 124–135.

1910 'Glasgow Studio Talk'. Vol. L, pp. 249, 250.

1912 'Glasgow Studio Talk'. Vol. L, No. 208, pp. 249–250.

1912 'Glasgow Studio Talk'. Vol. LVI, No. 234, pp. 318–321.

1912 'Review Notice: Educational Needlecraft'. Vol. LVI, p. 338.

1913 'Annie French'. Vol. LVIII, No. 241.

1916 'Glasgow Studio Talk'. Vol. LVII, pp. 262–266.

1916 J. Taylor. 'Glasgow School of Art'. Studio Yearbook.

1917 *The Studio Yearbook of Decorative Art*, pp. 79, 122–123.

BIBLIOGRAPHY

NEWSPAPERS

The Bailie
November, 1894.

The Bulletin
'Obituary: Dorothy Carleton Smyth', 16th February, 1933.
23rd September, 1931.

The Daily Telegraph
3rd October, 1896.

Evening Times
'In the Haunts of Art'. 5th February, 1895.

'Architect and Artist: Work of Charles Rennie Mackintosh, Memorial Exhibition in Glasgow'. March, 1933. Glasgow School of Art Press Cutting Books.

'Glasgow Should Honour Charles Mackintosh'. 1933 Glasgow School of Art Press Cutting Books.

Glasgow Evening News
13th April, 1895.

'The New Woman in Art'. 13th November, 1894.

'Letter to the Editor'. 16th November, 1894.

22nd May, 1895.

29th June, 1931.

Glasgow Evening Times
15th December, 1902.

Glasgow Herald,
Kelvin, J. 'Clubs and Women'. 11th March, 1897 and 28th March, 1936.

Downie, A. 'Portrait of A Lady Artist'. *The Woman's Herald.* 9th September, 1982.

The Liverpool Courier
Review Article, 29th August, 1896.

Review Article, 2nd May, 1908.

Review Article, 10th April, 1912.

The Liverpool Daily Post and Mercury
1st May, 1908.

Quiz
15th November, 1894.

Record
'Review Notice: School of Art Club', 11th November, 1901.

The Sketch
'Midsummer Night's Dream', 11th February, 1914.

The Tatler
'Midsummer Night's Dream'. 18th February, 1914.

The Times
London, 16th May, 1898.

Art Journal
Special Number, 1888.

The Westminster Gazette
10th May, 1899.

DISSERTATIONS

Banks, L. *Painters of Trifles: Women In Scottish Art History.* Glasgow School of Art, 1984.

Brady, S. *Book Illustrations of Jessie M. King.* Glasgow School of Art, 1986.

Burkhauser, J. *'Glasgow Girls': Women in the Art School, 1880–1920.* Glasgow School of Art, 1988.

Gordon, E. *Women and the Labour Movement in Scotland, 1850–1914.* PhD thesis, Faculty of Social Sciences, University of Glasgow, 1985.

Keir, L.J. *Charles Rennie Mackintosh as a Designer of Interiors and Textiles.* Glasgow School of Art, 1983.

Slack. J. *An Examination of the Work of Annie French.* Glasgow School of Art, 1988.

OTHER SOURCES

PERSONAL INTERVIEWS

Mary Armour
Lady Alice Barnes
John Blackie, Esq.
Jean Stewart Brown
Ruth Hedderwick
James Macaulay
Kathleen Mann
Grace Melvin
W.G. Morton
Jane Parkes
George Rawson
Dr Gillian Rodgers
Jean Smith
Ailsa Tanner

REPORTS, PROCEEDINGS AND PUBLIC LECTURES

'An account of the Opening Ceremonies', The Scottish Arts Club, 1894. Jessie M. King Collection, Special Collections, University of Glasgow Library.

Baillie, Martin. Commentary on the 1976 Helensburgh and District Art Club's Twenty-fifth Anniversary Loan Exhibition.

Bird, E. Design index, University of Glasgow Special Collections Library.

The Bookbinders and Machine Rulers' Consolidated Union Trade Circulars and Reports. 1896–1900.

Crum, H.E. 'Speech'. *Glasgow Mechanics Institute Report,* 1841, University of Strathclyde Archives.

Drapers' Record, 27th August, 1887 and 24th December, 1887.

Ferguson, R. 'Scottish Home Industries Association'. *Transactions of the Edinburgh Art Congress.* Edinburgh, 1890.

Irwin, M. 'Women's Industries in Scotland'. *Proceedings of the Philosophical Society of Glasgow.* 1895.

Mackintosh, C.R. Lecture. 'Seemliness', January, 1902. Hunterian Art Gallery, University of Glasgow.

Newbery, F. 'The Place of Art Schools in the Economy of Applied Art'. Address to the National Association for the Advancement of Art and its Application to Industry, London, 1890.

Robinson, H. and Students. *Women In Art Seminar.* Unpublished Statistics. Glasgow School of Art Department of Historical and Critical Studies, December, 1987.

'The Schools of Design'. *House of Commons Select Committee Report.* 1849. pp. 369–370 appendix.

Tate Gallery Archives. Minutes of the Council Meeting. International Society of Painters, Sculptors and Gravers. December, 1897 and February, March, 1899.

Transactions of the National Association for the Advancement of Art and its Application to Industry. Edinburgh meeting, London, 1890.

Walker, L. 'Women in Design' Conference, University of Edinburgh, 1989.

CORRESPONDENCE

Dewar, D.L. Letters to her parents in Ceylon, 1903–1906. Collection of H.L. Hamilton.

French, A. Letter to V. Gordon, 5th May, 1954. Glasgow Museums and Art Galleries.

Gray, N.N. Correspondence between Gray and Mr Yockney, 30th July, 1919. Imperial War Museum.

Kay, K.C. Letter to Douglas Percy Bliss, 15th March, 1949. Glasgow School of Art.

Mackintosh, C.R. Letters to Margaret Macdonald Mackintosh, 1927. Hunterian Art Gallery, University of Glasgow.

Mackintosh, C.R. Letter to Hermann Muthesius, 27th March, 1903. Hunterian Art Gallery, University of Glasgow.

MacNicol, B. Letters to E.A. Hornel, 1897, in the Broughton House Collection. Hornel Trust.

Newbery, J.R. Letter to Mrs Randolph Schwabe, 12th January, 1933.

Shand, P.M. Letter to William Davidson, 31st March, 1933. Hunterian Art Gallery, University of Glasgow.

Letter to William Davidson, 7th April, 1933. Hunterian Art Gallery, University of Glasgow.

MISCELLANEOUS

Dewar, D.L. 'War Diary', 1943. Strathclyde Regional Archives, Mitchell Library.

French, A. Unpublished sketchbook, c.1948. Collection of Glasgow Museums and Art Galleries.

Glasgow School of Art Annual Reports, 1847– to present, Glasgow School of Art, Mackintosh Library.

Glasgow School of Art Prospectuses, 1880–1920. Glasgow School of Art Library.

Glasgow School of Art Staff Lists. Glasgow School of Art.

Imperial War Museum Archives, London

King, J.M. 'Lecture on Design'. King Collection. Special Collections, Glasgow University Library.

University of Glasgow Archives.

University of Glasgow Special Collections Library.

PRESS CUTTING BOOKS

Mitchell Library, Glasgow.

Glasgow School of Art Collection.

Jessie M. King Collection, Special Collections, University of Glasgow.

PHOTOGRAPHS — Major Sources

T. & R. Annan and Sons, Ltd, Glasgow.

Glasgow Museums and Art Galleries, Glasgow.

Barclay Lennie Fine Art.

Glasgow School of Art, Mackintosh Library Archives.

Glasgow School of Art, Mackintosh Collection.

The Hunterian Art Gallery, Mackintosh Collection.

The People's Palace, Glasgow.

FOR FURTHER READING

BOOKS

Abbate, F. ed. *Art Nouveau: Style of the 1890s*. London and New York, 1972.

Bachmann, D. and S. Piland. *Women Artists: An Historical, Contemporary and Feminist Bibliography*. Metuchen, NJ, 1978.

Cavallo, A.S. *Needlework*. New York, 1979.

Clement, C.E.W. *Women in the Fine Arts from the Seventh Century B.C. to the Twentieth Century A.D.* Boston, 1904.

Hess, T. and C. Baker. *Art and Sexual Politics*. New York, 1973.

Johnson, D. *Fantastic Illustration and Design in Britain, 1850–1930*. Providence, RI, 1979.

Johnson, J. and A. Greutzner, eds. *Dictionary of British Artists, 1880–1940*. Suffolk, 1976.

Jones, M.E. *A History of Western Embroidery*. London, 1969.

Marsh, J. *Pre-Raphaelite Sisterhood*. London, 1985.

Miles, R. *The Women's History of the World*. Boston, 1988.

Scottish Arts Council. *Jessie M. King, 1875–1949*. Catalogue by Cordelia Oliver, Edinburgh, 1971.

Snyder-Ott, J. *Women and Creativity*. Millbrae, CA.

Sotheby, Parke Bernet and Co. *Sale Catalogue: Frances Macdonald and Margaret Macdonald*. New York, 1980.

Sparrow, W.S. *Women Painters of the World*. New York, 1905.

Waddell, R. ed. *The Art Nouveau Style in Jewelry, Metalwork, Glass, Ceramics, Textiles, Architecture and Furniture*. New York, 1977.

Waters, G.M. *Dictionary of British Artists Working 1900–1950*. Eastbourne, 1975.

Whitworth Art Gallery. *British Sources of Art Nouveau: An Exhibition of 19th and 20th Century British Textiles and Wallpapers*. Manchester, 1969.

Wittlich, P. *Art Nouveau Drawings*. London, 1974.

Women's History Research Center. *Female Artists Past and Present*. Berkeley, CA, 1974.

CONTRIBUTORS

Louise Annand: President, Glasgow Society of Women Artists; a member of the Royal Commission on Fine Arts for Scotland. Former Museum Education Officer, Glasgow Art Galleries and Museums, Artist/film and video productions including 'Jessie M. King'.

Mary Armour: Honorary President Glasgow School of Art. Attended Glasgow School of Art from 1920–25. LLD Glasgow University, RSA, RSW, RGI. Awarded the Guthrie Award 1957.

Liz Arthur: Curator, Costume and Textile Collections, Camphill House, Glasgow Art Gallery & Museums. Author 'Kathleen Whyte Embroiderer' (1989), numerous articles on Glasgow Style Embroiderers and with Fiona MacFarlane the catalogue for the exhibition *Glasgow School of Art Embroidery*, 1980.

Dr. Elizabeth Bird: Faculty, University of Bristol, Department of Continuing Education, author 'Ghouls & Gas Pipes : The Early Work of The Four', and 'Threading the Beads : Women and Art in Glasgow 1880–1920', *Uncharted Lives*, University of Glasgow. Established Design Index, University of Glasgow Special Collections. D. Phil. Sussex University, thesis: 'Cubism and the End of Individualism'.

Jude Burkhauser: Curator & Organiser, 'Glasgow Girls' 1990 Exhibition Project; Research Scholar, Glasgow School of Art 1990; Post Graduate Diploma '88; author Glasgow Girls': Women in the Art School, 1880–1920. Museum Studies Degree, New York University; BS Art, Moore College Art & Design (USA) MLS, Rutgers University (USA); Designer commissioned public Art-in-Architecture mosaics and fiber art installations; exhibited internationally.

Anne Ellis: Lecturer, Department of Adult and Continuing Education, University of Glasgow. Consultant, 'Design for Living' Exhibition, National Trust for Scotland. Resident Representative, The Hill House, Helensburgh.

Janice Helland: Assistant Professor Art History, Department of Visual Arts, Sir Wilfred Grenfell College, Memorial University, Corner Brook, Newfoundland, Canada. Ph.D. University of Victoria, Canada, dissertation (in progress) *The 'New Woman' in Fin-de-Siècle Art: Margaret and Frances Macdonald*.

Dr. Thomas Howarth: Architect; FRIBA, FRAIC, Hon. FAIA., Hon. Doctorate University of Stirling. Professor Emeritus, Department of Architecture, University of Toronto, Canada. World renowned scholar on Charles Rennie Mackintosh and his contemporaries. Author, Charles Rennie Mackintosh and the Modern Movement, 1952.

Juliet Kinchin: Lecturer, Department of the History of Art, University of Glasgow. (Course director, Christie's Decorative Arts Progamme, University of Glasgow.) Formerly worked for Glasgow Art Gallery and Museum and the Victoria and Albert Museum. Author of numerous publications, including *Glasgow's Great Exhibitions, The Glasgow Style* (co-author), 'The Wylie and Lochhead Style', 'Glasgow-Budapest 1902'. MA University of Cambridge, MA University of London, Courtauld Institute.

Jonathan Kinghorn: Curator, Pollok House and Assistant Keeper Furniture and Woodwork, Glasgow Museums and Art Galleries.

Ray McKenzie: Lecturer, Department Historical & Critical Studies, Glasgow School of Art. Co-founder 'Street Level' photography gallery and studio, Glasgow.

Ian Monie: Principal Librarian, Glasgow School of Art. Formerly Principal Librarian at Scottish College of Textiles. Secretary of Education Committee of Art Libraries Society, 1983–1986. Has contributed articles to Scottish Library Association News and Art Libraries Journal. M. Sc., F.L.A.

Timothy Neat: Art Historian and Filmmaker. Tutor at Duncan of Jordanstone College of Art, Fife, 1973–1988. His award-winning films include: *Hallaig* (Best New Director, Pascoe MacFarlane Award, 1985), *The Tree of Liberty* (Best Documentary, Celtic International Film Festival, 1987) *Play Me Something* (Europa Prize, Best Film, Barcelona Film Festival, 1989).

Adele Patrick: BA, MA Glasgow School of Art, Lecturer (Britain, W. Germany, America), writer, research (women's work in contemporary Visual Arts in Britain and Czechoslovakia). Joint co-ordinator of WOMEN IN PROFILE, Glasgow 1987–1990. Involved in co-ordination and research for Women's Season and International Conference, September, 1990.

Catriona Reynolds: MA Art History, Aberdeen University; formerly Phillips Fine Art Auctioneers, Glasgow, as specialist in late nineteenth and early twentieth-century art, especially Glasgow Style. Descendant of the Gray family.

Pamela Robertson: Curator, Mackintosh Collection, Hunterian Art Gallery & Museum, University of Glasgow. Curator/ author of *Margaret Macdonald Mackintosh* exhibition and catalogue, and numerous other articles on the Mackintosh circle.

Hilary Robinson: Freelance writer and lecturerer. Part-time tutor, Glasgow School of Art. Edited *Visibly Female: Feminism and Art Today*, 1987. MA by thesis, Royal College of Art. Thesis title: *The Subtle Abyss: Sexuality and Body Image in Contemporary Feminist Art*. Has written for various art magazines.

Ailsa Tanner: Artist and Freelance Exhibition Organiser and Author, 'West of Scotland Women Artists', 'A Centenary Exhibition to celebrate the founding of the Glasgow Society of Lady Artists in 1882' and others. MA Fine Art, Edinburgh University, DA Edinburgh College of Art.

Susan Taylor: BA History of Art and Design, Leicester Polytechnic. *Peter Wylie Davidson, 1870–1963, A Glasgow Craftworker*', unpublished BA dissertation, 1990.

Bille Wickre: Ph.D candidate, University of Michigan, (USA) History of Art, dissertation (in progress) *Collaboration in the Work of 'the Four'*, MA University of Iowa.